Pelican Books
Greek Art: Its Development, Character and Influence

R. M. Cook was born in 1909 and educated at Marlborough College and Cambridge University. He was lecturer at Manchester University and was made the Laurence Reader on Classical Archaeology at Cambridge University in 1945, an Ordinary Member of the German Archaeology Institute in 1953 and was Laurence Professor of Classical Archaeology at Cambridge University from 1962 until 1976. He was made a Fellow of the British Academy in 1976. Among his publications are *Greek Painted Pottery* (1960), *The Greeks till Alexander* (1962) and, with Kathleen Cook, *Southern Greece: An Archaeological Guide* (1968).

R. M. COOK

GREEK ART
Its Development, Character and Influence

PENGUIN BOOKS

PENGUIN BOOKS

Published by the Penguin Group
27 Wrights Lane, London w8 5tz, England
Viking Penguin Inc., 40 West 23rd Street, New York, New York 10010, USA
Penguin Books Australia Ltd, Ringwood, Victoria, Australia
Penguin Books Canada Ltd, 2801 John Street, Markham, Ontario, Canada l3r 1b4
Penguin Books (NZ) Ltd, 182–190 Wairau Road, Auckland 10, New Zealand

Penguin Books Ltd, Registered Offices: Harmondsworth, Middlesex, England

First published by Weidenfeld & Nicolson 1972
Published in Pelican Books 1976
10 9 8 7 6

Made and printed in Great Britain by
Richard Clay Ltd, Bungay, Suffolk
Set in Monotype Perpetua

CONTENTS

LIST OF ILLUSTRATIONS

65 'VENUS DI MILO'. Late second century. Marble. Height 2·04 m. *Paris, Louvre* 399

66 *a, b* DYING GAUL (cast). Roman copy of original of late third century. Marble (but the original was probably of bronze). Height 93 cm. *Rome, Capitoline Museum* Glad. 1

67 *a, b* PARTS OF MAIN FRIEZE OF GREAT ALTAR AT PERGAMUM. Artemis and Night attacking Giants. *c.* 180–60. Marble. Height 2·30 m. *Berlin, Pergamon Museum*

68 THE LAOCOON. *c.* 50–25. Marble. Height (from foot of right-hand boy) 1·87 m. *Rome, Vatican*

69 *a* ARCHAIC SEAL (impression). Mid seventh century. Ivory. Diameter 4·4 cm. *Athens, National Museum* (Perachora A34)

69 *b* ISLAND GEM (impression). Early sixth century. Grey serpentine. Max. diameter 2·5 cm. *British Museum* Cat. 162

69 *c* SCARABOID (impression). Early fifth century. Rock crystal. Max. diameter 2 cm. *British Museum* Cat. 538

69 *d* SCARAB (impression). *c.* 525. Rock crystal. Max. diameter 2·1 cm. *Hanover* 1965.6

69 *e* SCARABOID (impression). *c.* 500. Chalcedony. Max. diameter 1·7 cm. *New York, Metropolitan Museum* 31.11.5

69 *f* SCARABOID (impression). *c.* 400. Mottled jasper. Max. diameter 2·3 cm. *Syracuse*

69 *g* SCARABOID (impression). By Dexamenos, *c.* 440–30. Red and yellow mottled jasper. Max. diameter 2 cm. *Boston, Museum of Fine Arts* 23.580

69 *h* RINGSTONE (impression). Perhaps first century. Cornelian. Max. diameter 2·1 cm. *Boston, Museum of Fine Arts* 27.713

69 *i* RINGSTONE (impression). Perhaps third century. Garnet. Max. diameter 2·6 cm. *Boston, Museum of Fine Arts* 27.710

Berlin refers to the Museum at Charlottenburg in West Berlin; the Pergamon Museum is in East Berlin

ACKNOWLEDGMENTS

The casts illustrated on plates 69b-i belong to Mr J. Boardman, who made them. The other casts are in the Museum of Classical Archaeology in Cambridge (plates 34d,36a-b,42a-b,44a-c,45a-b,47a,49a-b,51a,54, 57a,59,60a,66,69a.)

German Archaeological Institute Athens 1a,b,c,2,3,4a,6b,8,39,41b, 70b,c

J.N. Coldstream 4b

Department of Ancient History and Archaeology, Birmingham University 4c

National Museum, Naples 5a

British Museum 5b,f,12a,14,23a,b,25b,51b,52,57b,61a,b,71a,c

Museum of Fine Arts, Boston 5c,d,24,62a,b

Allard Pierson Stichting, Amsterdam 5e,27a

Jahrbuch des Deutschen Archaeologischen Instituts 1888, pl. 3 6c

Revue Archéologique 1898, 213 fig. 2 7a

Archäologische Zeitung 1883, pl. 10.1 7b

Antike Denkmäler ii, pl. 44 7c

Athenische Mitteilungen 1905, pl.8 7d

Giraudon 9,10b,16b,72

A. Furtwängler and K. Reichhold, *Griechische Vasenmalerei* iii, pl.121 10a i, pl.11-12 11a

Soprintendenza Antichità, Florence 11b

Metropolitan Museum, New York 12b,18,25a,27b,37a,b,63b,c

Alinari 13,30b,31b,32

Staatliche Antikensammlungen und Glyptothek, Munich 15,19, 20,26,38a,b

Staatliche Museen, Berlin (West) 16a,34b,70a,71b

Martin von Wagner Museum, Würzburg 17a,21a,b

Service de Documentation de la Réunion des Musées Nationaux 17b, 22

Antike Denkmäler ii, pl.51.2 28

UDF, la Photothèque 28b

F. Weege, *Etruskische Malerei*. Beil.1 29a

Monumenti della Pittura antica scoperti in Italia i.2, pl.C 29b

A. Maiuri, *Roman Painting*, pl.10 30a, pl.37 31

Vatican Museums 33a

K. Woermann, *Die antiken Odyssee-Landschaften*, pl.6 33b

American School of Classical Studies, Athens 34a,62c,d

Hirmer 34c,35a,43a,b,50a,53,55,56,58,61c,d,64,65,68

Ephemeris Archaiologike 1937, 303 fig.1b 35b

Staatliche Museen, Berlin (East) 40a,b,67a,b

G. Rodenwaldt, *Korkyra* ii, pl.1 46a

D. Ohly, *Die Aegineten*, Beilage C, 46b

ILLUSTRATIONS

ACKNOWLEDGEMENTS

In writing this book I have had to learn and think about areas of
Classical Archaeology which till then I had neglected and my
indebtedness to others is that much the more. My wife, Mrs K.
Cook, whose visual memory is better than mine, has answered
a great many questions of fact and opinion. Mr M. H. Bräude and
Dr W. H. Plommer have read large parts of the text and given
me their advice. Mr J. N. Coldstream, Mr M. H. Crawford,
Professor M. I. Finley, Mr D. E. L. Haynes and Dr R. A.
Higgins also have read parts of the text and advised me. On
particular points I have had criticism and information from Dr
D. Ahrens, Professor E. Akurgal, Professor B. Ashmole, Mr J.
Boardman, Dr D. von Bothmer, Mr B. F. Cook, Professor P. E.
Corbett Dr J. J. Coulton, Mr V. R. d'A. Desborough, Professor
P. Grierson, Professor J. M. Hemelrijk, Professor R. J.
Hopper, Dr N. Kunisch, Dr J. V. Noble, Professor P. J. Riis,
Professor C. M. Robertson, Dr H. Scharmer, Mr J. E.
Sharwood Smith, Mr A. F. Stewart, Professor R. A.
Tomlinson, Professor C. C. Vermeule, Dr J. B. Ward-Perkins
and Dr G. B. Waywell. In procuring illustrations I have been
helped too by Dr G. Beckel, Professor N. Himmelmann-
Wildschutz, Professor E. Langlotz, Dr C. J. Makaronas, Dr
P. M. Petsas, Professor H. S. Robinson and Dr D. Willers.
Mr E. E. Jones has taken many photographs of casts and from
books. Mrs G. J. Blake has typed the text. To all these
persons and to others whose names are omitted as well as to
the owners of copyright mentioned in the photo
acknowledgements I offer my very warm thanks.

PRELIMINARY NOTES

The dates mentioned in this book are mostly BC and so, unless there is a risk of ambiguity, 'BC' is omitted. Conversely most dates AD are marked 'AD'.

Heights of statues usually include the plinth or, if it is low, the base. Measurements in the captions are metric, as has been regular in Classical Archaeology for at least a generation.

1 INTRODUCTION

Historical Background

By Greek art is usually meant the art of Greek-speaking peoples (except in Cyprus) from the eleventh to the first century BC, that is from the beginning of the Iron Age till the establishment of the Roman Empire. This restriction in time is less arbitrary than it may seem. The Mycenaean civilization of Late Bronze Age Greece used Greek as its language; but its architecture, of unknown origins, and its art, largely derived or adapted from Minoan Crete, followed different principles and what survived into the Iron Age was little and unimportant. At the other end Greek art and architecture both were basic constituents of their Roman successors and also continued for a time more or less independently, but Rome was now the centre of patronage and there were changes in aesthetic direction. Those who jib at so narrow a definition of the term 'Greek' can use 'Hellenic', since it was in the early Iron Age that the Greeks came to call themselves Hellenes: the Bronze Age then can be 'Prehellenic', and the Roman period 'Greco-Roman' or 'Hellenistic-Roman'. As for Cyprus, where there were Phoenicians and older inhabitants as well as Greeks, it belonged because of its position to the Eastern and not to the Aegean world, and the art of its Greek cities shows this unhappy connection till the third century, when the Eastern world had now been subjected to Greek domination.

When in the twelfth century the Mycenaean kingdoms collapsed, civilization in Greece receded abruptly to a peasant level. Most of the arts and architecture ceased completely, since they no longer had patrons, and it is only in humbler lines, especially pottery, that any continuity can be traced. There was, though, an extension of the territory occupied by Greeks. The Mycenaeans had spread to Crete, where the Minoans spoke a different language, to Rhodes and perhaps a few places along the west coast of Anatolia,

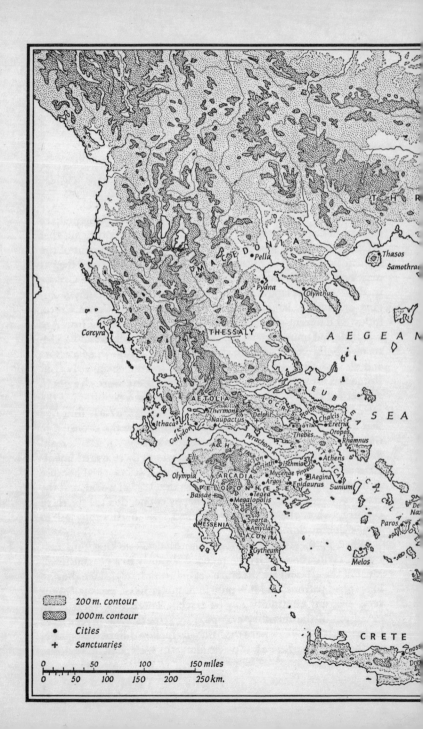

200 m. contour
1000 m. contour
• Cities
+ Sanctuaries

0 50 100 150 miles
0 50 100 150 200 250 km.

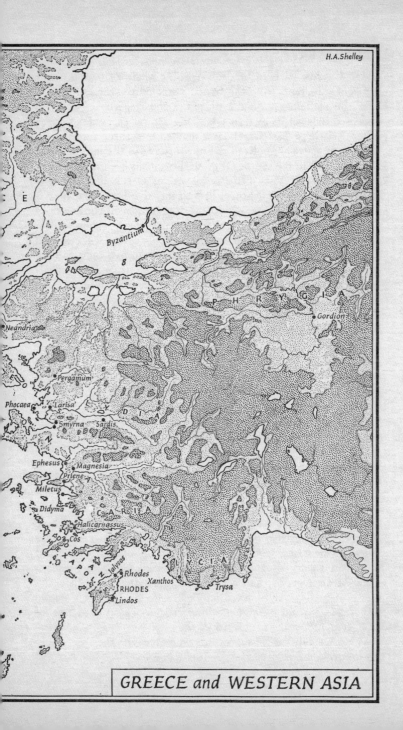

H.A.Shelley

E

Byzantium

P H R Y G I A

Gordion

Neandria

Pergamum

Phocaea
Larisa
L Y D I A
Smyrna Sardis
Ephesus Magnesia
Priene
Miletus
Didyma
C A R I A
Halicarnassus
Cos
Idyros
Rhodes L Y C I A
Xanthos
RHODES Trysa
Lindos

GREECE and WESTERN ASIA

and to Cyprus. Early in the Iron Age, for whatever reason, small bands of emigrants from the Greek mainland reinforced or took over the settlements on the islands of the Aegean Sea and also occupied most of its eastern side. This latter area, which may be called Asiatic or East Greek, was divided into three series of independent states – Aeolis in the north, Ionia in the middle and a Dorian group in the south. Of these the Ionians became much the most important. Very little is known of Greek life from the eleventh to the ninth century. Presumably there was a fairly self-sufficient rural economy, a political system of small communities dominated by landed aristocracies, recurrent aggression against neighbouring territory, and a little trade for essential metals and foreign luxuries; of local products which survive only painted pottery (in which Athens was the leader) and ornamental metalwork can be reckoned as art, and sculpture and architecture did not even exist. This period, the Early Iron Age, is often called the Geometric, a term borrowed from students of vase painting, though they now divide it into a Protogeometric and a more restricted Geometric phase.

In the eighth century a profound economic change becomes evident. Prosperity increased and there was a greater pressure of population, conditions that are not contradictory if they affect different classes. One consequence was emigration. From about 750 to about 600 new Greek settlements were founded along the coasts of South Italy and Sicily and as far away as Marseilles and Ampurias beyond the Spanish frontier; their inhabitants are called collectively the Western Greeks and their regional art, in so far as they reached that stage, was a rather provincial version of that of Greece itself. There were other settlements at the northern end of the Aegean, along the straits and the Sea of Marmara and finally (continuing here in the sixth century) round the Black Sea. These colonies, as they are called although from the beginning they were independent states, soon affected the economy of their homeland; most had a surplus of corn or other raw materials but wanted manufactured goods, and so some of the cities of Greece and western Anatolia could develop industry – admittedly in a simple way – and expand beyond the limits set by local production of food. The increasing prosperity of the eighth century, which began before colonization, appears in commerce with the East, partly for luxuries and partly for more useful commodities like flax and

linen. In the earlier Iron Age a few Eastern objects had been brought to Greece, whether by Phoenician and Syrian and Cypriot traders or even by Greek seamen; but by the beginning of the eighth century Greek merchants from the Aegean – so excavation shows – were living in Al Mina and elsewhere in coastal Syria (including Phoenicia), some North Syrian craftsmen set up in Greek lands, and Eastern metalwork and other objects of art were being imported more regularly. In general the source of these imports was again North Syria and Phoenicia and, though their style includes some Egyptian motives, these came at second-hand: Egypt, it seems, was hardly visited by Greeks before the mid seventh century and regular commerce does not appear for another generation. This needs stressing, since the old fallacy that Greece learnt its arts from Egypt is always cropping up.

When the Greeks began to take notice of Eastern art – perhaps as much from dissatisfaction with their native products as captivated by something not entirely new – its style and often its technique were much more sophisticated than their own, but fortunately – except in a few transient instances – they did not copy, but adapted and developed independently. The reason is not likely to have been innate good sense; rather the Eastern works came from a bewildering variety of schools and were not generally available to craftsmen for intimate study, since such imports were too expensive for them to possess nor had they travelled themselves in the East. Anyhow, the influence of Eastern models shows itself at different times and in different forms in the various Greek arts. It appears first around 750 on metalwork, both engraved and in relief. In vase painting it sets in some thirty years later, though since Eastern pottery was not imported the models must have been in other media, especially metalwork. In both metalwork and vase painting the borrowings from the East include a few human types or groups, such as the hero fighting a lion and later the 'Mistress of the Beasts' (a winged female grasping a small lion or a large bird in each hand); but the staples are a new range of animals and monsters and, for the first time since the Mycenaean period, floral and vegetable ornaments. In Greek art, which made the human figure its principal task, animal and floral designs normally remained decorative in character and of minor importance and this Orientalizing style, as it is called, was very soon a sideline, even though a popular one in vase painting till the sixth century.

GREEK ART

Of early Greek painting, other than on pottery, we know next to nothing; but since large pictures would hardly have been imported, it probably was, as far as Eastern models are concerned, an enlarged and perhaps also a more elaborated version of the style shown in vase painting. In figurines and terracotta reliefs Eastern influences become strong in the early seventh century and may have determined the style of early sculpture, which began soon after, though it is hard to believe that large-size statues were shipped in ready made from Eastern countries or that intending Greek sculptors went there to study. For architecture, which cannot be traced further back than 700, direct knowledge of Eastern work is still less likely, though as with sculpture Greek travellers who had seen such novelties no doubt created a desire for them and there were of course some Mycenaean remains still above ground. The pioneer of the new movements in both art and architecture seems to have been Corinth, which because of its position was becoming an important commercial city; Crete, though perhaps quicker to produce Orientalizing work, was mostly tentative and ineffectual.

In general the effect of the Eastern styles was to provide new standards rather than new models, and during the Archaic period (which archaeologists usually date from about 720 to 480) Greek art progressed steadily, if not altogether with uniformity. Painted pottery, being cheap to make, had a big enough market to support workshops in any sizable city, so that local schools could develop; even so the competition first of Corinthian and then of Attic exports gradually imposed itself and by 500 local production had been almost completely suppressed, except in distant Etruria. On the other hand for sculpture and architecture, where costs were high and demand much smaller and more selective, experts could be called in from another city and, though there were marked regional differences between European and Asiatic Greek, local differences within regions never had much positive significance. As for progress in quality, Greek artists unlike their contemporaries in the East were interested in a more accurate understanding and representation of the human figure. During the second half of the sixth century they took the lead and, when near the end of that century they broke with the convention (till then universal) that every part of a figure should be in strictly profile or frontal view, their superiority began to be recognized by Easterners

too. Again it is naive to suppose that the reasons were genetic. What is important is that the Archaic Greeks were not too much exposed to the inert weight of Eastern traditions and had no religious or court conventions which stopped them experimenting, although once a type had been fixed – usually at a very early stage – artists and architects restricted themselves for generations to improvements within that type, not unnaturally since their training had been as assistants in the workshops of practising masters.

It is not at all clear how much the development of Archaic art was affected by other changes in Greek life. In economically advancing states a new group which had made its fortune in commerce was soon claiming a share of power and in time poorer classes too became active. The political struggles were long and bitter and usually led to a generation or two of dictatorship ('tyranny' in the Greek vocabulary); but by the end of the sixth century the normal constitution, though often fluctuating, was either oligarchy, that is the rule of the rich, or democracy, where a larger part or the whole of the citizenry had equal rights. Even so, the old aristocratic families, though they had lost their political monopoly, kept their land – then the only reliable and respectable form of wealth – as well as the prestige due to their ancestry; and the Greek ideal remained aristocratic, a condition of mind that affected not only social attitudes and ultimately economic development, but also the content of art. All the new kinds of government encouraged civic pride, to the benefit of architects and sculptors, while the emergence of a middle class increased private patronage of the less expensive arts. As for external pressures, most Greek states were small communities consisting of an urban centre and a tract of land round it, and they were jealously and often acquisitively independent; though very conscious of a common culture and ready to support exclusive festivals for Greeks (as at Olympia and Delphi), they had little feeling of national unity and would cheerfully collaborate with non-Greeks to down a Greek enemy. That this system survived as long as it did in European Greece shows how little danger there was from foreign aggressors. Greek Asia was less fortunate. Here the mainland states became subject by the mid sixth century to the Lydians and soon afterwards passed from them to the Persians, who annexed some of the islands too; but though they restricted independence, both

the Lydians and the Persians were tolerant suzerains and economically the East Greek cities benefited by peace and wider markets. On the style of Greek art, which by now was justly self-confident, these conquests had no effect and indeed influence was the other way. Later the Persians pushed forward into Thrace and in 490 and again on a grander scale in 480 invaded Greece itself, though unsuccessfully. In the west the Greeks of Sicily were embroiled from time to time with the Carthaginians, but in South Italy the native peoples did not assert themselves till the fourth century and then only because the Greek states were weakened by their wars with one another. Here again artistically the Greeks were the givers. North of the Bay of Naples Greek expansion was stopped by the Etruscans, a people of uncertain antecedents, who developed a taste for Eastern luxury about the same time as the Greeks and soon, but only in art, became so dependent on them that Etruscan sculpture, engraving and painting (both on walls and on pottery) are virtually provincial Greek, though a more distinct tradition persisted in architecture. This estimate may not please all who admire Etruscan art; but if one subtracts its Greek constituents, what remains is a jumble of mostly incompetent deviations without any positive stylistic unity.

The Classical period extends from 480 to the time of Alexander the Great, who reigned from 336 to 323, and is usually considered the great period of Greek civilization. In 480 the Persians invaded Greece in force, occupied it as far south as Attica and the next year after two defeats withdrew. On the Greek side Athens, which had recently become a democracy, suffered most, since both city and countryside had been devastated systematically, but it now had the biggest and best navy and took the opportunity to organize the Greeks of Asia and other threatened parts in a league for protection against Persia. Within a few years the league was converted into an empire, from which Athens exacted tribute and other advantages. Yet although it was always ready to coerce other Greek states, their citizens were welcome to live and work as aliens in Athens and enjoy its climate of intellectual freedom. So it became not only much the largest and richest of Greek cities, but the centre of activity in literature, thought and the arts. This cultural primacy survived military defeat and the liberation of its subjects in 403. During the fourth century various Greek states jockeyed for political supremacy, till Philip II organized the

half-Greek kingdom of Macedonia in the north and in 338 forced Greece to recognize his supremacy. His son Alexander conquered the Persian Empire as well and died in Babylon in 323.

For the arts too the Classical period can be divided conveniently at the end of the fifth century. Sculpture in its first half had concentrated on the understanding of the new poses, ignoring decorative unessentials, and in its second exploited the suggestive use of drapery; in the fourth century technique and fidelity to natural appearances continued to improve, but even progressive masters seem to have been conscious of a classical past and the course of development became less unified. In architecture the Athenian achievement of the second half of the fifth century set a standard for later generations and, except in Greek Asia (where there was a revival of the local Ionic style), the best work of the fourth century appears to some critics as little more than elegant variation on it. Painting had presumably invented or accepted the new oblique and twisting poses at the end of the sixth century and soon after 480 a grand style began, but its culmination did not come till the later fourth century. Vase painting in the Classical period, though it accepted some innovations, no longer kept up with the progressive arts and when it abandoned human figures about the end of the fourth century can hardly be ranked even as a minor one. It is, though, a rash assumption that the evolution of Classical art and architecture was spiritually determined by historical events. In the arts the revolutionary changes which began the Classical style can be dated securely around 500, so that they cannot have been a result of the defeat of the Persians in 480–79 and some consequent efflorescence of the Greek genius; nor does one need conditions, probably not so widespread, of war-weariness and disillusion to explain any signs of uncertainty and lassitude in the sculpture and architecture of the fourth century. Art, after all, has its own momentum, though it is of course affected by demand. So in architecture the version of Ionic current in Asia suffered from lack of commissions for about a century, since the Greek states there were squeezed between Athens (or Sparta) and Persia from the liberation of 479 to their cession in 386; and in Greece the thorough devastation of Attica offered unusual scope, mainly for Doric, when the rebuilding of its temples began around 450. Further, the concentration of artistic talent in Athens during at least the fifth century is likely to have stimulated progress.

GREEK ART

Alexander the Great crossed into Asia in 334 and in a few years was master of all the lands from Anatolia and Egypt to Afghanistan. When he died unexpectedly in 323, there was no effective heir and his Macedonian generals fought for the succession among themselves, eventually carving out independent and mutually hostile kingdoms. Of these four are important – Syria, Egypt, Pergamum and Macedonia. Syria, the largest, at first included most of the Asiatic territories, but gradually lost the eastern parts; its Seleucid dynasty tried to impose Greek institutions and culture on its subjects and succeeded fairly well in the towns, anyhow with the richer classes. Egypt, under the Ptolemies, usually controlled Cyprus and meddled in the Aegean; here Greek culture was fostered in the new city of Alexandria, but elsewhere Egyptian traditions were recognized officially. Pergamum, the major power in western Asia Minor, and Macedonia with its interests in Greece had no such problems of assimilation. Outside these kingdoms Greece itself, still indulging in its expensive internal warfare, was now a backwater politically and economically, though Athens especially retained its cultural prestige; in the Aegean Rhodes became powerful; and in Sicily and South Italy, though remote from events further East, only Syracuse and Tarentum kept some importance and prosperity. Meanwhile Rome was emerging as the greatest power in Italy and then in the Mediterranean world. During the third century South Italy was conquered and Sicily annexed, in the second century Macedonia and then Greece came under direct rule and the Pergamene kingdom was taken over, and in the first century it was the turn of Syria and Egypt. So the whole Greek world was incorporated in a single empire ruled from Rome. 27 BC, when Augustus imposed a centralized system of administration, is a convenient date for ending the Hellenistic period.

The Hellenistic autocrats took seriously their policy of spreading Greek (or Hellenic) institutions, and indeed it is this Hellenizing that justifies the term Hellenistic. An immediate consequence was a much increased demand for the products of Greek architecture and art, and this led to some lowering of acceptable standards. There were changes in style too, though only for sculpture and architecture does enough survive to judge what they were. It is often said that these changes were evoked by the character of the new age; but they had begun by the middle of the

fourth century and were natural enough at that stage of Greek artistic and architectural evolution, and perhaps too the shifts in political power made less impression on the attitudes of the labouring than of the leisured classes. The effect of the Romans is more certain. In the third century they were brought into close contact with the Western Greeks, in the second they became acquainted with the Aegean lands and received as booty or loot large quantities of statues and pictures, and by the first century, if rich enough, they had acquired an almost obligatory taste for old masters for their private collections. To meet this taste some Greek sculptors turned to the making of copies of older works and others were encouraged in producing adaptations and pastiches. Further, the desire of Roman and Italian patrons for realistic portraits of themselves may have set new aims for a few Hellenistic workshops in Greek lands. Meanwhile in and round Rome itself a more positive direction was being given, first in architecture and then in sculpture, and a distinctive Roman style emerged, though elsewhere and especially in Greece itself Hellenistic traditions persisted more or less untouched.

The Conventional Periods

Historians and archaeologists divide the Greek era into four periods or five if the Early Iron Age is split in two. These divisions are of varying utility, but are too generally accepted to be changed easily. The Early Iron Age is and will probably always be obscure, and of its material remains little except the pottery is known. So it is on pottery that its current divisions are based. The Proto-geometric period, roughly from 1050 (when iron was coming into use) to 900, coincides with the duration of the leading Proto-geometric school of pottery, that of Athens, though in other places Protogeometric began and ended later. The Geometric period, rather less obscure, follows. It too is called after a style of pottery. Its initial date, about 900, is that of the beginning of the dominant Attic school of Geometric pottery, but its end – about 720 – is that given to the beginning of Orientalizing pottery in Corinth. For archaeologists the Protogeometric and Geometric periods, so defined, are reasonably convenient, since they are based on their most prolific material, the pottery; but for

historians the Early Iron Age is better taken as a whole and called by that name, and a terminal date about 750, when the Greek colonization of the West began, is probably more sensible. The next period, the Archaic, conventionally begins about 720 (or 750) and ends with 480, when the Persians made their big invasion of Greece. This invasion and its failure is usually considered a turning point in Greek history and the date has been accepted by archaeologists, partly because the early excavation of the Acropolis of Athens, which was sacked and destroyed by the Persians, provided welcome sealed deposits for dating. Yet later research has shown that the decisive changes that distinguish Classical from Archaic art are a little earlier – in the two-dimensional arts such as vase painting and relief sculpture just before 500 and in free-standing sculpture just before 480, while for architecture the term Archaic makes no stylistic sense, since in Doric there is no significant change after the beginning of the sixth century and we know too little of early Ionic. Still, officially, the Classical period begins in 480 and lasts to some date between 338, when Philip II of Macedonia forced Greece to submission, and 323, when his son Alexander died after conquering the Persian Empire. For historians these events begin a new epoch, but in art and architecture our knowledge is still too uncertain to decide at what point or points a valid division can be made: some experts in sculpture would prefer a transition from Classical to Hellenistic around 350, and in architecture perhaps a change becomes evident about 300. The Hellenistic period, which succeeds the Classical, ends with the establishment of the Roman Empire. 27 BC, when Augustus organized the imperial system and Greece became a Roman province, is historically a reasonable occasion, but for the arts a rather earlier date may prove to be more satisfactory. As knowledge increases, precisely dated periods usually become delusive.

Chronology

For dating any class of objects or monuments archaeologists usually proceed by arranging them in a sequence according to stylistic or technical development and, if excavation reports are available, by stratification or context. This gives what is called a relative chronology – object B, for example, is put later than object A but earlier

than object C. To convert a relative into an absolute chronology, that is a chronology with more or less exact calendar dates, some of the objects or stages in the relative sequence have to be connected with events that are themselves more or less exactly dated in calendar years. For Greece from the Late Bronze Age onwards the fixed dates are historical events, since scientific methods (such as that of radio-carbon) are, anyhow at present, much less exact. Roughly the present position is this. A chronology based on contemporary records, which exists for Egypt and Mesopotamia from the third millennium, does not begin in Greece till the late sixth century; and, though later writers give dates for some events further back, presumably at best estimated by such aids as genealogies, these dates cannot be trusted far, anyhow before the later eighth century. So for the archaeology of the Greek Early Iron Age we depend on fixed dates (accurate probably to about twenty-five years) in the early fourteenth century, when Mycenaean pottery is found in dated contexts in Egypt, and in the middle and later eighth century, when Attic and Corinthian pottery is found in Syria and the West; but so far there is no good absolute fix in the intervening six centuries and the calendar dates given there by archaeologists are in the main based on the supposed rate of stylistic development in painted pottery. For the seventh and sixth centuries there are perhaps half a dozen useful dates – for not all historical events can be connected with archaeological material – and the primary system is still that of painted pottery, to which other arts and architecture are related by style or contexts; for instance the Temple of Apollo at Thermon is dated by the style of its painted metopes, which is close to that of some Corinthian pots, and the Temple of Hera at Olympia is dated by pottery found below it and therefore of earlier date. During these two centuries the margin of error in the absolute chronology lessens, one may reasonably suppose, from about twenty-five to perhaps ten years for some kinds of pottery, though where other objects are dated by stylistic comparison with such pottery there cannot be as much precision. From the fifth century onwards dated historical events are numerous, and enough of them are useful archaeologically; there are a few contemporary records inscribed on stone, such as those which give accounts of work on the Parthenon and Erechtheum at Athens; and ancient writers inform us about the lifetimes of many sculptors and painters and a few

architects, some of whose works have been identified. Even so, most of the remains of Greek art and architecture of this period cannot be dated directly and the method of stylistic development remains important. Painted pottery, now lagging behind the progressive arts, still relies largely on contexts for its absolute dating. For architecture it is the mentions in ancient literature that provide most of the framework. So too with painting, where there is little else to go on, and with sculpture, though here after the fifth century the growing variety in style makes it more difficult to define a convincing relative series. In coinage historical events have a special relevance, but contexts and stylistic comparisons with sculpture are important, as they are also in those other arts of which much less has survived. Generally, the stylistic chronology of art and architecture is secure to ten or fifteen years in the fifth century, in the fourth century the play doubles and for the Hellenistic period experts sometimes differ by as much as a hundred years. Excavation might bring more accuracy to the Early Iron Age, particularly if Greek objects are found in closely datable contexts in the East or closely datable Eastern objects are found in Greek graves. Not much improvement is likely for the seventh, sixth and fifth centuries. For later times further study ought to increase precision, perhaps eventually to twenty or thirty years. Yet even then there will always be room enough for experts to disagree.

Survival

In the middle of the third century AD a large part of the products of Greek art and architecture was still intact. Losses had occurred through decay, fire, earthquakes and other accidents, and many movable objects had been transported, especially to Rome; but generally the works of the past were admired and cared for. In the next three or four hundred years there was a catastrophic change. Invaders from outside the Roman (and later the Byzantine) Empire devastated and looted most ancient sites, population and prosperity fell disastrously, public order weakened or collapsed, and with the establishment of Christianity the old religion was proscribed and pagan culture discouraged. So the time came when, except in Byzantium, there was no sentiment or authority which

could protect the heritage of antiquity, and even in Byzantium very little survived to modern times. The criterion now was utility and the fate of accessible remains depended mainly on their material.

Architecture did not do too badly, since stone is durable. A few ancient edifices continued to be useful, mostly as churches or fortifications, and were maintained after a fashion; the others were regarded as quarries by whoever lived nearby, and still are in some backward districts. Besides this reuse of old blocks, often broken up for new building, marble made good lime. Still, many ancient sites had more stone than the local population ever needed and some ruins were saved by their inaccessibility. Sculpture suffered more. Marble statues set up in public places were readily collected for making into lime and reliefs of all sorts were convenient slabs for paving or walling, but architectural figures and reliefs were often out of reach, as long as the colonnades or walls stood, and later might be buried under debris. As for bronze, the shortage of metal in the Middle Ages is very hard to conceive, till one sees the holes painfully hacked at the joints of many ancient walls to extract the small metal clamps and dowels, though only of iron, which tied the blocks together. Bronze statues contained vastly more metal and here the industry of the scrap-hunter was almost completely successful. Smaller metal objects went the same way, though they had more chance of being overlooked. Pottery, when broken, was good for nothing, though if exposed on the surface it was liable to be crushed or weathered. Paintings on walls and panels were by their nature extremely vulnerable, even when covered by debris, and it is not surprising that nothing of pictorial quality has come down to us above ground. Ancient gems, though, were valued for their material without much regard to their decoration, but they are easily lost and those that have survived in use are all or almost all Roman.

For most works of art and for architectural details the best hope of preservation was to be buried and forgotten. Burial might be deliberate, as in graves and sanctuary deposits, or accidental, under debris or detritus. The Greeks themselves were frugal in the equipment of the dead and their commonest grave goods were painted pottery, occasionally supplemented by jewellery or other small objects. Painted pottery again, mostly of the seventh to the fifth centuries, is the main contribution to Greek art of the underground tomb chambers constructed by the Etruscans and some of

the native peoples in Italy, though these are more richly furnished and sometimes were provided also with wall paintings or carved sarcophagi. In sanctuaries there were often deposits of votive gifts, cleared out and buried when they had become too numerous or been damaged; pottery and terracotta figurines are of course most frequent, but sometimes bronze and ivory work of fine quality was included though metal was liable to be melted down for reuse. With debris and detritus, unless the site was already abandoned, there was the danger that contemporaries who knew what was there would dig for valuables. There are also shipwrecks, which have given us several fine bronze statues and some marble sculpture too, though this has often suffered from its long submersion. It is unfortunate that no Greek settlement suffered the fate of Thera in the fifteenth century or of Pompeii and Herculaneum in the first century AD. Perhaps, though it is not very likely, the city of Helike, which sank into the sea in an earthquake of 373, may some time be recovered, preserved one hopes by mud.

Two examples may make clearer the kinds of ways in which antiquities have survived. Athens has always been inhabited, though for a long period its population was of only a few thousands. In AD 267 the lower town was taken and burnt by the Herulians, an uncivilized tribe from northern Germany, but the Acropolis (or citadel) held out. After this a new and much shorter city wall was built, using material from damaged buildings adjacent to it and incorporating and so preserving parts of the Stoa of Attalus and the Library of Hadrian. There was some revival till the sixth century and then the final decline. The Theseum (which somehow escaped serious damage by the Herulians), the Parthenon, the Erechtheum, the Temple of Athena Nike and the temple by the Ilissus (both later demolished by the Turks) were converted into churches, the Propylaea and the walls of the Acropolis remained useful as defences, and the Odeum of Herodes Atticus was turned before it was too late into a redoubt. The only other buildings that have left substantial remains are the Tower of the Winds, a convenient little room, the Choregic Monument of Lysicrates, which was at one time incorporated in a house, and the Temple of Olympian Zeus with sixteen of its original 104 columns, too big for casual demolition. As for sculpture, not a single bronze statue has survived; there are many architectural pieces, mostly rather battered, on or from surviving buildings; grave reliefs are numerous, some

salvaged from the city walls but most of them overturned and covered over in ancient times; and a large quantity of Archaic sculpture was recovered on the Acropolis, where it had been buried in pits after the Persian devastation of 480–79. The same deposits contained many bronze figurines and other small objects and, of course, a mass of painted pottery. Elsewhere in Athens numerous graves have turned up, providing more pottery, and foundations of various buildings; but how much more was destroyed is evident in the meagre remains of the Agora, where in spite of meticulous excavation much the biggest class of finds has been fragments of pottery. Olympia was always a different kind of site, a sanctuary in the countryside where the greatest of Greek athletic festivals was held. There dedications of one sort and another were very numerous: for instance, in the mid second century AD Pausanias found 213 statues of victors worth mentioning, and these were only a selection of what the Romans had spared. A century later, when the Herulians were on the march, the authorities decided to defend what they could and threw up a makeshift wall round the Temple of Zeus and the Bouleuterion, demolishing neighbouring buildings for material. As it happened, the Herulians did not come. Then in AD 393 the Olympic Games were suppressed and soon afterwards the temple too was closed, though it remained state property. Later, probably in the sixth century, what still stood was flattened by an earthquake and perhaps not long afterwards the whole site was covered by earth and silt and passed out of memory. At Olympia a fair amount of masonry and other architectural pieces survive, since the needs of the local inhabitants were insignificant and it was at most a few centuries before all was covered over. Even so, nearly all the marble used for architecture and sculpture must have gone into the lime kilns, which were the first discoveries of the excavators. Of marble sculpture the principal remains are the pedimental figures and metopes of the Temple of Zeus and the Nike of Paionios, all presumably inaccessible before the earthquake, the Hermes found in the debris of the mud brick walls of the Heraeum, and a set of miserable statues of Roman date from the Exedra of Herodes Atticus, which must have been overwhelmed by a landslide from the hill above it. No bronze statue has been found, except for the upper part of a beaten figure which had already been discarded in antiquity. On the other hand deposits of ancient

discards have been unusually rich for early bronze figurines, cauldrons and armour, while for once painted pottery is almost rare.

The effects of nature, man and chance have worked unequally for different classes of monuments. At present we have a fair sample of Doric architecture, but the remains of Ionic are patchy, anyhow till the fourth century; and temples and treasuries are better served than other types of buildings. Archaic statues are well represented in Attica, Boeotia and Samos, but the Peloponnese has provided very little; original Classical statues are rare everywhere and Hellenistic of good quality not much more common, though copies of both Classical and Hellenistic types popular in Roman times are almost too plentiful. Architectural sculpture, though often battered, is available in moderate and other relief sculpture in large quantity. Bronze figurines are numerous and widespread, the earlier ones being artistically the more important. For metalwork much survives from the seventh and sixth centuries, but later masterpieces are few. Gems are perhaps adequately represented. Coins, often hidden by their owners for safety, probably offer samples of most types that were struck. For painting, apart from the provincial murals of tombs outside Greece and the rather better ones at Vergina, no original even of second-rate quality is known and later copies are few and deceptive. Painted pottery, by contrast, is in exceptionally full supply, and during the last sixty years has been studied much more closely than any other branch of ancient Greek art.

Not all that survives has been discovered, nor have all discoveries been made known. Exploration so far has been intensive in southern Greece and, though more finds are sure to turn up there, it is in western Turkey and northern Greece that gaps in our series are most likely to be filled. To predict what will come to light is rash, but apart from spectacular surprises one might guess that the most useful contributions in the next twenty years would be to early Ionic architecture and to East Greek art and, if underwater searchers are lucky, a few more specimens of bronze statuary may be expected. There are as well plenty of finds that have not yet been studied and these should allow much better understanding of the arts and perhaps the architecture of the Hellenistic period and the fourth century; but research always tends to be directed to fashionable subjects and one cannot hope for quick results elsewhere.

Character of Greek Art and Architecture

For about three hundred years from the beginning of the Iron Age art in Greek lands was content with simple abstract ornaments, arranged neatly in narrow bands, and as can be seen in painted pottery (*plates 1-2*), which appears to have been a, or the, leading medium, the result was often admirable within the limits of a purely decorative system. Though clumsy and aesthetically negligible figurines of terracotta and even of bronze were being made throughout these early centuries, it was not much before 750 that serious attention was given to animate forms (*plate 6a*). Of these the human figure proved the most attractive and in the seventh century it was established permanently as the proper vehicle of high art, while animals and vegetable motives, mostly adapted from Eastern models, were (except for the horse) relegated to merely decorative status (*plate 9*). This preoccupation with the human figure was in effect the beginning of the characteristically Greek conception of art and, though it is often said that the discipline of the Protogeometric and Geometric styles was a necessary preliminary to subsequent developments, those developments were not a necessary consequence of what went before. In the representation of the human figure Greek artists were very soon concerned with anatomical accuracy and their advance in this direction, though slow, was steady; later, in the Classical period, they began to render mood and feeling as well. Even so, though they believed in fidelity to nature, nature to them was 'ideal', that is they studied not the accidental peculiarities of individuals (except to a limited extent in portraiture) but the perfect human form, generalized according to Greek notions of perfection. So in the young adult male, which was for a long time the principal subject of study, the regular standard was a well built but not overdeveloped figure – the athletic gentleman and not the specialized athlete; and such natural abnormalities as the Grecian profile and the protruding unguinal ligament became normal artistically. One corollary of this ideal approach was that the body was not neglected in comparison with the head, so distributing the spectator's attention over the whole figure, and for this reason the Greeks had not much use for the bust. For much the same reason anatomically implausible fantasies were avoided, anyhow after the Archaic style had ended. Even in the Hellenistic period, when

some artists deliberately emphasized the ravages of age or disease, their aberration can be regarded as a sort of inverted idealism, the representation of typical and not individual deformity.

Greek artists and architects, so ancient writers tell us, were very much interested in proportion and some of them composed treatises about it. Unfortunately these treatises have been lost nor have plausible systems been deduced from surviving works, so that it is unlikely that we shall ever know much about the theory and application of 'symmetria', as it was called. It must, though, have been an important factor in maintaining uniformity at any time. In their construction of forms, from human figures to abstract ornaments and in three as well as two dimensions, artists relied generally on a well-defined outline, complemented by a linear framework for the major inner detail. This can be seen admirably in the Doryphorus (*plate 49*), which may be the statue of whose proportions its sculptor published a close analysis. In execution a high standard of finish was always expected; the artist had to be a good and conscientious craftsman too. Indeed the same word 'techne' (from which comes our 'technique') was used for both arts and crafts and, though the aesthetic difference between the two was recognized clearly, socially and economically they were much the same. Craftsmen and artists were manual workers and so, unlike the poets and dramatists, could not be gentlemen. Some became prosperous and a few, because of their professional reputation or personal qualities, were accepted temporarily in upper-class circles, but it is only very rarely and late that we find artists honoured with civic dignities. In general training was in the workshop, though in the fourth century we hear exceptionally of a private school of painting; but normally an assistant worked his way up as best he could, preference being given naturally enough to the master's son, if he had any talent.

This method of training tended towards conservatism in style as well as technique and Greek art and architecture progressed by cautious and limited experiments with, very occasionally, bold innovations. On the other hand neither religion nor public taste interfered seriously, nor did past achievements trouble the new generation till the fourth century or become oppressive till the late second or first. To public taste modernity seems to have had as much attraction as tradition, though for official monuments of importance a proper decorum or nobility was expected – in

full-size statuary, for example, the female nude was not tolerated (after some Daedalic primitives) till the fourth century. As for religion, it may well be true that it pervaded Greek life, but orthodoxy was satisfied with a few simple rituals and there was no body of dogma to constrain creative work. This is evident in major dedications in sanctuaries and in the architectural sculpture of temples, since – however ingeniously one may extract a symbolic relevance – the subjects represented more often than not have no connection with the patron deity. To the Greeks generally the gods had human form and appetites, and what pleased men was likely to please gods too.

For groups of figures the main source of subjects was legend and mythology and after them typical scenes of upper-class life, but historical incidents were rare. The reasons are uncertain, but it seems that art was not normally required to be directly commemorative. In the use of these sources artists naturally took account of themes otherwise popular at the time, but the decisive factor was artistic suitability. For instance Heracles, the favourite hero of Greek myth, was also a favourite figure in art, but the choice of his adventures differed: in Archaic art his fight with the lion was dominant, though later this fell out of aesthetic fashion, presumably because the unarmed encounter was too implausible. Again, for friezes, where extended subjects were needed, battles between Greeks and Amazons were a staple theme; not that the Amazons were ever important in mythology, but they allowed sculptors a welcome alternation of male and female figures in varied action. Artistic considerations affected the details of the subjects too. So in representations of battle the combatants usually appear not in line but in a melée of small groups (*plate 10b*), since this allowed more freedom in composition and also avoided the difficulty of recession in depth; admittedly duels were regular in legend, as transmitted by epic poetry, yet the historical Greek infantry fought in strict line and for art the military equipment was contemporary and not that of epic. Similarly, male soldiers are often represented naked except for helmet and shield (*plates 10b* and *46b*) – a practical absurdity but a useful convention for the ideal artist – and in domestic scenes men are again often naked, though when respectable women were present this would have been most improper. Evidently then aesthetic logic was a dominant factor in the choice and treatment of subjects. Greek art was

intended primarily for enjoyment, not for religious or moral instruction.

Greek architecture, which dealt in abstract forms, had no such natural standards to which it could conform and after its invention developed very little except in the modification of details. So no valid comparison can be made between it and the figurative arts, though of course both evolved from clumsiness to finesse. The choice of the elements of the orders was, it seems, in origin largely arbitrary and the form of their detail was governed by aesthetic principles. The system of trabeation (or lintel and post construction) was basic; proportion and balance were considered with great care, harmony was usually more important than grandeur, and visual effect was at least as important as utility; generally, as in the figurative arts, interest was distributed over the whole structure and not concentrated on one part; and skilled craftsmanship and precise finish were essentials of good work. In fact Greek architecture in its finest productions can reasonably be considered as a branch of abstract sculpture rather than of constructional engineering, though an appearance of structural logic was always maintained.

Relative Status of the Arts

Painting, as it came to maturity, was perhaps considered the greatest of the arts. Others in the first rank were sculpture and architecture and – more for their quality than originality – metalwork in its higher forms and gem-cutting. Painted pottery, once these other arts were established, was only secondary, but till the early fifth century its painters kept more or less abreast with progress in other two-dimensional media. Coins were not a regular aesthetic form, though occasionally a gem-cutter or metalworker of quality was commissioned to make dies. This may not be the impression normally given; but painting has perished almost completely, sculpture is known largely from battered originals and copies, fine metalwork is rare, gems are not well known, and architecture is ruinous. So attention tends to be concentrated on what has survived best, and because of their natures we have an ample supply of painted pots and coins in excellent condition. In this book the order in which the arts are discussed follows a

different logic. Painted pottery is put first, since it began first and its development is well understood; painting follows, because of its early kinship; next is sculpture, the dominant medium for work in the round; after it comes metalwork and gems, since though earlier in inception, they soon became followers in the rendering of human forms; and architecture, being abstract, and interior decoration (which was a craft rather than an art) are taken separately at the end.

2 PAINTED POTTERY

Introduction

The number of painted Greek pots (or, more grandiosely, vases) that have been recovered either whole or in intelligible fragments must reach at least six figures; there were no later copies in ancient times; and for technical reasons passable forgeries hardly came in till the 1960s. So students of Greek art are offered an easier task in painted pottery than elsewhere and in this century much – perhaps too much – effort has been concentrated on it, till by now most of the local schools have been analysed fairly well and more than a thousand vase painters – some of them considerable artistic personalities – have been detected by their style. Further, since painted pottery is plentiful in archaeological contexts, it is more easily dated than most other forms of Greek art, and the lack of references to it in the works of ancient writers can hardly be counted a handicap.

Technique

Most of the Greek procedure for making fine pottery is familiar enough. First, the clay was dug and prepared. Then the pot was formed, often in separate parts, on a simple wheel, which was spun rapidly by an assistant or the potter himself. Next, after some drying in the air, the shaping was completed, again on the wheel; parts were assembled with a solution of clay to bind them, the surface was trimmed and handles were attached. After that came the painting and lastly the firing, and it is in these processes that Greek practice needs explanation. On pieces like those illustrated on Plates 12 and 21 the paint is black and very shiny while the ground is reddish brown and fairly shiny. Yet laboratory analyses

prove that the sheen does not come from a true vitreous glaze and that both colours are due to iron oxide, which when reduced appears black and when oxidized appears red. How this combination of reduction and oxidization can be obtained on the same pot has been shown by modern research. The ultimately black paint is an illite clay of the kind used for the pot itself, but refined further (by levigation). A sheen may then result simply from the alignment of fine plate-like particles on the surface, especially if the surface has been burnished; but a stronger sheen can be produced by sintering – that is partial vitrifaction – which may occur at temperatures between 825° and 950° C. For the contrast between black and red, the greater fineness and compactness of the paint anyhow retards reduction and oxidation during firing; but if sintering occurs, that also by insulating the particles of iron oxide prevents further change until the temperature is raised above 1050° C. Further, the elimination of coarser particles increases the proportion of iron oxide in the residue and so intensifies the potential colour of the paint. So the blackness and shininess of the paint depends on the degree of refinement of the clay and on the control of temperature in the kiln. Though the best results were not achieved till the sixth century, the exploitation of some of these properties of suitable clays goes back much further. On pots such as those illustrated on Plate 1 there is some sheen and a contrast of warm brown surface and black or dark brown paint, even if this often shades into red; presumably a black colour was not yet fixed by sintering. Nor was such practice then new. It was regular in Mycenaean Greece and has been traced back as far as Neolithic times.

When the shaping had been finished, the pot was ready for painting. First its exposed surface was burnished. Then it was brushed over with a thin coating of the paint, very much diluted with water and in fine work from the sixth century onwards enriched by the addition of yellow ochre. A second burnishing may have followed. After this came the painting proper. Where the decoration was to be dark on a light ground (as on Plates 1-17), figures and other largish objects were outlined with a brush and then filled in as required. After this on such pots as those of Plates 7 and 9-13 the inner detail was incised – that is engraved – with a pointed tool and white or purple touches might be added: these added colours, especially the white, were not as durable as

the black paint and have often disappeared (Plate 12b, where the women's faces should be white), though with luck their former presence can be detected by the mattness of the surface they once covered. Incidentally it is this technique with incision which is known to archaeologists as 'black-figure', while the blacker silhouetting of Plate 6a is not so called. For the 'red-figure' technique, where the colouring is reversed (plates 18-23, 26-7), a broadish band was painted round the figures and inner details were executed either by flush lines, often of diluted paint, or – for greater emphasis – by relief lines, which stand up perceptibly from the surface and seem to have been applied in very stiff paint by some kind of brush or syringe. Many red-figure and some black-figure pots show the indentations of a rough preliminary sketch, done perhaps in charcoal which was consumed in the firing; but more often the painter had no such guides, although the nature of the paint made correction of mistakes unsatisfactory. On some white-ground pots, most notably the Attic white lekythoi (plate 24), which were made only for funerary ritual, more delicate colours were used on drapery; but because of their composition these colours were put on after the firing of the pot and generally have vanished.

Firing was done in a kiln of simple construction. Essentially it was a smallish clay-walled chamber with a domed clay top that may have been broken up after each firing. A short tunnel for stoking led into the bottom of the chamber, and there was a chimney hole at the top. The pots were stacked on a perforated floor or some other kind of open support above the bottom of the chamber and, since there was to be no vitrifaction, they could rest on each other (like modern bricks) without danger of fusing together in the firing. This was in three continuous stages, or so it is strongly suggested by modern experiment and misfired ancient pieces. In the first stage dry fuel was used and ventilation was free, so that the atmosphere in the kiln was oxidizing, and the temperature was gradually raised to about 800°C; by the end, on a pot like that of Plate 13, the paint was deep red and the rest of the surface a reddish brown. Next, all vents in the kiln were stopped (and possibly damp fuel was added) so that the atmosphere became reducing, while the temperature was raised to about 950°C; this turned the paint black and the rest of the surface grey, and where the paint was fine enough caused sintering. Lastly the temperature

was allowed to fall and, when it had come down to about 900°C, ventilation was restored and with it an oxidizing atmosphere; but since the paint was denser than the rest of the pot, it had either sintered and so remained black or, if it did not sinter, it was naturally slower to reoxidize and so the potter had to contrive that the effective firing ended when the rest of the pot had turned reddish brown again but the paint was still black. How ancient potters judged their temperature we do not know, but their rate of success was reasonably high, especially after the improvements of the early sixth century.

Shapes

Most painted pottery was made not for display but for use and so its shapes were practical, though of course practicability allowed any shape a fair range in form and size. The largest group was for drinking, the next for toilet; plates and other dishes for food were less frequent; and at various times some pots were made specially for funerals. There were also miniatures, dedicated in great numbers in some sanctuaries, but usually they are too roughly made and decorated to be considered in the study of Greek art. Since these shapes do not always have modern counterparts and anyhow specialists tend to concoct an impressive terminology, the commoner names in use need explaining: they are mostly Greek words – with plurals perplexing for those who do not know the ancient language – but are not always those which were used by the Greeks themselves.

The male drinking party, which might be enlivened by female prostitutes, was a favourite recreation of higher Greek society (*plates 19* and *21*). The drink was wine, but mixed with water. So the necessary equipment was decanters, water jars, mixing bowls, jugs and cups. The decanter or amphora was a tall jar with two handles: usually it had a well defined neck (*plates 1c* and *2*), but besides this neck-amphora Attic potters from the mid sixth to the mid fifth century were fond of a one-piece amphora, in which the transition from neck to body is a continuous curve (*plate 13*). The water jar (hydria or calpis) has two horizontally set handles on the belly – for lifting – and a vertical handle at the back – for dipping –

and is usually broader than the amphora: here too the earlier types were necked (*plate 17b*), but after the middle of the sixth century a one-piece type began to supplant it (*plate 23*). The mixing bowl or krater (the same word as crater) is wide and open, and there are various types (*plates 12b, 11b* and *22*): another variety has no foot but a rounded base which needs a separate pedestal (*plate 9*) and then is conventionally differentiated as a dinos or lebes. The jug or oinochoe most often has a trefoil mouth (*plate 15*): it was used for pouring the diluted wine into cups and sometimes probably as a decanter. The cup, always wide and two-handled, has three main shapes. The commonest and widest is in its simpler types often called a skyphos (*plates 1a-b* and *4a*) and in its more developed forms a cylix (*plates 12a* and *21*). The kantharos generally is deeper and has high vertical handles (*plate 19*, in the hand of the man on the left). The kotyle – though confusingly some students call this shape the skyphos – is also deep, but its handles are horizontal and its lip is not offset (*plate 4c*).

Since they did not have soap, the Greeks used oil for cleaning themselves and they liked perfume too. For these liquids narrow-necked flasks were needed, of various shapes. The name lekythos is conventionally restricted to that of which the body is shown on Plate 24 and to its more pot-bellied predecessors. The best known examples are those made for burials in Athens in the middle and later fifth century; like the one illustrated they have a white ground for the painting and tend to be too large for convenient use. Some even have a small container inside attached to the neck, so that – to deceive the dead or the other mourners – the lekythos could appear full without much expense. The so-called aryballos (*plate 5a-e*) is usually smaller, so that it can easily be clasped in the hand; and the alabastron has a sagging or tubular body, normally without any foot (*plate 5f*). None of these shapes was continually in favour, but small jugs with narrow necks and round or trefoil mouths served equally well. There is also the pyxis, a circular box with convex or straight or concave sides and a fitted lid; this may have held cosmetics or personal ornaments.

Shapes varied from time to time and place to place, but were in the main carefully proportioned and well trimmed with sharply cut details. The Greeks took full advantage of the wheel, which is as useful for turnery as for drawing up the clay in fluent curves. Yet there is undeniable neglect of exact symmetry. Many Greek

pots do not stand level on their feet, so that one side of the lip is higher than the other, or the neck has been pushed in by the attaching of the handles, or the handles are not set true: Plates 1a, 5d and 12a show a variety of such faults. This is not because the Greeks saw any virtue in imperfection, but painted pottery was a cheap product, not worth the laborious precision that was demanded in more expensive arts.

Signatures

Some hundreds of signatures are known on Greek pots, mostly Attic of the sixth and fifth centuries. These signatures are of two kinds – 'so and so made me' and 'so and so painted me'. What 'painted' means is clear enough; but 'made' (*epoiesen*) is as ambiguous in Greek as in English, since it can refer either to a manufacturer or to an operative. Most students now take 'making' to be the operation of shaping a pot, though there are strong arguments against them: a cup, no more elaborate than that of Plate 12a, is signed by two 'makers' but two shapers seems excessive, and lexically one may doubt whether the word 'making' could be restricted to one only of the three operations in producing a painted pot – shaping, painting and firing. This is not just an academic conundrum. If the 'maker' was the shaper, then the Greeks must have valued the shape of a pot considerably more than its decoration, since the signatures of 'makers' were written by the painters and yet are more numerous than painters' signatures. Often, of course, especially in earlier centuries, the owner of the workshop (or manufacturer) must have been the principal painter and shaper too.

The Protogeometric Style

In Late Bronze Age Greece the production of painted pottery was a busy and technically skilled craft, though aesthetic quality hardly ranks it as more than that. Being cheap and useful it was still wanted when the luxury arts disappeared, and its makers – or enough of them – survived the upsets of the end of the Mycenaean

civilization. That can be inferred from the continuity in technique and style, though at first standards declined and when revival began the course of stylistic development changed, so effectively indeed that earlier students who did not know the Protogeometric stage intervening between them saw no possible connection between Mycenaean and Geometric pottery and gave the credit for Geometric to the Dorian invaders or pre-Mycenaean survivors. This late recognition of Protogeometric is also responsible for its name; the style which succeeded it had already been defined as 'Geometric', and 'Proto-' (as also in Protocorinthian and Protoattic) is a conveniently imposing prefix for denoting a preceding stage.

The Protogeometric style emerged first, it seems fairly certain, in Athens at about the beginning of the Iron Age – perhaps about 1050 – and lasted there till perhaps about 900. Elsewhere it both began and ended later. At the height of the Mycenaean civilization the style of painted pottery had been remarkably uniform in all places where it was made, but towards the end local divergences were growing and this trend continued in the Iron Age, so that there are several distinguishable schools of Protogeometric pottery. That of Athens was evidently the leading one, both for quality and influence. The Argive, Corinthian and Boeotian schools and those of the Aegean Islands and western Asia Minor learnt the new style from Athens, but except for Argos not till its mature phase: generally they have a poorer repertory and less assurance, and their development is sluggish and occasionally eccentric. In Thessaly, where much of an older tradition was retained, and in Euboea Protogeometric began early but with more independence; and some of their peculiarities were copied in nearby islands. In Laconia and up western Greece the contemporary schools were clumsier and did not have much connection with the Attic standard, so that they cannot be classed as Protogeometric in the same sense. Lastly in Crete, potters, though (as a few imports show) aware of what was happening in Athens, still looked back to the Minoan style of the Late Bronze Age. Here it will be enough to describe the Attic – that is the Athenian – school.

In Attic Protogeometric the exposed surface of the clay is a lightish to medium brown, sometimes covered with a yellowish wash, and the paint is dark brown to black, often misfired to a reddish brown. Sheen on the clay's surface is weak, on the paint

stronger. The commonest shapes are the amphora with handles set horizontally on the belly (*plate 1c*) or rising vertically to the neck, trefoil-mouthed oinochoe, krater, two-handled cup (*plate 1a-b*), a smaller and narrower cup with one handle like a tea-cup (these last three normally with a high conical foot), a lekythos with narrow neck and swelling body, pyxis, and kalathos (a small container resembling an inverted bell). Most of these shapes were inherited from Mycenaean, but though plump they are modelled more firmly, with their parts clearly if not sharply defined. Development is towards rather narrower forms and more precise definition. The decorative repertory is simple and limited. The most typical units are the sets of concentric circles (*plate 1a*) and concentric semicircles (*plate 1c*), both drawn with compasses and the multiple brush; they replace, by a characteristic process of tidying, the freehand spirals and arcs (originally flowers) of later Mycenaean. Other regular components are cross-hatched rectangles (*plate 1b*), lozenges and triangles, small chequers (also *plate 1b*), the row of solid triangles, the simple zigzag which is often in dilute paint (*plate 1a*) and thick wavy lines. The basic system of arrangement can be seen on Plate 1, but the position and choice of ornaments varies from shape to shape. On the belly-handled amphora (*plate 1c*) the main decoration is on the shoulder and consists of sets of semicircles, which fit conveniently into a field which narrows to the top; usually there are two or three wavy lines in the field between the handles, a Mycenaean legacy like the surprisingly careless daubs running down from the handles; the neck is painted over and so sometimes is the lowest division of the body. The cup with its short lip, deep bowl and high conical foot – a wholly Protogeometric feature – offers a nearly rectangular field for decoration; this is occupied by three sets of concentric circles (*plate 1a*), or by two such sets flanking a panel of cross-hatched ornament, or less often by a series of panels (*plate 1b*). Usually the rest of the surface is painted over. These principles apply to most of the other shapes. The krater follows the cup, but the less important tea-cup generally has only a zigzag on the lip while the body is dark. The neck-handled amphora is treated much like the belly-handled type, but with the lekythos and the oinochoe the narrowness across the shoulder made it difficult to fit the normal ornaments there and an alternative and radically different formula became popular for the oinochoe. Here the

whole of the outside is covered with paint except for a narrow band round the belly, usually containing an unemphatic zigzag in dilute and so light brown paint. The pyxis is inconstant in both shape and decoration. The kalathos curiously has narrow bands of ornament only round its flat base. Generally for the total effect there is a trend from a light-ground to a dark-ground system, that is towards a completer painting over of the surface, and panel decoration becomes commoner later; but as groups of pots from the same grave show, evolution is unsteady and varies from shape to shape, the amphora in particular being more conservative than the oinochoe or the cup.

The innovations which transformed the latest Mycenaean style into Protogeometric were presumably due to the invention of Attic potters, since there seem to be no models from which they could have been copied. To judge by the relative quantities of finds and by grave groups, this transformation was completed fairly quickly – perhaps in forty or fifty years – and a later transformation, also at Athens, of Protogeometric into Geometric was at least as rapid. In between there was a longish period of stability. At its best Protogeometric was a respectable style, simple and sturdy but limited; though it provided a discipline that Mycenaean had lacked, to see in it the germ of Classical Greek art is a romantic assumption.

The Geometric Style

The Geometric style, so named for the linear regularity of its ornaments, was like Protogeometric established and dominated by Athens. There it appeared around 900 and lasted roughly for two centuries. Elsewhere the Argolid adopted the new style immediately, but other places were mostly content with the old for another twenty-five or fifty years. In part Geometric evolved from Protogeometric, but there were also some radical innovations, which for want of any other likely source should be credited to the imagination of Attic craftsmen. In Protogeometric there had been a trend towards more constricted and precisely defined shapes; this trend continued in Geometric, but the rejection of the conical foot of cups was abrupt. Though the comparison of the

amphoras of Plates 1c and 2 is not fair, since neck-handled am-
phoras were normally narrower than belly-handled ones, the cups
of Plates 1a-b and 4a are instructive, not only about the foot but
also for the depth of the bowl. In the system of decoration a dislike
for large blank spaces had been growing in the Protogeometric
style and in Geometric is regular, but now the decorative em-
phasis shifts from the shoulder to the neck and belly of amphoras
and other closed shapes (that is shapes where the neck is much nar-
rower than the body); the shift, consequent on the constriction of
the shoulder, had been accepted on some latish Protogeometric
oinochoes, but in Geometric was applied to other shapes and
more boldly (compare Plates 1c and 2). As for the units of decora-
tion, the concentric semicircles disappear completely, the circles
are no longer set in rows (anyhow in the Attic school) and a new
motive – the rectilinear meander – is introduced and after a little
experiment becomes in a big, lightly hatched version the charac-
teristic ornament of the Geometric style (*plate 2* and for more
elaborate developments *plate 3*).

The course of the Attic school of Geometric, which set a stan-
dard for other schools, was fairly consistent. In clay there is no
significant difference from Protogeometric, though the paint tends
to get thinner. Of shapes the most important were neck-handled
amphora (*plate 2*), oinochoe, krater and cup (*plate 4a*); the leky-
thos was replaced by a narrow-necked jug with trefoil lip; and the
one-handled cup was no longer worth decorating. In the amphora
the trend was to slimmer proportions and higher belly; but
oinochoes were fat, even when made in very large sizes, as hap-
pened in the second half of the eighth century (*plate 3*). The
system of decoration was soon improved by adjusting the level of
fields to agree with the handles (as on Plate 2 at the top); it also
but more slowly was enriched by adding subsidiary fields, till by
the middle of the eighth century almost the whole visible surface
might be covered with bands of ornament (*plate 3*). A further
development was the division of the important fields into panels,
some with the ornament set vertically; but though helping to
make those fields properly conspicuous, the effect was more often
one of restlessness. At the same time new ornaments were intro-
duced, constructed on linear principles but some of them (like
the strident panel of small chequers) disturbing the even harmony
of the ornamentation. In general the abstract Geometric style in

the ninth century was simple and austere and, when it had settled down, shows an admirable sense of how to relate decoration to shape; in the earlier eighth century there was a mellowing, but to some degree earlier principles were compromised; and in the later part of that century the Attic school became florid or negligent, as the more ambitious painters turned their attention to figures and especially human figures.

Silhouette figures of horses and men had appeared, though very rarely, even on Protogeometric pots and they became less uncommon in the early eighth century, but still without any coherent style. The first vase painter to consider figures seriously was the Dipylon painter, who was working around 750 and is called after the locality where his most famous piece was found; he is also the first personality we can identify in Greek vase painting. His style, which appears to us fully developed, combines originality with respect for the principles of abstract Geometric art. On his name-piece, the Dipylon amphora, a pot five feet high which stood as a monument over a grave, the main field with mourners round the bier (*plate 6a*) is set between the handles, which here (like those of the contemporary krater) are on the belly. The minor figured fields, high up and at the bottom of the neck, contain respectively grazing deer and recumbent goats, each pose elegantly stereotyped: there is a similar file of grazing deer on an oinochoe by the same painter (*plate 3*), which also shows how the figures are harmonized with the abstract ornament. It is interesting that even at this early stage Greek artists treated animals generally as no more than decorative units; the exception is the horse, which normally appears in human scenes, and later and less regularly the dog. For his human type (*plate 6a*) the Dipylon painter continued the practice of full silhouette and the construction of the figure from fully profile or, for the thorax, frontal views; this kind of construction was of course universal before the end of the sixth century, but in silhouette is also obligatory if the separate parts are to be recognizable. For his anatomical canon, the Dipylon painter distinguished the head by a protruding chin, converted the thorax into a long isosceles triangle (extended in most of his mourning women by their bent arms) and allowed plausible curves in the thighs and calves, both of which normally are shown. He also preferred his figures naked and without physical indications of sex, for reasons not so obvious. It is very unlikely that in the mid eighth century

Greek mourners performed without their clothes, so that their nakedness here looks like an artist's reduction of humanity to its essential form, and yet in battle scenes the Dipylon painter often obscures his figures from shoulder to mid thigh by a cut-away shield (a more elegant version of that shown on Plate 6b). As for sexlessness, presumably he felt that small protuberances would spoil the severity of his outlines and usually his men and women could be distinguished in other ways: in the scene of Plate 6a the spectator knew that mourning was usually done by women, but the two figures at the far left (who are beating their heads with only one hand) wear sword and dagger and so must be male, while the corpse appears to be skirted to make clear that it is female, as – it seems – the recipients of these grave amphoras normally were. In the composition, as silhouette requires, overlapping of figures is avoided, except reasonably enough for teams of horses (compare Plate 6b), and spatial relationships may be adjusted to fill vacant places or make a representation more complete. So in our mourning scene the seated figures are not to be thought of as under the bier, nor – on a krater by this painter – in a gallery above it. Similarly the pall is supposed to be covering the body of the corpse and its apparent elevation is a device to give proper clarity to the principal figure of the scene. On the limits of this kind of clarification there was not always agreement. The earlier practice was to show both wheels of chariots, as on Plate 6b, but later one was thought enough; sometimes two and sometimes four legs of the bier were represented (*plate 6a* and *b*); and with ships, which are viewed in profile, occasionally the rowers of the far side appear, inevitably (because it was the only space available) above the heads of those of the near side. With these conventions Geometric vase painters could do justice to a fair range of subjects; the principal ones, besides the mourning at the bier, were processions of chariots and battles by land or sea, especially on the big kraters which stood on the graves only, it seems, of males and depict activities that brought honour to a gentleman. Usually and perhaps always these subjects are general, or at least there is no good evidence that particular incidents were intended: admittedly chariots in battle scenes should reflect legendary or epic tradition, since in the eighth century their only use was for racing, but the combatants are not identified – even the occasional linking of the bodies of two soldiers is better explained by shortage of space or

carelessness than as a reference to the obscure Siamese twins of Nestor's anecdote in the *Iliad*. To return to the painters, the formula set by the Dipylon painter for the human figure was in its way final; it could be superseded but not improved. His successors, artistically inferior, might add eyes and women's breasts (*plate 6b*), hair and cross-hatched skirts, or towards the end exaggerate buttocks and give a swing to skirts (as in the women of Plate 6c); but progress, except towards mannerism, required a new anatomical ideal. It is worth making detailed comparisons of Plate 6a with Plate 6b, a work that is not much later, and with Plate 6c, where for other reasons too the style can no longer be defined as Geometric.

Eventually the Geometric style became universal in Greece as far north as Thessaly, across the Aegean to the Asiatic coast, and in Crete. Till the middle of the eighth century the other local schools mostly borrowed from Attic, the extent of indebtedness roughly corresponding to distance; then their Late Geometric styles strayed off on their own. Of these schools the Argive began the earliest and was the most robust; those of the west side of Greece remained the most parochial; the Euboean, though artistically undistinguished, is useful for the history of the first Greek settlements in both East and West; but that of Corinth has a special importance. Here the Geometric style, always modest, concentrated about 750 on a trim elegance and its products were soon exported and imitated widely. The kotyle of Plate 4c, though later, keeps much of the character of this Corinthian Late Geometric: the shape, derived (by eliminating the lip and raising the body) from the cup of the type of Plate 4a, has a very thin wall, the banding is punctiliously fine and the main field – between the handles – shows a calculated simplicity. Finally, in the West not only Greek colonies but some of the earlier inhabitants adopted the Geometric style: the oldest and most vigorous of these schools was that of Etruria, established a little before 750 on the basis perhaps of Atticizing Euboean models.

In the Late Geometric phase, which began around 750, the production of pottery increased greatly. This can hardly be due to the chances of discovery nor to a too short chronology for the period. Rather, as other evidence shows, the Greek economy and the population were expanding.

The Archaic Styles

INTRODUCTION About the middle of the eighth century Corinth with its unassuming but neat Late Geometric style had begun to attract the notice of other Greek schools and, when around 720 it turned to the exploitation of Eastern motives, the new product was accepted widely and eagerly. Though within the next fifty years Archaic styles generally superseded Geometric, the Corinthian school kept and even increased its lead till the early sixth century. Then about the 570s, perhaps mainly because its clay was better, Athens became dominant again and finally. Archaic vase painting may be divided roughly into four stages. In the first after some experiment the Orientalizing motives are treated with systematic delicacy (*plates 5c-d*). Then about 625 a coarser and profuser use of animals becomes prevalent (*plates 5e-f* and *9*). Next, around the 570s, human figures replace animals as the standard decoration (*plate 11*). Lastly, about 530 Athens introduced the red-figure style, where the figures are – more naturally and tractably – light against a dark ground (*plate 18*); but though for a generation or so still Archaic in style, red-figure vase painting is more conveniently dealt with as a unity, anyhow in a book of this scale. Elsewhere the Archaic schools were not important, though sometimes pleasing (*plates 14-15*) and occasionally distinguished (*plates 16b-17*), and gradually most of them succumbed to Corinthian or Attic competition, even in their home market, so that by the end of the sixth century the only busy production of Greek or Greek-type painted pottery outside Athens was in remote Etruria. The reasons for this concentration were aesthetic and technical superiority and increasing commerce within the Greek world; to postulate any official economic policy is wantonly anachronistic.

Archaic pottery varies greatly in appearance from one school to another. In Geometric (as in Protogeometric) the clay had been normally a lightish to medium brown, though particularly towards the end some workshops covered the visible surface with a yellowish slip. In Athens the Geometric standard hardly changed till the early sixth century, when quality of clay was improved and colour deepened; but in Corinth a fine, very pale clay was regular from the later eighth century on, and elsewhere – for instance in the East Greek and Laconian schools – yellowish or whitish slips were

very frequent. There was local variation in shapes too, though for larger pots the general tendency was to broader forms and higher bellies and, especially at Athens in the sixth century, to more sensitive modelling. The progress of the cup is an extreme example of this refinement: from the Geometric type of Plate 4a there develops in the seventh century a cup comparable in shape to that of Plate 16a, and this leads in the mid sixth century to the so-called lip cup (*plate 12a*), while the type illustrated by Plate 17a is a new invention of the 530s. The system of decoration changed more slowly; the single large field or panel had obvious advantages pictorially (*plates 12b-13*), but it was not till the middle of the sixth century that the tradition of multiple zones (as on Plates 9 and 11b) was at last given up. As for methods of drawing, the choice was now between reservation and incision. In the reserving method figures and other objects were drawn in outline, usually partial (*plate 15*). The incising or, as it is called, the black-figure method worked with a silhouette, on which details were engraved (*plate 13*), and surprisingly was preferred by the more progressive schools. In both methods patches of purple and white (or yellow) might be added. Full silhouette continued only in some very minor groups.

SUBGEOMETRIC Geometric did not die out at once when the new styles began – at times which varied from one school to another. On the Cycladic jug of Plate 14 a Geometric hatched meander shares a band with an Orientalizing cable, here in uneasy association. Besides such survivals of isolated ornaments there was also a more thoroughgoing Subgeometric – that is decayed Geometric – manner, as in the large class of East Greek pots known as Bird bowls (*plate 4b*), which were popular throughout the seventh century, and less markedly on many simple Corinthian pots which continued almost as long with the Late Geometric system of banding (*plate 4c*). Even when obsolete, the Geometric tradition was tenacious.

ORIENTALIZING Some simple abstract ornaments perhaps of Eastern origin had appeared on painted pottery in central Crete as far back as the later ninth century, but this curious experiment (which because it follows a laggard Protogeometric style is known as Protogeometric B) was after a generation or so perversely

superseded by a Geometric of Attic affinity. It was not till around 720 and then at Corinth that Orientalizing motives established themselves effectively in Greek vase painting. Most, if not all, of the requisite models could have been and presumably were provided by the arts of North Syria and Phoenicia, though usually it is impracticable to distinguish the immediate Eastern source for any particular Orientalizing derivative: Greek potters (like other craftsmen) were eclectic and adapted rather than copied, their models were bronzework or ivories or perhaps textiles but not pottery, and knowledge of the Eastern schools – themselves mixed in styles – is still hazy. The motives selected by the Greeks separate roughly into three categories – animal, vegetable and abstract. Of the abstract ornaments some are obvious borrowings, but others were analogous creations. For instance the cable (*plates 8, 14-16a* and, as a filling ornament, *plate 6c*) comes straight from Eastern art; but the rays round the base of many Archaic pots (*plates 4c, 5b-d*, etc.) may be derived from the cross-hatched triangles on the shoulder of some Late Geometric pots (compare Plate 5a), transposed to a happier position and appropriately solidified and lengthened. Geometric artists had rigorously excluded vegetable motives or reduced them to abstract patterns; their successors took from the East lotus flowers and buds, palmettes and volutes and refined them into less natural but more lively forms. The lotus chain of Plate 15, though relatively late, is almost unimproved, but a more characteristic sequence can be followed on Plates 5c, 5d, 9, 13 and 18, which also show the development of the palmette. The principal Orientalizing animals are lion, bull, boar, goat and deer, the last two of types different from those of Geometric, and there is also – especially later – a feline with frontal head (which Greek archaeologists for economy of description describe as a panther, whether or not it is spotted). Of hybrid creatures the principal newcomers were the sphinx and the griffin, a Mycenaean monster now reintroduced from the East. The birds, of various species, may mostly be of Greek invention. Generally, this Orientalizing fauna had only a limited development. Once an anatomically plausible and aesthetically satisfactory formula had been devised, little or no attempt was made to improve it by observation. The poses too remained conventional; animals walk in orderly file or, when facing, make a threat of aggression though occasionally a lion mauls a bull with more spirit. Plates 5, 9 and

11b offer a fair sample from the Orientalizing bestiary of Archaic Corinthian and Attic vase painting, and Plates 14-15 show parallels in other schools. It is evident, especially in the later pieces, that the function of these figures is wholly decorative and, though lions and sphinxes appear as statues surmounting grave monuments and panthers or other beasts are prominent in some early pediments (*plate 46a*), there is no good reason to think that they also conveyed a specific religious (or 'daimonic') significance to the Greeks or generally, for that matter, to the Easterners from whom they learnt them.

In Corinth the period of selection and preliminary adaptation of Eastern motives took perhaps thirty years and other schools in their time either borrowed from Corinth or selected and adapted for themselves. Afterwards Greek vase painters refined their Orientalizing repertory and only occasionally consulted new Eastern models. The most conspicuous example is in Corinthian, where about 625 the old Hittite lion of North Syria (*plate 5d*) was replaced by a showier Assyrian species (*plate 5f*). In general, though, Archaic Greek art after its first recourse to the East relied on its own resources. In vase painting Orientalizing motives had their greatest popularity in the seventh century, but by the middle of the sixth the animals were becoming uncommon, and in the Classical period they were rare. Even so the animal tradition persisted, perhaps mainly in textiles, and recurs for instance on the neck of the bronze krater from Derveni (*plate 73*), which is of the later fourth century. In contrast, the vegetable ornaments, evolving in a quite un-Oriental way (as on Plates 19 and 23), became a characteristic element of Greek decorative art and, in debased or revived forms, have persisted till today. Some of the abstract patterns too, particularly the cable, have had a long run.

HUMAN FIGURES The human and partly human figures of vase painting were not much influenced by Eastern models. A few types were taken over, such as the 'Mistress of the Beasts', a winged female with a lion or bird gripped in each hand, but she was not assimilated into Greek mythology or religion and generally became a decorative component. Of poses the most important borrowing was the half-kneeling formula, which Archaic artists found convenient for some running and flying figures (*plate 46a*). Anatomy developed with still less help from sophisticated Eastern

forms. At Corinth in the second quarter of the seventh century some heads (*plates 5c* and *7a-b*) have an Egyptianizing style of hair-dressing which came from Syrian art and had a longer vogue in sculpture (*plates 34-5*); in Attic the fleshy facial type introduced by the Analatos painter about 690 may have Eastern antecedents; and there must be other borrowings which were equally impermanent. That Greek vase painters were so independent in their elucidation of the human figure is puzzling, but fortunate.

Briefly, anatomical evolution till the red-figure style was introduced consisted of improving proportions and clarifying the structure. Figures were still drawn in fully frontal or profile views, but as inner detailing was mastered it became easier to show an arm crossing the body and so the thorax too was often represented in profile. The break with the Geometric style can be seen on a hydria of about 700 by the Analatos painter (*plate 6c*). Here the women's bodies keep to a mannered Geometric formula, but the men's show observation of natural forms in the rounding of the shoulders, the organic transition at the waist and the distinct curvature of buttocks and thighs. The heads too, especially those of the women, have a new and more human profile, though the spiky nose is an eccentricity of the painter and his Attic colleagues that is not found in contemporary and more typical Corinthian work (*plate 5b*). About twenty-five years later comes the Corinthian aryballos from which the figured field, an inch or so high, is drawn out on Plate 7a. The clumsiness of these figures is due partly to their diminutive scale, but the painter is no longer concerned with Geometric abstraction, most obviously in his heads and waists. Another Corinthian aryballos (*plate 7b*), of about 660–50, is more accomplished, though the height of the field is even less: here, unusually, human flesh is done in a light brown, presumably imitated from panel painting, though incision is kept for inner detail. The Chigi vase, also Corinthian and some ten years later, is exceptionally ambitious in the massing of figures in the field illustrated on Plate 7c and also has the light brown for male flesh: its soldiers, nearly two inches high, have kneecaps and elbows incised. With the Eurytos krater (*plate 10b*) we reach the end of the seventh century. The pot itself is eighteen inches high, so that the figures are much larger than in the preceding examples; but by now even at a lesser scale, as on the rather later bottle of Plate 7d, the marking of collar-bones and the big muscles is frequent.

Further progress can be studied on the krater of Plate 12b, painted by Lydos in the 540s, where according to a distinction regular from around 600 the women's flesh was originally overpainted in white.

The same series of illustrations can be used to show the increasing versatility in pose and composition. The crossing of limbs began early (*plate 7a*) and was followed soon by overlapping of figures (*plate 7b*) which – especially if helped by contrast of colour – could be several rows deep (*plate 11b* in main field). Yet even in such abnormally crowded scenes the action was deployed along the field and movement remained in the plane of its surface. As for poses, the improved delineation of anatomical forms allowed more variety, within of course the convention of profile and frontal views, but to make the action clearly intelligible attitudes and gestures had to be emphatic. When artists at last came to the subtler expression of mood, as on the Vatican amphora painted by Exekias about 530 (*plate 13*), the black-figure style was stretched beyond its limits and a more fluent medium became necessary. So progressive vase painters turned away from silhouette and incision to the version of outline drawing with painted linear detail that is known as red-figure.

CORINTH The Archaic school of Corinth is divided reasonably into two main stages, the first called Protocorinthian and the second simply Corinthian or, if one objects to the ambiguity, Ripe Corinthian. Protocorinthian started about 720 and for perhaps thirty years experimented with new motives and methods. Then it settled down into a disciplined black-figure style, normally on a miniature scale and based on an Orientalizing fauna and flora, improving steadily in precision and elegance: human figures are throughout uncommon and their development, which is regular, may be partly dependent on panel painting, even though its technique was not black-figure (*plate 28a-b*). After the middle of the seventh century the animals of Protocorinthian begin to show weariness and by about 625 the Ripe Corinthian style has taken its place. In effect and presumably in origin too this was a cheapening of the Orientalizing standard. Protocorinthian had kept its animal decoration for higher-class works, which were much less numerous than pots painted with simple linear patterns (*plate 4c*). In Ripe Corinthian the staple product is decorated with animals, larger in

average size and flashy rather than delicate in design. The new recipe had a startling success, with massive exports to most Greek markets and nearly as widespread imitation; but further evolution was only towards negligence and decay, and in the early sixth century the style became less fashionable and by the middle was obsolete. Human figures were more promising and about 600 a larger and more pictorial style appears, also imitated by other schools. Its misfortune was the growing competition of Athens, based on the superior quality of its clay; and though in the 570s Corinthian potters concocted a reddish slip which provided for their human scenes a ground which looked like Attic, customers were not fooled and in spite of the impressive quality of the painting production ended twenty or thirty years later.

These developments are shown rather patchily in the illustrations. Plate 5a represents the Early phase of Protocorinthian, from about 720 to about 690. The shape is the aryballos, a small oil flask which was invented about this time, became immediately the commonest of Corinthian pots with Orientalizing decoration and because of its changing proportions is an invaluable chronological aid to excavators. In Protocorinthian there is a steady narrowing of the body and widening of the lip (*plates 5 a-d*) and in Ripe Corinthian a reversion to a globular type, which sometimes has a foot but is easily distinguished from the Early Protocorinthian by its wide mouth, coarser manufacture and larger size (*plate 5e*). To return to Plate 5a, the decoration of the main field is characteristically experimental. A cock advances on a hen (further round the pot) and, though the forms are rudimentary, there is almost nothing Geometric in the structure and spirit of the figures or in the filling ornament which encumbers the space. Here the method of drawing is that of reservation; other contemporary vase painters were trying their hand at incision and in Middle Protocorinthian this is regular for figures, though not yet for floral ornament. Plate 5c shows an aryballos of about 675; exuberance has gone, but the sphinxes are planned neatly and consistently and the filling ornament is being subordinated. This tidying is taken further on the aryballos of Plate 5d, which is some twenty years later and in the line work of the lions has an elegant precision that is remarkable at its scale; as on other Protocorinthian oil flasks, the figures are rarely more than an inch in height. Ripe Corinthian has a radically different character, as can be seen on

the aryballos and alabastron of Plate 5e-f, one a more careful and the other a more careless product of the later seventh century. Here delicacy is too laborious and the first aim is to offer a tolerable general effect, with the thick filling ornament distracting the viewer from too close inspection of the animals. The solid rosettes of this filling come from Assyrian art, as does the new lion (*plate 5f*), which replaces the earlier Hittite type (*plate 5d*); but now such borrowings come from an eclectic search for floridly decorative motives rather than a reviving interest in Eastern models. This Ripe Corinthian style was imitated elsewhere with varying success: Plate 9 shows an Attic version of about 590, not yet stale from repetition.

In Early Protocorinthian human figures are very rare. On the aryballos of Plate 5b, of about 700, the horse is still more or less Geometric, but outline is used for the men, their heads have a new and more developed profile, and the body too is beginning to fill out. Very soon afterwards a black-figure method is regular, as for animals, even if few pottery workshops yet ventured to represent mankind. Plate 7a illustrates unrolled the main field of an aryballos of about 675. The drawing is less sure than on the contemporary aryballos with sphinxes (*plate 5c*), since human anatomy and action were less readily governed by decorative formulas, and the complete rejection of the Geometric tradition has had curiously awkward results in the two men on the right. The subject is usually interpreted as the rescue of Helen by her brothers Castor and Pollux after she had been abducted by Theseus and Pirithous. Another aryballos, about twenty years on in date and skill, has the scene (unrolled on Plate 7b) of Heracles shooting the Centaurs. The method is the unusual variety of black-figure where flesh is covered with a light brown. In the filling ornament the dot rosette is now dominant, a lighter and less rapid form than the solid rosette of Ripe Corinthian (*plate 5e-f*). The Chigi vase is a later work of the same painter, but perhaps in the scene of Plate 7c under much stronger influence from panel painting; beside the flesh colour there is an attempt at composition in depth which is quite exceptional in vase painting. By now – the 640s – filling ornament is being abandoned as clogging the appreciation of human scenes and single figures of better quality. The pictorial benefit that resulted can be seen in the hunter, two feet high, painted in outline technique but Corinthian style, who occupies one of the

terracotta metopes of the Temple of Apollo at Thermon (*plate 28a*): this is dated about 630. The Eurytos krater, thirty years or so later, is Ripe Corinthian and the figures of its main field are more largely conceived: Plate 10b reproduces the less important side, where (as is usual in Greek art) soldiers fight in duels or small groups. A bottle painted by Timonidas, whose signature is just behind the tree on Plate 7d, has the legendary subject, popular in the sixth century, of Achilles ambushing Troilus at a fountain: a later stage in this affair can be seen in the fourth field of the François vase (*plate 11b*). On the aryballos of Plate 7a Helen had been black like the men, but around 650 female flesh was beginning to be distinguished by reservation or, as later was more usual, by white paint. The distinction can be seen on Timonidas's bottle and soon after, in the 570s, a balance of colour is being attempted with black, white, purple and the yellowish tone of the ground having more or less equal value. This interest in colour, peculiar at that time to the Corinthian school, is still more apparent on the Amphiaraos krater (*plate 10a*), painted about the 550s at the end of the local tradition of vase painting. The scene illustrated is the departure of Amphiaraos to his doom at Thebes, while on the far left his wife displays for artistic intelligibility the necklace with which she was bribed. Even this short selection of Corinthian work shows its methodical advance towards a more natural standard; the most obvious evolution is in the height of the forehead, a criterion much used for stylistic dating.

ATHENS In Athens too, if red-figure is excluded, Archaic vase painting divides into two parts, the earlier called Protoattic and the later Attic Black-figure: the transition comes near the end of the seventh century. The founder of Protoattic was the Analatos painter, a restless personality whose career can be followed for some thirty years. His earliest work is undistinguished Late Geometric, but about 700 he broke away and, as he grew older, did not tire of experiment. From him his successors inherited a method of outline drawing with extensive use of white and an occasional but inconsistent admixture of incision, human figures presented on a large scale, and a contempt for proportion and precision. Not surprisingly the decoration of small pots – with animals and ornaments – was often deplorable. Then in or near the 630s the discipline of the Corinthian school, which provided

about a tenth of the painted pottery found in the Athenian Agora, began to be emulated and some Attic painters achieved a controlled grandeur; but as the influence of Corinth increased, grandeur was suppressed, so that by about 600 the best work is not much more than tidy and in the early sixth century much has become abjectly Corinthianizing. Around the 570s technical improvements by Attic potters gave a finer clay with a deeper tone to its surface and at the same time a more positive Attic style emerges, which has little use for Orientalizing animals or very soon for the gay effects of colour that were being exploited in Corinth. The next generation revised and refined the shapes of pots, reorganized the system of decoration and improved the anatomy and poses of its human figures, till about 530 the inadequacy of the black-figure method of silhouette and incision brought about the introduction of red-figure outline drawing. Still black-figure did not die out at once. In fact till about 500 its production increased and its style developed, if rather waywardly, and respectable work continued to be done for another thirty or forty years. Afterwards, by a curious quirk of conservatism, it was still required on the amphoras presented full of oil to victors in the Panathenaic Games, but the style became an unsatisfactory translation of current red-figure, so long as there was red-figure to translate, or a mannered reinterpretation of Archaic forms.

The figures on the neck of the Analatos hydria (*plate 6c*) have been discussed on p. 41. Not long afterwards its painter produced a new type of head with face in outline; the nose is fleshy and generally the features are heavier. Later still he took a fancy to large areas of white paint. The effects are visible on a big amphora found at Eleusis (*plate 8*), which exhibits the blinding of Polyphemus by Odysseus and the pursuit of Perseus by the Gorgons. This piece is dated around 660 and so is more or less contemporary with the Protocorinthian aryballos of Plate 7b; the two schools are about as far apart as the limits of Archaic conventions allow. On the Eleusis amphora the figures in the upper field are over fifteen inches high and those on the body twenty, but in spite of their size they are constructed with lumpish forms and a deliberate disregard for natural proportions most obvious in the human heads and arms. The method of drawing is outline with lavish use of white, but there is also a little inconsequent incision for toes and ankle bones and on the shoulders of the animals,

which again should be compared with those of Protocorinthian (*plate 5 d*). The filling ornaments are gay but not well matched and the decoration of the handles is confused. The fields of the front continue round the back of the pot, but for their decoration there the painter was satisfied with big, hastily scrawled spirals and loops, except where the decapitated figure of Medusa floats horizontally in mid air. This, the Middle phase of Protoattic has at least the virtues of the preposterous.

A bowl and stand in the Louvre (*plate 9*) is Attic Black-figure of about 590. The types of human figures, animals and ornaments and the method of drawing are based on Corinthian models, though Plates 10b and 5e-f do not offer the best parallels. Very little is derived from the older Attic style represented by the Eleusis amphora (*plate 8*), though conveniently both pots have versions of the same scene of Perseus pursued by the Gorgons. The Louvre bowl is one of the finest Attic pieces of its time, well planned and executed correctly but tame. The François vase (*plate 11*), painted by Clitias but called after its discoverer, is of about 570 and, though the Corinthianizing tradition has been reinforced by more recent borrowings, there is also a new independence. The line drawing is both finer and crisper than that of Corinth and more inquisitive, for instance in the rendering of folds in drapery, and there is less reliance on added colours. The shape too has an elaborate precision which is Attic. The François vase is exceptional in the number of human figures it carries. On the side illustrated we have the Hunt of the Calydonian Boar, the Funeral Games of Patroclus, the Marriage of Peleus and Thetis, the Pursuit of Troilus, Orientalizing animals, and the Battle of the Pygmies and the Cranes. The other side presents the Return of Theseus, the Battle of the Lapiths and the Centaurs (a detail on Plate 11a), the continuation of the Marriage procession, the Return of Hephaestus, more animals, and the rest of the Cranes and Pygmies. There are figures on the handles too – a Mistress of the Beasts above Ajax carrying back the body of Achilles. A cup (*plate 12a*), perhaps twenty years later and showing the plastic quality of refined Attic clay, has in its Birth of Athena a perky gaiety derived from Clitias, though the figures are diminutive; but progress is through such works as the krater in New York (*plate 12b*), which Lydos painted in the 540s. Here the decorative system has been simplified to the benefit of the main field, the

figures are more largely conceived and more naturally propor-
tioned and posed, and purple and white (which was added for
female flesh but has perished) are subordinate to the black of the
paint and the warm brown of the clay. The subject is the mythical
return of Hephaestus, seated drunk on a mule and escorted by
Satyrs and Maenads with their leader Dionysus on the other side of
the pot. Other vase paintings of this time are more serious in tone.
The culmination is in the work of Exekias whose famous amphora
in the Vatican is shown on Plate 13. The shape is the one-piece
amphora, which became important in the mid sixth century and
with its single deep panel surrounded by dark paint gives greater
value to its smaller group of figures. Here Achilles and Ajax, fully
armed (even to thigh guards), are playing backgammon so intently
that they do not hear the Trojan attack and, though sedentary, the
figures have an active vitality. Yet exquisite as the line drawing is,
the incising black-figure method now appears overtaxed.

OTHER ARCHAIC SCHOOLS As standards became more exacting,
other schools found it increasingly difficult to compete with
Corinth and Athens even in their home territories, and there
were other obstacles too. In the *Argolid* the Late Geometric style
was vigorous enough to persist into the seventh century and by
then it was too late to create an important Archaic style in a
district so close to Corinth. *Laconia* was more remote and, though
development was slow and uncertain, a black-figure style was
formed in the late seventh century, came to its maturity towards
the middle of the sixth and petered out about 525. Though relying
on Corinthian and later perhaps on Attic models, this Laconian
school has a sturdy, if sometimes stupid, independence which
does not try more than it can achieve. It is known best from the
high-stemmed cups found in most parts of the Greek world, less
perhaps because of their aesthetic merits than because ships
rounding the Peloponnese must often have put in at the Laconian
port of Gytheum and cups were easier to sell than other pots. The
example illustrated (*plate 16b*) is of about 550 and typical enough.
The composition is curiously insensitive to the shape of the field,
as if the painter had had before him a rectangular scene of a boar
hunt, like that on the lip of the François vase (*plate 11b*), and
extracted a random circle. The figures themselves are solid and
the anatomical detail adequately done. The intrusive birds and the

clumsy fish in the exergue are familiar motives in this school. Colouring is pleasant, with good black paint, some purple additions and a creamy ground, and the shaping too is competent. In *Thessaly* and *Western Greece* no Archaic style took root, though there are some disordered local versions of early Orientalizing forms in the museum on Ithaca. *Boeotia*, though close to Athens and Corinth, had surprisingly a provincial tenacity. A Subgeometric style lasted through the seventh century and in the sixth the Bird cup group has at least originality in its rustic birds and ornaments. There is also some imitation of Corinthian and later more of Attic. For *Euboea* there is a little clumsy Archaic from Eretria and in the middle of the sixth century what looks like the product of a few trained emigrants from Athens. In the *Cyclades* in the early seventh century several small workshops show a mannered elegance, whether using a Geometric or an Orientalizing repertory. The method is regularly outline drawing. On a jug in the British Museum (*plate 14*), which ends very unusually in a griffin's head and neck, the animals on the shoulder are an exercise in interesting line and contrast of dark and light. The date of the Griffin jug may be about 675, the same as that of the Corinthian aryballos of Plate 5c. Afterwards, in the later seventh and early sixth centuries, a more successful but less delicate school arose, perhaps in Paros though it is called 'Melian'. Here the human figures are based on Corinthian and the animals on East Greek or Corinthian, while the heavy ornaments may be its own contribution. *Crete* did not produce any substantial Archaic style, though there was a willingness to experiment and some minor pieces have an individual charm.

The Archaic pottery of the *East Greek* region is much more uniform than that of Greece itself and major local schools have not yet been distinguished convincingly. In the far north, in Lesbos and on the coast opposite, a grey ware was preferred to painted pottery. Elsewhere weak Geometric and Subgeometric schools continued well into the seventh century; there was then probably in some places a short period of mostly futile experiment; and not long before 650 the Wild Goat style began. The oinochoe of Plate 15, of about 625, is a good example of its maturity. The surface has a whitish to yellowish slip, the paint is blackish to dark brown, and purple patches enhance animals and lotus buds. There is no incision. The figures with very rare exceptions are of animals and

birds, arranged in a few stock poses and quickly tending to monotony; on the belly of the piece illustrated even the units of the filling ornament have each its appointed place. The formula is repeated, becoming simpler and coarser, till about 600. Then, though a reserving style continues, a black-figure style also was introduced with fauna and filling ornaments more or less closely imitating Corinthian, and both styles are often juxtaposed on the same pot. This phase lasts perhaps till around 570 and is succeeded by two new styles. In the south, particularly at Miletus, much of the older tradition survives in what is called Fikellura, where black-figure is imitated by reserved instead of incised detail; and in the north, round the Gulf of Smyrna, a more orthodox black-figure develops, properly interested in human figures; but these schools were small and tailed off before the end of the sixth century. Neither in these wares nor in the Wild Goat style were cups included in the normal range of shapes. During the seventh century the need for more elaborate drinking vessels was filled by the so-called Bird bowls (*plate 4b*), which were produced in quantity in several places. Their clay is usually fine and brownish, and the upper field is decorated with standardized Subgeometric motives, though later the lower part of the bowl has hollow rays instead of being painted over. In the sixth century cups with more than simple banding are fewer. The largest and most elegant group is known as Vroulian (*plate 16a*), with lotus flowers, palmettes and other ornaments incised on the painted ground and alternate members filled with purple: this technique, which is called black polychrome, occurs now and then in other schools. To sum up, East Greek vase painting is disappointing. The Wild Goat style was content to be decorative and its successors had no sustained ambition.

The Greek cities of South Italy and Sicily did not themselves persevere with the production of painted pottery and imported heavily from Corinth and then Athens. Corinthian and Attic were imported in *Etruria* too – and many of our finest pieces have been found there – but the market was large and distant enough to support local schools. Besides the grey ware known as Bucchero, of native origin but improved by better firing and Greek shapes, there was from the beginning of the seventh century to the middle of the sixth much imitation of Corinthian. This Italocorinthian style manages fairly well with abstract motives, but distorts the

animals and only rarely attempts human figures. Towards 550 the more accomplished Pontic school began, based mainly but not only on Attic Black-figure and showing some versatility in its adaptation of Greek forms. Here, except on small pots, the surface is covered with multiple fields; human figures take precedence but there are also rows of animals; and purple and white are added freely. At the beginning, though never delicate, Pontic had a colourful gaiety, but soon it became drabber and less competent and in the later sixth century was supplanted by what is called Etruscan Black-figure, a school remoter from Greek models and standards. Both Italocorinthian and Pontic may have been founded by emigrant Greeks, but their continuation was left to local trainees. There are other, smaller groups of pots which were more certainly the work of Greek settlers in Etruria. Of these the most remarkable are the Caeretan hydrias (*plate 17b*), which on style should be dated in the last thirty years of the sixth century. The method of drawing is black-figure, anyhow for the figures, but there is a very free use of purple and white and for extra variety flesh is sometimes light brown. Though the detail is not fine, figures are planned solidly and the spirit of the scenes is often refreshlingly comic. On the piece illustrated, Heracles brings back Cerberus, and Eurystheus, who ordered it, yammers from the insecure refuge of a big oil or wine jar. Where the Caeretan painter learnt his trade is not clear; there are some resemblances to East Greek, but they are not close. Anyhow he could write Greek and had an unusual knowledge of Greek mythological themes. Finally, the 'Chalcidian' school is puzzling in a different way. Here several painters have been identified, working from about 550 to about 500. This is the only school of its time which stands comparison with Attic Black-figure, by which it was evidently inspired. The cup of Plate 17a, almost fifteen inches wide without its handles, was made about 520. Its clay has the quality and colour of Attic, the shape is equally elegant, and the decoration – on the outside nose, eyes, ears and Satyrs engaged with Maenads – has precision and zest. Many students find 'Chalcidian' too good to have been made in the West and still locate the workshop in Chalcis, though nothing has been found in Greece or the Aegean. More likely choices are some Greek city of South Italy or even Etruria. Again the painters wrote Greek.

The Red-figure Style

About 530 the Red-figure method of vase painting appeared suddenly at Athens. In it (plates 18-23) the figures are in outline and inner details are given by thin lines of paint, as in contemporary panel painting (plate 28b); but the black background and the abstention from other colours must have been the vase painter's own idea. So too was the refinement, which very soon became regular, of emphasizing major lines by using a more viscous solution of the black paint so that they stand out in relief (p. 26). To artists interested in a more natural representation of human anatomy and expression the reversal of the colour scheme of black-figure was by itself beneficial, but there was a greater benefit in the replacement of engraving by the more flexible technique of drawing and the new technique led almost immediately to a new style. This was, one may presume, the reason for its introduction, since evidently customers were still satisfied with black-figure and in fact its sales increased for another generation. Meanwhile the early red-figure vase painters, who often continued to work in black-figure too, were exploring the possibilities of the new medium and in the last ten years of the sixth century broke successfully with the ancient tradition that a figure should be composed only of strictly profile or frontal views. The new freedom of pose, used judiciously, and other less radical improvements give the better work of the first quarter of the fifth century an exemplary assurance and grace. Then in the 470s fresh advances were made in picture painting, which vase painters after a few experiments did not adopt, so resigning themselves to the status of deliberately retarded artists, and though later red-figure accepted contemporary types of figures and drapery, spontaneity was lost and average quality declined. A more promising sideline was the white-ground style, which was developed in the 460s for funerary lekythoi and in technique was closer to panel paintings of its time; but after a generation the standard of execution sank and by 400 production had ended. In red-figure about this time there were new attempts to emulate some of the grander effects of picture painting and these continued in a few workshops of the fourth century. The end came at Athens in the 320s. Elsewhere in Greece there was only a little manufacture of red-figure, mainly in Boeotia and at Corinth, and these imitations did not begin much before the

middle and the end of the fifth century. The West was more enterprising. Etruria had its own version of red-figure from early in the fifth century, but output was small even after the arrival of Attic specialists soon after 400. Much more important was the red-figure style of the Greek territories in South Italy and Sicily. There in the generation after 450 Attic emigrants founded three local schools, which flourished and subdivided, though that of Apulia (based on Tarentum) remained the most influential. Some of the painters were both competent and ambitious, but generally they had not the discretion of their Attic contemporaries and, though details may be excellent, composition is usually clumsy and there is an increasing addiction to the florid. The South Italian and Sicilian schools were prolific (though their frequency in museums is inflated by the fortunes of discovery) and the last of them endured into the early third century. Afterwards Greek vase painting was not even a minor art.

The pioneer of Attic red-figure was appropriately a pupil of Exekias, or so stylistic examination suggests. His name is not recorded, but some of the pots he painted are signed for the 'maker' Andocides and so he is known as the Andocides painter. Plate 18 is an example of his work, which may have been done soon after 520: the scene is the struggle of Heracles and Apollo for the Delphic tripod and it comes from an amphora much like that of Plate 13. Compared with Exekias the Andocides painter is a less sensitive artist, but because of the different medium his red figures look nearer to nature. The drapery too is more fluent and the tentative rounding of the lower edges of folds gives them a stronger suggestion of depth. More revolutionary is the treatment of the naked belly of Heracles, awkward and unsuccessful as it is. Since the middle of the sixth century artists had betrayed occasional doubts of the dogma that the parts of a figure should be shown in strictly profile or frontal view, but here there is more open disbelief and in the last ten years of the century a new anatomical system was revealed and welcomed exuberantly. The most complete demonstration we have is on another one-piece amphora, illustrated on Plate 19; and evidently its painter intended it to be so, since he not only signed with 'Euthymides painted (me)', but added in this panel 'as never Euphronios', Euphronios being the other major vase painter of his time. Here the three men from a drinking party exhibit different versions of oblique and twisted

posing, as convincingly as such economical line drawing allows; but these innovations are confined to the torso and, though legs now may be in full front or back view, the head remains obstinately profile and movement continues to be lateral along the surface of the field, as on the contemporary marble relief of a ball game (*plate 45a*). The next generation of vase painters, brought up with the new anatomy, used it more easily and sparingly. The amphora of Plate 20, of the shape used for prizes at the Panathenaic Games, was painted about 490 by a pupil of Euthymides, the Berlin painter (so-called after another amphora in Berlin). His style tends to the exquisite – slim figures with elegantly small heads, interesting enough in themselves to be posed solitary in an unframed field: it is worth comparing this Satyr playing his lyre with those of Lydos (*plate 12b*) to appreciate the progress made in not more than sixty years. Proportions are more normal on an equally instructive cup by the Brygos painter (*plate 21*), which is little if any later. Its subjects, again taken from the drinking party, are on the outside bearded men passing from wine to song and women or boys, while the interior shows a helpful prostitute holding a young man's head as he throws up. The treatment of this gross incident is remarkably delicate and sympathetic, an effect obtained partly by the poses but also through the simple attention given to eyes and mouths. Till almost the end of the sixth century, though the face was in profile, the eye was always shown frontally with the eyeball central; on the amphora by Euthymides (*plate 19*) the eyeball has moved forward; here and on the Berlin painter's amphora the eye is opening in front and beginning to shorten to a correct profile view. The drapery too is changing from a decorative to a more natural system of folds, but still cloaks rather than reveals the underlying forms, so that for instance the back, belly and left thigh of the girl of Plate 21b are outlined rather disconcertingly through her clothing. As for subjects, scenes of human life are commoner, especially the convivial and the athletic, but even there vigorous activity is becoming less and less necessary. This stage of vase painting, from Euthymides to the Berlin and Brygos painters, is already essentially Classical, even though from custom students count it as late Archaic.

During the 470s picture painting had another round of innovations, this time less directed to foreshortening of figures than to a simple but intelligible representation of spatial depth. Faces were

now shown obliquely, so that interest was no longer directed along the plane of the painted surface, and figures were placed at different levels which rose according to notional distance from the foreground, though there was no attempt to reduce them in size: the terrain was represented only by occasional ground lines and vestigial scraps of vegetation. There are a few vase paintings of this time which experiment with the new perspective, most notably those on a krater of the 450s by the Niobid painter, one side of which shows Apollo and Artemis shooting down Niobe's sons and daughters (*plate 22*); but presumably because they felt that the decoration of a pot should appear to be on its surface and not penetrate behind it, red-figure vase painters stuck to their old rules with the usual consequence that their work tended to become stale or affected. An early example of affectation can be seen on a pyxis by the Penthesilea painter (*plate 25a*), of about 460. Its subject, unrolled in the illustration, is the Judgment of Paris: Hermes, recognizable by his herald's staff, conducts the three goddesses to the shepherd prince who (as on sentimental greetings cards) looks improbably childish for his task or for Helen. On this pyxis the vase painter has used the method regular in picture and panel painting (*plate 28b*) of a white ground and washes of colour – here purple on the drapery – but the style remains that of his red-figure work. Some of his contemporaries were more alert to the possibilities of the medium and developed what may be called a white-ground style. The most pictorial in feeling, though he sticks to profile faces and lateral movement, was the Sotades painter (*plate 25b*). The scene, not identified satisfactorily, is set in what looks like a tholos tomb and, as on other cups of his, the figures are in scale with the architectural or natural setting. In a lesser way panel painting influenced the funeral lekythoi which are much the most numerous class of white-ground pottery in the mid and later fifth century. These lekythoi were made specifically as offerings to the dead and, since they were not subject to the wear of household use, could like pictures be painted with friable colours. The example illustrated on Plate 24, by the Achilles painter, is of about 440. The colouring is in part lost, so that the servant who stands before her mistress appears to be wearing a transparent dress. Forms, attitudes and expressions belong to the High Classical repertory, though the closest parallel seems to be in unambitious panel painting (*plate 30a*).

Contemporary red-figure is stiffer and less sensitive in quality.

Though a conservative tradition persisted, Attic vase painting of the later fifth century shows tendencies to a more passionate representation of feeling and also to an ornater style. These tendencies had their most spectacular exponent in the Midias painter, one of whose grander pieces is a hydria in the British Museum which is dated just before 400 (*plate 23*). In the upper field Castor and Pollux are abducting the daughters of Leucippus from a sanctuary (indicated by an altar and a statue of a goddess) and a lower band depicts a beardless Heracles resting in the Garden of the Hesperides and – round the back – other legendary encounters. The system of composition recalls that of the Niobid krater (*plate 22*) in its representation of spatial depth by setting figures at different levels, and there is a similar fondness for three-quarter views of heads. Poses, whether of action or repose, have a versatile competence and the use of the modelling line (see p. 121) is understood, if not always remembered; for example, on the man at the left of Plate 23a the natural rounding of the legs is emphasized by the curving folds of the drapery, but the forms of the woman in the chariot appear flattened by the clumsy sets of more or less straight strokes which dissect her dress. Generally, though, the quality of the Midias painter's drawing is good and indeed correct, in spite of the enhancement of selected details by gilding. His sensual and florid ideal is paralleled in sculpture around 400, but did not have much following in the next generation of vase painters. Then in the second quarter and middle of the fourth century Attic red-figure has a last flowering; a few skilful artists, still capable of being creative, adapted contemporary types of figures to the old method of line drawing and contrived to reconcile some suggestion of depth with respect for the plane of the surface of the pot. White is used freely and cupids play around – common practices in the fourth century – and the delineation of inner detail tends to be sketchier, but the best work of this group has both dignity and grace (*plate 26*). Whatever killed Attic red-figure, it was not senility.

The two examples of South Italian red-figure illustrated here are both Apulian. The fragment on Plate 27a, of the 380s, is from a krater of the type of Plate 22. A boyish Apollo, identified by an inscription to the right of his head, sits in front of a temple with a statue of himself at a maturer age inside – the bow in the left hand

makes the identification certain. The red-figure drawing of the living Apollo is sure and clean, even if – as very often in the fourth century – the effect is rather effeminate; but the statue is modelled by high-lighting in yellow paint – one of several testimonies that from the late fifth century onwards some Greek vase painters, Attic as well as Italian, understood shading but rejected it in purely red-figure work. The composition again attempts spatial depth and even an emphatic architectural perspective with diminution corresponding to distance; this is visible in the open leaves of the door and, to judge by other South Italian vase paintings, probable for the side colonnade too. There is also shading of the underside of the architrave of the porch and the inner side of the door jamb. Though in quality of workmanship this piece is equal to the best Attic of its time, the canon of artistic propriety is looser: at Athens a temple so assertively foreshortened would have seemed inappropriate in a vase painting, yet by South Italian standards the foreshortening here is modest. Later Apulian divides into a plainer and an ornater stream. A sort of pail in New York (*plate 27b*) may serve as a restrained sample of the ornate style. Its decoration is the work of the Lycurgus painter, one of the leaders of the school, and its date is about 350, so that it is more or less exactly contemporary with the Attic krater of Plate 26. A detailed comparison of the two illustrations is worth more than a written commentary on the merits and faults of the mature South Italian style.

Influence

From the eight century on Greek pottery was imitated by some of the earlier inhabitants of Italy, especially the Etruscans; but generally their productions may be considered as provincial Greek. There were similar but less successful borrowings in Lydia and other parts of western Anatolia adjacent to Greek settlements; these seem to have begun earlier but ended during the sixth century. In the Hellenistic period unambitious workshops in Carthage and Spain made some use of Greek motives. For one reason or another neither the sophisticated nor the backward peoples of non-Greek lands, except in Italy, had much taste or use for the painted earthenware of the Greeks and what demand there might

be was met by imports. Later, in Roman times, when an admiration of the antique had developed, the decorated pottery of the Archaic and Classical periods was no longer in circulation and though finds must have been made in graves (as perhaps at Capua in 45 BC) collectors were never stirred to more than a passing interest, perhaps because the material was cheap.

Chance discoveries must have continued throughout the Middle Ages and the Renaissance, but while moulded decoration had admirers vase painting did not. It is not till the sixteenth century that there is even a mention of a painted pot nor till the eighteenth that collecting began seriously. Here Sir William Hamilton, the British Envoy at Naples, deserves to be celebrated, not only as a connoisseur and student but also because in 1766–7 he published his first collection in four handsome folio volumes, with the purpose – disinterested since he knew it would be at a financial loss to himself – of making correct models available to artists and manufacturers, who otherwise could not have studied the antique. Yet though Wedgwood did very well out of his imitations and some Neoclassical artists borrowed occasionally from red-figure vases, both Attic and South Italian, this branch of ancient art had little effect. Now it is valued by collectors, as prices and organized smuggling prove; but studio potters on the whole regard Greek principles of shaping and decoration as almost morally depraved and it is left to commercial designers to make casual borrowings of one motive or another to give novelty to a carpet or a curtain.

3 PANEL AND MURAL PAINTING

The remains of Greek painting are so miserable that it is hard for us to believe that Hellenistic and Roman critics thought quite as highly of it as of sculpture. From the Archaic period we have some painted slabs of terracotta and stone, parts of four wooden plaques, wall paintings (particularly in underground tombs in Etruria) and the indirect evidence of vase painting. The last two sources continue in the Classical period and there appear also to be later copies of Classical pictures on marble panels and in wall paintings in Italy. In the Hellenistic period vase painting soon fades out, but paintings on the walls of tombs and houses and on gravestones are more numerous and some pictorial mosaics survive. Further, there are many references to painters and painting in the elder Pliny and other ancient writers. All this is very unsatisfactory. Vase painting differed from painting in technique, scale and purpose; during the Archaic period it seems to have had the same rules for composition and for the representation of anatomy and drapery, but afterwards it is mostly in abnormal experiments that one may suspect the influence of painting. Terracotta slabs share at least their technique with vases, the wooden plaques are small and cheap and the gravestones not much better, while mosaic is anyhow an unaccommodating medium. The wall paintings are more imposing but mostly provincial and inferior, and with copies it is difficult to decide how faithful each may be. As for the notices of ancient writers, these make a few useful points but in general give very little idea of artistic style. The fact is that we do not possess any original Greek painting of the first rank nor are we ever likely to possess one, so that though the general development of the art may be inferred we cannot reconstruct its detailed history or even form much idea of the quality of its masterpieces.

For surfaces on which to paint Greek artists used walls, panels of wood or marble, terracotta slabs or plaques, and sometimes pieces of ivory, leather, parchment or linen. Of these surfaces wooden panels, undercoated with white paint, were probably the most usual for major as well as minor works, and Pliny remarks that no artist became famous by painting walls. From the seventh century on the available range of colours was satisfactorily wide, except of course for work on terracotta where the paints had to undergo firing in the kiln. On walls the methods of painting were tempera and fresco, on wood and marble tempera and encaustic – a technique, not fully understood, in which the colours were mixed with wax, applied to the surface and then 'burnt in' with a red-hot rod. Encaustic was more durable than tempera, though more laborious, and had some of the richness of tone of oil painting, a technique unknown to the Greeks. It is said that encaustic first became regular on marble statues and architectural details during the sixth century and was adopted for panel painting in the fifth, but since Greek artists often practised both sculpture and painting, it would be surprising if the interval was long.

Wood does not have much chance of preservation in Greece, but the occasional flat plaques of terracotta with holes in the corners to hang them by presumably imitate wooden plaques and, if so, show that painting on wood goes back at least to the end of the eighth century. It is, though, unlikely that such painting had a successful outline technique of its own before the second quarter of the next century, or else there would have been little reason for Corinthian vase painters to develop the black-figure technique, which is based on metal engraving, and the vase painters of Corinth were the most progressive of that time. Anyhow, the earliest considerable examples of larger paintings that survive, the terracotta metopes from the Temple of Apollo at Thermon in Aetolia (*plate 28a*) are later, around 630. Here the pictorial field is about two feet square and the figures occupy its full height, but the style is that of Corinthian vase-painting – of a stage that is a little later than the Chigi vase (*plate 7c*) – and the artist has used the larger scale not to increase or improve the details of anatomy, but only to multiply the patterns of the drapery. His palette is no wider than the vase painter's – black, white, purple and light brown (for male flesh), all used in flat washes – but he was of course restricted to colours that would stand firing. A technical

difference is that on the metopes outlines and lines of inner detail are drawn and not incised, but incision would not have been effective in work of this scale and anyhow outline drawing was regular in contemporary vase painting outside Corinth. These metopes were probably not the earliest paintings in this technique nor the most ambitious of their time. Light brown for men's flesh had occurred sporadically in vase painting for a generation or so before the Thermon metopes and may well have been borrowed from paintings on wood, and the unusually intricate battle scene on the Chigi vase (*plate 7c*) perhaps gives some idea of the more ambitious of contemporary pictures; the Thermon metopes because of their shape allowed only single figures or small compact groups. There are some similar but slightly later metopes from Calydon, also in Aetolia, but they are more damaged.

Four small wooden plaques found at Pitsa twenty-five miles west of Corinth, one of them according to its inscription either dedicated or painted by a Corinthian (*plate 28b*), show the same system of coloured drawing in a style which might be that of the vase painting of Corinth around 530, if vases had still been being painted in the Corinthian style. The ground is white and the colours used are black, red, light brown, dark brown and blue. Rather later are fragments of painted plaster found at Gordion in Phrygia and wall paintings in tombs at Kizibel and Karaburun in Lycia; the subjects are from mythology and daily life and the style near enough to that of East Greek vase painting. The painters of terracotta plaques were demonstrably sometimes and perhaps usually vase painters too, but we do not know about Archaic painters on other materials; if work was plentiful, the technical differences between ceramic and other painting must have encouraged specialization, though the general uniformity of style (which is shared with relief sculpture) shows that artists in various crafts kept in touch with one another.

A similar stylistic relation to vase painting, this time Attic red-figure, is apparent in the fairly numerous wall paintings of Late Archaic style in Etruscan tombs (*plate 29a*). Etruscan art has acquired its own mystique, but the tomb paintings (while occasionally showing Etruscan details of dress and customs) are in style essentially Greek, as is obvious from a comparison of the anatomy of human figures, their poses and the treatment of drapery (*plate 21*), nor are the aberrations from Greek standards consistent

enough to be attributed to any positive local tradition. Etruscan painting like other branches of art in Etruria, is provincial and tends to be backward, but there are signs that some contemporary painting in Greece was more adventurous.

Just before 500 oblique and other novel views of the human body and limbs became established in Greek vase painting (*plate 19*) and little, if any, later in relief sculpture too (*plate 45a*). This revolution, which was the first step towards illusionism, may well have begun in painting, but hardly much earlier; otherwise it is hard to explain why the experiments in avoiding strict frontality that occur in some of the earlier red-figure vase paintings are so timorous and untutored. Still it was in painting that the revolution was taken further, much further indeed than vase painters or sculptors cared or were able to follow.

Polygnotus of Thasos, an island in the North Aegean (though we do not know if he trained there), was the first Greek painter whom the later critics recognized as a great master and also the first of whose artistic personality they had any clear conception. Much of his work was done in or near Athens soon after 480 and was still to be seen more than six hundred years later. His figures were celebrated for their *ethos* or expression of character, and it seems probable that they had the aristocratic detachment of the best early Classical art. Pliny attributes to him various innovations, most of which had occurred already even in vase painting, but another important innovation did appear in Polygnotus's pictures, as Pausanias reveals incidentally when describing the subjects of the pair in the Lesche of the Cnidians at Delphi. This was the representation or rather the recognition of depth by setting figures at different levels, a greater height denoting a greater distance, and letting them thrust forwards or backwards out of the plane of the surface. The formula, without any perspective diminution, is found on a few Attic red-figure vases of the 460s (*plate 22*) together with three-quarter faces, which are almost equally abnormal in the vase painting of that time, and unusually statuesque poses. These also were presumably characteristics of Polygnotus, if (as is very likely) the painted vases show an abortive attempt to transfer to their medium the new style of pictures. The technique was still that of line drawing with flat washes for colour, though rocks and other inanimate objects were probably filled in with paint of uneven density (as on Plate 25a), inner lines may

have been thickened to show depth of folds (as on Plate 30a), and the edges of shields and other curved objects were perhaps lightly hatched. The background was presumably blank white with separate base lines for the various figures or groups of figures and occasional trees and other simple scenery. As on the Thermon metopes, names were often written against the figures. Though 'primitive', Polygnotus with his contemporary Mikon of Athens was always admired and in the first century AD some connoisseurs even preferred him to the maturer masters, perhaps (as Quintilian remarks) to advertise their superior perception.

The recorded titles of pictures in the grand style of Polygnotus and his circle, whether quiet tableaux or scenes of action, came mostly from mythology and only occasionally (like the Battle of Marathon) from recent history. Other Early Classical paintings of good quality were less heroic and at the bottom of the scale the cheap little votive plaques, produced for dedication in sanctuaries, must often have ignored or been slow to follow the advances made by the leading artists. By now painting had a much wider range of subjects, treatment and quality than the other figurative arts and such originals, copies or reflections as survive need to be assessed very cautiously.

The Attic white lekythoi, which begin in the 460s and end about 400, have been recognized as having a close relation to painting in their technical characteristics of white ground and range of added colour, and a painting of the first century found on a wall of the Farnesina house in Rome (*plate 30a*) shows a very similar style to that of the earlier lekythoi (*plate 24a*). Since the Farnesina picture can hardly have copied the lekythoi, which had been buried for several centuries, its model was presumably a painted panel that had survived from the mid fifth century. In such simple decorative compositions it looks as if the style too was more conservative; though there is here shading in folds of drapery and on the framework of the chair, the three-quarter face, for instance, was not yet fashionable.

In vase painting indications of setting are rare, partly because of the small size of the field, but Polygnotus's big pictures at Delphi showed some trees and reeds and even the pebbles of the shore (presumably as on Plate 25b). Much greater importance is given to the setting in murals of the inner room of the Etruscan 'Tomb of Hunting and Fishing' (*plate 29b*), where the style though probably

retarded is that of the end of the sixth century and the figures are in scale, both for size and importance, with the natural surroundings. It is often asserted that an interest in nature is a special characteristic of Italian or at least Etruscan art; but the only parallel in Italy around that time is at Greek Paestum and, though there are of course no original pictures from Greece to compare with them, we have an earlier seascape at Kizibel in Lycia and something of the same kind can be found in Attic vase painting (compare Plate 25b, where because of the white ground one might anyhow suspect a special connection with painting). Some interest in setting can indeed be traced back beyond the middle of the sixth century in vase painting and curiously in a pedimental sculpture from the Acropolis at Athens, which shows a wellhouse and a tree; presumably with its more convenient medium painting did not lag behind. Even so, the setting can have been only subsidiary in the more famous Classical pictures.

In spite of its mastery of foreshortening the technique of Early Classical painters was still outline drawing with economical linear detail. Modelling, by hatching or gradation of colour, seems to have come slowly and perhaps intermittently. Just before 500 some Attic red-figure vase painters had begun occasionally to fill in the outlines of pelts and rocks with an uneven wash of dilute paint (compare Plate 25a), though probably only to indicate roughness of texture or to give substance to a shape that had no self-explanatory contour. By the second quarter of the fifth century folds were sometimes (but not very often) emphasized by thickened lines or shading, so giving some effect of shadow – this occurs also on the Farnesina panel (*plate 30a*) – and about the same time and not only on vases which for other reasons seem connected with the new painting light hatching or shading now and then reinforces the edges of round objects, such as the bowls of shields or the vault of the tomb on the Sotades painter's cup (*plate 25b*). By the 420s a red-figure vase painter could do a rapid and passable job of modelling the form of a wine bowl and the deep folds of drapery, but there is still no sign of experiment on human anatomy, though that was the principal interest of Greek artists. Such experiment appears first in a small and otherwise mediocre group of Attic white lekythoi of the last ten or fifteen years of the fifth century; here male flesh is modelled strongly, though female flesh is not. Plate 27a shows part of a South Italian

vase painting of slightly later date and more advanced technique, where the statue within the temple is high-lighted with added yellow and the youth in front is in a purely red-figure technique. This obdurate fidelity of red-figure vase painting to its linear tradition makes one wonder whether modelling may have developed appreciably earlier in painting. Still the nickname of *Skiagraphos* ('Shadow-painter') given to Apollodorus, who was working in the late fifth century and 'opened the doors of the art', suggests that he was anyhow the first to exploit the new technique. His younger contemporary Zeuxis is said to have gone still further. As for women's flesh, copies of major and surviving specimens of minor Greek painting and the wall pictures in Etruscan tombs show that modelling was admitted about the middle of the fourth century. Cast shadows are more puzzling; they do not appear in pictures or copies of pictures till the late fourth century nor were they used with strong effect till the third; yet there is an instance – the more striking because irrelevant – in a second-rate Attic red-figure vase painting soon after the middle of the fifth century, and a hundred years or so later the 'Boy blowing a fire' of Antiphilus, which was admired for the reflection of the flames on the boy's face, presumably required strong shadows. Probably, though, an even vertical lighting was usual in Classical pictures and so in general cast shadows were considered fussy.

In much the same way painters were reluctant to make regular use of perspective, in the sense of diminution of size according to distance, a phenomenon on which so much ordinary observation depends. Anyhow there is no sign of perspective in Polygnotan painting, in spite of its conscious feeling for spatial depth, and it was in stage scenery (presumably architectural) that according to Vitruvius it was attempted for the first time. The occasion was the production of a play by Aeschylus and, though this may have been after the dramatist's death in 456, the theory was investigated by Anaxagoras and he died in 428. Since Anaxagoras was an intelligent geometrician, it should follow that a useful system of perspective was available not long after the middle of the fifth century, whether or not it was much used. Attic vase painters generally rejected any spatial depth and were content with occasional foreshortening of furniture (compare Plate 30a); the rare copies that we have of later Classical pictures and the early Hellenistic originals do not need much perspective in their composition, and it is

not perhaps till the second century that we find a coherently receding interior in paintings; and yet during the fourth century Greek sculptors carving reliefs for Lycian dynasts (whose tastes were not purely Greek) occasionally put a little perspective into their views of towns and some ambitious vase painters in South Italy were indulging already in bold if inaccurate architectural recession (*plate 27a*). Some students deny that Greek painting ever achieved consistent perspective with a single vanishing point, but in the first century a few of the architectural vistas painted by interior decorators on the walls of houses at Pompeii show a system too coherent to be accidental and Vitruvius evidently knew of theoretical principles. An aerial perspective – that is the toning down of colours in the distant background – did not appear, so far as we know, before the second century. With this Greek artists had all the technical devices needed for fully illusionist painting.

The training of painters was normally by working as assistant in a master's workshop, a system much like that of apprenticeship, though about the middle of the fourth century Pamphilos set up a painting school at Sicyon and had distinguished pupils. Painting from life had begun by the end of the fifth century, as Xenophon mentions in his memoirs of Socrates. Theory too was studied: several painters wrote about their art and Pamphilos included arithmetic and geometry in his curriculum, insisting that they were indispensable to proper practice. Through his efforts painting (or drawing) also became a recognized subject in the education of Greek boys, with what effects we do not know.

Not all Classical and Hellenistic painters exploited the full repertory of technical devices that were available. In the fifth and fourth centuries there was a vogue for four-colour painting, the four colours being black, white, red and yellow and their combinations (*plate 32*). Why painters chose so to restrict their palette is not known, but since these were the colours that vase painters had found satisfactory for firing, it is tempting to guess that at this time they were also the most satisfactory in encaustic. There was monochrome painting too, which sometimes had the effect of pastel (*plate 30b*) and sometimes simulated sculpture in relief. Simple line drawing also had its admirers and Pliny remarks that Parrhasios's sketches were studied by later artists. It is worth remembering that the Greek word *grapho* includes both painting and drawing.

Subjects varied too. Large compositions, especially battle pieces (*plate 32*), had a steady though limited market; but to judge from titles listed by Pliny, the standard masterpiece was a small group of mythological figures, such as Leto and Niobe (*plate 30b*), Perseus freeing Andromeda (*plate 31b*) or the sacrifice of Iphigeneia. It was probably the demands of private customers which encouraged the production of erotic pictures, mentioned already in the late fifth century, and of still life, which began not later than the fourth. Caricature may go back to the end of the fifth century and portraiture to the middle of the fourth. Landscape as an independent branch of art (*plate 33*) perhaps did not develop till the second century, since our written sources first mention a landscape painter in 164, though the painting of stage scenery – without figures – must go back to the fifth. As for treatment, the range – anyhow in the Hellenistic period – was from the sublime to the sentimental.

Clearly the technical equipment of Greek painters from the late fifth century on was very highly developed, but the quality of the work they produced is much harder to judge. The originals that survive are all second-rate or worse and most of them provincial too, nor do they represent fairly the more important kinds of painting. The copies or supposed copies are on the whole not only unreliable but disillusioning. Of the more ambitious most are wall paintings, especially from Pompeii and Herculaneum, works done by hacks, presumably working under contract and without the opportunity (to say nothing of the ability) to reproduce an original with fair accuracy. An accurate representation could only be made in front of the original (or of another accurate reproduction so made) and indeed there seem to be a few such reproductions (*plates 30a-b* and *32*); but the inferior painters, so evident at Pompeii, could have had nothing better than rough copy books (since neither photography nor printing had been invented) and of course their memories. So it is less surprising that they often altered the style of figures from old masterpieces, reset them in enlarged compositions and modernized the backgrounds. For instance, the 'Perseus and Andromeda' of Plate 31b may well go back to an original by Nicias of the mid fourth century; but the brush work is impressionistic, the character of the faces perhaps insufficiently heroic and the cast shadows too emphatic, and beyond all this the effect is stodgily dull. Other copies of the same

original, also at Pompeii, are freer and more expansive (*plate 31a*). These warnings must be remembered whenever one examines any specimen of ancient painting.

The so-called 'Astragalizusae' (or 'Girls playing knucklebones') is a smallish picture on marble found at Herculaneum (*plate 30b*). The marble was imported from Greece, presumably already painted. The technique is monochrome in various shades of brown, the style relies very much on line without shading of the female flesh, and the background is blank and white. The subject is in appearance a domestic scene, rendered with Classical serenity, but neat little names beside each figure label it as mythological, an incident in the relations of Leto and Niobe.before their disastrous quarrel. The picture seems to be a faithful copy of an original of the end of the fifth century, except for the forms of the letters, which are of the early first century. (The signature, Alexander of Athens, like those on some statues should be that of the copyist.) The 'Astragalizusae' cannot be considered fully typical of the time of its original. Apart from its technique, it has very little of the expression of character and emotion attributed to some contemporary masters: Timanthes, for example, was famous for the gradations of grief he depicted in his 'Sacrifice of Iphigeneia'.

The original of the 'Perseus freeing Andromeda' on Plate 31b was probably of the mid fourth century, the copy of the earlier first century AD. The main alterations of the copyists have just been mentioned, but the composition, the heroic build and statuesque modelling of the figures, and the simple setting with neutral background seem reliable and characteristic of many Late Classical pictures. Unfortunately the quality of the copy is very poor, so that one would never suppose that it represented the beginning of the period – the second half of the fourth century – which was afterwards regarded as the age when Greek painting was at its greatest.

The Alexander mosaic (*plate 32*) depicts the encounter of Alexander the Great and the Persian king Darius at the battle of Issus in 333. The accuracy of the representation of contemporary Persian costume is strong evidence that the mosaic, so far as its medium allows, is a faithful copy of a painting of the late fourth century, executed in the four-colour system. Once again the background is a white void and the single object in it is a lopped

and leafless tree, put into balance Darius more than to suggest landscape; and the foreground too is blank, except for a little debris from the fighting. The artist's interest is concentrated on his figures, modelled with bold light and shade, expressive of feeling and arranged in a crowded but carefully controlled composition. The mosaicist who made this copy in the first century must have coarsened the effect of the original picture, since its fluent lines and gradations of colour had to be rendered by square tesserae, each of uniform tone; but even so, it is an extraordinary feat of virtuosity, and all the more valuable because among our remains of ancient painting there is nothing comparable to this battle piece. In reconstructing Greek painting one must beware of arguing from absence; without the Alexander mosaic few students would have believed that there were pictures of this kind in the late fourth century.

Hellenistic painting seems at first to have exaggerated the pathos exhibited in the Alexander mosaic and to have developed a more richly pictorial style, of which the big Pergamum frieze (plate 67) is a counterpart in sculpture; but in the second century an academic reaction began and with it intensive adaptation and copying. Of new kinds of painting landscape was probably the most important, though again we have only one good example, the incomplete set of illustrations of the Odyssey, found in a house on the Esquiline hill in Rome (plate 33). The Odyssey landscapes were painted in the first century, but may be copies of pictures a hundred years or so earlier. Here the figures are dominated by the setting, which is emphasized by strong light and shade, the brushwork is competently sketchy, and in the distance the colours fade with a skill that shows established practice. Curiously in this sophisticated illusionism some old-fashioned conventions are cherished: many of the figures have their names written neatly beside them, so that we know at once whom Odysseus is meeting. Yet the Alexander mosaic (plate 32) and the 'Perseus freeing Andromeda' (plate 31) had done without this labelling. Odyssey landscapes were, Vitruvius says, a favourite subject of late Hellenistic painting, and the Esquiline set is too slick to have been pioneering work.

Both the 'Astragalizusae' (plate 30b) and the Alexander mosaic (plate 32) are copies of good quality, but presumably their originals were better. How much better we are never likely to know,

since the chances of finding an original Greek masterpiece are very small. It is clear though that the general standard of competence was high even in provincial studios. Here the Egyptian-Greek mummy portraits from the Fayum are a better guide than the interior decorations of Pompeii. Though of the Roman period, they still continue the Hellenistic traditions of portraiture and brushwork.

There is no genuine distinction between Greek and Roman painting, unless it is relevant that by the end of the first century BC creative impulses had failed. In the Augustan period an academic style was cultivated, which neatly balanced the claims of figures and background, and during the next three hundred years fashion shifted between that and the more full-blooded imitation of earlier Hellenistic; in general originality was diverted into adaptation or whimsicality. It is not surprising that in the mid first century AD Pliny the Elder described painting as a dying art. By the fourth century AD technical standards were falling and, though for two or three hundred years longer some respectable work was done in the old tradition (mainly by miniaturists and the illustrators of expensive manuscripts), the hieratic style of Byzantine painting was becoming established. By Greek standards this is a depraved art – technically incompetent, contemptuous of the ideal beauty of the human figure, and ignorant of the rules of optics; and though it developed a mystical theory of its own, there seems always to have been a consciousness of its Greek heritage – evident in the modelling of forms by shading and high lights, in the use of foreshortening and in the retention of a sort of perspective – so that it was always turning back towards Greek models, dimly preserved in the illustrations of manuscripts. In Western Europe except for Italy, which kept a connection with the Byzantine world, the barbarian invasions more or less wiped out painting, but as it revived it inevitably borrowed much from the art of Byzantium, then culturally the most sophisticated centre of Christendom. Even so, though Greek painting was the basic ingredient of Medieval painting, both Western and Byzantine, it was not a fertile ingredient. Byzantine painting may have developed, but it did not progress; and the progress of late Medieval painting in the West was due almost entirely to native originality.

The Renaissance began in the fifteenth century in Central Italy and the casual observation of the antique, which had appeared

erratically in works of the later Middle Ages, developed into a systematic study by the artists of the time; but the objects of this study, by painters as well as sculptors, were ancient statues and reliefs, not pictures. There is an obvious reason; the busy search for antiquities turned up plenty of sculpture, but very little painting and that generally of a quality both artistically and technically inferior to the standard of the Renaissance masters. It is sometimes claimed that one or another of their pictures shows the influence of an ancient painting from a Roman house or even an Etruscan tomb, without good reasons; ancient painting too was related to sculpture, though there painting seems to have given more than it received, and since Renaissance painters drew on their knowledge of ancient sculpture it is perhaps more surprising that there are so few convergences apparent between their pictures and those of the Roman past. This study of ancient sculpture remained a basic part of the training of painters till the nineteenth century and continually showed its effects in their figures, but the effects of ancient painting were always negligible. The minor technique of grisaille was imitated from mural decorations found in Rome, some subjects recorded or described by ancient writers were reinterpreted according to the canons of the time, and from the middle of the eighteenth century a few Neoclassicists – for instance Mengs – turned out an occasional pastiche of wall paintings from Herculaneum or Pompeii. Ancient Greek painting was ill-fated: very little of its achievement has survived and its useful legacy amounted only to a few, though very important, technical devices.

4 SCULPTURE

Sources

Monumental Greek sculpture started in the mid-seventh century and by the beginning of the sixth was a major art with an established and growing market. It supplied cult figures of gods, dedications in sanctuaries, monuments to stand above (but not inside) graves, architectural decorations, and eventually statues and reliefs for wealthy private houses. Of all this relatively little remains. As might be expected much has perished from natural causes, but still more was destroyed deliberately during medieval and, in backward regions, modern times. The reason was not usually religious zeal, but the value of marble as raw material for lime and – more compellingly – of bronze for scrap, so that to survive sculpture had to be out of sight or reach and, as a result, what we now have is a sample unevenly distributed in time, type and quality. Architectural sculpture, while still in place, was not likely to be removed and, when the building collapsed, might be buried under a mass of masonry; independent reliefs, especially gravestones, were liable to fall down and, if covered over, be forgotten; and any slab carved in low relief could be reused as a structural block. Free-standing statues had poorer chances, since they were less likely to be hidden sufficiently by debris, especially in populous places. Metal, of course, was worth digging for and so less than a score of Greek bronze statues have turned up that are reasonably complete, several of them dredged up from the sea. As for marble sculpture, Archaic did best; being less admired it was less carefully conserved by later Greeks and Romans and so could be lost before the period of destruction set in, and there is also the big cache from the Acropolis of Athens where much of the statuary which the Persians broke in 480–79 was used as fill in the restoration that followed. At the other end we have a surfeit of Roman copies of popular Classical and Hellenistic works; output was very

large and they were put up much more widely in private as well as public places.

These copies, some by conventional dating Late Hellenistic but more of them Roman, hinder as well as help the enjoyment and study of Greek sculpture. Though the copyists fixed points by measurement, the points were much sparser than in modern practice and the intervening spaces and the details were carved freehand and usually without much care, as can be seen when comparing different reproductions of the same original. In general copies are fairly reliable for pose, but mostly so harsh and insensitive in their treatment of surface that now they more often repel than interest the unprejudiced viewer; and with the finer examples there is the problem whether the copyists may not also have been creative. Unfortunately very few first-rate Classical and Hellenistic statues have survived in the original and those that are known through copies are far more numerous, so that copies have to be used in any stylistic survey of Greek sculpture, though not as much as is often done.

Besides the surviving originals and copies there is another source of information in the remains of Greek and Latin literature. Pliny the Elder includes a continuous account of Greek sculpture in the *Natural History* he compiled around the middle of the first century AD, Pausanias a century later mentions many of the works he saw when travelling round for his *Description of Greece*, and there are casual references to sculptors and sculptures by other authors. These casual remarks are generally trivial, except for a few shrewd verdicts of Quintilian's; Pausanias was congenitally uncritical, reporting faithfully what was told him but more interested in mythology than in art; and Pliny's account, mainly second-hand, is compounded of colourful but untrustworthy anecdotes, lists of sculptors and their most famous works, and a series of stylistic judgments that were probably taken from a Greek critic of the third century with a good and sensitive knowledge of Classical sculpture but very little of Archaic. In a way it is a pity that Pliny's history has come down to us. If students of the last hundred years had spent less time trying to identify the works and personalities he mentions, our understanding of general trends should have got much further.

In practice our understanding of the development of Greek sculpture depends on the stylistic analysis of surviving works,

supported by a miscellany of dates from historical records and inscriptions. The most important of these dates are the Persian capture of the Acropolis of Athens in 480, which gives a lower limit for the works they damaged; the completion of the Temple of Zeus at Olympia not later than 456; the sculptural decoration of the Parthenon, carried out in sequence from 447 to 432; the Nike of Paionios, commissioned about 420; the gravestone of Dexileos, killed at Corinth in 394; the building of the Mausoleum, which was going on in the 350s; the embellishment of the Great Altar at Pergamum, which is very probably of the early second century; the destruction of Delos in 69, again a lower limit for the statues found there; and the dedication of the Ara Pacis at Rome in 9 BC. There are other recorded dates, either precise but for works of little artistic importance or for important works but too vague to be helpful; archaeological contexts are usually disappointing; and Pliny's chronology of sculptors only gives the Olympiad (a period of four years) in which they 'flourished', whatever that may mean.

The present state of knowledge is very uneven. For the Archaic period, where there are no lists in Pliny to distract students, the examination of style has produced a reasonably credible evolution, as it has too – in spite of Pliny – for the Classical period till near the end of the fifth century; but even here experts are liable to disagree by as much as twenty years over the dating of particular works. The fourth century is obscure, whatever the text-books say, and the Hellenistic period still more so, except perhaps towards its end. Though in time there should be more precision about trends, it does not seem that we shall ever have enough material to understand the personalities of Greek sculpture, not that that will deter the many students who remain devoted to their *Natural History*.

Materials and Technique

The principal materials for Greek sculpture were marble and bronze; limestone, terracotta and wood were much inferior; and there were a few 'chryselephantine' statues, of gold sheeting and ivory mounted on a wooden core. Marble, which was used from the beginning, occurs in several places in and around the Aegean,

though not – anyhow of satisfactory quality – in South Italy and Sicily; the Greeks liked white, medium- to fine-grained varieties, with much more sparkle than the Carrara (or Luna) later exploited by the Romans and still familiar in the cemeteries of Western Europe. Limestone, which Classical archaeologists often call 'poros', is plentiful in most Greek lands and some of it is of very fine quality; it was the commonest stone for statues in the seventh century, but afterwards passed as reputable only for architectural sculpture in places like Sicily, where marble was too expensive. Terracotta too was an economical material for architectural work, particularly antefixes and acroteria. Wood, of course, had little chance of surviving, and to judge by ancient records was never in regular use for finished sculpture, though possibly the moulds for bronze statues were formed on wooden figures. Bronze was not important till the second half of the sixth century, when the hammering of sheet metal was replaced by hollow casting, but by the early fifth century was the preferred medium for free-standing statues (though not for reliefs and architectural sculpture). Chryselephantine statues, which were too expensive and perhaps also too easily damaged to be common, go back at least to the middle years of the sixth century: they were appreciated particularly as cult images in temples. There are other instances, also infrequent, of combinations of materials: some large statues were 'acrolithic', that is of stone for the flesh and wood for the other parts, and occasionally the hair of marble statues was completed in stucco.

Greek sculpture was coloured, as was most sculpture till the Renaissance, and indeed if the ancient marble statues which were found and admired at that time had kept their paint, the more conservative of us would probably still expect colouring on sculpture. Of the details of the Greek painting of marble, with which goes that of limestone and wood, our information is patchy. For the sixth century the finds on the Acropolis of Athens give good samples and there are later sarcophagi from Sidon and Etruria where the colours are well preserved, but usually we are lucky if we have traces even of the boundaries of painted areas. On terracotta the paint has survived much better, since it was fired on, but unfortunately because of the firing the range of colours was limited and rather crude. There is the difficulty too that through chemical action some colours may have changed – in particular

blues have sometimes turned into greens – and red, which is the most persistent pigment, may sometimes have served as an undercoating. Still one may say confidently that eyes, hair, lips and nipples were regularly and cheeks sometimes painted, that female flesh was left in the natural white of the marble or only tinted lightly, that male flesh was often coloured a warm brown, and that drapery was usually painted over completely unless for contrast a garment was left white. Generally there was till the fourth century a continuous progress towards subtler and more natural colouring, though later it became commoner for hair to be gilded. With this taste for polychromy it is not surprising that the Greeks were ready to add such accessories as ear-rings and weapons in metal – how extensively may be judged by the holes drilled for their attachment. The result of all this was to make ancient sculpture much more vivacious, most obviously in giving sight to the eyes (*plate 58*). It is harder to calculate the effects in drapery, but sometimes the composition must have been clarified or strengthened by contrasting colour, as on the Nike of Paionios (*plate 55*), where one thigh was naked and the other covered. For reliefs one must also reckon that the background was painted red or blue, and for pediments blue. As for bronze, Greek taste preferred to keep it shiny and patination was a sign of neglect, though in the Roman period some collectors considered patina a certificate of antiquity. Eyes were regularly filled with paste or some other substance, and lips and nipples were often inlaid with copper or silver, but experts still dispute whether hair and other areas were darkened artificially or even painted. So when one looks at Greek sculpture it is worth making the effort to remember that there was more to it than form.

For reliefs it is natural to sketch the subject on the prepared surface and to work from that sketch, but till well on in the Hellenistic period Greek marble sculptors did not use detailed models when carving statues, or so – in spite of the incredulity of some students – it can reasonably be inferred from finished and unfinished works. First, it is not till the last century BC that there are traces of any system of pointing – the method by which positions determined on a model are transferred precisely to the block from which the final statue is to be carved – and even then the points were far enough apart for large areas to be left to freehand carving. Secondly, in pedimental sculpture, where at least the

relationship of the figures had to be planned accurately before-hand, the various sculptors of the team could develop the drapery of their figures as they chose; this is very clear in the west pediment of the Temple of Zeus at Olympia where on some figures the treatment of folds is old-fashioned and on others discordantly progressive. From the identity of style with that of marble statues bronze statues too must usually have depended on carving, presumably here of the preliminary figure, and it is hardly before the second century that there is any suggestion in finished work of that fluid kind of modelling which is encouraged by soft clay or wax. More surprisingly there is no such plastic modelling in terra-cottas either. Evidently the Greek sculptural tradition was founded on and fixed by carving.

Surviving originals which were abandoned at various stages of progress show that the normal procedure of carving a marble statue was not to finish one part at a time (as usually happens with pointing from a scale model), but to work round the figure stage by stage. This meant that there was not much that the sculptor could delegate safely to an assistant and that he was continually reminded of the effect of the whole as he dealt with the detail. Presumably he began by drawing the outlines of his figure on all four sides of the block; this would have been practicable enough with the uncomplicated, four-square poses that were regular for statuary till the fourth century. Next he removed the surplus stone to within an inch or so of the intended final surface, using first the pick-hammer and the drill and then increasingly the punch. Tools were of iron and punch, point and chisels were struck with a wooden mallet. There followed the rough shaping of the figure with the point, a fine punch which can be recognized by the pitting it leaves, and awkward cavities (such as the space between an arm and the body or deep folds of drapery) were partly hollowed out by the drill. The drill, which had a round chisel for its bit, was used in two ways, either to bore single holes or series of holes, or (as a 'running' drill) travelling obliquely forward to cut a furrow. The method of the running drill seems to have been invented little, if at all, earlier than the 370s and, since it saved labour, soon became very popular. The next and most decisive stage of the carving was the detailed modelling of the surface by chisels of various types – the claw chisel (which seems to have been invented around 560), the flat chisel and the

round chisel; these chisels were used both obliquely and vertically, as was the point, and normally with short, gentle strokes. After the modelling the surface was smoothed with rasps of suitable shapes and gauge, and then came a finer smoothing with abrasives, probably emery chips and powder followed by powdered pumice. This smoothing did not produce the high gloss of much Roman and recent sculpture; for gloss the surface needs to be polished with finer abrasives, such as putty powder or rouge. Finally the statue was painted, by the fifth century usually in the encaustic technique, and any metal accessories were attached. For reliefs the procedure was much the same. First the subject must have been sketched on the prepared block. Then the outline was cut out, on deeper reliefs often by a drill, and after that the point, chisel, rasp and abrasives were used in sequence. Generally Greek sculptors of reliefs carved no part much further back from the front plane than was required by the effective modelling of that part. So (in contrast to much recent work) the background tends not to be level and the depth at which figures and parts of figures are set is governed more by optical than natural relationships. For example on a slab from the frieze of the Parthenon (plate 51a) the figures are shown in side view, but their heels and the foot of the second chair are carved almost in the same surface plane. For pedimental figures practice varied; sometimes the procedure was that used for free-standing statues, though often the back was unfinished, but sometimes – as with the bodies of the Centaurs at Olympia (plate 47a) they were treated much like high relief.

The standard of finish was very high and all visible tool marks of one stage were expected to be cleared away in the next, though there were awkward places where abrasives or the rasp could not be used properly and very occasionally a tool dug too deep on an open surface. Taste in finishing varied, but was less exacting as time went on. On reliefs backgrounds and large neutral areas like seats were often rasped, but not smoothed further by abrasives; in the fourth century some sculptors chose to leave drapery only rasped, for contrast of texture with the fully smoothed flesh; and in lesser pieces there was an increasing tendency to negligence. Even so, the difference between even mediocre Greek carving and the average Roman copy is obvious; the copyists only occasionally took trouble over the chisel work. It has been

calculated that the carving of a full-size marble statue must have taken a Greek sculptor from six to nine months.

Bronze statues are rare, so that it is much more difficult than it is with marble statues to deduce the methods by which they were made and the summary account that follows may be wrong in parts. During the seventh and the early sixth centuries some sizable statues were constructed in the 'sphyrelaton' technique – thin sheets of bronze hammered into shape and fastened with nails to a wooden frame or core – but the results were not satisfactory; and though small figurines were cast solid in moulds, solid casting was too expensive (even if practicable) for large figures. Then, probably about the middle of the sixth century, a process of hollow casting which had been used for some time for smallish objects was borrowed and developed for full-size statues. The Greeks were not advanced enough in their metallurgy to construct large frames as rigid as is needed for sand-box casting and so, anyhow for statuary, must have depended on a 'lost wax' process. The regular sequence of work seems to have been something like this. First the sculptor prepared his preliminary figure in full and precise detail; the material is likely to have been wax, or perhaps clay or wood, but anyhow the effect suggests carving rather than modelling of the surface. Then this figure was coated with clay (or possibly plaster) to make a mould. Next the mould and the preliminary figure had to be separated, and here more uncertainty comes in. The following stage required the mould to have been slit open, and besides that it was usual to cast large statues in several parts. If then the material of the preliminary figure was soft – that is wax or clay – it could be prised or dug away or perhaps run or washed out; or else – and necessarily if it was hard, as wood is – the figure was removed intact and, since undercutting was frequent, especially in folds of drapery, this means either that the figure had already been dissected into many separable pieces or that an equally complex dissection was now performed on the mould, though if the mould was so dissected most of the smaller pieces must have been reassembled before the next stage. In this the open mould was lined with wax (or some comparable material) to whatever thickness was wanted for the bronze wall of the finished statue; this is a safe inference from the character and markings of the internal surface of surviving statues. In turn the wax lining was lined with clay to form a core, which

was connected to the mould by metal pegs ('chaplets'), so that mould and core would keep their relative positions when the wax was melted out: this clay core may have been slapped on moist or poured in liquid, and depending on the process used the mould was reassembled in its complete parts after or before the making of the core. If the mould was of plaster an extra operation was necessary, since the plaster had to be removed carefully from the wax-covered core and replaced by a thick coating of clay. (The procedure described so far is that of indirect 'lost wax' casting, but – so fragments of statues show – Greek sculptors sometimes used the less economical direct procedure instead: here the preliminary figure, which is of clay and also serves as a core, is itself coated with a layer of wax and this layer, which is finished in full detail, is enclosed in a casing of clay.) All was now ready for the firing. The moulds with their cores were warmed so that the wax melted out and molten bronze was run into the cavities left by the wax; but since air-dried clay will not take molten metal without at least buckling, one may presume that after the wax had melted the moulds and cores were fired to the temperature required for terracotta or even higher and the metal was run in while they were still at this heat. Then, when everything had cooled, the bronze casting was freed by breaking off the outer mould or coating; as it happens, parts of such a casing, found in the Agora at Athens, are our earliest evidence for the hollow-cast human figure in Greek statuary. It was not, of course, necessary to pick out all the core and in fact lumps of core have been found still surviving inside bronze statues. There was still plenty of work to be done. At this stage the casting has a granular skin, which needed scraping off; cracks were plugged and faults made good by cutting out and filling with strips of metal plate (the rectangular depressions visible on some surviving statues are such cuttings from which the fillings have fallen out); the separately moulded pieces were joined together, by tongue and groove if large or by welding or soldering if small; details were engraved, eyes were inserted and fixed, often lips and nipples were inlaid in copper or some other metal, and the whole surface was burnished thoroughly to conceal the edges of joins and patchings and to produce a proper shine. The shine was maintained, as records show, by applications of oil or resin, and perhaps bitumen too was used. Altogether the making of a bronze statue was a complicated job and the risks

of failure in firing the mould and founding the metal must have been serious. Probably it was more than the greater cost of the materials that made bronze statues dearer than statues of marble.

Some statues, especially smallish ones, were put on high pedestals or even columns or piers, but the most normal type of Greek base was of marble and rectangular, simple and lowish. In the fifth century for a full-size statue the base was commonly rather less than a foot high and its surface might be finished only with the point, though later there was a tendency to something taller and more ornate. Standing marble statues were carved with a small plinth round the feet and this was let into the base and fixed with lead, often untidily. Bronze statues were pegged. The setting was usually in the open air and, since by the fifth century Greek sculptors were sophisticated enough to make optical corrections for the angle of viewing, one must assume that they also took account of the nature of the lighting. These very important factors are often ignored in the exhibiting of Greek sculpture in both old and new museums, where statues are mostly set too high above the ground and their illumination is likely to be one-sided and oblique. Nor is the arrangement altogether correct, in long rows or studied groupings; the Greek habit was to consider each statue as an independent entity and to site it, anyhow in sanctuaries, in some conveniently vac~~t place without much concern for its aesthetic relationship to neighbouring statues or buildings.

There is one more warning. Most ancient statues have been mutilated in the passage of time. From the sixteenth to the nineteenth century it was usual to restore at least the more obvious deficiencies and though the current fashion abhors any restoration – extravagantly so, since a face looks silly without a nose – many pieces are still exhibited which have been restored, sometimes misleadingly. There is a fairly reliable rule for distinguishing what is original in a marble statue and what is not. When two pieces of stone are joined, it is very hard to disguise the line of the join. Now a natural break leaves an irregular edge and, if a line of joining is irregular, the two pieces can be taken as belonging to each other. But since one needs a regular surface to fit a new piece onto another, a straight joining line shows that one of these pieces, usually that further from the centre of the figure, is an addition and one may suspect that the jagged surface of an old break has been cut down and smoothed to make a clean fit for a

replacement. Occasionally such replacements were made in ancient times, as for instance on the Critian Boy (*plate 43*) where presumably the original head had been damaged in the workshop, and some statues were made in several pieces, though where possible the joins were concealed under drapery; but generally where one can expect that the figure or the relevant part of the figure was carved from a single block, a straight join is valid evidence that there has been restoration in modern times, whether with a new piece or some fragment of another ancient statue. The National Museum at Naples, which inherited the magnificent Renaissance collection of the Farnese family, is an admirable place for practising this test of authenticity.

Purpose

The Greeks used statues for so-called cult figures of deities, dedications, monuments on graves and architectural decoration, but it was not until the Hellenistic period that they acquired or commissioned more than statuettes for private enjoyment. The uses of reliefs were similar, except that they did not serve as cult figures.

Cult statues, sometimes colossal, were comparatively rare. Normally one such statue, of the patron god or goddess, stood at the end of the cella of a temple, but the term 'cult statue' is misleading. These sculptures were regarded as works of human craftsmanship, illustrating but not embodying the deity, and though admired were not worshipped. The true cult idols, which a god or goddess was supposed in some sense to inhabit, were usually small and more or less shapeless blocks of wood or stone of miraculous antiquity. So at Athens Phidias's great statue of Athena in the Parthenon was the masterpiece of sculpture on the Acropolis, but the robe brought by the Panathenaic procession (represented on the frieze of the Parthenon) was presented to an ancient wooden idol that was without any sculptural pretensions.

Dedications were set up in sanctuaries and other public places, by private persons or by communities, to celebrate victory in athletic competitions or war, to pay a vow or a fine, to express gratitude for success or safety, and to advertise a donor. With them one may reckon the honorary statues with which from the fourth century onwards states and corporations more and more

often commemorated distinguished citizens or encouraged foreign benefactors. Some popular sites became crowded with these dedicatory statues, as is very evident from the surviving bases in the sanctuary of Apollo at Delphi. Reliefs were usually less imposing and cheaper; they vary widely in size and quality and were especially popular as votive offerings, like the painted wooden or terracotta plaques offered by the poor. Much the most numerous class of statues were dedications.

Grave monuments were another important class of sculpture. Most of them were in relief. But those who could afford it sometimes preferred a statue, especially in the Archaic period, and indeed most of the kouroi found in Attica served as monuments of this kind. Though the Greeks respected the graves of their dead, the memorials above them satisfied family feeling and ostentation rather than religious necessities; and so in a public emergency grave sculptures could be demolished to provide stone for fortifications and at Athens on two occasions funerary expenditure was restricted successfully by civil legislation. Again in the siting and choice of monuments not much notice was taken of those on neighbouring plots; the main cemeteries ran along the roads outside the city gates, with the dead competing (sometimes explicitly) for the notice of every passer-by.

In Greek architecture, especially for temples, sculpture in the round could be used for acroteria and antefixes, and spouts often took the shape of lion heads. Further, the figures of pedimental sculpture soon came to stand clear of their background, though in composition and poses they were still close to reliefs. The metopes of the Doric order were often carved in relief and so in the Ionic order were the frieze and occasionally column drums, dadoes and even parapets. Other uses for architectural sculpture are found among foreign peoples who admired and followed Greek art; in particular, statues were sometimes put by Etruscans along the ridge of a temple roof and by Lycians in the intervals of the raised colonnade embellishing an aristocratic tomb.

Most of these uses of sculpture were connected with sanctuaries and graves, but even if religion permeated Greek life, Greek art was in no significant sense religious. Representations of gods and goddesses, who were conceived as only too fully human, gave them their appropriate maturity and attributes – so Zeus was regularly bearded and Athena usually wore helmet and aegis – but

Greek artists, unlike Egyptian, were hardly at all cramped by hieratic regulations. The standard by which an artist's work was judged was not some immanent magical potency, but its aesthetic value within, of course, the limits allowed by public opinion. This limitation applied particularly to sculpture – and to statues more than reliefs – since sculpture of any consequence was set up only in public places. That presumably is why the first statue of a nude female did not occur till the middle of the fourth century, though in vase painting and for figurines (and indeed in relief sculpture) the type had been accepted long before; but painted vases and figurines were made for private customers and, even if dedicated in a sanctuary, they were not exhibited conspicuously. Sculptors only became free of such restraint in the Hellenistic period, when public opinion had changed and they were at last enabled to exploit without disguise their own or their customers' tastes for the unheroic, the erotic and the sentimental.

It is much the same with sculptural types and subjects. Throughout the Archaic period the two principal types were the kouros or standing naked male (as Plate 38) and the kore or standing draped female (as Plate 41), and these could serve indiscriminately as cult statues or dedications or grave monuments. So too to a lesser degree did the Classical successors of the kouros and kore. Some gods and heroes had a characteristic attribute to identify them – Asklepios a snake or Heracles his club – but generally till the Hellenistic period the subjects of statues were unspecialized types, conserved because they were convenient vehicles for artistic expression. For instance the kouros is a regular type of statue on Archaic graves, but there is no good reason to think that these most expensive of contemporary sepulchral monuments were put up only for very young men who had not lived long enough to grow a beard. Again, in the later sixth century the standard dedication on the Acropolis at Athens was a kore; but because of its dress this figure did not represent Athena, to whom it was dedicated, nor because of its sex the donor, anyhow in those instances where the donor's name is recorded. It is interesting that 'agalma', one of the two common Greek words for a statue, had an original meaning of 'a thing to take pleasure in'. Reliefs, of course, where several figures are included, require some coherent subject to avoid dullness, but in the metopes and friezes of temples (and also in the pediments) the subject, regularly from mythology, was not

so often one particularly appropriate to the patron deity. The battle of the Lapiths and the Centaurs, which occupies the west pediment of the Temple of Zeus at Olympia (*plate 47a*) and the south set of metopes of the Parthenon at Athens (*plate 51b*), took place far away in Thessaly and was a minor incident in Greek myth; but it gave artists a convenient excuse for practising their skill in human anatomy, both male and female, and varying the effect with some equine. Grave reliefs developed their own conventions of domestic scenes of pleasure or grief (*plate 56*) and votive reliefs often depicted the appropriate divinities with worshippers approaching them, but the figures of the dead or the donors remained standard types. Even in portraits, or what pass as portraits, it was not until the Hellenistic period that sculptors tried seriously for a speaking likeness of their sitter. It is hard to avoid the conclusion that in the choice and even more in the treatment of types and subjects the dominant motives were aesthetic, and so one may with good conscience enjoy Greek sculpture as art without worrying about any esoteric meaning.

Origins

During the eighth century, at least in Crete, some simple reliefs of soft limestone show an Oriental and particularly Syrian manner, but this was a false start and is ignored here. Greek sculpture as we know it began with the so-called Daedalic style, which appeared towards the middle of the seventh century.

The problem of origins is best split into two – how did the Greeks get the idea of large statues of stone and how did they get the style? To the first question there is a ready answer: at that time Greeks were certainly visiting Syria, which had some stone sculpture, and perhaps Egypt, which had more. On the source of the style there are various theories. The one most widely held is that early Greek sculpture was based on Egyptian – because of the pose (especially of the male figure), the wig-like coiffure, and perhaps the technique of carving hard stone; yet the Greek male pose differs from the Egyptian in tilt and stance and had indeed been used in rather earlier Greek figurines, the coiffure was familiar in Syrian art as well, Greek masons may already have been used to marble, and lastly Egyptian forms are full and rounded and to

some degree individualized while Daedalic figures have a spare and unnaturally simplified structure. This last argument is valid also against the claim sometimes made for Syrian sculpture as parent at least of the female type. Another notion, that the Daedalic style of stone sculpture continued an earlier Greek style of carving in wood, has few supporters, since the Greek figurines of the early seventh and late eighth centuries are radically different from Daedalic in style and so too are the very rare stone carvings that may be of the same date. If these objections are good, then the style of Greek sculpture cannot have been derived from that of any sculptural school and in origin it may be simply an enlargement of the style of the contemporary Daedalic figurines of clay, which appeared suddenly at the beginning of the seventh century and both in style and technique – the use of a mould – were indebted to a class of cheap Syrian plaques and figurines (*plate 34a*); the shallowness of their moulding would also explain the neglect of the side view that is a characteristic of the earliest Greek statues. Still, not everyone can stomach so humble an ancestry for so high an art.

If, though, Egypt had no direct part in the creation of Greek sculpture, it may yet have had some influence later. The kouros in New York (*plate 37*), which was made about 600, conforms in some points to the standard grid used by the Egyptians for plotting out a statue and this may not be coincidence. Even so, the sculptor of the New York kouros was an eccentric, and more orthodox kouroi of the time show no such conformity; by then the sculpture like the other arts of European Greece was established firmly and what borrowings it made from outside were only casual. It may have been different in the East Greek region, along the west coast of Turkey, where a new and distinct style appears at the beginning of the sixth century, perhaps inspired by ivory statuettes from the Syrian region. But as more early sculpture is discovered, the problems or origins and influences will no doubt become more complicated.

The Daedalic Style

The first stage of Greek sculpture is usually called Daedalic (after Daedalus, a presumably legendary founder of the art). Its style is

based on a simple formula which remained dominant, though with evolutionary modifications, for about two generations – from the second to the last quarter of the seventh century. The principal view is frontal, so much so that in statues the side elevation can be compressed unnaturally and in reliefs full-face heads are common (*plate 35a*) – in notable contrast to the rule in contemporary vase painting and in the succeeding stage of Archaic sculpture. The face (*plate 34b*) is a long triangle with a low horizontal forehead, big eyes and nose, and at first anyhow a straightish mouth; the cranium too is low; the ears either are omitted or project at right angles; and the hair (rather like a full-bottomed wig) falls in solid masses at the front and back, relieved by horizontal grooving and sometimes a row of curls over the forehead, or less often it is divided into thick vertical locks. The body is still more perfunctory in its modelling and detail, with very long legs and high narrow waist, which is usually decorated with a deep belt. Apart from this belt male figures are naked (*plate 35c-d*), but females normally wear a heavy dress (the so-called 'peplos'), which fits closely above the waist and becomes a more or less rectangular sheath below, and sometimes there is also a short cape over the shoulders (*plate 34c-d*). The other distinctions between male and female are in the genitals, sometimes though not always in the breast, and probably in the length of the hair (compare Plates 34c-d and 35c-d); but since the bodice of the peplos is skintight, it is often difficult or impossible to determine the sex of a Daedalic torso or, if the hair is broken off, that of a head.

The trend in Greek sculpture was towards a sort of natural verisimilitude, and the development of the Daedalic style can be followed in part in the illustrations. Plate 34a shows a small and careless terracotta plaque, found at Corinth but thought to have been made in Syria; its date is perhaps around 680 and its very early Daedalic style is represented in Greek plaques and figurines of terracotta but not in stone sculpture or in bronzes. Next comes the bronze disc in Berlin (*plate 34b*), once perhaps the central ornament of a shield; it is hammered in fairly low relief, about two-thirds of life size, and dated in the 650s. A further shortening of the chin is one of the advances in the 'Auxerre Goddess' (*plate 34c-d*), so called because, whether goddess or not, it came to light in the Museum at Auxerre, a limestone statue of about 640 and not much over two feet high; in the bronze figurine from Delphi

(*plate 35 c-d*), only eight inches high and little if any later; and in the limestone relief from Mycenae (*plate 35a*), which was carved not much before 630. In both the Auxerre Goddess and the Delphi bronze the side view has considerable depth, though this may be partly because of their small size. The half-size terracotta head from Calydon (*plate 35b*), an antefix from the roof of a temple, is later – of about 625 – and the contours of the face are rounder, though one must for fair comparison discount the liveliness given by the survival of the paint on its eyeballs. Other changes occur in the proportions and less obviously in the modelling of bodies, and sometimes the ends of the mouth are turned up in a smile.

Traces of colouring are very rare. The head from Calydon (*plate 35b*) had white flesh, red lips and hair, black eyeballs and lashes and brows, and the same colours decorated its cap (or 'polos'); but this head is of terracotta and its maker's palette was restricted to pigments that would stand firing. On the limestone Auxerre Goddess spots of red survive in two of the scales on the chest, but over the whole surface of the figure there are scratched lines which can only have marked the boundaries between different colours and, if contrast was kept faithfully, there must have been at least four of them. A fair idea of the original effect is given in Plate 34d, from a tentatively restored cast: the colours used there are red, blue, black and yellow and the flesh is left in the off-white of the natural stone. As for bronze, the figurine from Delphi (*plate 35c-d*) was too small for inlays, but the Berlin disc (*plate 34b*) obviously needs some filling in the sockets of the eyes.

Three types of statue were regular, all symmetrically and frontally composed – the standing naked male, the standing draped female, and the seated draped figure (presumably also female). The standing naked male (*plate 35c-d*) is beardless and has his arms by his sides and the left leg advanced; this type, which lasted throughout the Archaic period, is now known as the 'kouros' type. The standing draped female (*plate 34c-d*) is similarly called 'kore'; here the feet are together and one or both arms may cross the body. So far no naked female statue has turned up, though there are naked females on reliefs and the type is common for terracotta plaques and figurines of Daedalic style, as for their Syrian predecessors. One may guess that a naked female figure set up in a public place would have offended Greek respectability,

even though the right hand of the Auxerre Goddess performs a pudic gesture more appropriate to a nude (*plate 34a*). The seated figure, which has no short archaeological name, is unsuitable for simple shallow moulds and so appears rarely and awkwardly among the small terracottas; nor is the sculptural type much better, with its unconvincing right-angle bend from body to legs and the forearms resting flatly along the thighs. Among the Daedalic terracottas female figures greatly outnumber the male and in sculpture too they seem to be more common, perhaps because the comparable Syrian figurines are mostly female and also that drapery conveniently cloaks inexperience in anatomy. There is no need or reason to suppose that in the seventh century the Greeks took a much greater interest in female deities than they did in the sixth.

There is more variety in reliefs. Some (contrary to later practice) contain only a frontal head, some a single frontal figure of a type regular for statues, some a simple group. For instance a large limestone relief from Gortyn in Crete exhibits a naked male (with frontal head and chest but profile hips and legs) embracing two naked frontal women, a subject hard to interpret canonically. Other reliefs have more active scenes, notably the fragments found on the citadel at Mycenae (*plate ˜5a*) and perhaps originally panels round an altar there, but because of their size hardly triglyphs from a primitive Doric temple. The piece illustrated, which is the best preserved, shows a woman whose body is in right profile, though she turns her face to the spectator and not to the action in which she takes part. Other panels show two creatures with feline legs lifting a rigid male corpse and male figures apparently fighting. For figures in action Daedalic sculptures kept to the convenient formula of Geometric vase painting (and most early art), that is frontal chest and profile hips and legs with an abrupt 90° swivel at the waist; only, unlike both their precursors and successors, the head tends to be frontal. This frontality, which is abnormal in Egyptian and Syrian as well as in earlier Greek reliefs, is suggestive for the origin of Daedalic sculpture.

So far Daedalic sculptures in stone have been found at several sites in Crete, at Sparta, Tegea, Mycenae and Sicyon, in eastern Locris, in Delos (then an important sanctuary for the Aegean), in Samos and – rather impurely – in Etruria. These finds are

mostly isolated so that the grand total is very small. Daedalic terracottas, though, are numerous but not ubiquitous. In Argos and Athens the local terracottas were in a different and un-formed style; for Naxos, Paros and the other Cycladic islands there is not yet enough material; Samos had a weak Daedalic school, and Crete, Sparta (or Laconia), Corinth and Rhodes had vigorous schools, of which the Corinthian is the highest in quality. The Daedalic style was used too for fine miniature work in metal and ivory, perhaps more widely. On this evidence it is difficult, if not impossible, to distinguish local schools of Daedalic sculpture – for instance the Auxerre Goddess is sometimes identified as Cretan and sometimes as Corinthian; if only because of their scale the style of large stone figures had diverged from that of small terracotta figurines, and also sculptors (unlike the makers of figurines) were likely to travel round, work-ing in local stones and influencing one another. This becomes even likelier if one compares our stocks of Daedalic and of later Archaic sculpture, for which the chances of survival were similar; it is clear that in the Daedalic period sculpture in stone was a relatively uncommon art and there would not have been work for resident specialists in every city.

In what Greek region or city Daedalic sculpture began may never be known. There were much later traditions that Daedalus, who worked in Crete, was the first Greek sculptor and that Dipoinos and Skyllis, who were born in Crete but migrated to Sicyon, were the first to become famous; but Greek traditions were conflicting and often manufactured or manipulated, so that they cannot be trusted. Still Crete always has an attraction, and some students claim that island as the original home of Daedalic sculpture, partly because of these traditions and partly because Crete was open very early to Oriental art; besides, more Daedalic sculptures have turned up in Crete than in any other region (though they are still too few for useful statistics) and Crete also had flourishing Daedalic schools for terracottas and finer small-scale work. Others prefer the north-east Peloponnese or more specifically Corinth, which was at the time the dominating centre for Orientalizing vase painting and possibly for the Doric style of architecture. Yet others argue for Naxos, since the Daedalic statues found at Delos and probably the Samos statue too are made of Naxian marble and one anyhow was dedicated by a Naxian. This

is a six-foot kore, now in the National Museum at Athens, with both arms down-stretched and primitive in proportions and model-ling, which displays an inscription cut up and down the left side of the skirt – 'Nikandre, daughter of Deinodikes the Naxian, out-standing among women, sister of Deinomenes and wife of Phraxos, dedicated me to the far-shooting archeress' (that is to Artemis) – more an advertisement of the donor than the deity. Unfortunately this gauntly impressive figure, which on style should not be later than about 650, is too weatherbeaten for easy study. But it is our earliest properly monumental work of Greek sculpture and to judge by its ingenuousness might well have been in its way a pioneering experiment. Anyhow, wherever Daedalic sculpture was invented, it seems that the choice of marble for its material can be credited to Naxos.

The dating of Daedalic sculpture is a little safer than might be thought. It is tied to that of the Daedalic terracottas, which are numerous enough to show a detailed stylistic development, and these in turn tie in with Corinthian vase painting. Although the conventions of the two arts do not allow much direct comparison, since one insists on frontal and the other on profile heads, there are a few painted vases which also carry plastic decoration in the form of Daedalic or slightly later heads. So Daedalic sculpture can be fitted fairly comfortably into the re'⸗tive chronology for seventh-century Greek art, though of course the absolute dates are not so reliable.

One may admire the severe principles of Daedalic sculpture, but they did not leave much room for development and the head from Mycenae (*plate 35a*) perhaps has already a touch of manner-ism. Not much later the formula passed away and (except in Etruria) very quickly, nor – perhaps because specimens were rare – did it ever catch the fancy of archaizing sculptors or connois-seurs. What remained were the kouros and kore types, the habit of working to an intellectually conceived ideal without direct imitation of nature, and some ability to carve marble.

The Archaic Style

Though it is correct to put the beginning of the Archaic period in the later eighth century, for sculpture it is more convenient to

restrict 'Archaic' to the style that succeeded Daedalic towards the end of the seventh century and lasted till the beginning of the fifth. This Archaic style is distinguished from Daedalic by its interest in depth and a more solid and credible anatomy, and the change seems to have been rapid, if not sudden. In European Greece one can see some signs of a transition, though there may also have been a stimulus from the maturer statuary of Egypt, where Greeks were now settling; but in Greek Asia it looks as if Syrian models had a more direct influence. Anyhow, with the appearance of the Archaic style the output of Greek sculpture became much greater – or so the finds suggest – and with the new confidence in the art larger statues became normal, some of them – especially at the beginning – well above natural size.

The Daedalic style, wherever its centres were, had been re-markably uniform. In the Archaic style there are two principal divisions, European and Asiatic (or East) Greek, sharing types and anatomical innovations, but the European more concerned with the structure of the figure and the Asiatic with its surface. Within these divisions there were some local schools, but how much they differed is still guesswork. One may assume that except at the sanctuaries of Delphi, Olympia and Delos, which attracted Greeks from a wide area and had no nearby city of any size, most of the sculpture found in the territory of any state was made by sculptors who lived there, and so one should be able to distinguish in the finds a fairly homogeneous group and an exotic miscellany, made by travelling masters of other states or (less probably) imported ready made. Unfortunately only two artistically important areas, Attica and Samos, have produced considerable series of sculpture and they belong one to the European and the other to the East Greek region. Elsewhere there are enough kouroi from the Ptoion sanctuary near Thebes and reliefs from Sparta and its neighbour-hood to show that the local sculptors of Boeotia and Laconia were as provincial as the vase painters; but from the territories of Corinth, Sicyon, Aegina, Argos, Naxos and Paros – all, according to later records or surviving signatures, the homes of notable Archaic sculptors – we have only isolated works, so that for in-stance we do not know if the heavy forms of Cleobis (*plate 36*) are characteristic of the Argolid or what, if anything, is peculiarly Aeginetan about the figures of the Aegina pediment. More serious is our ignorance about Paros, which now supplied from its

quarries the marble most preferred by the Greeks and was, at least geographically, halfway between the mainlands of European and Asiatic Greece. As it is, the reconstructed history of Archaic sculpture has a heavy bias towards Athens.

The two principal Archaic types of statue were still the kouros and the kore. From European Greece we have also a few seated figures, men on horseback, and – especially from earlier grave monuments – sphinxes squatting on their hind legs. In the East Greek region, where sculptors had different ideals, the draped male was fairly common, usually seated but sometimes standing or even reclining. Other types were very rare. Till the transition at the end of the Archaic style poses of statues remained frontal and symmetrical, and such exceptions as occurred were not significant. Some of the later korai have a very slight turn of the head or tilt of the shoulders and, since the standard of workmanship was meticulous, these deviations may have been deliberate attempts to give a little surreptitious variety to the stock formula. Other, more obvious exceptions can be explained by the requirement of a fully frontal view of the human face. With sphinxes, if the body was presented in side view, it was only reasonable to turn the head a full right angle; and when in an equestrian statue the head of the horse would have blocked the view of the rider's head for the spectator standing directly in front, it was a logical compromise to turn the rider's head a little to one side. Reliefs and pedimental sculpture with their necessarily greater variety of poses had comparable rules, which will be discussed later.

On the colouring of Archaic sculpture, so it happens, we are fairly knowledgeable, since because of the Persian invasion of 480 many works, recently painted or well maintained, were damaged and buried (or buried to escape damage) and sometimes, as on the Acropolis of Athens, conditions below ground proved kind. For marble the practice was at first to paint all the surface except the flesh, anyhow of women; later, from the third quarter of the sixth century on, large areas of drapery were often left unpainted except for bands of pattern along borders and down the middle of skirts and a scattering of small ornaments elsewhere. What the rule was for men's flesh we do not know, but sometimes it was tinted a lightish brown. The principal colours were red, blue and yellow, others were black, green and brown. The choice of colours may have been limited by the pigments available, but its aim was

largely decorative without close attention to natural shades. The Berlin Standing Goddess (*plate 40*) and the kore Acropolis 682 (*plate 41*) still have useful traces of their colouring, described a few pages later. On limestone figures the surface was of poorer quality than marble and so usually it was painted all over. Archaic bronze statues, which are extremely rare, show no special peculiarities.

Very few Archaic sculptures are dated usefully by context or records. Herodotus implies that the Siphnian Treasury at Delphi was built about 525 and the latest statues from the debris of the Acropolis of Athens should be very little earlier than 480, when the Persians sacked it. So, as usual, the accepted chronology depends on stylistic criteria, here principally the progress in the natural rendering of anatomy, it being assumed that this progress was simultaneous everywhere. The anatomical criterion runs into difficulty for female figures, since they were draped, and does not allow for conservatism or backwardness, but as a rough guide it seems to work. For absolute dates before the Siphnian Treasury students rely almost entirely on connections with vase painting, unfortunately of only limited help, since the conventions of the two arts were not so close nor indeed is the absolute dating of vases itself reliable. This makes it even riskier to connect changes in sculptural style with historical personages like Pisistratus and Polycrates, tempting though such connections always are.

It was on the kouros that Archaic sculptors made their most enduring progress, since the Archaic kouros was naked – more naked even than the Daedalic which wore a belt – and so the problems of anatomy could not be ignored. Since more than a hundred kouros statues survive, complete or in sizeable fragments, we can follow in detail the trend towards more natural proportions and articulation. Generally foreheads became higher and skulls more rounded, eyes smaller, shoulders narrower and waists thicker; the structure of face, ears, neck, chest, belly, hips and knees was represented with closer understanding and less emphasis of selected features; and modelling more and more superseded incision of detail. Evidently the sculptors observed human bodies, but their observations were combined and resolved in a sort of generalized theoretical system which did not regard the peculiarities of any particular model: in other words Archaic sculpture was 'ideal'. By the end of the sixth century the anatomy

of the kouros had become natural enough for its pose to appear unnatural, and it was time to abandon stiffly symmetrical frontality. As for size, some of the early Archaic kouroi are much larger than life; afterwards rather under-sized statues became common, but gradually a standard emerged of a figure a little over six feet tall, impressive but not arrantly superhuman.

The statue usually called 'Cleobis' (*plate 36*) is a convenient example of the early Archaic style of around 600. It is the better preserved of a pair of kouroi found at Delphi and identified by the inscription on their plinths and a passage of Herodotus as representations of Cleobis and Biton, though it is not certain which statue is of which. The story is that at a festival of Hera, when their mother (who was a priestess) was held up for lack of oxen, Cleobis and Biton pulled her cart the five miles to the sanctuary, that as a reward the deity let them die that night in their sleep, and that in commemoration the Argives put up statues of them at Delphi. The statues, of a marble that is said to be Cycladic, are over seven feet high and as like as can be expected from free-hand carving. Traces of Daedalic can be observed in the lowness of the forehead and the lingering triangularity of the front view of the face; but there is a new emphasis on solidity and depth, the body appears as an integral and interesting part of the whole figure and no longer primarily a support for the head, and the anatomy though still very inexperienced has been considered. The cheek-bones are managed with rather better logic than before; attention has been given to the ear, throat and collar-bones; the hair (always difficult to render by carving) is divided into knobbly strands that now look more like locks than a wig; the pectoral muscles and the knees are modelled heavily; the muscles down the side of the thighs are outlined by grooves; but the upper boundary of the belly is only incised and the waist still makes a simple concave curve which ignores the hips. Though these two kouroi are not in any sense portraits, some concession is made to their subject; as hauliers, Cleobis and Biton wear boots, close-fitting but originally made distinct by colour, and perhaps it was to show the strength for which they became famous that the figures are so massively proportioned, not because such proportions were typical of an Argive school of sculpture. For the sculptor was an Argive, so the inscription says, with a name ending in '-medes', often restored as 'Polymedes' though there are other

possibilities. Incidentally, Cleobis and Biton are among the dozen or so original Greek statues now surviving which are mentioned in what we have of Greek and Latin literature.

The New York kouros (*plate 37*), of Cycladic marble and six feet high, is the most complete of a group of early kouroi found in Attica and so close to each other in style that they must have been made by one sculptor or workshop. The face of the New York figure with its oval contour and high rounded forehead and skull is the antithesis of Daedalic, perhaps deliberately so, and the eyes are very much the dominant feature, as can be seen on the illustration if one lays a pencil across them. The nose regrettably is broken off, but must have been narrow and prominent. There is more indication here than on Cleobis of anatomical features of the body – by modelling and grooving – and an awareness, if nothing more, of the existence of the hips. A few traces of red paint survive in the nostrils, on the nipples and on the bands tying the tips of the hair at the back. If one compares the New York statue with Cleobis (*plate 36*), it is remarkable what difference in effect could be produced by contemporary sculptors within the strict formula of the kouros type. The length of the arms is particularly illuminating – short in the compactly balanced Cleobis, reaching further down the thighs in the New York statue to compensate for top-heaviness – if one blacks out the figure below the chest a quite different substructure might be expected. The date of the New York kouros should be much the same as that of Cleobis, around 600, since in some details it is more advanced even though its general effect is more primitive. The reason is probably that the sculptor of the New York kouros was unorthodox. He has no obvious ancestry and may well have been the first sculptor to establish himself in Attica; anyhow though so much Archaic sculpture has been found in Attica, there is so far nothing earlier than his work. Nor did this sculptor have much influence on his successors: in Attica the Berlin Standing Goddess (*plate 40*) is related in the position of the eyes, and there is some general resemblance in the faces of the Naxian sphinx at Delphi and one of the korai of the Acropolis of Athens (no. 677), both presumably Cycladic products of about 570; but the main line of development on the Greek mainland passes through such figures as Cleobis. It is curious that the New York statue, the first kouros for which close correspondence with the Egyptian canon has been claimed – in the

level of knees, navel, nipples, eyes and perhaps hands – in style does not look particularly Egyptian.

The 'Apollo of Tenea' (*plate 38*), found at Tenea near Corinth and not an image of Apollo but a grave monument, is also of Cycladic marble, five feet high and in unusually fine condition. Its date is about 560, a good generation later than Cleobis and the New York kouros. The human figure is now much more naturally proportioned, though still too broad in the shoulders and too narrow in the waist, and the features of the anatomy are modelled organically and without exaggeration, in strong contrast to the New York kouros where they appear as superficial and almost decorative adjuncts (there indeed the knob on the wrist seems as functionless as the band encircling the neck). In the Apollo of Tenea the head, at least in front view, is hardly more interesting than the body; the hair has been simplified, the eyes – reduced in size – are recessed at the inner corner, and the lips curved cheerfully up in the 'Archaic smile'; but the modelling of the belly shows much more subtlety and if the figure is decapitated it suffers surprisingly little. In construction the front and side views are still cardinal, though the transitions are managed better than in earlier works and altogether this is a rendering of a man which appears capable of flexibly human motion. Admittedly the Apollo of Tenea is outstanding in quality for its time, but it is a pity that there is not more Archaic sculpture from the Corinthia.

The kouros of Aristodikos (*plate 39*) is another grave monument, found in the country east of Mount Hymettus where Athenian nobles had estates. The title 'of Aristodikos' is carved on the upper step of the base, with the letters (as was usual) picked out in red paint. Presumably, like some other Archaic statues from Attica, it was buried at the time of the Persian invasion but unluckily on its back, so that its face has been scarred by modern ploughing. The Aristodikos kouros is nearly six and a half feet high, of Parian marble and very little earlier than 500. By now the structure of the body is broadly understood, even at the waist, and similarly the face has a unified form without special emphasis of any single feature. Even the hair of the head is not allowed to distract attention from the anatomy. Short and close-fitting, it has two rows of simple conventional curls round the edge, while the remaining part is finished roughly with a point – an unusual alternative to the fine waving current at the time (*see plate 43*) unless

it was intended as a bedding for stucco. The most noticeably ornamental detail of this sober figure is the pubic hair, shaped according to a convention fashionable at the end of the sixth century and the beginning of the fifth. In general the kouros of Aristodikos has reached the limits of the Archaic style; for a figure so naturally constructed, the pose has come to look uncomfortably stiff. Perhaps the sculptor felt this too and for variety bent the arms forward at the elbows, although it required the unsightly use of struts. Anyhow, though the composition is still based on the four regular elevations, there is more liveliness in an intermediate view. The next stage is shown in the Critian Boy (*plate 43*).

The four kouroi that have been discussed all come from European Greece and except for the New York statue are typical for the general style of that region. The schools of the Cyclades seem to have been fairly close, though some pieces show a rather softer treatment. Further away softness was dominant in East Greek workshops, which concentrated on plump, superficial forms and even took pleasure in the creases of a well-rounded belly. Still, both the European and the East Greek ideals may be considered aristocratic, one representing the gentleman with the time to indulge in athletics and the other the man of property who could afford to eat.

The Archaic kore developed in a very different way from the kouros. Since it had to be fully clothed, sculptors did not feel so much incentive to explore female anatomy and, until a robuster style came in soon after 500, their aims were increasingly decorative. This shows in the treatment of the hair and even of the features of the face as well as in the drapery, for which a new formula was devised around the middle of the sixth century. Greek dress, though basically simple, needs some consideration. The two principal garments, both for men and women, were the heavy sleeveless 'peplos' and the light sleeved 'chiton' (to use these names as archaeologists have chosen to define them) and both are said to have consisted of rectangular unshaped pieces of material, which were pinned or buttoned or sewn up as required and were gathered at the waist by a girdle. So the Auxerre Goddess (*plate 34c-d*) wears a simple peplos with a separate cape over the shoulders; the heroines of the east pediment at Olympia (*plate 48b*) wear a peplos with overfall, that is the upper part of the rectangle has been folded over double as far down as the waist;

and the kore of Plate 41 wears a chiton and above it a sort of cloak (or 'himation'), draped diagonally over one shoulder. Yet the chiton of this kore is carved as if the upper and lower parts were two separate garments, which in better preserved examples may differ in colour too; and even on the Auxerre Goddess the patterning of the peplos – with scales on the chest but not on the back and the strip of meander down the front of the skirt – seems improbable on a single piece of material, if one thinks of it opened out. It may well be that Greek clothes were sometimes more sophisticated than is supposed, but artists have often ignored the logic of drapery.

The 'Berlin Standing Goddess' (plate 40) is said to have been found in the countryside of Attica, wrapped in lead sheeting and buried, presumably in 480 to escape destruction by the Persians. It is of local marble, six feet high and dated about 575 or, to put it another way, between the kouroi of Plates 36-37 and the Apollo of Tenea (plate 38) but nearer to the Apollo. Of the original colouring the red is fairly and the yellow less well preserved, and there are a few traces of blue. The flesh was not painted, the hair was yellow, the chiton was red, but we do not know the colour of the shawl. Of decorative details the flowers on the polos (or cap) were red; the meander at the neck of the chiton was picked out in red, yellow, blue and white, and that down the front of the skirt in red, yellow and blue; and the sandals had red straps and yellow soles. As for the carving, the head shows no trace of the Daedalic scheme and the hair is done with a simplicity that both conforms reasonably to nature and does not distract attention from the face with its emphatic eyes, nose, cheeks and mouth, fixed like that of the Apollo of Tenea (plate 38) in the 'Archaic smile'. This smile may, as some students claim, come from deeper cutting at the corners of the lips, though that does not explain their upward curve; but whatever its cause, it soon became a mannerism, even – in reliefs and pediments – for figures whose situation leaves nothing to smile at. The pose is of course symmetrical, though for variety both arms are brought across the body in positions that are appropriate to a naked Eastern goddess (plate 34a), but here can be no more than an artistic survival without any ritual meaning. The drapery too has advanced beyond Daedalic flatness (plate 34c-d) and is carved in broad shallow folds, which fall vertically except on the back of the shawl where they

make a set of simple loops hanging from one shoulder to the other as far down as the waist. Whom the figure represents is, as often, uncertain, since neither the polos nor the pomegranate grasped in the right hand help to decide between a goddess and a mortal. The Berlin statue is a solidly effective female figure, though there is nothing specifically feminine about the face nor the body either, so far as it can be made out under the enveloping dress.

About this time some workshops further east were experimenting with a different version of the kore. The form of some of these statues is much more cylindrical, so much so that one may suspect the influence of ivory figurines, whether Syrian or their Greek successors, which in shape tended to keep to that of the tusk they were carved from. The dress here is the chiton, soon regularly supplemented by a cloak worn on one shoulder and crossing the chest, and each garment is decorated with close shallow folds that follow its lie. Only one statue of this kind still keeps its head, and that has a solid fullness which might be derived from such earlier works as the New York kouros (*plate 37*). Often one hand is laid on the breasts, holding some small offering and the other hangs down by the side of the thigh. But soon, perhaps about 560, this hand is employed to clutch the side of the skirt, so deflecting its folds; and the next step, no later than 550, is to exploit the consequences of the clutch by arranging the skirt in radiating folds across the front and skin-tight across the buttocks and the back of the legs, while for further contrast the folds of the cloak are stepped and cut more deeply (*plate 41*); the face and hair too become prettified; and usually one foot is slightly advanced, whether to enliven the pose or to improve the mechanical stability of the statue. This kind of kore is generally thought to be an Ionian or East Greek invention, but the most elaborate specimens seem to be Cycladic, while those found so far in Ionia are rather plain, and – for what it is worth – the earliest fully 'Ionic' korai have been found in European Greece. Still, wherever the new kore was invented or developed, it spread quickly throughout the Greek world.

The statue no. 682 of the Acropolis of Athens (*plate 41*) is one of the riper korai, not later than about 525. It is almost six feet high, of Cycladic marble and – unusually – made in two main parts, the join being at the knees. The right forearm too, which stretched straight forward, was – as usually – a separate piece, the

stump of which is still fixed in its socket; the end of the cloak that
hangs down at the front was also carved separately; and on the
chest one can see the drill holes where extra lengths of hair were
pegged on. The hair was red, the eyebrows black, the diadem
decorated with red and blue palmettes. The upper part of the
chiton was perhaps yellow or blue, the rest of the drapery un-
painted except for bands of pattern along borders and down the
front of the skirt and a scattering of neat little ornaments else-
where; this decoration was mainly in red and blue with probably
touches of green and yellow. There was also a necklace, painted
but not carved; the bracelet was coloured blue; and the sandals
were red with blue details. To complete the original effect, the
metal rod on the top of the head should be straightened and
capped with a little bronze umbrella (the 'meniskos'), a common
protection against birds when statues stood in the open. Com-
pared with contemporary kouroi the head of Acropolis 682 is
interesting. Obviously it was meant to be fashionably feminine
with its high domed skull, slanting eyes (once filled with paste),
half-shut overhanging lids and prominent cheek-bones; but apart
from the implausible breasts there is not much attention to the
characteristic forms of the female body and, though the sculptor
gave himself opportunity enough in the lower part of his figure,
it seems that he used the kouros as his model. This revealing of
the shapes of buttocks and legs was a sculptural vagary, not found
so early in vase painting; and the trick of making tightly stretched
material follow the inside curves of the legs is sculptural too, not
a substitute for the transparency that is possible in painting, since
painters of that time avoided the back and even the front view.
The style of such korai as this is clever and even brilliant, but it
led no further and within a generation sculptors were turning
towards an austerer but more promising standard for their female
figures.

The fragmentary kore dedicated by Euthydikos (*plate 42*) is one
of the latest statues from the Persian debris of the Athenian
Acropolis and may be dated in the 480s. The middle is lost but
originally it must have been about four feet high, not including
the unfluted Doric column on which it was perched. The system
of drapery and the style of the hair are those of the 'Ionic' kore
(*plate 41*), though much of the detail is perfunctory and even
harsh, but there are also positive innovations. This is most obvious

in the face with its severe unified structure, rejection of feminine charm and aggressively unsmiling mouth; and the body too is more solid, especially in its depth from front to back. This is a statue of more historical than aesthetic value, and its effect must have been even more incongruous when it was complete. The 'Ionic' formula for the kore did not suit the austerer standards to which artists were being attracted in the early years of the fifth century and what was needed was not adaptation but a revolutionary change.

Archaic reliefs fall into three classes according to the shape of the field. Many sixth-century gravestones were tall narrow slabs, carved (or merely painted) with a single figure, standing and in profile. This kind of grave monument is best known in Attica, where it might be surmounted by a small compact statue of a sitting sphinx or later by a palmette. The change came soon after the middle of the century when, as anatomical skill and taste improved, monsters and animals (other than the horse) became subjects unworthy of the serious sculptor. Incidentally, both the sphinx and the lion (also found on early grave monuments) could be used as dedications in sanctuaries and so were hardly symbols of death; the Greeks may have had some notion of their being a sort of watchdog, but as vase paintings show such creatures would not have been tolerated in art unless they had been thought decorative. The second class of reliefs, more or less square, includes the carved metopes of Doric temples and treasuries as well as some grave reliefs. Here, to fill the space, a group of two or three figures is usual; and if there is only one figure, it is posed to spread sideways, like the single figures of vase painting inside Archaic cups. Lastly, there are long reliefs – for the friezes of Ionic architecture (*plate 44*) or the bases of statues. In such fields scenes of action are almost inevitable.

Composition and poses are very much the same as in vase painting. The heads of figures normally reached the top of the field, in groups there is some overlapping which evades rather than indicates depth of scene, and it is very rarely that the setting is even suggested (as, for instance, by the wall behind the sitting figure at the left of Plate 46a). Faces are usually in profile though fully frontal views are perhaps less uncommon than on vases; the shoulders and chest are frontal or profile according to the action of the figure, and the belly and legs are in profile; the junctions

between frontal and profile views are abrupt, without any organic transition, though later some sensitive sculptors tried to mask the clumsy swivel at the waist of a nude figure by bringing an arm across in front of it. The direction of movement is of course lateral, and poses and gestures are clear and emphatic. The depth of carving varies; gravestones, for obvious reasons, are usually in much shallower relief than architectural sculpture.

Of the Archaic reliefs illustrated here those of Plate 44 are parts of the east frieze of the Siphnian Treasury at Delphi, a small but lavishly decorated Ionic building. This frieze is of Parian marble, two feet high and Attic or near-Attic work of about 525; the subject on the east side is one of the fights in the Trojan War with gods and goddesses as interested spectators; and the quality of both style and execution is unusually fine. Originally the background was blue and the plinth on which the figures are placed was red. Red was used for hair, bands along the edges of drapery, crests of helmets and the insides of shields, except for the blue straps through which the arm passes. The chariot behind the horses was painted in yellow but not carved, and the harness too was only painted. The crest of the first soldier's helmet was attached separately and may have been of bronze, and the spear held in his missing right hand and originally passing in front of his head must have been a bronze attachment. Some of the figures had their names painted beside them – a practice familiar in both painting and vase painting, to which relief sculpture was closely related. The slab with the assembly of the gods is remarkable for the subtlety of its posing; the sculptor has learnt to shift the feet and even to turn and bend the body, so that his figures look detachable from their seats. Earlier, and some later, Greek sculptors sit their figures stiffly like dummies and there are few if any worse Archaic statues than the seated East Greek notables from Didyma (or Branchidae) near Miletus – several of them now in the British Museum – whom the Turks once excusably used for target practice. In the battle scene the soldiers are more conventional, though their forms are modelled firmly, their corselets partly hide the awkwardness at the waist, and the shields are sunk boldly into the background; but there is more interest in the horses, since the team is shown in a compromise between a side and a three-quarter view, and the wheels of the chariot were boldly and fairly accurately foreshortened. Progressive sculptors were now

finding Archaic frontality too restrictive and experimenting with inherently revolutionary solutions.

The only large unbroken areas on the outside of the standard Doric temple were in the pediments at each end (*plate 79*), and their position too invited decoration. Perhaps at first these fields were filled by painting, but if so the sculptors had taken over early in the sixth century. The special problem set by the pediment was in its low triangular shape, unlike that of any other field that Greek artists had to fill, but before the end of the century a solution was found that satisfied their principles for Greek figurative art. The sculpture in pediments was of course coloured and its background was normally blue.

The earliest pedimental sculpture that survives is of about 580 and comes from the Temple of Artemis at Corcyra or, to use the familiar Venetian name, Corfu (*plate 46a*). The material was limestone, the field about 55 feet long by 8½ high at the centre, and the design of both pediments unusually alike. In the west pediment, which is much the better preserved, the central group is composed of the Gorgon Medusa with her two children, the winged horse Pegasus and the human Chrysaor; on each side lies a 'panther' (or rather, since it has spots, a leopard); at the far right Zeus, recognizable by his thunderbolt, is killing a Giant beside a tree, and another Giant must have lain in the corner; and in the left corner there is another corpse, then a wall in end view (the bricks or blocks clearly marked), and a seated figure threatened by another figure with a spear – either an incident from the Sack of Troy or another excerpt from the battle of the Gods and the Giants. Some students invest the panthers with vague supernatural functions, but it is more credible that they are primarily decorative (like the lions of Plate 9), chosen because they fitted conveniently into the field and could be carved quickly – a desirable economy in so big a job; nor is Medusa necessarily 'apotropaic'. The design of this pediment is impressive, except perhaps at the ends, but there is no unity of scale or subject. So Zeus, though the greatest of the gods, is a midget in comparison with Medusa, who was only a minor personage in mythology and not even immortal. There is also the unsatisfactory consequence that the large figures appear in relatively low relief, while the artistically subordinate groups in the corners stand out almost in the round, and the contrast must originally have been still more

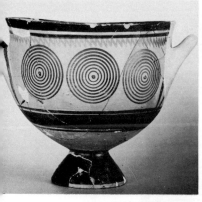
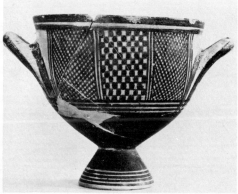

1a Attic Protogeometric cup, late eleventh century (p. 32)
1b Attic Protogeometric cup, tenth century (p. 32)
1c Attic Protogeometric amphora, late tenth century (p. 32)

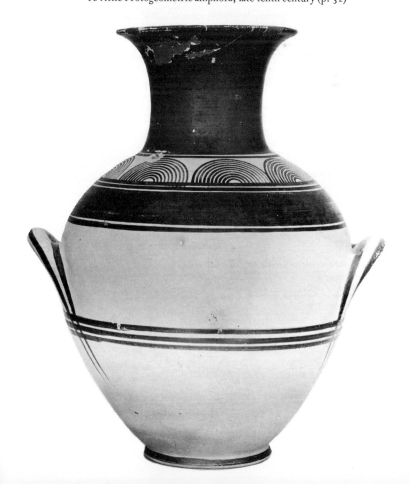

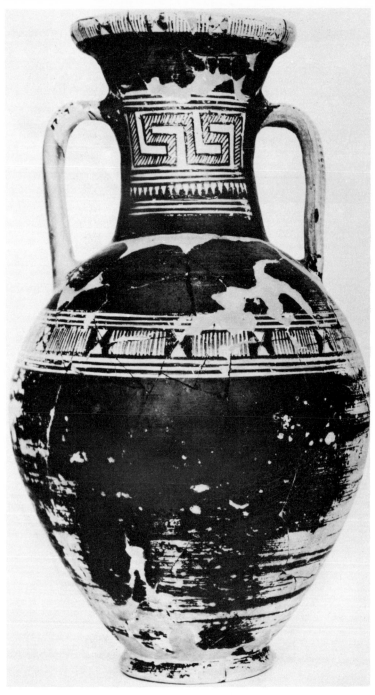

2 Attic Geometric amphora, *c.* 850–25 (p. 33)

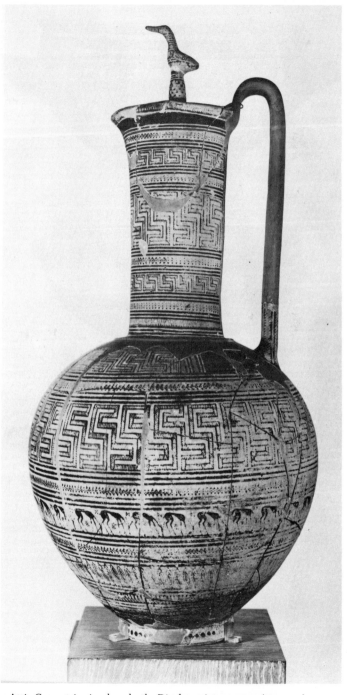

3 Attic Geometric oinochoe, by the Dipylon painter, c. 750 (pp. 33–4)

4a Attic Geometric cup, *c.* 875–50 (p. 33)

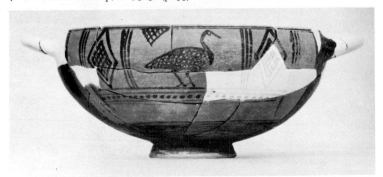

4b East Greek cup (Bird Bowl), *c.* 690–75 (p. 50)

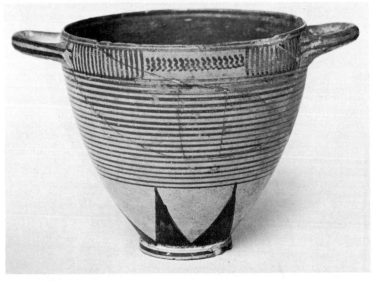

4c Protocorinthian kotyle, *c.* 675–50 (p. 36)

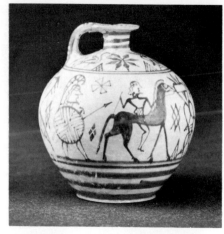

Protocorinthian aryballos,
c. 720–690
Protocorinthian aryballos, c. 700
Protocorinthian aryballos, c. 675
Protocorinthian aryballos, by the
Sacrifice painter, c. 650
Ripe Corinthian aryballos,
625–600
Ripe Corinthian alabastron,
625–600 (pp. 43–4)

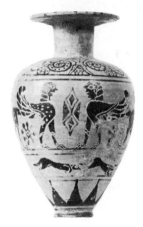

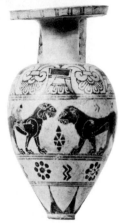

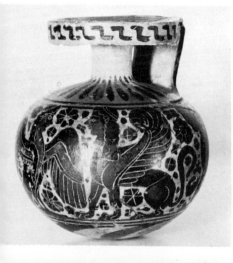

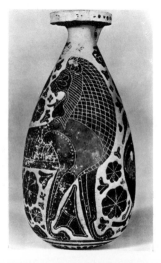

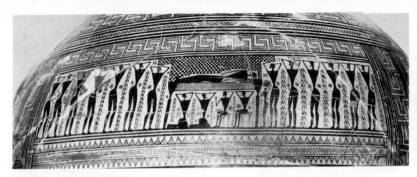

6a Detail of Attic Geometric amphora (the 'Dipylon amphora'), by the Dipylon painter, *c.* 750 (pp. 34–6)

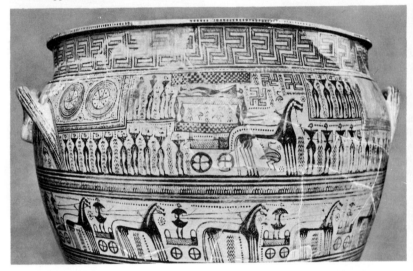

6b Detail of Attic Geometric krater (the 'Hirschfeld krater'), by the Hirschfeld painter, *c.* 740 (pp. 35–6)

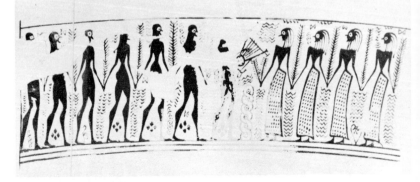

6c Detail of Protoattic hydria (the 'Analatos hydria'), by the Analatos painter, *c.* 700 (pp. 36, 41)

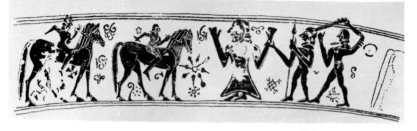

7a Detail of Protocorinthian aryballos, by the Ajax painter, *c.* 675 (pp. 41, 44)

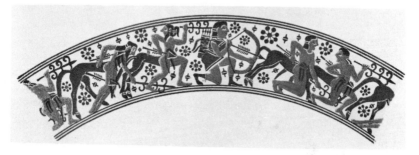

7b Detail of Protocorinthian aryballos, by the Macmillan painter, *c.* 660–50 (pp. 41, 44)

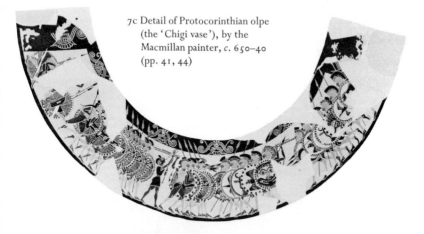

7c Detail of Protocorinthian olpe (the 'Chigi vase'), by the Macmillan painter, *c.* 650–40 (pp. 41, 44)

7d Detail of Ripe Corinthian bottle, by Timonidas, *c.* 580 (p. 45)

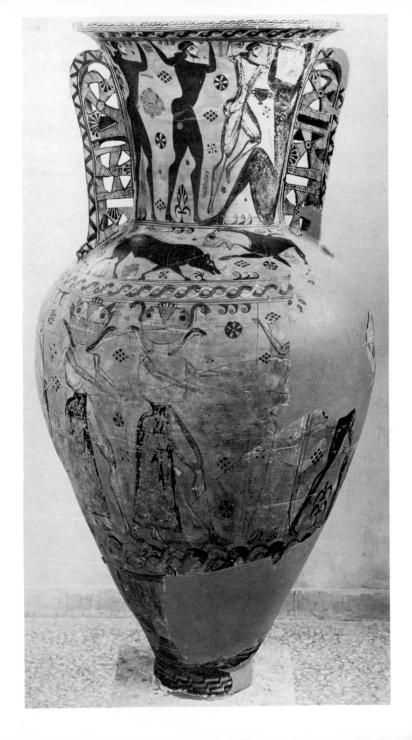

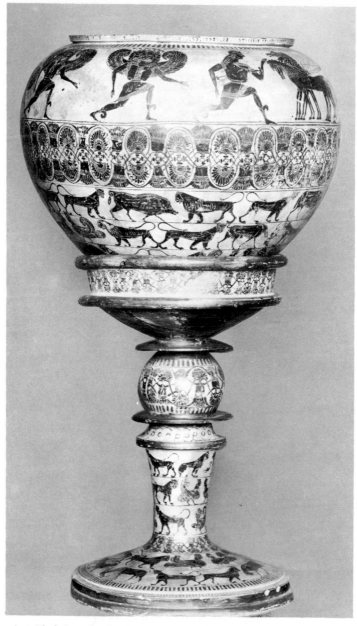

9 Attic Black-figure bowl and stand, by the Gorgon painter, *c.* 590 (p. 47)

◀ 8 Protoattic amphora, by the Polyphemus painter, *c.* 660 (pp. 46–7)

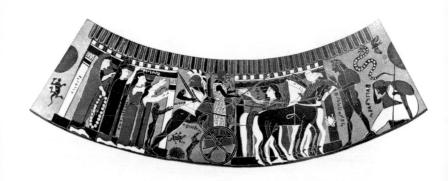

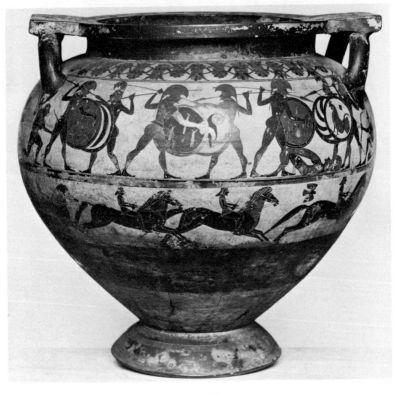

10a Detail of Ripe Corinthian krater (the 'Amphiaraos krater'), by the Amphiaraos painter, c. 560–50 (p. 45)
10b Ripe Corinthian krater (the 'Eurytos krater'), c. 600 (pp. 41, 45)

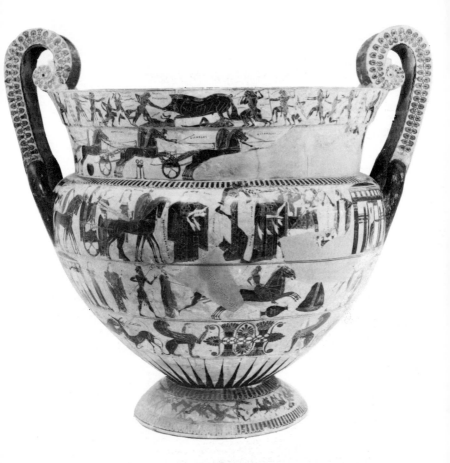

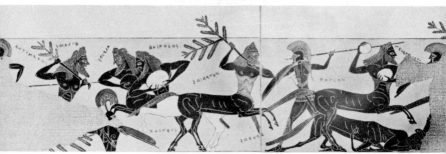

11a Attic Black-figure krater (the 'François vase'), by Clitias, c. 570 (p. 47)
11b Detail of neck of other side of 11a

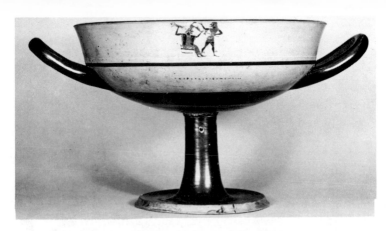

12a Attic Black-figure cup, made by Phrynos, c. 550 (p. 47)

12b Attic Black-figure krater, by Lydos, c. 550–40 (pp. 47–8)

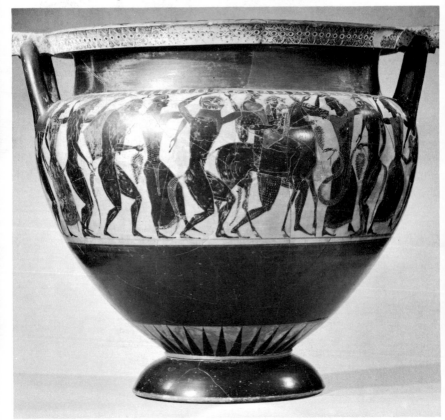

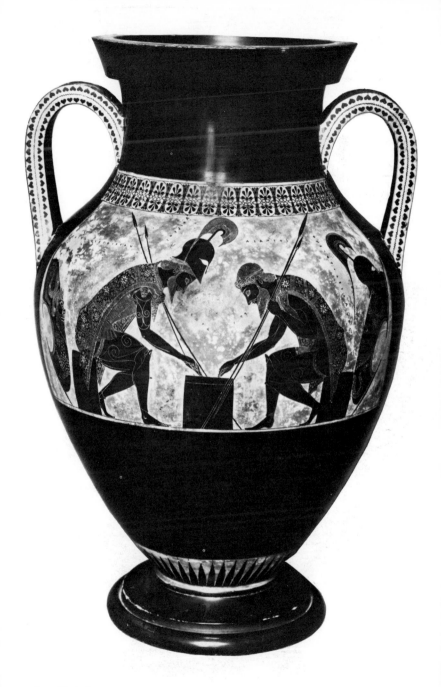

13 Attic Black-figure amphora, by Exekias, *c.* 530 (p. 48)

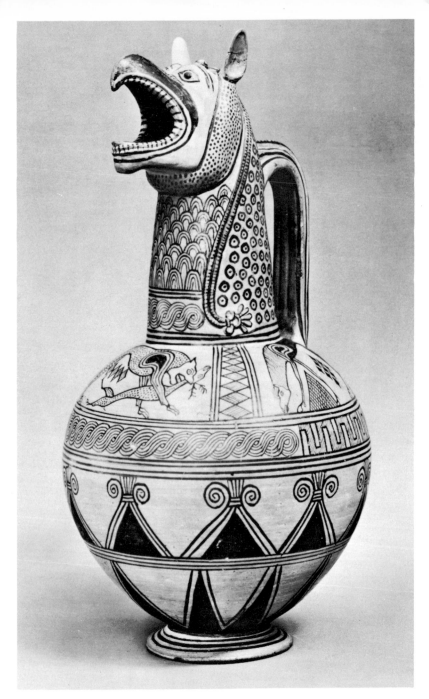

14 Cycladic jug (near Linear Island group), c. 675 (p. 49)

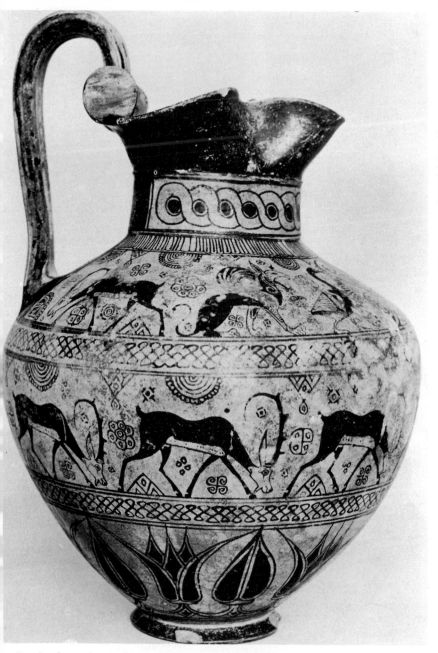

15 East Greek oinochoe (Wild Goat style), c. 625 (pp. 49–50)

16a East Greek cup ('Vroulian' style), early or middle sixth century (p. 50)

16b Laconian cup, by the Hunt painter, c. 550 (pp. 48–9)

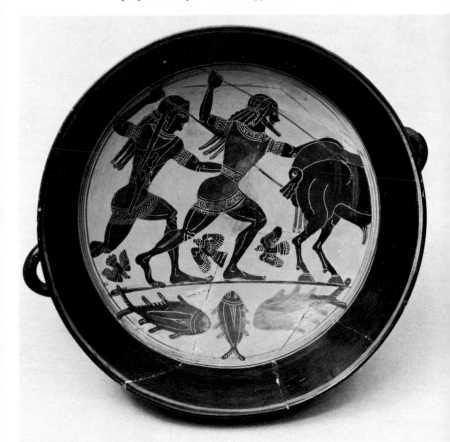

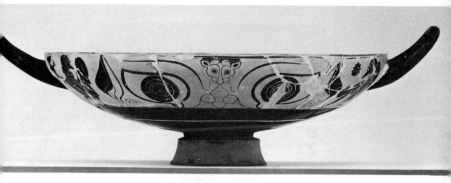

17a 'Chalcidian' cup, by the Phineus painter, *c.* 520 (p. 51)

17b Caeretan hydria, *c.* 530–20 (p. 51)

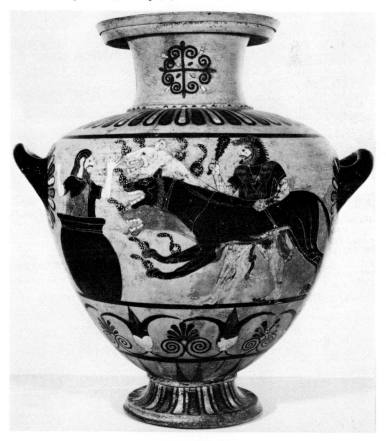

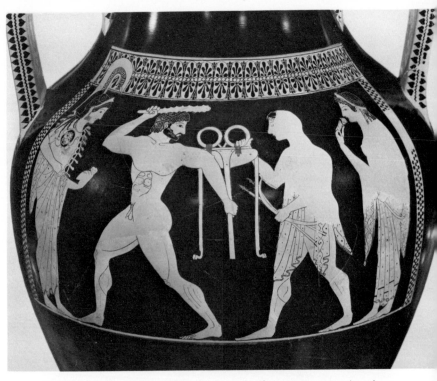

18 Detail of Attic Red-figure amphora, by the Andocides painter, 520–10 (p. 53)

19 Detail of Attic Red-figure amphora, by Euthymides, 510–500 (pp. 53–4)

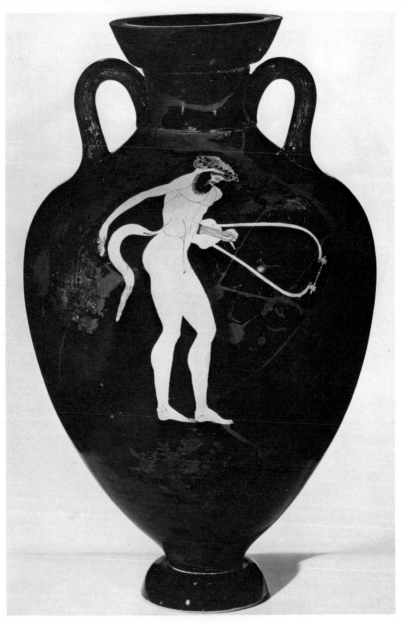

20 Attic Red-figure amphora, by the Berlin painter, *c.* 490 (p. 54)

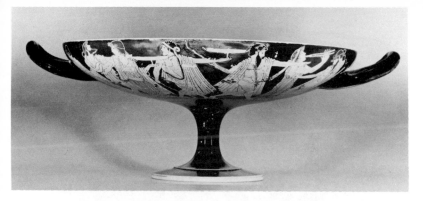

21a Attic Red-figure cup, by the Brygos painter, 490–80 (p. 54)

21b Detail of inside of 21a

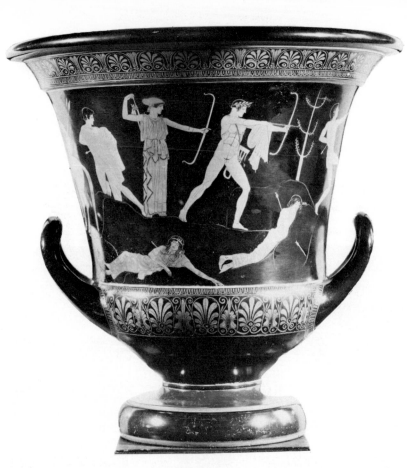

22 Attic Red-figure krater, by the Niobid painter, c. 460–50 (pp. 55, 62)

23a Attic Red-figure hydria, by the Midias painter, c. 410–400 (p. 56)

23b Detail of shoulder of 23a

▶

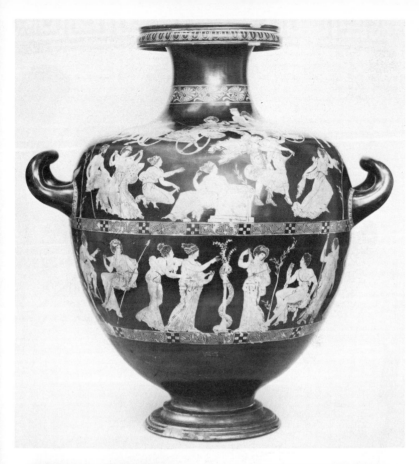

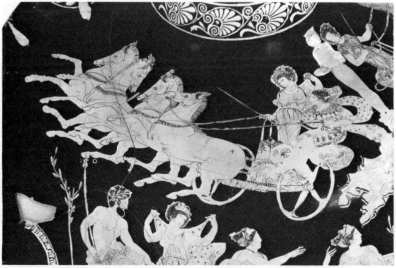

24 Detail of Attic White-ground lekythos, by the Achilles painter, *c.* 440 (p. 55)

25a Detail of Attic White-ground pyxis, by the Penthesilea painter, *c.* 460
(pp. 55–62)

25b Attic White-ground cup, by the Sotades painter, *c.* 460 (pp. 55, 63, 64)

26 Attic Red-figure krater, *c.* 350 (p. 56)

27a Detail of Apulian Red-figure krater, by the painter of the
Birth of Dionysus, *c.* 390–80 (pp. 56–7, 66, 108, 229) ▸
27b Apulian Red-figure pail ('situla'), by the Lycurgus painter,
c. 350 (p. 57)

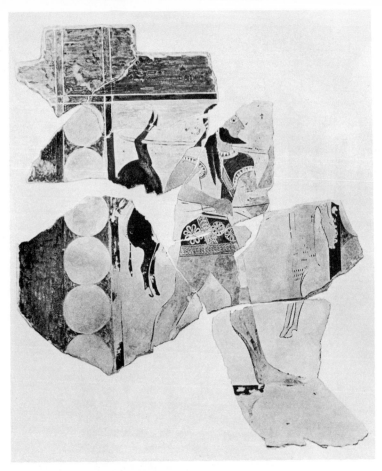

28a Painted terracotta metope from Thermon, c. 630 (pp. 45, 60–61)

28b Painted wooden plaque from Pitsa (copy), c. 530 (p. 61)

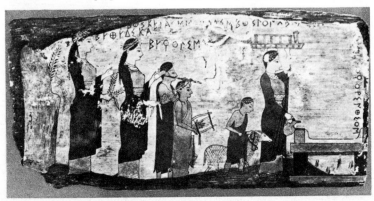

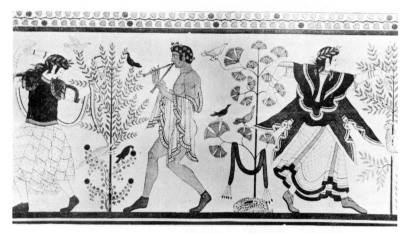

29a Wall painting of Tomb of Triclinium, Tarquinia, *c.* 470 (pp. 61–2, 252)

29b Wall painting of Tomb of Hunting and Fishing, Tarquinia, early fifth century
 (pp. 63–4)

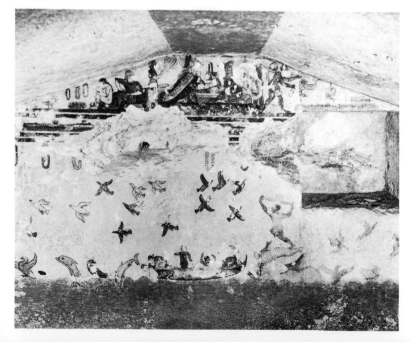

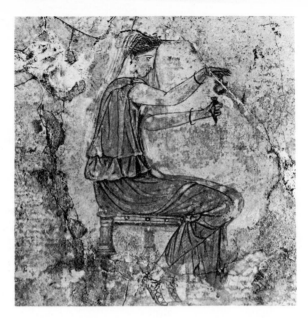

30a Wall painting from Farnesina house, early first century copy
of original of *c.* 460 (pp. 63–4)

30b Painting on marble (the 'Astragalizusae'), first century copy
of original of *c.* 400 (pp. 66–8)

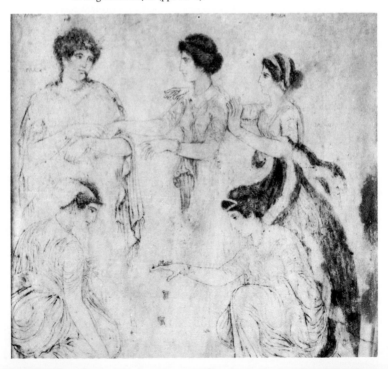

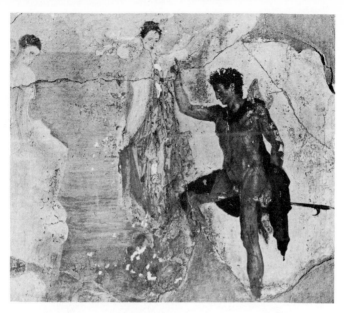

31a Wall painting of Perseus and Andromeda, early or middle first
century A D, copy of original of *c.* 350 (p. 67)

31b Wall painting of Perseus and Andromeda, early first century A D, copy
of original of *c.* 350 (pp. 67–8)

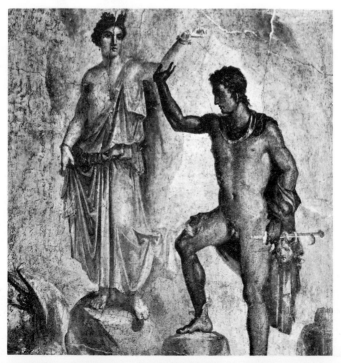

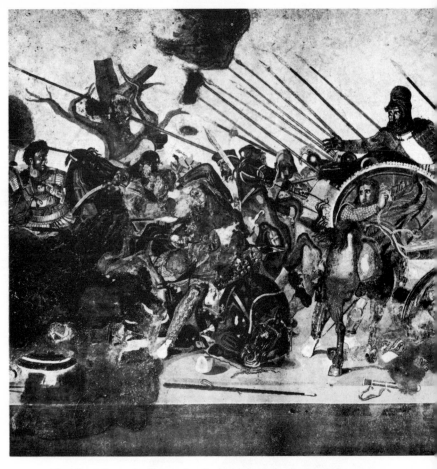

32a The 'Alexander mosaic', second or first century, copy of original of *c.* 300 (pp. 66–9, 251)

32b Detail

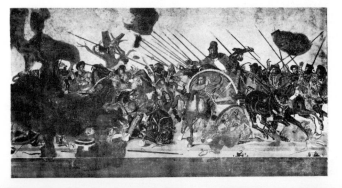

33a 'Odyssey fresco' from the Esquiline, first century copy of original of
second century (pp. 67, 69)

33b Modern drawing of 33a (to show detail)

34a Moulded terracotta
 plaque, probably Syrian,
 c. 680 (pp. 86–8)
34b Bronze disc, *c.* 660–50
 (pp. 87–8, 162)

34c 'Auxerre Goddess', *c.* 640 (pp. 87–8)
34d Restored cast of 34c

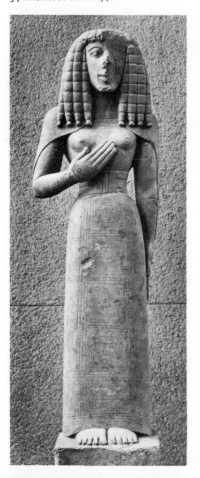

35a Relief from Mycenae, c. 635–30
35b Antefix from Calydon, c. 625 (pp. 88, 199)
35c, d Figurine of kouros at Delphi, c. 640 (pp. 87–8, 164)

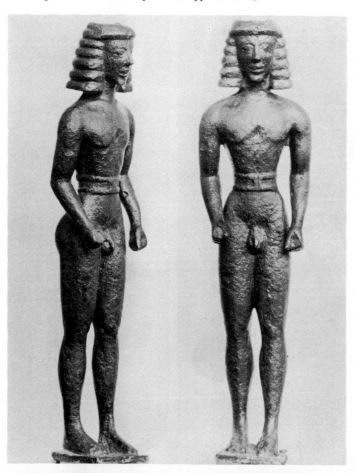

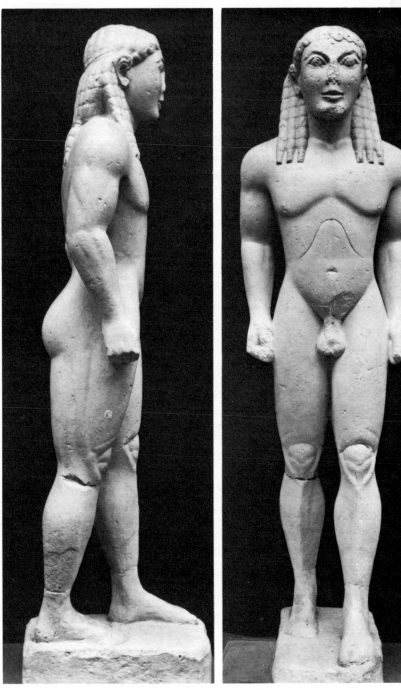

36a, b Cleobis (cast), *c.* 600 (pp. 95–6)

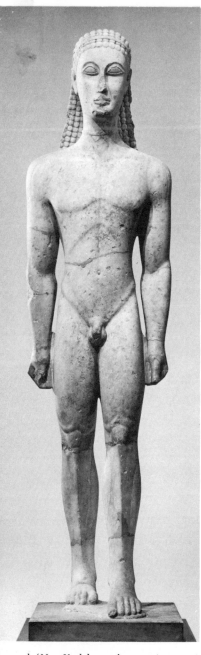
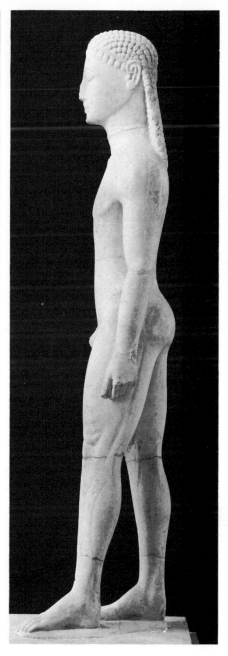

37a, b 'New York kouros', c. 600 (pp. 96–7)

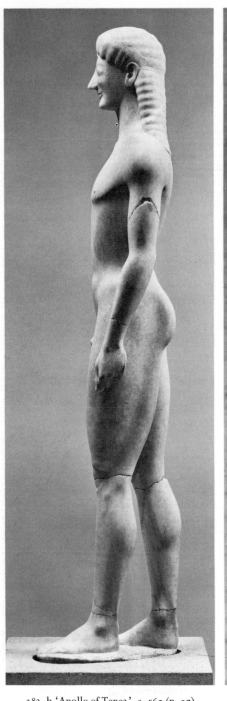
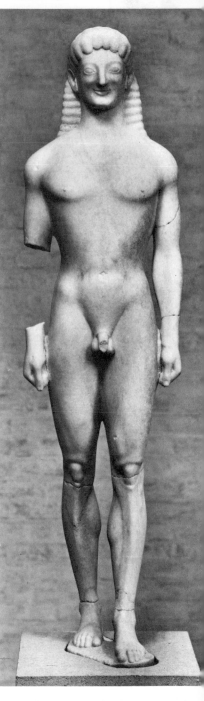

38a, b 'Apollo of Tenea', c. 560 (p. 97)

39a, b Kouros of Aristodikos, *c.* 510–500 (pp. 98–9)

40a, b 'Berlin Standing Goddess', *c.* 575 (pp. 99–100)

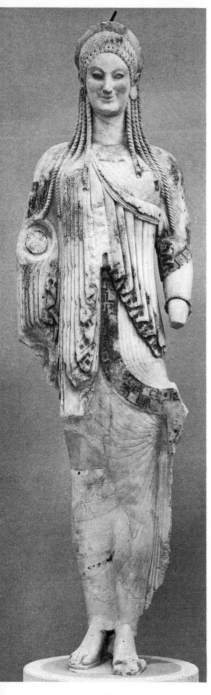
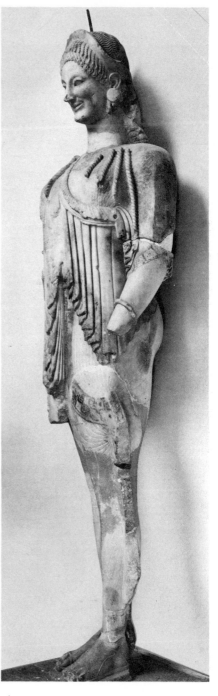

41a, b Kore, Acropolis 682, c. 525 (pp. 100–101)

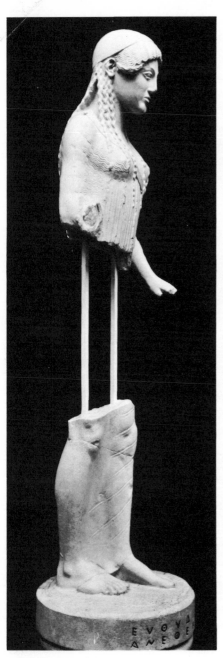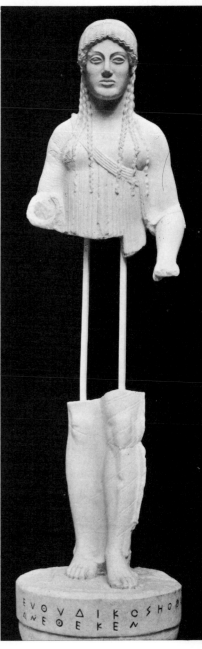

42a, b Kore of Euthydikos (cast), *c.* 490–80 (pp. 101–2)

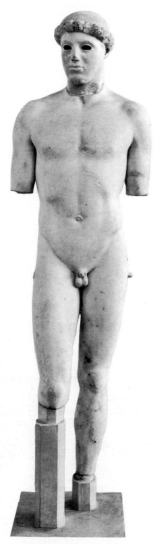
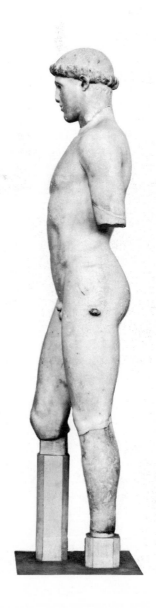

43a, b 'Critian Boy', c. 485–80 (p. 115)

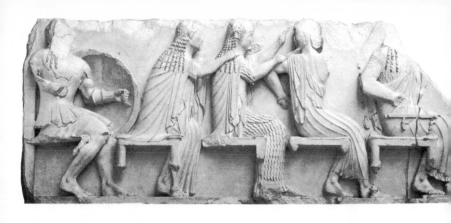

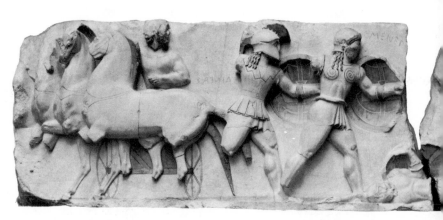

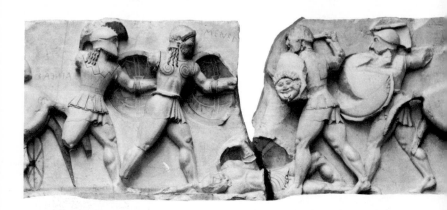

44a, b, c Parts of east frieze of Siphnian Treasury (casts), *c.* 525 (p. 103)

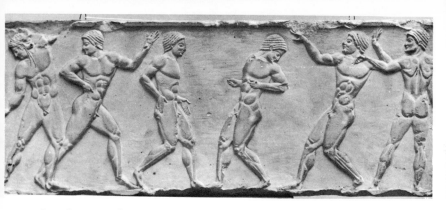

45a Base of statue (cast), *c.* 510–500 (p. 112)
45b Metope of Athenian Treasury at Delphi (cast), *c.* 500 (p. 113)

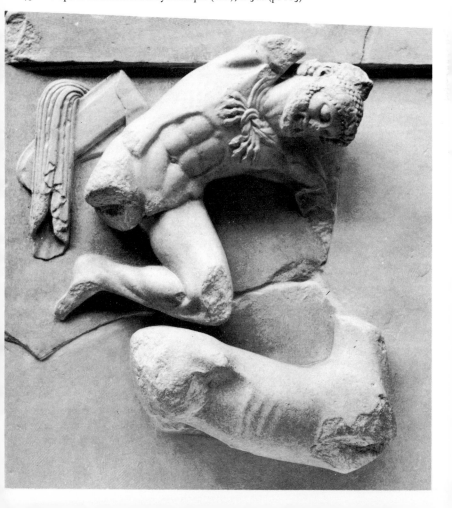

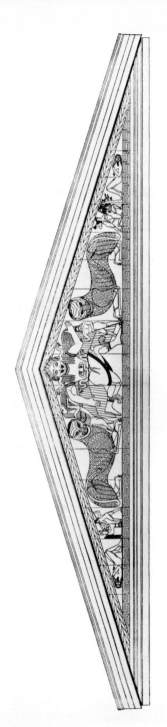

46a Temple of Artemis, Corcyra, restoration of west pediment, c. 580
(pp. 104–5)

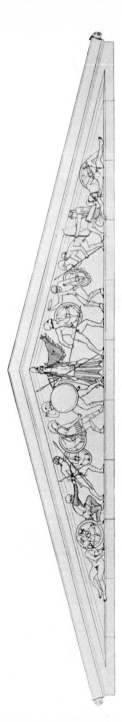

46b Temple of Aphaia, Aegina, restoration of east pediment, c. 510–500
(pp. 106–7)

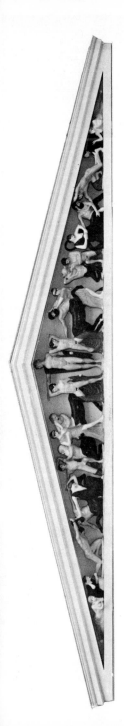

47a Temple of Zeus, Olympia, restoration of west pediment, c. 460 (p. 114)

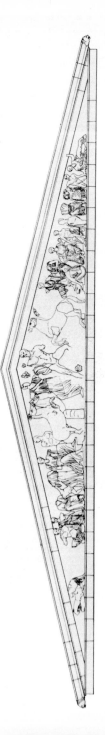

47b Parthenon, Athens, partial restoration of west pediment, c. 435 (p. 128)

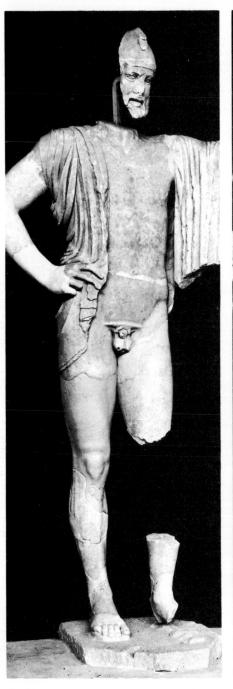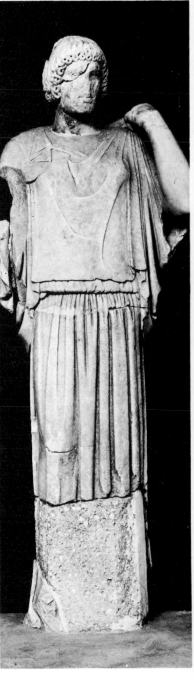

48a, b Oenomaus and Hippodamia (?) from east pediment of Temple of Zeus at Olympia, c. 460 (pp. 115–17)

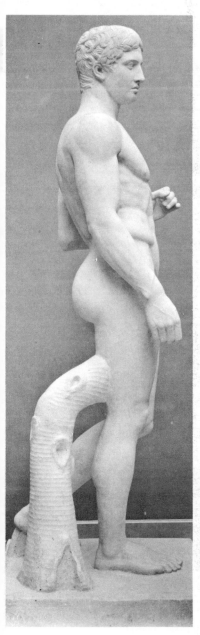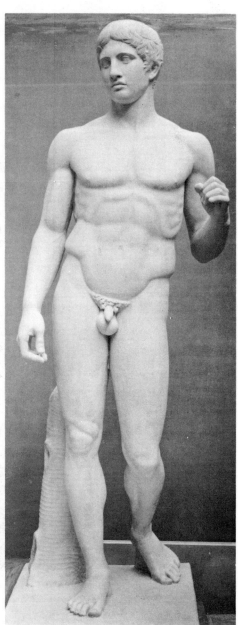

49a, b The Doryphorus (cast), Roman copy of original of *c.* 440 (pp. 125–6)

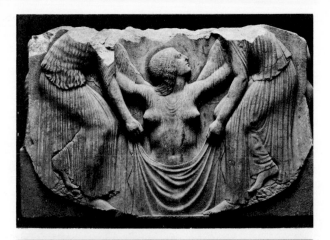

50a Front of 'Ludovisi Throne', c. 460 (pp. 113–14)
50b 'Penelope' from Persepolis, c. 460 (pp. 117–18)

51a Part of frieze of Parthenon (cast), c. 440 (pp. 129–30)
51b Metope of Parthenon, c. 445 (p. 129)

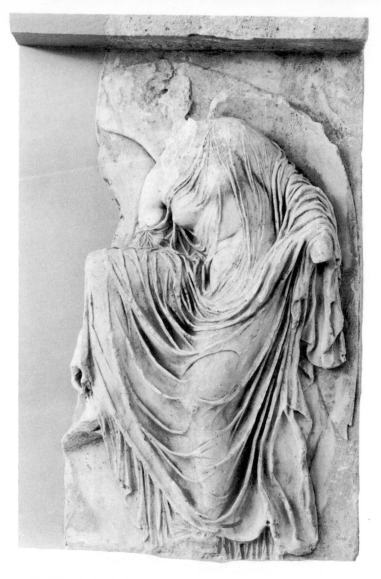

53 'Sandal-binder' from the Nike Balustrade, c. 415 (p. 129)

◀ 52 'Iris' from west pediment of Parthenon, c. 435 (pp. 120–21)

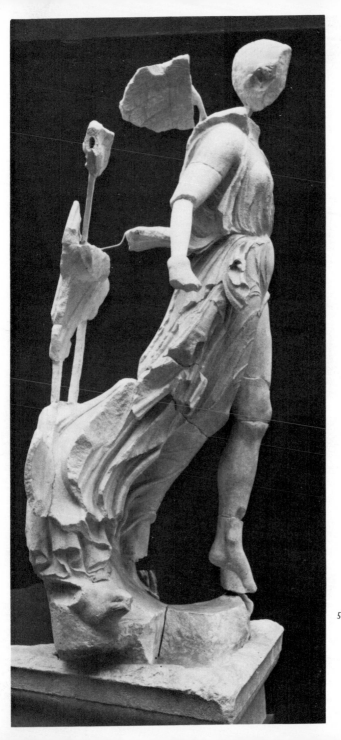

54, 55 Nike of Paion
(54 from cast)
420 (pp. 127-

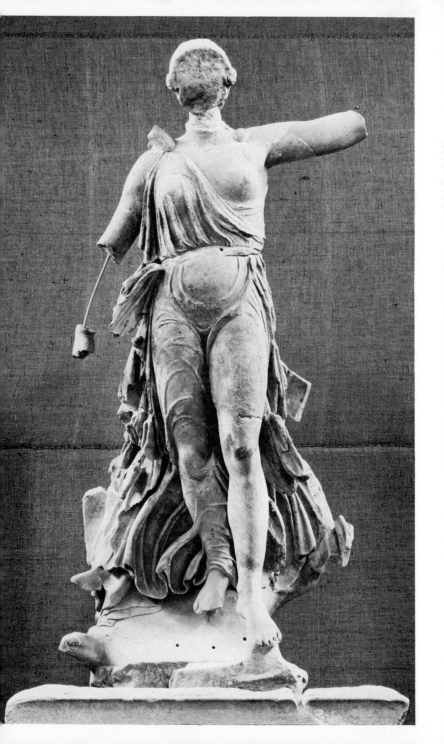

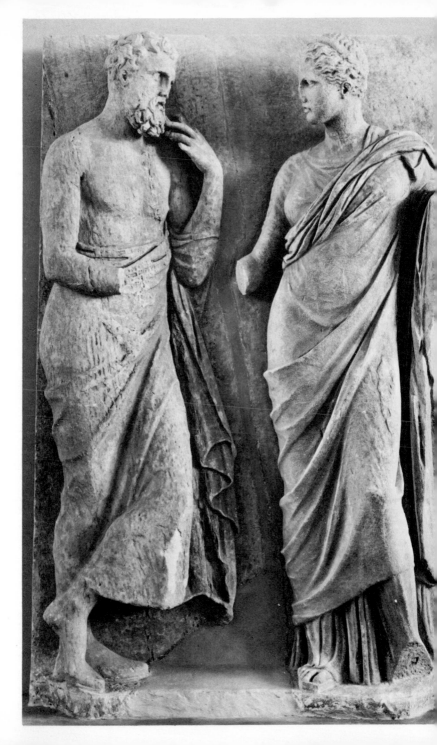

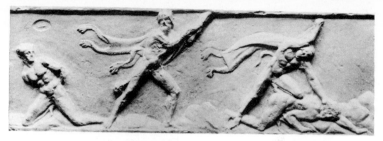

57a Detail of frieze of Choregic Monument of Lysicrates (cast), *c.* 334 (pp. 140–41)
57b Base of column from the Artemisium at Ephesus, *c.* 350–40
 (pp. 131, 132, 135)

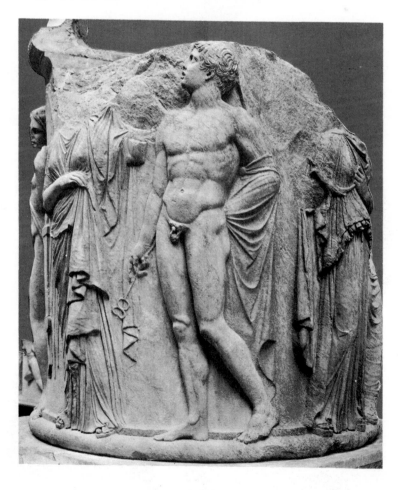

◀ 56 Gravestone from Rhamnus, *c.* 325 (pp. 132, 140)

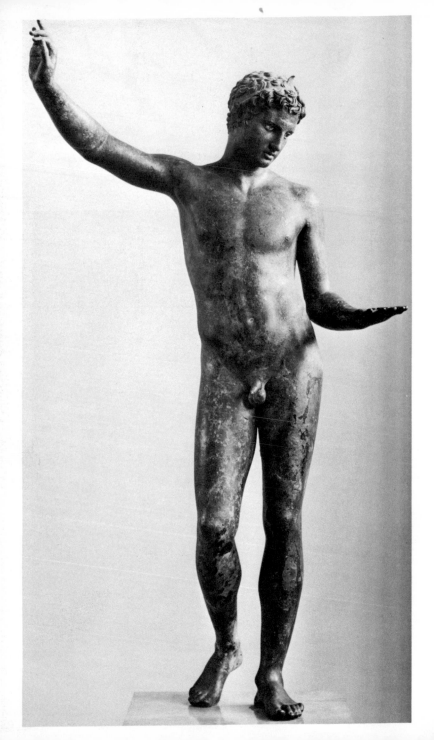

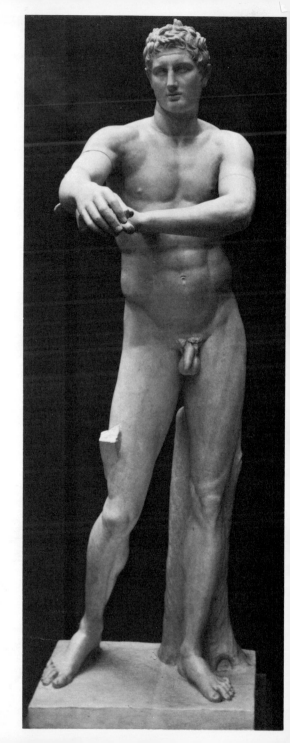

58 'Marathon Boy',
c. 340 (pp. 135–6)
59 The Apoxyomenos
(cast), Roman copy
of original of c. 330
(p. 136)

60a, b 'Lemnian Athena' (cast), Roman copy of original of *c.* 450 (p. 123)
60c, d 'Leconfield head', *c.* 350 (p. 133)

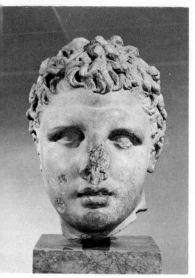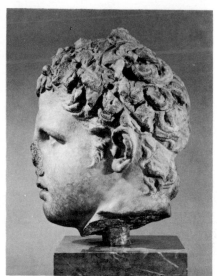

61a, b 'Aberdeen head', c. 350 (p. 132)
61c, d Head of boxer from Olympia, c. 350 (p. 139)

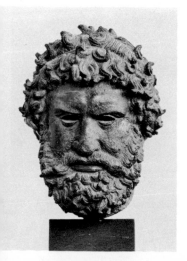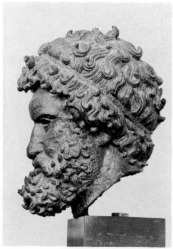

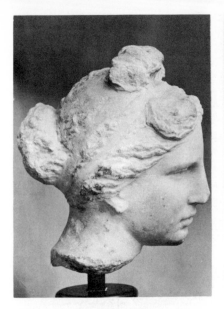
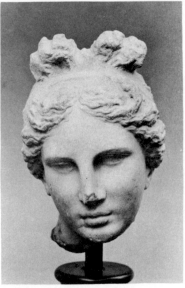

62a, b 'Bartlett head', later fourth century (p. 143)
62c, d Head of priest from the Agora, Athens, c. 50 (p. 154)

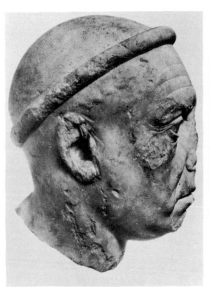
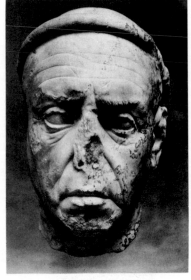

63a Boy with goose, Roman copy of original of early third ▶
century (p. 151)
63b, c 'Baker dancer', c. 230 (pp. 149–50, 164)

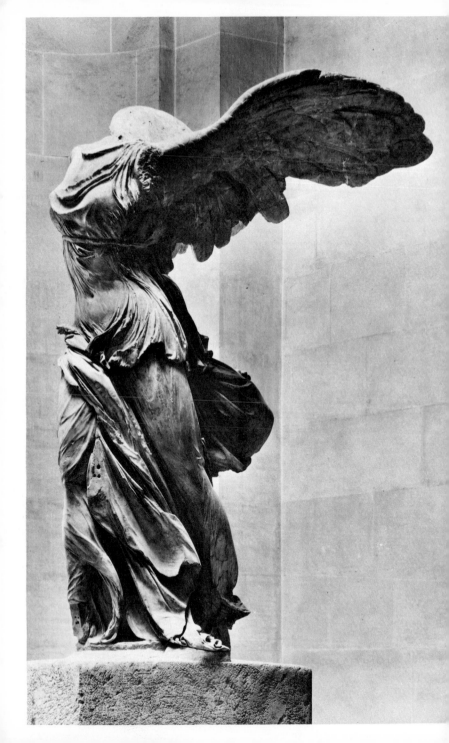

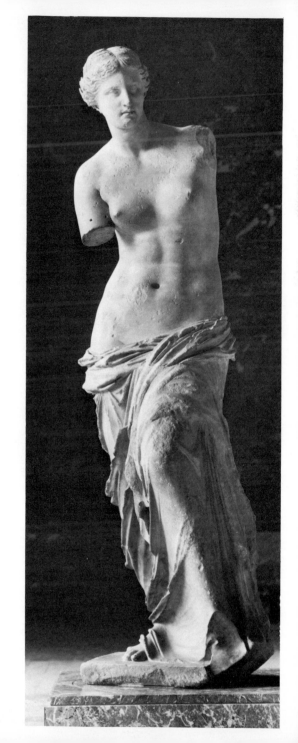

64 Nike of Samothrace,
 c. 200 (p. 150)
65 'Venus di Milo', late
 second century (p. 150)

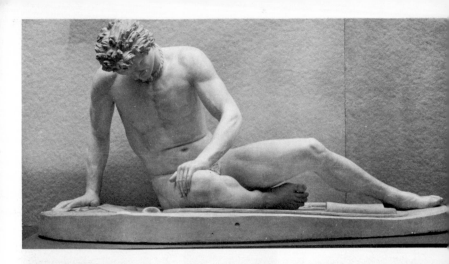
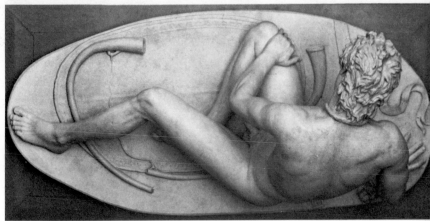

66a, b Dying Gaul (cast), Roman copy of original of late third century (pp. 151–2)

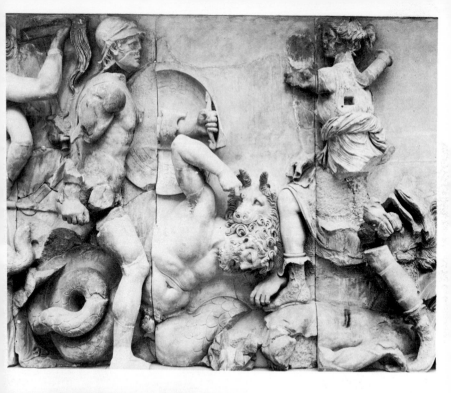

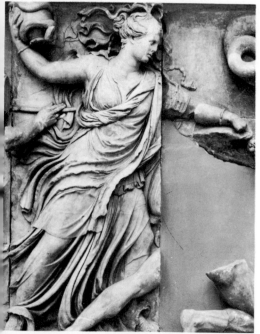

67a, b Details of main frieze of
Great Altar at Pergamum,
c. 180–60 (pp. 151–2)

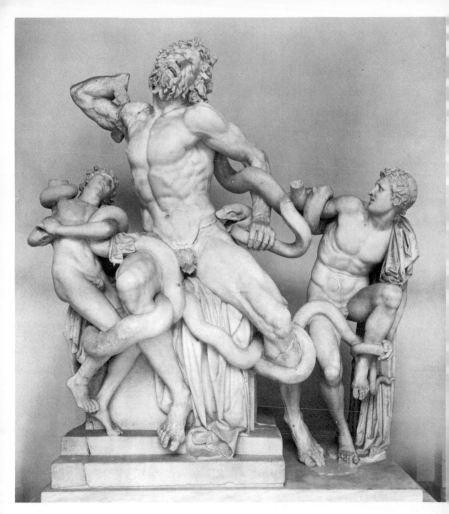

68 Laocoon, c. 50–25 (pp. 153–4)

Seals and gems from impressions

69a Archaic seal, mid seventh century (p. 167)
69b Island gem, early sixth century (p. 167)
69c Scaraboid, early fifth century (p. 168)

69d Scarab, c. 525 (p. 168)
69e Scaraboid, c. 500 (p. 168)
69f Scaraboid, c. 400 (p. 168)

69g Scaraboid, by Dexamenos, c. 440–30 (pp. 138, 168–9)
69h Ringstone, perhaps first century (p. 169)
69i Ringstone, perhaps third century (p. 169)

70a Figurine of horse, c. 725–700 (pp. 161, 164)
70b, c Figurine of helmeted man, c. 725 (pp. 161, 164)

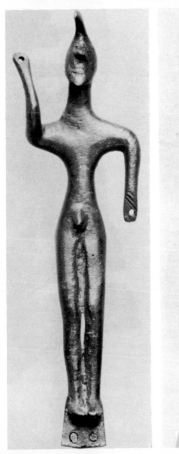

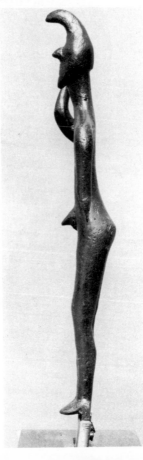

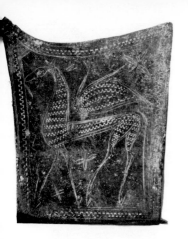

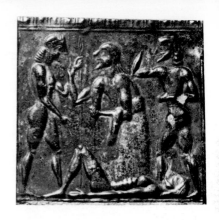

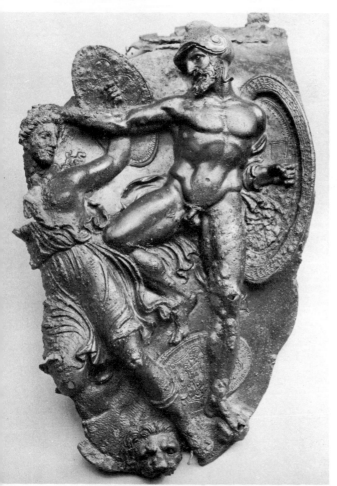

71a Catchplate of a
brooch, c. 700
(p. 162)
71b Panel from
handle of mirror,
c. 570–60
(p. 162)
71c 'Siris bronze',
shoulder plate
of corslet, c. 400
(p. 163)

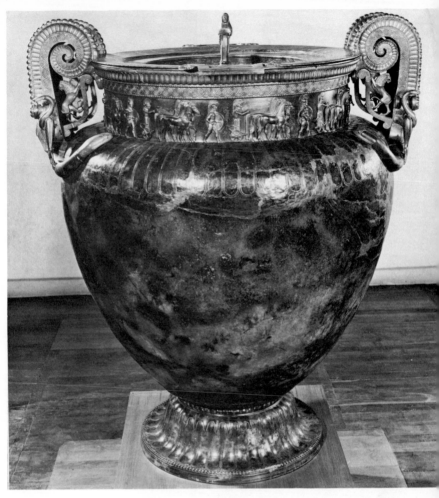

72 The 'Vix krater', c. 530 (p. 162)

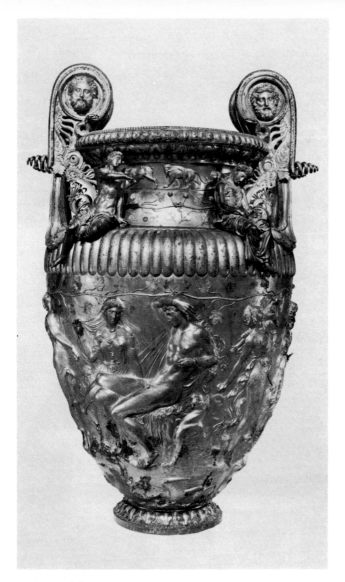

73 The 'Derveni krater', c. 350–25 (pp. 137, 163)

74a House ('Megaron Hall'), Emporio. Plan, *c.* 700 (pp. 176–7, 192, 242)
74b Terracotta model of temple from Perachora. Restored, *c.* 750–20
 (pp. 176–7, 192)

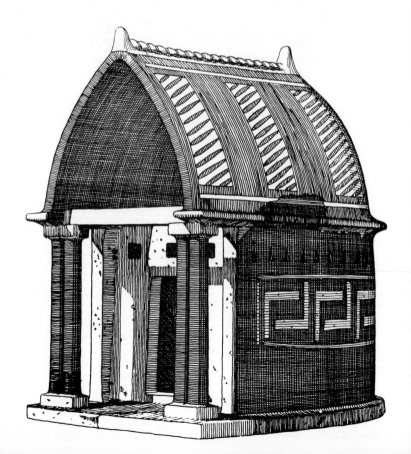

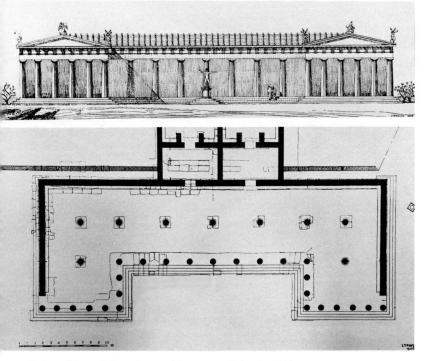

75a, b Stoa of Zeus, Athens. Restored elevation and plan, late fifth century
(pp. 187, 229)

75c Theatre, Priene. Restored view, as in late second century. (In the
background is the sanctuary of Athena with propylon and temple)
(pp. 187, 189–90)

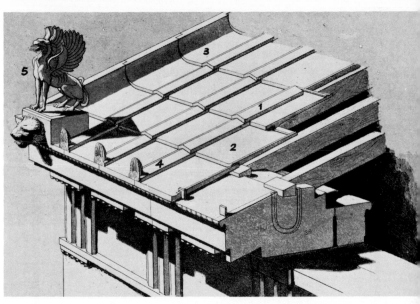

76a System of roof tiling
 1. cover tile
 2. pan tile
 3. pan tile with sima
 4. cover tile with antefix
 5. acroterion (p.179)

76b System of wall masonry
1. levering boss
2. protective surface
3. strip dressed back to final surface
4. smooth projecting band for anathyrosis
5. metal clamp
6. metal dowel (pp. 181–2)

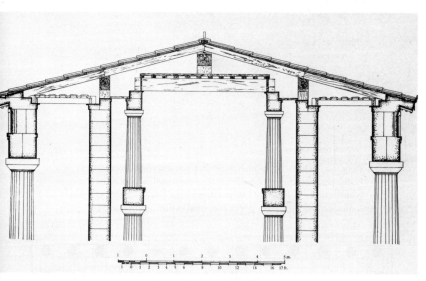

77 Theseum, Athens. Restored section of roof, c. 445 (pp. 199–200, 202)

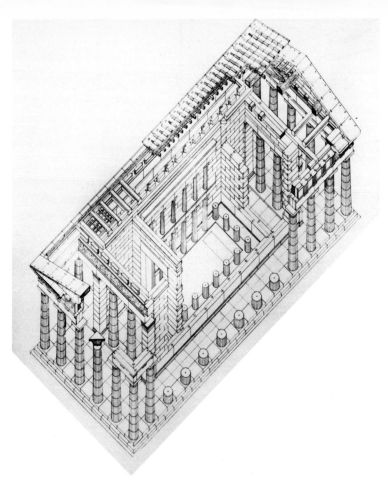

78a, b Theseum, Athens. Axonometric restoration and plan, Doric, *c.* 445.
(The frieze across the front inner porch is abnormal, as also is the consequent
alignment of the columns of that porch with the third columns of the side
colonnades: the back inner porch is normal in plan) (pp. 194, 200, 202–3,
207–8, 229)

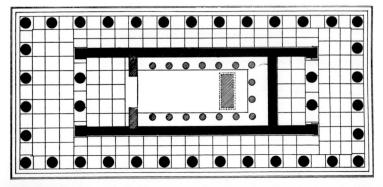

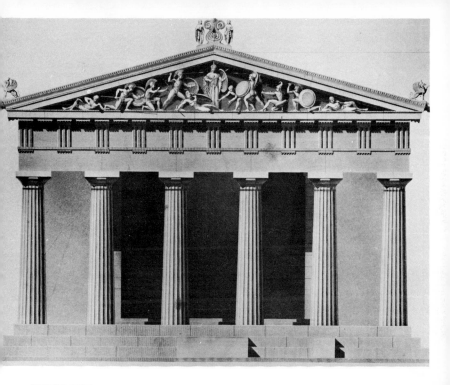

79 Temple of Aphaia, Aegina. Restored elevation and section of west end, Doric, *c.* 500. (The sculpture in the pediment is restored wrongly and the step on which it stood is omitted in the section) (pp. 193–8, 200, 204, 208–9)

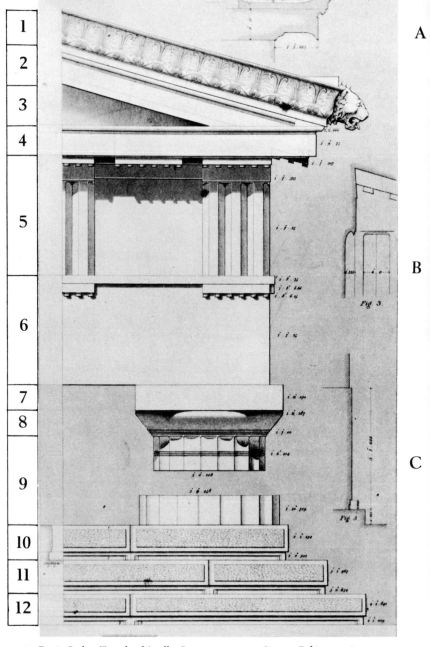

80 Doric Order. Temple of Apollo, Bassae, 450–20. 1. Sima 2. Raking cornice
3. Tympanum 4. Horizontal cornice 5. Frieze 6. Architrave 7–8. Capital
(7. Abacus 8. Echinus) 9. Column shaft 10–12. Steps or crepis (10. Stylobate).
A. section of raking cornice B. section of parts of horizontal cornice and frieze
(through the triglyph) C. section of foot of cella wall (pp. 193–9)

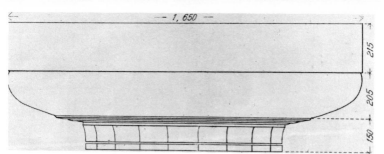

81a Doric column capital of Temple of Hera, Olympia, early sixth century
(pp. 194, 206)

81b Doric column capital of Temple of Zeus, Olympia, c. 465 (pp. 194, 206)

81c Doric column capital of 'South Hall', Olympia, mid fourth century
(pp. 194, 206)

81d Doric anta capital of Temple of Apollo, Bassae, 450–20 (pp. 200–201)

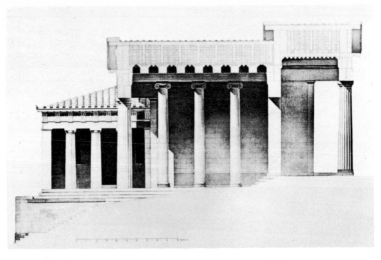

82a, b Propylaea, Athens. Restored longitudinal section and plan, Doric, 437–2. (On 82b the dotted lines represent the positions of architraves and ceiling beams) (pp. 187, 202, 229, 233–4)

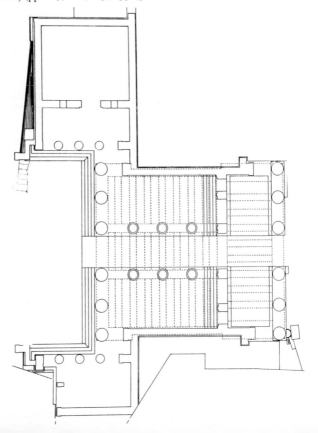

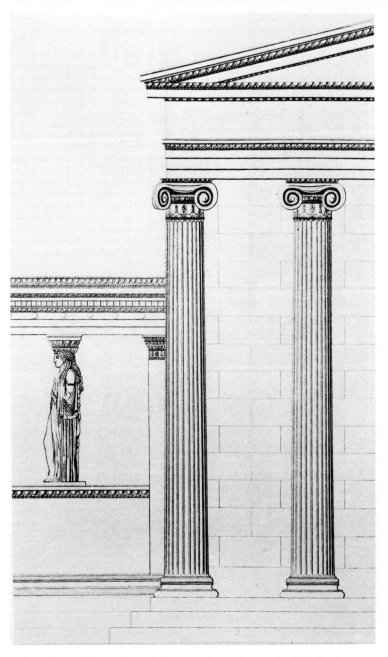

83 Erechtheum, Athens. Restored elevation of parts of east end and of side of
 Caryatid porch, Ionic (Attic for east façade, Asiatic for Caryatid porch),
 421–05 (pp. 214–23, 234–5)

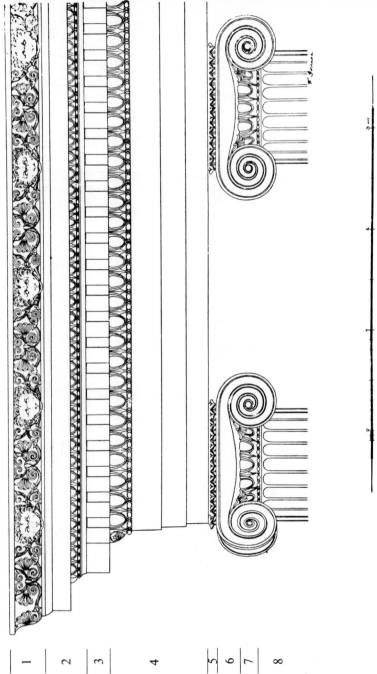

84 Temple of Athena Polias, Priene. Restored elevation of upper part of one
bay of side, Ionic (Asiatic) c. 340 (pp. 199, 215–21, 236) 1. Sima 2–3.
Horizontal cornice (3. Dentils) 4. Architrave 5–7. Capital (5. Abacus 6.
Volute member 7. Echinus) 8. Shaft

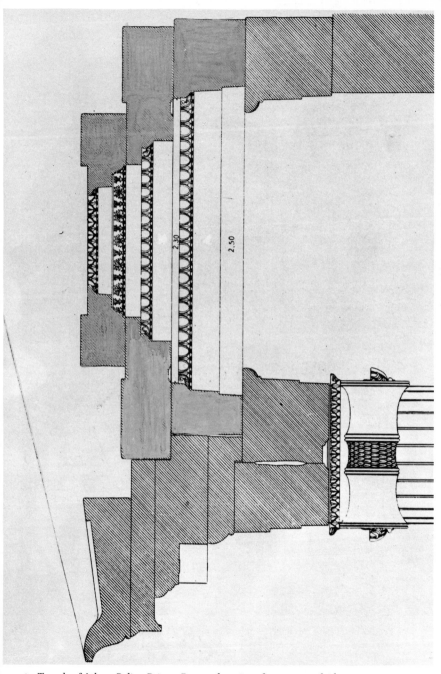

85 Temple of Athena Polias, Priene. Restored section of upper part of side
pteron, Ionic (Asiatic), c. 340 (pp. 215–23)

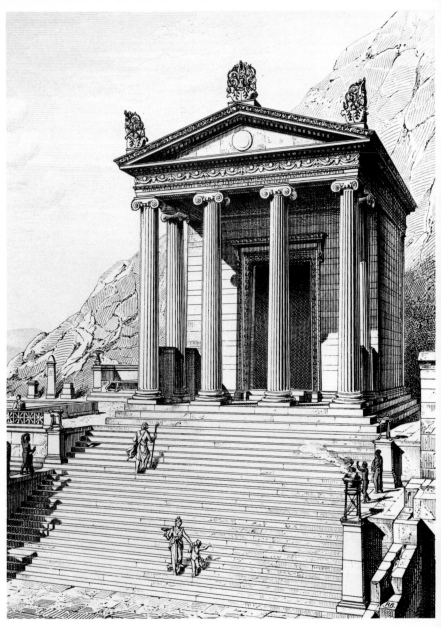

86 Temple on Theatre terrace ('Temple of Dionysus'), Pergamum. Restoration, Ionic, early or middle second century (pp. 180, 214–16, 220–21, 223, 228)

87 Choregic Monument of Lysicrates, Athens. Restoration, ▶
Ionic, c. 334 (pp. 180, 182, 190, 220, 223, 236–7)

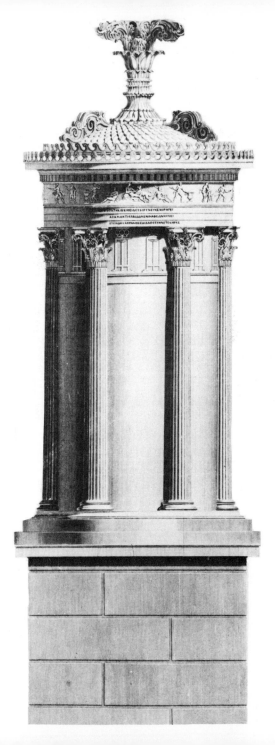

88a Aeolic capital of temple at Neandria, middle or later sixth century (p. 212)
88b Ionic corner capital of Erechtheum, Athens (plan), 421–05 (pp. 216–17)
88c Asiatic Ionic base of Temple of Athena Polias, Priene, c. 340 (p. 215)
88d Corinthian capital of propylon of Bouleuterion, Miletus, c. 170
88e Ionic capital of Temple of Artemis, Ephesus, c. 560 (pp. 216–17)

89 Mouldings. A. Cyma recta above cavetto B. Ovolo above astragal
C. Taenia D. Hawksbeak E. Cyma reversa (pp. 203–4, 224)

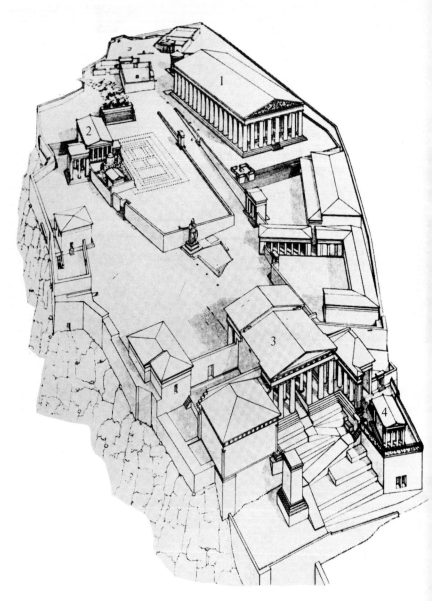

90 Acropolis, Athens. Restoration. 1. Parthenon 2. Erechtheum (dotted plan
to right is of its predecessor) 3. Propylaea 4. Temple of Athena Nike.
The narrow ramp up to the Propylaea should be straight, not zigzag
(pp.233–5, 240–41).

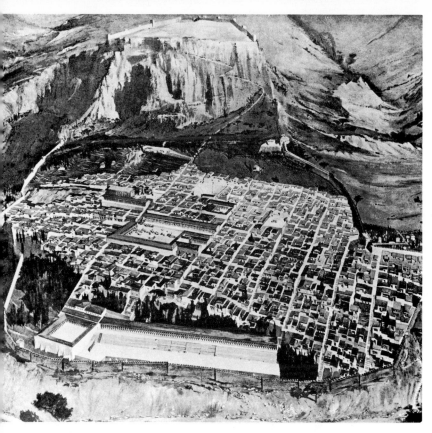

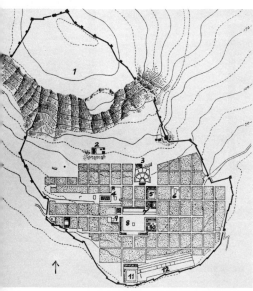

91a, b Priene. Restored general
view and plan (pp. 187, 240)
1. Acropolis 2. Temple
3. Theatre 4. Temple of Athena
5. Gymnasium 6. Temple
7. Council house 8. Agora
9. Fish and meat market
10. Temple 11. Gymnasium
12. Stadium

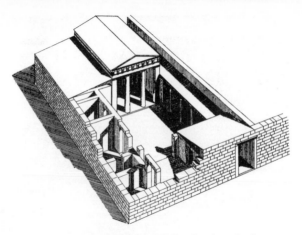

92a, b Priene, house XXIII. Restoration and plan, late fourth or third century
(pp. 242–4)

93a, b Delos, house ('Maison de la Colline'). Restored section and plan, *c.* 100
 (pp. 242–4, 253)

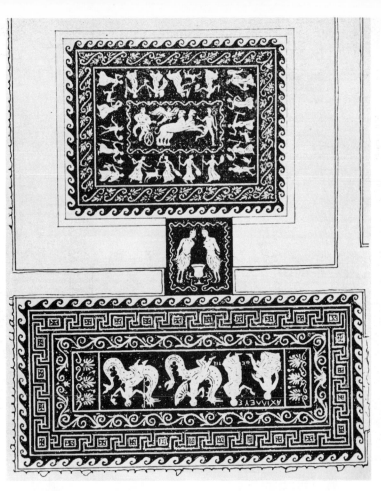

94a, b Pebble mosaic at Olynthus, later fifth or earlier fourth century (p. 248)

95a Pebble mosaic at Pella, late fourth or earlier third century (pp. 248–9)
95b Detail of 95a

96a Tessellated mosaic of 'House of Masks', Delos, later second century (p. 250)
96b Detail of 96a

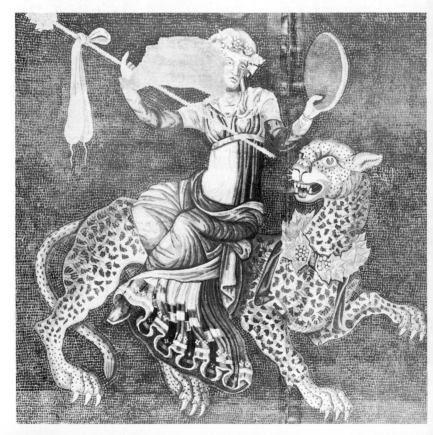

disturbing when the sculptures were exposed to direct sunlight. It looks as if the sculptor must have been one of the pioneers of pedimental composition.

The 'Bluebeard pediment' has been put together from fragments found on and near the Acropolis of Athens, though some still doubt whether the centre and the two sides belong to each other. It too is of limestone, of about the same size as the Corfu pediment and, to judge by the human heads, only a few years later. Here the centre is filled by two lions mauling a bull, a theme used decoratively in vase painting too; on the left Heracles is struggling with Triton; and on the right there is a three-bodied monster and space for another figure, now missing but possibly a running man. The colours are strikingly preserved – red for flesh and red and blue for other parts. In composition this pediment is less ambitious and more successful than that of Corfu; the heads are posed to give various views – an indication that this kind of sculpture was now making its own rules – and the figures agree tolerably well in size, but the filling of the corners with fish and snake tails is rather facile. The scheme is repeated in skeleton in the other pediment from the same temple, if it has been restored rightly with two crouching lions, each flanked by a big snake. Again there is a discrepancy, though less emphatic than at Corfu, between the central and the side groups, one in relief and the others carved partly in the round.

Some other sets of pedimental sculptures, contemporary with the Bluebeard pediment or not much later, were also found on the Athenian Acropolis. These too are of limestone, but from lesser buildings (like treasuries) and perhaps because of their small size more experimental, though experiment consists partly of forcing into a triangular frame a composition designed for a rectangular field. The technique varies from low relief to figures in the round and they offer unified subjects from mythology. The east pediment of the Siphnian Treasury at Delphi, which measured 19 by $2\frac{1}{2}$ feet, is hardly more advanced, although it is of marble and as late as 525. Its subject is the brawl between Heracles and Apollo over the Delphic tripod with a fully dressed Zeus intervening. On either side there are bystanders and the sculptor has not made much effort to vary their poses, so that the composition is monotonous and the figures are fitted into the field by the unhappy expedient of reducing their height away from the centre. A

stranger piece of clumsiness is the wall that reaches halfway up the pediment and involves the carving of the lower parts of some figures in relief, while their upper parts stand free. Very obviously the man who made this pediment was not the creator of the east frieze (plate 44).

The Gigantomachy pediment, also of about 525, is the first big marble pediment we know of. It belonged to a temple of the Acropolis of Athens and its field is estimated at about 65 by 8 feet. What remains suggests that Zeus and Athena were placed back to back in the centre, striking at opponents, and there are also a Giant collapsing and two more Giants who must be from the corners, since they are crawling on the ground. The original total of figures was probably only ten, but though the composition was loose it provided a satisfactory solution to the main problem of pedimental art – satisfactory, that is, for an art devoted to the human form; a battle, with fallen and crouching combatants, allows a logical and integrated filling of the field with figures of the same scale (plate 46b). The other solution, a sort of informal picnic party (plate 47b), needs much more sophistication. There is some evidence that the pediment at the other end of this temple had the old-fashioned centrepiece of lions savaging a bull.

The Temple of Aphaia on Aegina was built near the end of the Archaic period and we have much of its two sets of marble pedimental sculpture and, puzzlingly, fragments of extra figures and an acroterion in the style of the west pediment; these seem to have been intended for the east pediment, but could have been discarded before being put in place. The west pediment, about 43 feet wide and 6 feet high, has at the centre Athena standing apart, a head taller than mortals, and on each side of her six soldiers stabbing and shooting it out towards the corner. The poses are varied thoughtfully and the composition is held firmly together by a system of oblique lines. In the east pediment (plate 46b) Athena is again in the centre, though less stationary, and on each side there is a group of four figures engaged in battle while a fifth twists dying in the corner. The soldiers falling backwards, one on each side, are an experiment that did not succeed; for figures fully in the round (as pedimental sculptures now regularly were) Greek sculpture never brought itself to approve of such apparent defiance of gravity. The style of the east pediment looks a little more advanced than that of the other, but it still makes no

attempt to represent torsion in the body and, if the theory of later replacement can be discounted, the two sets may as well be contemporary works of about 510 to 500, one by a conservative and the other by a modern master. The Aegina pediments are so crisply carved that some students think – without compelling reasons – that they were inspired by bronze work and so assuredly composed that they give the impression almost of academic exercises in the filling of a tapering field.

Though the sculpture of the pediments was the most imposing decoration of the outside of a temple, the Greeks felt no need for its subject to be particularly connected with the god or goddess to whom the temple belonged. The Corfu pediments have nothing to do with Artemis nor the Bluebeard pediment and its counterpart with Athena, though the subject of the Siphnian Treasury is appro-priate to Delphi and in the Gigantomachy pediment Athena has a leading part. As for the Aegina pediments, Aphaia to whom the temple was dedicated is for us a shadowy deity connected with Artemis, but the goddess dominating each set of sculptures is unmistakably Athena. So it seems that the sculptures of pedi-ments, like those of metopes and friezes, were intended more to delight than to glorify the patron deity.

Already in the Corfu pediment some figures had been carved almost in the round and, as this practice became commoner, even backs were often finished with more or less careful detail, so that in their form pedimental figures might often be considered as statues. Yet the free poses of these pedimental statues had no influence on ordinary statues, which till the beginning of the fifth century were still governed by the rules of frontal symmetry. This was probably the deliberate choice of the sculptors as much as of their clients, since though a few deviations from the standard can be found, it would have been easy to introduce more and unobtru-sively, nor are all clients likely to have been conservative. In effect then pedimental sculpture was regarded as a special kind of relief, at least till the remarkable innovations of the Parthenon, and the reason why it was carved in the round was presumably to make it stand out more emphatically in its exalted position.

The Greeks of South Italy and Sicily naturally accepted the Archaic style of sculpture, in the main following the lead of European Greece though often belatedly. This backwardness was certainly not due to poverty or inertia, and the chief reason may

have been remoteness from supplies of marble, so that the local workshops had to make do much longer with the inferior medium of limestone. One curious idiosyncrasy is a liking for carving on the metopes but not in the pediments of Doric temples, the contrary of the fashion of contemporary Greece. In Etruria the ingredients of the local Archaic sculpture were more varied and there were more vagaries in their use, so that it is hard to define a general Etruscan style. Here the local stone, a soft tufa, did not allow any delicacy of carving and the best work was done in terracotta, even for architectural statuary. Whether because of difficulty in attracting Greek artists or some peculiarity of native taste, much Etruscan sculpture remained basically Archaic till near the end of the fifth century. In the opposite direction Cyprus borrowed some features of Greek Archaic for its hybrid limestone statues, with characteristically unhappy results. Cyprus was partly a Greek country, but in the later sixth century Greek art was making an impression on the non-Greek civilizations of the East: along the Syrian and Phoenician coast local figurines began to borrow from the Archaic style, and the court sculpture of the Persian empire (which had annexed Ionia and the rest of western Anatolia in 547) included some Greek features in its formula.

In Greece itself few Archaic details survived the transition to Classical in the early fifth century. The most notable example is the hair of herms – those rectangular blocks of stone with a head on top and a phallus in front which, anyhow in Athens, became familiar objects of private piety. There are also the cult statues which occur in some Classical vase paintings and reliefs and are often represented in a stiff Archaic manner (*plate 27a*), less perhaps to give them an air of age and venerability than because otherwise they could not be distinguished easily from animate figures. In time, though, some sculptors became mildly interested in the Archaic and from the later fifth century on there are occasional reminiscences or adaptations in the treatment of hair or of drapery. Later, during the Hellenistic period and much more so towards its end, small Archaistic schools developed, producing mainly reliefs for eclectic customers. In most Archaistic works the poses were stiff enough and the hair was fairly true to the Archaic formulas, but usually the drapery was distorted to give exaggerated swallowtail folds and the faces were modernized – deliberately, since plenty of Archaic sculpture was around to

study and, when required, good copies or forgeries could be turned out. During the Roman period there was from time to time a limited vogue for the Archaic style, but generally antiquarian taste went back no further than the Early Classical.

In modern times the first recognition of Archaic sculpture came with the discovery of the pedimental figures of Aegina in 1811 and their exhibition in Munich in 1830 (*plate 46b*), but they were alien to the taste of the period and, though Thorvaldsen restored them with creditable understanding and even attempted original work in their style, they had no appreciable effect. Gradually more Archaic statues and reliefs came to light and in the 1880s there was the rich haul from the Athenian Acropolis, so that the archaeologists at least became familiar with the Archaic style, even if most of them still judged it by Classical standards. It was not till early in this century that some sculptors, for instance Meštrović and Eric Gill, found something congenial in Greek Archaic, though true to the tradition of Praxiteles they did not abandon the female nude. Cultured taste has followed and since the 1920s Archaic sculpture has been admired, not always critically. Certainly its composition is simple, there is a studied contrast between strong forms and decorative details (though the decoration may seem rather overdone on many of the korai), the quality of finish is very high, more so in fact than in any other period of Greek sculpture, and appreciation is not soured by inferior copies. Yet though the merits of the Archaic style are obvious, so too should be its limits.

The Early Classical Style

The principal difference between the Archaic and the Classical styles is, at least externally, in the poses. With minor exceptions Archaic statues were constructed of four strictly frontal or profile elevations and, though usually one leg was advanced and the other drawn back, the left and right halves of the body were rigidly symmetrical. Classical statues are still broadly four-square in design, but the balance of the standing figure is shifted so that the axis of the body becomes a long double curve, and to mitigate frontality the head (except in cult statues) is turned regularly towards the side. In reliefs and pedimental sculpture the Archaic formula always allowed free movement, but each part of the figure

was normally shown as fully frontal or profile. The Classical style encourages oblique views and even the twisting of bodies. This revolution in artistic anatomy, which probably began among painters (see pp. 62 and 53–4), reached the various branches of sculpture at different times. In low relief it arrives with all the exuberance of novelty rather before 500 and in high relief little if any later. For the standing male statue the relaxed pose appears first in the 480s, for the standing female statue probably not before the 470s. One may, to preserve the convenient boundary of 480, call the earlier examples of the new style Transitional, but in essence they are already Early Classical.

This Early Classical style, which was dominant till about 450, is also known as the Severe style and with reason. It repudiates conscientiously the decorative detail of much sixth-century sculpture: the Archaic smile is replaced by a frown, hair is rendered by simple strands or flat close curls, and the forms of the face and the body become more unified but with emphasis on a few selected features. Though truer in its general effect to nature, this selection is sometimes arbitrarily 'ideal', most obviously in the Grecian profile which unites forehead and nose in a continuous straight line (*plate 42b* and *60d*) and in the unguinal ligament which supports the belly and marks the trunk off from the legs (*plates 43a* and *48a*). Yet while severity is characteristic of Early Classical sculpture, it had its beginnings in Archaic. During the second half of the sixth century the kouroi of European Greece were becoming steadily less decorative and in the korai of the early fifth a similar austerity was invading the old formulas. The comparison of Plates 38, 39 and 43 and of Plates 41-42 should make much of this clear; the Archaic aim was on the whole a sociable vivacity, the Early Classical an often vacuous detachment.

Though the main trend was towards a severe simplicity of expression, there was some progress in representing feeling and condition. Occasionally pain was suggested by parting the lips – a device that appears in some late Archaic works – and by creasing the forehead, and such subhuman creatures as Centaurs could as before display their native ferocity. Similarly distinctions in age were indicated more effectively; children are still stunted adults, but old men have heavier torsos and receding hair, though for signs of physical decay one must look to provincial works like the Boston counterpart of the Ludovisi Throne. Yet such essays in

characterization continue to be ideal, not individual, and emotion was conveyed more by pose and gesture than facial expression. Evidently, as the rare deviations show, this was a deliberate choice of the sculptors and of Early Classical artists generally.

Bronze was now becoming the standard material for free-standing figures, but this does not seem to have had much influence on the composition of sculpture. It is true that since bronze statues (being cast hollow) were lighter than statues of marble and had effectively greater tensile strength, their poses could be extended without as much danger of overbalancing or breakage; but widely extended poses were uncommon and indeed later copies show that they were practicable in marble too. More important perhaps was the economy of labour: if a statue was to be carved from a single rectangular block without joining of pieces, then an out-stretched arm meant that the block must be much larger, with the consequences that the transport of the block was more difficult and the removal of the surplus stone a longer job. As for style, the difference of medium had no results, except in such details as the form of curls. If the Charioteer of Delphi or the Marathon Boy (*plate 58*) had been executed in marble, the only considerable difference would have been in the colour.

On the system of colouring for Early Classical sculpture in marble our knowledge is very patchy, though some sound inferences can be made. To take the pedimental figures of the Temple of Zeus at Olympia (*plates 47a* and *48*), one may reasonably suppose that the drapery was painted in flat washes of blue, red and yellow, with a stripe along the borders to clarify the folds (compare Plate 22); that the bodies of the Centaurs were a reddish brown; that other male flesh was a lightish brown; and that hair, eyes, nipples, fingernails and other details were picked out in appropriate colours. Whether the flesh of female figures too was tinted is uncertain, though on the contemporary limestone metopes of Temple E at Selinus it probably was not; otherwise there would have been no reason to distinguish it by marble insets. There may of course have been various systems in use, but the general trend was towards more natural effects. The colouring of bronze remains obscure.

For dating there are some useful fixed points. The Persian capture of Athens in 480 gives a terminal date for pieces found in the debris they left, a new pair of statues of the Tyrannicides is

said to have been set up in Athens in 477 and we have copies of them, the Charioteer at Delphi commemorates a racing victory probably won in 474, and (if Pausanias can be believed on this) the Temple of Zeus at Olympia should have been completed by 456. Since development seems to have been fairly steady and uniform, anyhow in progressive workshops, it is reasonable to date other statues and reliefs by their stylistic relationships to these works, though of course there must have been more conservative and backward sculpture than is allowed for.

Although, as is clear from Pliny and Pausanias, output was large in this period, not much survives. Original Classical statues are anyhow rare, since there was no convenient Persian devastation, nor are copies very numerous, since the Early Classical style was too austere for most later collectors. Reliefs and architectural sculpture usually had a better chance of survival, but there was not much building of temples between 480 and 450 and in Attica the rarity of carved gravestones has made many students think that there must at that time have been a law limiting funeral expenses. Still, we are lucky to have four full-size Early Classical statues of bronze, all of them complete and well preserved, and a large part of the architectural sculpture of the Temple of Zeus at Olympia.

The Ball-players relief (*plate 45a*) is a very early example of the new style. It is of Attic marble, about a foot high, and one of the sides of a square base for a statue, probably (to judge by the cuttings for the feet) a conventional kouros. The carving is in very low relief and the background still shows its red paint, though the hair and other details of the figures have lost most of their original colouring. The base is decorated on three of its faces. The front has athletes practising, one side young men setting a dog against a cat, and the other side some kind of team game with a player on the left throwing in – a subject very rare in Greek art, but well suited for the display of oblique and twisted poses; indeed only one figure keeps to the old formula, perhaps to remind the spectator of the sculptor's modernity. This base was found built into the city wall of Athens which Themistocles improvised in 479, but the anatomy of the figures has the ostentatious novelty of the last few years of the sixth century as seen in the vase paintings of Euthymides and Euphronios (*plate 19*), and like the vase paintings this relief too is faithful to the profile view of the head.

High relief was by its nature less close to painting and so it need not be accidental that our first examples in the Early Classical style appear a little later. According to Pausanias the Athenians built their treasury at Delphi to commemorate the victory at Marathon in 490, but many students find this incredible, since the stylistic stage of its sculpture is little if any later than 500 nor does the workmanship look retarded. In the metope with Heracles clubbing the Cerynean hind or stag (*plate 45b*), of Parian marble and about two feet square, there is a confident exaggeration in musculature and pose, so much so that the hero seems to be bursting out of the field in his exertion, and the effect must have been even stronger when the sculpture was complete and the club stretched downwards at the far right. With its emphatic modelling and the turn of the head this metope is much less dependent on painting than is the Ball-players relief (*plate 45a*). The contrast with the east frieze of the Siphnian Treasury (*plate 44*), carved by a leading sculptor around 525, illustrates very clearly the extraordinary development of Greek figurative art in less than one generation.

Later reliefs (and indeed other metopes from the Athenian Treasury) do not obtrude the new knowledge. For gravestones a narrowish field was still popular, with room for only one or two standing figures, but even in wider fields quiet scenes are commoner than before. This is characteristic of Classical art generally, where as skill in representation increased mood became as important as action. There is not much sign of continuing pictorial influence on relief sculpture and none yet of the composition in depth that was introduced into painting by Polygnotus in the 470s; even indications of landscape are few, and the least uncommon – rocks for figures to sit on – are almost natural in sculpture in stone. The front of the 'Ludovisi Throne' (*plate 50a*), which is 4 feet 8 inches wide, offers an exceptional instance of Early Classical sculpture emulating painting: in contemporary painting it was easy to show the outline of a leg through drapery, but this attempt at transparency in relief is technically inept with its harsh back contour and the illogical diversion of folds of the skirt. There is also the pebbly ground on which the side figures stand. Still, though this 'Throne' – perhaps really a fender for an altar or a sacred well or pit – was made of marble imported from Thasos, its style is provincial, concocted in some Greek workshop of South Italy, and provincial art is liable to erratic experiment.

This explains also the odd flavour of archaism in the hair of the central figure and the bodice of the attendant to the right; but the poses of the attendants, the rest of the drapery and the expression of the surviving face are Early Classical and there is an unexpected subtlety in the folds of the cloth discreetly held by the attendants. The subject is obscure, perhaps a goddess or priestess emerging from a ritual bath or even Aphrodite rising from the sea. The date may be about 460, contemporary with the stylistically more advanced sculptures of the Temple of Zeus at Olympia.

In pedimental sculpture, which was always closer to reliefs than to free-standing statuary, one would expect the new torsion of the body to have been adopted by the 490s at the latest, but we are short of examples unless of course the Aegina pediments (*plate 46b*) with the ugly swivelling at the waists of their corner figures are so late. The only fairly complete pediments in the Early Classical style are those from the Temple of Zeus at Olympia (*plates 47a* and *48*), dated about 460, the one at the east or front end showing in a static grouping the legendary local heroes, Oenomaus and Pelops, preparing for their chariot race and the other at the west the savage fight at the wedding of Pirithous with the Lapiths rescuing their womenfolk from the drunken Centaurs. As for composition, the Olympia pediments are no more advanced than those of Aegina (*plate 46b*); in each of them there is a deity standing detached in the centre and the other figures are deployed at either side. The style of course is more advanced at Olympia and in the west pediment the variety of figures – male, female and equine – is more sophisticated.

Throughout the Classical period the standing nude was still the commonest type of male statue, though because of the greater range of poses it was less uniform and less ubiquitous than the Archaic kouros which preceded it. Its principal use was to represent athletes who had won in the major Games, and it served also for heroes and deities and with the addition of helmet and beard for successful statesmen (or generals); but statues on graves were now less fashionable. The standard size was a little more than life.

In reliefs and pediments the activity of the figures invited sculptors immediately to apply their new anatomical knowledge, but there was no opportunity for such improvements in the kouros, unless its pose was altered. So radical a break with tradition was

not accepted, it seems, before the 480s and the 'Critian Boy' (*plate 43*) is a very early example of the new Early Classical standing male. This statue, which gets its name from a resemblance to the copies of the Tyrannicides of Critios and Nesiotes, is of Parian marble and about four feet high and should be a little earlier than 480, since it was found on the Acropolis of Athens and most probably in debris from the Persian sack. Originally, as attachments show, both arms stretched down in the old Archaic manner, and the eyes were filled with paste or coloured stones. A curious but unimportant peculiarity is that the head was made separately from the body – the join is smooth – and yet the style of both parts is contemporary; presumably then the statue was damaged in the workshop while being carved. What is novel in the Critian Boy is the shift of its balance. In Archaic statues the feet had taken an unnaturally equal burden, but here the weight is on the left leg, while the right leg hangs free, and in consequence the right hip is lower than the left and the belly (as the navel makes clear) is displaced correspondingly to the side. This swing is not continued in the chest, the shoulders are level and both arms hang down by the sides, but the head is turned slightly to the right. Compared with even the late kouroi, such as that of Aristodikos (*plate 39*), the Critian Boy has a natural liveliness, and besides the liberating effect of the pose there is a more coherent modelling of the anatomy. The deep full jaw is typical of an Early Classical trend that did not last; its successful competitor was a shorter, sparer and more triangular face.

There was not much progress in this type during the next thirty or forty years. The marble figure of Oenomaus from the east pediment of the Temple of Zeus at Olympia (*plate 48 a*), though not strictly a free-standing statue, shows the stage reached by 460. Again the weight is on one leg, the other (as often) set a little off to the side, and the effect on the hips and belly is observed, but now the swing is carried up through the chest, even if the shoulders are still kept level. The head of course is turned towards the side, and the sculptor feels free to move the arms – the left one to be restored bent upwards at the elbow with the hand grasping a grounded spear. The modelling is anatomically a little more advanced than that of the Critian Boy (*plate 43*), though because of its scale and setting much harsher; originally it stood about fifty feet above ground level and was itself about nine feet

high. Since the figure was in one piece and the block from which it was carved was quarried on Paros, transport must have been expensive and difficult; the Greeks were particular about their materials.

Because of its drapery the kore was a much more intractable problem for the pioneers of Early Classical sculpture. The statue dedicated by Euthydikos (*plate 42*) is still reluctantly Archaic, in spite of the severe treatment of the face and the simplification of the detail of hair and dress. What was needed was a complete change in the style of the drapery, replacing the finicky cross-folds and crinkles by a plainer and dominantly vertical system. Such a scheme is displayed with deliberate emphasis on a diminutive kore from the Athenian Acropolis (no. 688), which should be earlier than 480: here the dress is the chiton, but the skirt is not clutched at the side and the himation has been turned into a scarf which hangs down from each shoulder, so that both garments fall straight. Yet though the chiton could be adapted to suit the new principles and indeed continued in sculptural use (*plate 50a-b*), the peplos is the standard Early Classical dress, since being of heavier material it could plausibly be disposed in fewer and deeper folds. When first it appears – in the 470s – the result is monotonous; the figure is posed with legs together and the skirt hangs round them like a bell, even concealing the feet. Later, about 460, the looser stance of the standing male was adapted, as in the Hippodamia of the east pediment of the Temple of Zeus at Olympia (*plate 48b*). Here the right leg, which is free of weight, is bent and the knee thrust forward, so flattening out the folds over it. Afterwards the thrust becomes more emphatic and its effects more complex. In much the same way the early V-shaped folds over the chest give way to a more casual arrangement, on the Hippodamia almost meaninglessly so. The new form of dress appears less happily in low reliefs of this time, where in the profile view the further leg thrusts forward and the different character or even absence of folds across it makes the limb look disconnected. The turning of the head, so typical of the Early Classical style, seems to have come in about the same time as the peplos, and with it or very little later movement of the arms – Hippodamia, without much motivation, is adjusting the shoulder of her dress; but even after the stance was revised the drapery was too heavy for speculation about the bodily forms underneath. The hair now is

normally fastened up in a bun, which is sometimes kept in place by a plain snood.

It is sometimes said that the peplos (and severity too) was a Dorian, specifically Peloponnesian, contribution to the development of Greek art. This is naive. In later Archaic sculpture the 'Ionic' chiton was popular universally, and so was the 'Doric' peplos in Early Classical. Freaks like the two statues from Xanthos in Lycia of a standing woman wearing the peplos but still clutching the side of her skirt, are provincial and not racial in their origin. Nor need the change of dress in sculpture reflect a radical change in social custom. Respectable Greek women, other than those of Sparta, wore some sort of wrap over the chiton or peplos when in public and, if for some reason no wrap was worn, would certainly not have left one side of the peplos open, as statues and statuettes of young women sometimes do. In drapery even more than anatomy art tends to make its own rules, and artistic need is a sufficient explanation of the adoption and use of the peplos in Early Classical sculpture.

Besides revising the standing figure, sculptors sometimes experimented with other poses for free-standing statues. The models may have been ultimately in painting, but if so they were transposed in terms of relief. This is obvious if one looks at the full and the end views of the fancifully named 'Penelope' (*plate 50b*), a marble figure, rather under life size, of a sorrowing woman, with – originally – head bowed and supported by the right hand, the elbow being propped on the thigh. If one compares the seated deities of the east frieze of the Siphnian Treasury (*plate 44a*), there is much greater sophistication in the Penelope and mood is expressed more subtly, but the statue is in effect more two-dimensional than the relief; at least a statue based on the goddesses of the relief would present four, not two, presentable elevations. The copies of Myron's Discobolus (or man throwing a discus) show that this apparently intricate figure was constructed on the same principle as the Penelope, as if a relief had been cut out and completed at the back. So too with the well-known bronze statue fished up off Cape Artemisium, variously interpreted (since in Greek art there is no intrinsic difference between gods and men) as Poseidon or Zeus or an athlete throwing a javelin; the intended view is that of the figure in full extension, though the end view which presents a nearly frontal face is also impressive. In figurines

active poses are sometimes bolder and more successful, because of the very small scale; but Early Classical sculptors still conceived their statues as exercises in two dimensions or at most two and a half.

The Penelope (*plate 50b*), usually dated about 460, wears a chiton, showing on the arms, the front of the body and the lower part of the legs, and a cloak which covers her hair, hangs down the back and is brought forward across the thighs. The effect, by later Classical standards, is confused. Over the chest the thick folds have a generally vertical fall, awkwardly so at the breasts, and the small system of V's do little more than emphasize the faultiness of the anatomy. Below the waist the character and direction of the folds changes, making the statue appear even flatter than it is, and then near the knee vertical lines begin abruptly again. At the back the folds are fewer and shallower, with the upper ends of the cloak hanging vertically from the shoulders and lower down three or four aimless groups of lines which radiate from each hip and under the right buttock. Early Classical sculptors were at a loss when managing drapery, except on standing figures. They were unhappy too over the anatomy of figures in action: indeed the chests of both the Artemisium bronze of about 460 and the still later Discobolus show no muscular response to the action of the arms and could belong to quite static figures. Yet already on the Temple of Zeus at Olympia some sculptors had found these effects unsatisfactory and one or two of those who worked there were experimenting in search of solutions.

Incidentally the Penelope illustrated on Plate 50b, now in Teheran, is an original work of about 460, and there are Roman copies of the same type in which the resemblance, even of details, is too close to be fortuitous. Yet the Teheran statue was buried in Persepolis from 330 BC till AD 1936 and could not have been a model for copyists in the Roman period. The only reasonable conclusion is that the archetype of the Penelope was duplicated more or less exactly in the workshop that made it, a procedure one might anyhow expect from an economical artist, even in Classical Greece. Cleobis and Biton (see pp. 95–6) offer another and much earlier example of duplication, though admittedly they were commissioned as a pair. It is from evidence such as this that one must try to reconstruct the workshop practices of Greek sculptors.

In Etruria the Early Classical style was accepted, though often

with an admixture of Archaic, but a fairly pure Archaic style persisted too. In Lycia, a non-Greek region of south-west Anatolia, a taste for Greek sculpture had begun in the sixth century and grew in the fifth, though there is some provincial lag. More remarkable is the effect of the Early Classical style in Phoenicia, where marble sarcophagi of Egyptian type were fashionable from the early fifth till the later fourth century, many of them made of Parian marble and adorned with faces in more or less Greek style. The Persians, though, seem to have found the new development of Greek sculpture too revolutionary to be adopted in their official Achaemenid art.

Early Classical sculpture or some of it was admired by later generations, but it was not imitated till the first century BC. Then copying began on a limited scale, and there was some adaptation and even original creation in an Early Classical manner. Some of these pastiches, if the word is not too unkind, have an independent merit with their nicely calculated admixtures of sentiment or self-consciousness. In modern times the Early Classical style was hardly noticed before the discovery of the pedimental figures of the Temple of Zeus at Olympia in the late 1870s and at first their rawness was found shocking. The subsequent recognition of this phase of Greek sculpture, both by practising artists and by critics, is indistinguishable from that of Archaic.

The High Classical Style

The High Classical style began around 450 and developed very quickly; its end is not defined clearly, but for convenience might be put about 400. In the face a serene detachment replaces the severity of Early Classical; anatomy becomes more accurate both generally and in particular; drapery is elaborated with a novel sense of purpose; and poses – anyhow of statues – are easier but compact. It is a style worked out with much more thorough intelligence than any of its predecessors and, judged by its standards, Early Classical sculpture appears clumsy and Archaic ridiculous.

In the natural rendering of bodily forms there was steady progress. This is seen at its subtlest on the trunks of figures (usually slurred in copies) and more obviously in such details as the eye where the upper lid soon regularly overlaps the lower, but even

so some artificial conventions were maintained for the sake of ideal beauty or structural clarity; the Grecian profile for example, which is abnormal in nature, has the merit of making the nose appear an integral part of the face and not a casual excrescence, though High Classical sculptors were more compromising than their predecessors (compare Plates 42b and 60b). Another major advance was in the understanding of the female anatomy, which was encouraged by the new and more revealing style of drapery: one may contrast the Nike of Paionios (*plate 55*) with the central figure of the Ludovisi Throne (*plate 50a*) or, so far as the heavy peplos permits, the Hippodamia of the Olympia pediment (*plate 48b*). At the same time progressive sculptors studied the effects of activity on the musculation, so giving more importance to the torso at the expense of the face. Whether for this reason or some sense of artistic propriety facial expression of emotion becomes even rarer than in Early Classical, sometimes absurdly so; on one of the metopes of the Parthenon (*plate 51b*), which was carved as early as the 440s, the Centaur braining a Lapith has the typical High Classical look of pensive, almost melancholy detachment. Still more curious are the refined, dispassionate faces in the brothel scenes reproduced on some Arretine pots of the late first century; the subject may be Classicizing, but the treatment is purely Classical.

The typical drapery of the Early Classical style had muffled the figure in a system of deep folds which in the main followed the line of the body and legs. If the pose was upright, the folds fell vertically (*plate 48b*); and if the pose was inclined or bent, so also most often was the direction of the folds (*plate 50b*). The effects were stately enough in standing figures, but otherwise seemed much too monotonous and restricting for High Classical sculptors, who regarded drapery as a means of explaining or emphasizing the anatomy and action of the subject. Yet though more convincing in appearance, the new arrangements were not more true to fact and they were based less on the observation of draped models than on the study of optical illusions. This is characteristic of ideal sculpture, which represents nature not as it is but as it should be.

If one looks at the Penelope (*plate 50b*) and then at the Iris of the west pediment of the Parthenon (*plate 52*), both of them carved fully in the round, the forms of the Iris appear much more rounded. What produces this appearance is the arrangement of the

drapery and here there are two important innovations – 'transparency' and the 'modelling line'. Transparent drapery, or more accurately drapery that clings to the figure as if it were some wet thin material, had been used for the lower parts of late Archaic korai and in the Early Classical style was attempted by the provincial sculptor of the Ludovisi Throne (*plate 50a*), but on the Iris transparency is much more sophisticated, modelling particularly the belly and the breasts by smooth surfaces and high narrow ridges; the purpose of these ridges, incidentally, was not a sop to propriety, since paint was enough to show that the figure was clothed, but to complete the general design and also to emphasize the modelling. Whether or not transparency was suggested to High Classical sculptors by paintings, their use of the device was thoroughly sculptural.

The 'modelling line' is demonstrated very clearly by the right thigh of the Iris (*plate 52*) and also by the thighs of the gods from the frieze of the Parthenon (*plate 51a*). On the Penelope (*plate 50b*) the folds of the drapery over the thighs appear more or less as straight lines, whether vertical or oblique, and the effect is flat. On the Iris and the gods of the frieze the folds curve over at the top, as if reproducing the profile of the thigh, and this or some similar reflex of vision gives an impression of roundness in depth, an impression particularly needed in low relief. On a few of the pedimental figures of the Temple of Zeus at Olympia there seems to be a groping attempt at this optical trick and there may be something of the sort, though less intelligently applied, in the folds over the lower part of the further leg of the right-hand attendant on the Ludovisi Throne (*plate 50a*). In a more advanced form the modelling line occurs, though infrequently, in vase painting from about the same date and so it is likely that it was invented by painters, who at that time had not developed shading and could indicate roundness and foreshortening only by linear devices. Anyhow sculptors had mastered its possibilities by the 440s and the Iris, of about 435, shows it in use not only on the thighs but also and more subtly on the belly and round the breasts.

Drapery streaming behind a figure makes it appear to be moving forward, but the effect is much more convincing if the lines of the drapery follow a double curve. This is obvious in the side view of the Nike of Paionios (*plate 54*). Without the drapery the figure might appear to be balancing on one foot, with the drapery there

is no doubt that it is in rapid motion. On this Nike the 'motion line' is developed with unusual exuberance; a more modest yet effective use occurs on the left thigh of the Iris of the Parthenon (*plate 52*), a figure which, incomplete as it is, is evidently rushing to the left. In the fourth century, acroteria from the Temple of Asklepios at Epidaurus show a curious extension of the device; a woman is riding sidesaddle on a galloping horse and her skirt curves out in the direction in which the horse is moving, whether for an illogical decorative effect or perhaps, if she is about to jump off, to indicate her imminent recession relatively to the horse. Like the 'modelling line' the 'motion line' may have come to High Classical sculptors from painting; though it hardly occurs in vase painting of the mid fifth century, it is a basically linear device.

'Catenaries' or heavy looped folds, which occur naturally in certain kinds of dress, were used from time to time on the backs of Archaic korai, for example the Berlin Standing Goddess (Plate 40 shows only front and side views, but the folds on the back can be inferred), and there is a good Early Classical specimen in the wrap or towel that is held in front of the emergent figure of the Ludovisi Throne (*plate 50a*) and ties the two attendants closer into the composition. High Classical sculptors used catenaries more often and more subtly. On the figure of the Nike Balustrade who is unfastening her sandal (*plate 53*) their points of attachment are at different heights – along the left arm and the right leg – and the effect is to bind the figure together and so give coherence and grace to a pose that in the nude would be clumsy and unbalanced. A less important High Classical use of catenaries is, as in Archaic, on the backs of standing draped statues: it is a quiet, dignified and economical way of dealing with their least interesting aspect.

Besides exploiting these special devices High Classical sculptors multiplied and varied the folds of their drapery. The normal practice in the Early Classical style had been for the folds in any major area of the dress to be of nearly equal depth and width and set at nearly equal distances from one another. This is shown most typically in such standing statues as the Charioteer of Delphi and with some modification in the later and more advanced Hippodamia of the Temple of Zeus at Olympia (*plate 48b*); and for less happy effects there is the Penelope (*plate 50b*), where the folds are closer, shallower and less regular, but lose grandeur without gaining liveliness. In the High Classical style it is broadly the general

composition that determines the spacing of the folds as well as their width and depth, now often much greater than before, and to avoid monotony there is more detailed variation in these particulars and also in the contours of each fold. There are modest examples of such variation on Plate 51a, which reproduces part of the frieze of the Parthenon, and spectacular examples on the Nike of Paionios (*plates 54-55*). An unfortunate consequence of this treatment of drapery is that when the crests of deep folds are broken away, as has happened often in the course of time, much of the original effect is destroyed, since the pattern of shade and light is altered and the hollows of folds that were invisible and not easily accessible now display their unfinished surfaces.

In the figures of the pediments of the Temple of Zeus at Olympia, which seemed to have been carved around 460, there are only faint intimations of the High Classical style. Within twenty-five years at the most, as the sculptures of the Parthenon demonstrate, that style had been established more or less completely. If an individual master is needed to account for the speed and character of this development, the obvious candidate must be Phidias, whom later Greek and Roman writers considered the greatest sculptor of the fifth century. So far no original work of Phidias has been identified with any probability and only one or two stylistically trustworthy copies; perhaps the so-called 'Lemnian Athena' (*plate 60a-b*) might reproduce one of his early works, of around 450. There is also the sculpture of the Parthenon to be considered. According to Plutarch, who wrote in the second century AD, Phidias was in general charge of the building programme at Athens, and though it is not likely that he himself carved any of the architectural sculptures of the Parthenon – for one thing he was busy on the forty-foot chryselephantine cult statue that stood inside it – the general style of those sculptures suggests the influence of a single personality. The metopes, which were carved first, differ remarkably not only in the expressions and anatomical details of the figures but also in the composition of the whole, so that it is evident that both backward and modern craftsmen were employed and given only verbal instructions without any model or sketch; but in the frieze and the pediments the design is unified and, though the various craftsmen showed their individuality in details, their style too has a general unity. Since Phidias was at that time the dominant personality in Attic sculpture, it is likely that the

style of the Parthenon reflects that of Phidias; the composition of
the frieze and pediments might even be his directly.

For the character of the High Classical style it is easy to rely too
much on the architectural sculptures of the Parthenon, since they
form the only large body of original work of first-rate quality that
has survived. There are, though, enough later pieces to show how
the style developed. From financial inscriptions it follows that the
metopes, frieze and pediments of the Parthenon were carved (in
that order) from 447 to 432. Here the new style appears with
confident clarity and strength. In the next generation there are no
major innovations, but a tendency towards elegance or flamboy-
ance. For this development one can compare among pieces illus-
trated the Iris of the west pediment of the Parthenon, carved
about 435, and the Nike of Paionios, probably some fifteen years
later (*plates 52* and *54-55*), or the gods of the Parthenon frieze of
about 440 and the figure undoing her sandal from the Nike
Balustrade, which should be within a few years of 415 (*plates 51a*
and *53*). A curious minor vagary of this period is a limited revival
of modified Archaic details, especially rows of snailshell curls at
the front of the hair; perhaps the aim was to give an old-fashioned
venerability to static images of divinities.

The great sculptors of the High Classical style were assured and
inquisitive enough to speculate about their art and Polyclitus of
Argos, who was later considered Phidias's nearest competitor,
both made a statue and wrote a treatise to explain his theories.
Most of the scraps which survive from the treatise are concerned
with detailed arithmetical proportions for the parts of the human
figure, though measurement of copies of the Doryphorus (*plate
49*), which may have been his model statue, and of other works of
the time have not yet produced any coherent numerical system.
That Polyclitus's exposition went deeper is suggested by his enig-
matic remark that the sculptor's work is most difficult when the
clay is in the fingernail. Even so, many of the subtleties of High
Classical sculpture were hardly susceptible to theoretical analysis,
for instance the adjustments of proportions and angles to correct
foreshortening of the upper parts of large figures viewed from
below, which some but not all contemporary masters allowed for,
though asymmetry of a face that was intended to be seen obliquely
was already an old practice, as may be observed in the Charioteer
at Delphi of about 470.

There is almost no evidence about the colouring of marble sculpture in this period, but to judge by paintings or rather vase paintings more delicate and more natural shades were used. One may expect further that the contrasts of colour were more deliberately calculated, and this too needs to be remembered when one is considering the original effect of draped and partly draped figures, as for example the Nike of Paionios (*plates 54-55*). There was also an increase in the practice of leaving minor but tiresome details uncarved and simply painting them in – for instance the straps of the sandal and the feathers of the wings of the Nike of Plate 53; and metal accessories of course remained in use. In the treatment of bronze statues it is unlikely that there was any change.

As for dating, inscriptions inform us that the sculptures of the Parthenon were executed between 447 and 432, and it is reasonable to allow five years each in succession for the work on metopes (*plate 51b*), frieze (*plate 51a*) and pediments (*plate 52*). For historical reasons the Nike of Paionios (*plates 54-55*) should have been carved within a year or two of 420, and the architectural sculpture of the new temple at the Argive Heraeum must be later – but probably not much later – than 423, when the old one burnt down. The Caryatids of the Erechtheum at Athens were completed probably only a little before 413 and the frieze certainly between 409 and 406; these dates again come from inscriptions, which for the frieze even detailed payments to particular craftsmen for particular jobs. There are besides a few precisely dated reliefs on slabs recording public decrees at Athens, but their quality is too poor to be of much help. For the rest dating is mostly by subjective comparisons of style or even more subjective inferences from historical events. Still the main trend is clear.

Very few original High Classical statues survive and those are not very well preserved; but Roman copies are plentiful, some fair and one or two excellent in finish. There is much architectural sculpture, of which the British Museum has its share. Other reliefs too are numerous, but the quality varies. No major bronze statue has yet been found, and the general standard of figurines falls off quickly, though a few fine specimens offer consolation.

The standing male nude found a classical solution in the Doryphorus or Spear-carrier of Polyclitus, made perhaps about 440 and one of the favourite subjects for copyists in Roman times (*plate 49*). The original, which did not have the tree trunk, was of

bronze and just under seven feet high, excluding the spear which rested on the left shoulder and was held in the left hand. This, as later writers make plain, was Polyclitus's most famous work and may well have been the 'canon' which was analysed in his treatise; and it is significant, both for the undifferentiated character of much Classical sculpture and for the prevalence of an aesthetic attitude to art, that this statue came to be known by a descriptive name and that we cannot tell what god, hero or man it represented. In pose the Doryphorus completes the development begun in the Critian Boy (*plate 43*) and continued in the Oenomaus (*plate 48a*). There the stance had been freed, but the upper part of the body still looked stiff. Here the whole figure has a studied ease of balance: taut right leg contrasts with slack left leg and conversely taut left arm with slack right arm, the median line of the figure makes a gentle double curve that continues through the face, and the axes through knees, hips, pectorals, shoulders and eyes are inclined in a sort of rotation. Though the head is turned a little to one side, the statue is still composed of four main elevations – front, two sides and back – and not only their contours but also their principal features are planned basically in a linear design; this may be one reason for the retention of the unguinal ligament, which delineates so firmly the boundary between trunk and legs. The four-square linear conception of figures in the round, which goes back to the beginning of Greek sculpture, remains regular till the late fourth century and, if intermediate views are often satisfactory, that is an accidental by-product of the cardinal views; for the Doryphorus, anyhow, the three-quarter view from the right is sloppy. The face of the Doryphorus in its form and expression is typically High Classical and perhaps one can see through the copy, if it is compared with the head of Plate 60a-b, what ancient critics meant when they said that Phidias was a sculptor of gods and Polyclitus of men; still our Doryphorus is a copy of fair but not excellent quality, and the original must have been subtler and livelier in its finish. The pattern of the Doryphorus was varied in other male nudes of Polyclitus and his contemporaries, especially in the movement of the arms, but the balance, the median curve and the easiness of pose remained constant. As literary records and inscribed bases show, the type of the standing naked male was popular throughout the Classical period for monuments to successful athletes.

For older males, and especially the senior gods, some drapery had long been considered proper, even when standing. The usual High Classical formulas left the chest bare (as it had been in the Zeus of the east pediment of the temple at Olympia) with the garment tucked in optimistically at the waist and sometimes one end thrown over the shoulder. Both fashions can be seen on the two seated gods of the relief illustrated on Plate 51a. The new style of drapery was of course an asset to such figures.

Standing female figures were now, so it seems, less frequent than those of standing males. Some of them have an equal easiness of pose and also take full advantage of the new effects of drapery, others because of their position or function were more restrained. So in Phidias's colossal cult statue of Athena Parthenos, which stood in the cella of the Parthenon, both the pose and the dress had a strongly vertical accent; and the Caryatids of the Erechtheum, which as architectural members supported an entablature on their heads, could not be allowed any appearance of swaying. Here in compensation sculptors tended to increase the fullness of the costume, but generally the results did not express the High Classical style most happily. The so-called Lemnian Athena – Plate 60a-b shows a remarkably fine copy of its head – is rather different: the original, which the eye sockets suggest was a bronze, must have been made about 450 and one may perhaps feel that the somewhat severer arrangement of drapery which it inherits from the Early Classical style is better suited to a pose that is still basically Early Classical.

As their skill increased, sculptors looked for new poses or variations of old ones. Besides seated there are now lounging figures (*plate 51a*), wounded Amazons appear and occasionally a statue is allowed to step decisively forward. One of the boldest of High Classical inventions is the monument at Olympia made by Paionios for the Messenians and Naupactians (*plates 54-55*). This figure of Nike (or Victory), flying down from heaven, is of Parian marble and rather over life size. Originally it had wings, which rose behind the shoulders, its left forearm was bent slightly upwards, and an open cloak, held by the two hands, billowed out behind to reach down on each side to about the level of the ankles. The figure is supported on a shapeless lump of stone from which an eagle's head emerges, presumably to represent cloud or perhaps sky, and this in turn rested on a slightly tapering pier,

triangular in section and nearly thirty feet high. In the front view the modelling line is used with exuberant mastery, so much so that the draped right thigh looks rounder than the naked left, and in the side view the motion line has its turn; but the two views are not co-ordinated completely and that of the back has hardly been considered, though of course its tilt made it not very noticeable from the ground. As dress the drapery makes little sense, either in its mass or in the way it laps round the right leg without, though, affecting the major folds; but its function was to explain and enhance the figure, and this it does admirably in the principal views, even if one has no longer the help of colour to distinguish from each other the nude parts, peplos, cloak, wings and – probably – the support. Compared with the Iris of the Parthenon (*plate 52*), which also had wings, the Nike of Paionios is flamboyant. It should be about fifteen years later, of about 420.

The sculptures of the pediments of the Parthenon, carved within two or three years of 435, were executed with remarkably detailed care and the composition has a complexity and sophistication which, so far as we know, was not even approached in any earlier or later pediment. The subjects, appropriate to a temple of Athena, are in the east the birth of that goddess and in the west her contest with Poseidon for the land of Attica (*plate 47b*). In both the action is in the centre and the movement and attention of the surrounding deities dies away towards the corners, so that there is little narrative interest to supplement the aesthetic effect and success depended on the pattern made by the crowded whole (which cannot be reconstructed in enough detail for complete judgement) and on the excellence of particular figures (*plate 52*) and groups. Another bold novelty is the transgression of pedimental space; figures project forward beyond the frame, most noticeably in the corners of the east pediment, where the heads of horses represent the chariots of Sun and Moon, about to rise or already sunk beneath the floor of the field. Though it is obvious that the pediments of the Parthenon must have been planned in a very carefully measured design or model, close examination of the drapery suggests that the sculptors who carved the figures still had some freedom in their choice of detail.

The most important reliefs are architectural friezes and metopes, and some gravestones have an equal quality, particularly those from Athens, where carved monuments of this kind reappeared

about 440. Their shape is now broad enough to take two or three figures, normally posed in some quiet domestic scene and suggesting by face and attitude no more than sympathetic resignation: Plate 56 shows a later Attic gravestone, deeper in its relief and more directly emotional in expression. Votive reliefs too become common, dedicated by private individuals to personal and often minor divinities; they are mostly of inferior workmanship, though already a few are interesting for their imitation of the three-dimensional effects of painting. There are also the small reliefs occasionally heading the texts of a public decree, but their style – sometimes old-fashioned – is usually perfunctory.

In the main High Classical reliefs follow free-standing statuary, with of course a wider range of poses for scenes of battle or other vigorous action. Sometimes these poses have an exaggerated violence, though except in old-fashioned work the face regularly remains impassive; and sometimes, as on one of the metopes of the Parthenon (*plate 51b*), even the poses have a studied calm. For quiet compositions there are excellent examples at the east end of the frieze of the Parthenon (*plate 51a*), which was carved around 440, just after the metopes, and contrasts illuminatingly in the treatment of seated figures with the Archaic onlookers of the Siphnian Treasury (*plate 44a*). Here, as is usual in good Classical reliefs, the fully profile pose is avoided and further variety is given in the dress; one may note the bunching of material across the lap of the god at the left, a device used more emphatically on seated statues. A naturalistic detail, surprising alongside the formal arrangement of folds, is the selvedge of the hem below the left elbow of the turning figure. The relief of Nike undoing her sandal (*plate 53*), one of nearly fifty representations of that goddess on the Nike Balustrade at the south-west corner of the Acropolis of Athens, is a consummate illustration of High Classical artifice. The graceful and carefully revealed figure is extended in a pose that in nature is ungainly and precarious, but the design is held together by the looping catenary folds and stabilized by the weaker vertical folds of the undergarment which reach to the ground and appear to give a firm support. For historical reasons the Nike Balustrade should have been carved between 425 and 405, but anyhow its style looks more assured than the Nike of Paionios.

On the slab from the Parthenon frieze (*plate 51a*) the four deities are to be considered as sitting side by side and the complete

composition of the east part of this frieze denies depth in space still more determinedly, with groups of figures to be aligned – for the interpretation of the subject – in three different planes. This denial of depth is regular in Classical sculpture, except on some minor products – votive reliefs for Greeks and grander monuments commissioned by non-Greek patrons. With the same exceptions landscape elements (compare Plate 57a) are rare, except for rocky seats and less often an undulating ground line for a battle; but even in 'pictorial' reliefs these accessories are used mainly to indicate setting and not in their own right. Serious Classical sculptors regarded figures in relief as flattened statues rather than as cut-out paintings and, low though their relief is, it would not need much adjustment to convert the seated gods or the Nike of Plates 51a and 53 into creditable sculptures in the round.

In Etruria the High Classical style was too subtle and difficult for the local craftsmen and had little effect. In Lycia native poten- tates had employed Greek sculptors since Archaic times, often dictating the themes and sometimes in consequence the composi- tion of reliefs: so the limestone frieze of the Heröon of Gjölbaschi (or Trysa), carved probably between 420 and 410, includes the storming of a town, with walls and buildings behind them – some- times in partial perspective – and figures at various levels. Further east in Phoenicia there is among much else some Greek work of better quality and excellent preservation, especially from the burial vaults of the kings of Sidon: even in their old and alien culture the artistic superiority of High Classical art had now been recognized.

High Classical sculpture became at once 'classical', and during the next three centuries had a fluctuating influence on its succes- sors. In the late second century a fully classicizing style appeared, which adapted or repeated the old formulas and sometimes so skilfully that Classicizing productions have passed and no doubt still pass for genuine works of the fifth century. At the same time straight copying too became an industry, which lasted till the fourth century AD or even longer, but the quality is not usually better than mediocre. Many of these copies came to light again from the later fifteenth century on, but since they rarely trans- mitted the quiet subtlety of the High Classical style the painters and sculptors of the Renaissance turned rather to the more

dramatic statuary of the Hellenistic period, and it was not till 1807, when Lord Elgin exhibited in London his collection from the Parthenon, that the quality of High Classical was recognized and almost universally appreciated. For sculptors this was too late for any effective influence, though Canova (the chief exponent of the then fashionable Neoclassical style) regretted that he had been born too late to profit by the revelation and casts were bought widely by Art Schools for their students to draw, as some still do. The critics too were impressed and paid at least lip service to High Classical sculpture, until in the present century the more modish of them found its character too naturalistic or too florid and saw more virtue in its provincial products, such as the Dying Niobid in Rome and especially in views not originally intended.

The Late Classical Style

Till the end of the High Classical style the development of Greek sculpture had been mainly uniform. Afterwards, because of the success of that style, even leading masters tended to look back to it as a sort of standard, repeating its formulas in varying degree and making equally selective use of the innovations of their contemporaries. Since also there are few usefully dated originals or copies either, the history of the Late Classical style has not yet been worked out in convincing detail and students disagree widely on the chronology and assessment of important pieces. In general it looks as if the High Classical tradition remained dominant till the 370s, sometimes fairly pure and sometimes in a mannered exaggeration (as in the drapery of the woman on the right on Plate 57b), but later new trends asserted themselves more insistently. These trends were not ubiquitous nor were they all combined in any one work, but on the whole their direction was towards a closer imitation of nature in flesh, facial expression, drapery and pose, though the requirements of ideal art were not forgotten. The end of the Late Classical style is usually put at the death of Alexander the Great in 323, but the most significant changes may have occurred some thirty or forty years earlier and perhaps the conventional periods of Greek sculpture ought to be revised.

By the end of the fourth century, so Pliny says, some sculptors

were taking plaster casts from human models, but advances in superficial anatomy had of course been appearing earlier. The Aberdeen head (*plate 61 a-b*), which should not be much later than 350, is an admirable example of a successful new type. The face has become rounder and the flesh is more delicately and credibly modelled, so much so that one might expect the cheeks to quiver if the statue was shaken; the eyes are more deep-set, the lower eyelid merges imperceptibly into the cheek, and the brow above is padded comfortably with fat; the lips are slightly parted; and the hair is tousled and more deeply carved. The effect, though still ideal, is softer and more sensuous than that of any fifth-century face, and the expression suggests an intensity of feeling that High Classical sculptors would have thought embarrassing. The Marathon Boy (*plate 58*) is also softly modelled, though – partly because of its material – less palpably than the Aberdeen head, but here the treatment of the body can be studied; while the linear definition of the parts is still clear, the transitions between them are smoother and more fluid. Yet in other figures of this period the modelling of bodily forms keeps an old-fashioned emphatic firmness (*plate 57b*). For a movement away from naturalism there is the Apoxyomenos (*plate 59*) or the grave relief from Rhamnus (*plate 56*), where a new canon of proportions makes the head noticeably smaller, one eighth instead of one seventh of the total height of the figure: the aim like that of the Berlin painter more than a century earlier (*plate 20*) was greater elegance.

Drapery in the early fourth century continued much in the High Classical manner or even more so. Again new formulas had become established before 350, though they did not completely replace the old. A favourite system is a series of strong folds radiating from the armpit or the hip (*plate 56*) and this may be combined with a bunching of material around the waist (*plate 57b*, left), sometimes so emphatically that the figure seems composed in three sections. As a result the dress, even when closely swathed, often becomes more or less independent of the body, concealing it instead of combining to produce a unified effect (compare for instance Plate 57b, left, with Plate 53). Another novelty is a higher girdle, which like the smaller head has an effect of elegance. For natural detail there is more use of casually interrupted folds and some of crumpling (*plate 57b*, left), and occasionally to show his virtuosity a sculptor even recorded the creases

made in a garment by folding it up; but at least in major works the new masters did not lose sight of the general composition and they still found use for the devices inherited from the High Classical style.

It is much the same with the poses. Alongside High Classical survivals (*plate 57b*, middle) there are new developments from the old types. So the standing figure may be more indolently relaxed, with the median line making a stronger double curve (*plate 58*) and its balance sometimes is so far displaced that – at least for optical equilibrium – it needs a pillar or other support to lean on. Or the figure may stand stably upright, but the feet be placed to give an effect of shifting movement instead of stable poise (*plate 59*). The arms too are often extended more loosely and the head turned further to the side (*plate 58*). Such modifications of stance and gesture sometimes contravene the principles of the four-square construction of a statue and before the end of the fourth century some sculptors appear to have been planning deliberately for more than the four cardinal views (*plate 59*), if still with very limited success.

In studies of Late Classical sculpture three masters are usually picked out for special attention. Scopas, whose activity began before 350, is supposed to have invented the new intensity of facial expression, though the evidence is not decisive. Of Praxiteles we know more, since copies of several of his works have been identified convincingly. He was working around the middle of the century, especially in marble, and had a taste for soft modelling, more appropriate to that material than to bronze, and for indolent poses which were designed for frontal (or posterior) viewing; Plates 58 and 60c-d reflect his style, and 61a-b might even be by his hand. He also sanctified the female nude as a subject for free-standing statuary and so became for later antiquity the most celebrated of all sculptors. His type of female face with triangular forehead (*plate 60c-d*) remains standard in later Greek and Roman ideal sculpture. Lysippus, whose long working life had begun by the 360s and lasted for at least fifty years, has been credited with all sorts of inventions; the supposed copies of his works are not so impressive or illuminating, except that the Apoxyomenos (*plate 59*) shows the new canon of proportions attributed to him by Pliny and an early stage in the creation of the omnifacial statue – that is the statue which offers a satisfactory view at any angle.

In the carving of marble two labour-saving advances were made. The running drill (see p. 77) was coming into use by the 370s and soon established itself for hollowing folds and sometimes – at first discreetly – for cutting a channel round figures in relief, so outlining them more sharply against their background. Further, about the middle of the century, some sculptors took to leaving the rasp marks on the drapery of both statues and reliefs and so obtained a quite novel contrast in the texture of surfaces; but this practice never became regular. For the colouring of marble our direct evidence comes from reliefs and may not be altogether valid for free-standing statues. On friezes of the Mausoleum, carved in the 350s, the background was blue and male flesh brownish red, all in the High Classical tradition. On the other hand the Mourning Women sarcophagus from Sidon, of much the same date, had the background unpainted, and on a big Athenian relief of a Negro and a horse, which should not be much later, the horse as well as the background seems to have been left in the natural colour of the marble; in these works, which were not architectural, there may well be more influence of pictorial art, where a white ground was still usual enough. The background is again unpainted on the so-called Alexander sarcophagus, also from the royal vaults of Sidon and dated around 320; here the male flesh is only lightly tinted and animals too are tinted or left unpainted, drapery is in flat colour – violet and red in various tones, yellow and some blue – but high lights are added in white on the pupils of eyes and the curved reflecting surfaces of shields. Something of this sort might be expected on free-standing statues too, if Pliny is right in his statement that Praxiteles had several of his marble statues coloured by Nicias, one of the great picture-painters of the time.

As has been said, there are not many useful fixed dates for Late Classical sculpture. The gravestone of Dexileos at Athens should not be long after 394, when Dexileos was killed. The 'Irene and Plutus' (or 'Peace and Wealth') of Cephisodotus, if rightly identified in copies, may have been made soon after 375, when the cult of Peace is said to have been recognized officially in Athens: it is anyhow a statue still High Classical in pose and drapery. Of the sculptures of the Temple of Asklepios at Epidaurus, which also are largely High Classical in style, inscriptions tell us that the work was completed in under five years, but not which those years were: still its architect also worked on the Mausoleum at

Halicarnassus, built probably in the years round 353, when Mausolus died. The Temple of Artemis at Ephesus was burnt down in 356, and so the carved column bases of its successor must be later, though perhaps by no more than five or ten years. The Daochus group at Delphi was pretty certainly put up between 339 and 334, when the donor held office there. The Alexander sarcophagus was beyond reasonable doubt made for himself by King Abdalonymus of Sidon, who had been appointed by Alexander in 332 and presumably died not long after 323. Other closely dated monuments, particularly the reliefs on slabs recording Athenian decrees, are not of a quality or character to allow reliable comparisons; nor are there helpful contexts from excavation.

Of original Late Classical works most are again 1eliefs – architectural, on gravestones or votive, though the two last classes are mostly poor in quality. A few fragments from pediments survive and a number of fairly complete free-standing statues (some of them made for architectural settings) and also several good heads. Copies are numerous, but not altogether representative: athletic statues in particular are comparatively few, presumably because the later purchasers of copies preferred High Classical versions of the type. There are also four or five good originals in bronze.

Standing male nudes differ widely. The Hermes of the column base from Ephesus (*plate 57b*, middle), which can hardly be earlier than 350, follows such High Classical models as the Doryphorus (*plate 49*) both in pose and in structure of the body, though the face is softer and more yearning. The Marathon Boy (*plate 58*), usually dated about 340, is more progressive. It is an original bronze four feet three inches high, which was fished up from an ancient wreck off Marathon, and is still designed with an emphatically frontal view; but the modelling is softer and the pose is more sinuous, so that the figure's centre of gravity falls near the slack right foot and its balance appears to be only momentary. The lateral sway is even more pronounced in other works of the time and often the figure has to have a support to lean on, a device occasionally used by High Classical masters, though more discreetly. This type of pose, so copies show, was exploited by Praxiteles and may have been his invention, but others used it too. What the Marathon Boy was represented as doing can only be guessed. Originally some object, at which he was looking, was

secured by a pin to his left palm, but the position of the right arm and of its fingers should also have some active intention.

The Apoxyomenos or man scraping himself (*plate 59*) is a mediocre marble copy, almost six feet nine inches high, of a presumably bronze statue of about 330 and perhaps by Lysippus. The dullness of the detail, which shows especially in the expression of the face, may be the fault of the copyist, but primarily the Apoxyomenos seems to be an exercise in composing a statue that is no longer dependent on the four cardinal elevations – front, two sides and back. This is done by extending both arms in a direction noticeably different from that of the trunk, so that it is not immediately obvious which view is intended as the principal one – from the front, that is, since there is no doubt at the back. To modern spectators the pose may seem purposeless and contrived; but originally the left hand held a strigil, a sort of long thin scoop of bronze with which athletes scraped themselves clean after exercise, and the Apoxyomenos is using it on his right arm. This is an obviously momentary, though balanced, pose and the position of the feet is in harmony. In its proportions the Apoxyomenos follows the new system, attributed to Lysippus, of smaller head and longer legs, so making the figure appear more elegant; and indeed, if one looks separately at the Doryphorus (*plate 49*) and the Apoxyomenos – or casts of them – the usual impression is that the Apoxyomenos is the taller, though by measurement – excluding the plinth – their height is almost exactly the same.

Sinuous poses are much rarer for standing statues of draped goddesses and women, perhaps because they would have disturbed the effects desired in drapery or from a prejudice against indolent attitudes in the female sex. The figures on Plates 57b and 56, though in relief, are typical for statues too – upright, four-square and with the slack leg pushed a little way out to the side. Generally the progressive Late Classical sculptors were more interested in the drapery than the body. Among minor works some small statues of 'Bears' (or young girls) from Brauron are curious as precocious essays in sentimentality. Draped male statues too usually stand erect, some – like the famous 'portrait' of Sophocles – with more than a suggestion of posturing; still to the Greeks it was an essential sign of good breeding to wear their untailored dress with correct formality and Sophocles, though a poet, was a gentleman.

From the Early Classical period onwards reliefs and figurines had occasionally represented the female nude, but it was not accepted as a subject for full-size statues till about the middle of the fourth century. Perhaps the first and certainly the most famous example was Praxiteles' Aphrodite of Cnidos, which Pliny, a knowledgeable if insensitive judge, described as the greatest statue in the world. The original, which is known through copies, was of marble, about six feet nine inches high, and designed to be seen only from the front and the back. The goddess stands upright and quite naked, with thighs together and the slack left leg slightly turned out; the left arm is dropping her clothing onto a water jar, the head is turned to the left, and the right hand is brought across in front of the pudenda – a gesture that from repetition now seems prudish or banal, though here there is no hint of self-consciousness. Unfortunately the numerous copies are too poor to show the quality of the treatment of surface detail, which must have given the original most of its sensuous effect. The Cnidian Aphrodite fixed the sculptural canon for the Greek female nude, with mature figure and, to the anatomist, startlingly immature breasts – in these particulars following earlier Greek tradition – but there was more variation in the pose. An early byform was the half-naked figure, where the drapery has slipped down almost to the groin; this allowed contrast of texture and perhaps freer movement of the legs without offence to current standards of decency. The Leconfield head (*plate 60c-d*) comes from one of these naked or half-naked figures. It is life size, of Parian marble, and probably an original – even, some claim, a late work of Praxiteles himself. Certainly the grave, calm expression, which avoids both the sensual and the sentimental, is characteristic of that master; so too, though not peculiarly, are the soft modelling and the impressionistic treatment of the hair.

In seated statues, which are more frequent than before, the tendency is to make the pose more casual, by stretching one leg further forward and tucking the other further back or raising it to nurse the knee: the Dionysus on the Derveni krater (*plate 73*), with his leg on his consort's lap, illustrates the new mobility, though with an abandon not yet tolerated in statuary. There are also figures tilted forward in running or attack, and Maenads and other dancers caught in more ecstatic movement (compare Plate 73, on the right). Groups, though still rare, are more compactly

planned; a god balancing an infant on one arm is not much more than a single figure with an adjunct, but in such works as Leda protecting the Swan or Ganymede carried off by the Eagle the two components are fully complementary. These last two subjects (appropriately still under life size) exude a new, mildly erotic flavour, as does Eros (or Cupid) who is now coming to be represented as a child rather than a youth – another sign that a more trivial taste was beginning to find expression in a major art.

Portraiture at last established itself as a distinct branch of sculpture. In the Archaic period kouroi and grave reliefs, as their inscriptions show, had often represented particular individuals (*plate 39*), but without any pretence of reproducing the individual particularities of their appearance, and Early and High Classical 'portrait' statues were still stock ideal types, though since the range of types was greater some generic characterization was possible. So Pericles appears as a calmly confident soldier, mature enough to wear a beard, and the poet Anacreon is a robust old gentleman, accompanying himself on the lyre – appropriate but impersonal embodiments of their public reputations. This was not because Greek artists of that time were unable to produce a likeness or at least plausibly individual features (*plate 69g*), but perhaps there was a feeling that to exhibit in public the facsimile of a living man might be dangerous arrogance and anyhow the tradition of ideal art was pervasive. For the same reason – that they were standard ideal types – Greek portrait statues remained full-length, although sculptors and their clients were used to the representation of heads without bodies, as for instance on herms: it was left to the Romans to establish the bust as a normal vehicle of portraiture, a sensible reform when it had become difficult to provide a suitable body for a head which stressed the ravages of age or disease.

During the fourth century, as portraits multiplied, the idealized likeness began to compete with the ideal type, but though ancient writers mention sculptors who aimed at strict imitation of nature or emphasized ugly features, most were concerned more with characterization and for athletic statues and grave reliefs impersonality was still regular. By the accidents of Roman taste we have a disproportionately large number of copies from portraits of celebrities of philosophy and literature, some living when the original was made but others long dead; and since there is no

obvious difference in credibility between the two classes, it seems that characterization was usually more important than fidelity to physical appearance. The portraits of the great Attic tragedians – Aeschylus, Sophocles and Euripides – convincingly incarnate the characters we may deduce from their writings and the anecdotes that survive about them; but since the last of the trio died in 406 and the statues were not made till the 330s, this only shows that the sculptors made the same deductions as we do. Indeed one might argue that the closer a portrait agrees with our impressions of the subject's personality, the less likely it is to be true to life. Statues of philosophers were usually seated, as if engaged in teaching, but political figures preferred to stand – a more heroic posture – and usually required a more ideal treatment. So the various heads of Alexander have in common an intensity of expression and a wildness in the hair, presumably demanded by the sitter, but otherwise conform less to a single physical pattern than to the particular sculptor's ideal style. A life-size original bronze head from Olympia (*plate 61c-d*), recognizable by the cauliflower ears as a boxer's, can serve as an example of Late Classical portraiture. Compared with the Aberdeen head (*plate 61a-b*), which should be of much the same date – not much after the middle of the century – it is evident that ideal beauty has been replaced by attentive ferocity and the features have become appropriately coarser; note, as one example, how the eyebrow makes a sharp angle with the nose instead of passing into it in a continuous curve. Some students think that this boxer's head comes from a statue of Satyros by Silanion and it is possible, since Silanion was famous for thoroughgoing characterization: how like Satyros it was we have no means of knowing.

Pedimental sculpture and architectural reliefs show in their composition no advance on their High Classical predecessors. In style they follow the various major trends of their time and their quality is often excellent. Plate 57b illustrates a carved column base from the new Temple of Artemis at Ephesus, which was begun soon after 356. The figures, about five feet nine inches high, are instructive. Hermes, recognizable by his herald's staff, in his anatomy and pose is a High Classical type, reminiscent of the Doryphorus (*plate 49*) but with a modernized treatment of the eye and mouth; the woman on the right is also generally High Classical in style; but the other woman's drapery has a new system of folds

and details. On other bases of this temple the subjects include a more active scene where a woman lunges away from a fallen man and an ineptly composed row of upright figures. Evidently the sculptors who carved different bases had a fairly free hand in their design.

Grave reliefs in the fourth century supported a flourishing industry, anyhow at Athens. There some inferior craftsmen specialized in this line of work, though occasionally a leading master might accept a commission. The normal shape for these gravestones was an upright oblong (as Plate 56), framed by antae and a low pediment, and the subjects were mostly stock – the lady of the house with a slave woman in attendance, the deceased and members of the family in poses of farewell, or relatives gazing intently at each other (*plate 56*). The trend was towards deeper framing and figures more fully in the round, so that they appear like statues in a little porch, though those in the background are sometimes added in incongruously low relief. This neglect of artistic propriety, judged by ideal standards, appears also in increasingly blatant displays of emotion and naturalistic representation of drapery, especially where the workmanship was of lower quality. Here at last, with sculptors of weak principles, private customers were able to assert their personal tastes, but even so there was no attempt at portraiture; for this incapacity is a sufficient reason, and of course gravestones were often sold from stock. The Attic series ended abruptly between 317 and 307, when a sumptuary law prohibited such expensive monuments. A gravestone from Rhamnus (*plate 56*), near the northern frontier of Attica, is one of the latest, but of unusually high quality and of course restraint. The elderly husband looks with quiet and bewildered sadness at his lost wife, the style is that of major sculpture and the composition is unified by the direction of the eyes more than the contact of the now missing hands.

Votive reliefs too are mostly from Attica, where they were usually made in specialist workshops according to special conventions. The subjects range from the dedicator with his family being received by his divine patrons, at least half as tall again as ordinary mortals, to Pan and other rustic presences manifesting themselves on a rocky hillside. Generally, though, the landscape and architectural elements – such as rocks, trees and shrines – are still no more than required to give the setting of the subject. For this

Plate 57a, though not strictly a votive relief, may serve as an example. The subject here is the fate of the pirates who seized Dionysus, were attacked by Satyrs and turned into dolphins, and the scene is set on a rocky shore. This relief, of which the illustration gives about a fifth, is the frieze of the Choregic Monument of Lysicrates at Athens (plate 87), erected within a year or two of 334, and is only twenty inches high. Votive reliefs were at their best in the late fifth and early fourth centuries, but their style soon became feeble, sometimes resorting to Archaistic details, and at Athens they had become rare by 300: by then perhaps dedicators thought pictures better value for their money.

The novelties of the Late Classical style were welcomed in the Greek cities of South Italy, where the local workshops tended to provincial exaggerations. They penetrated also to Etruria, whether by direct contact with Greece or through South Italian inter- mediaries, but there the influence was only sporadic. In Lycia Greek sculptors were even more active than before, still working to suit their patrons' aberrant tastes, and in Phoenicia the demand for truly Greek work increased. Carthage too, the Phoenician colony which dominated much of the western Mediterranean, began to imitate Greek sculpture more assiduously, though the local craftsmen, some of them presumably immigrant Greeks, were provincial in style and often compromising. From there, or perhaps more directly, the natives of Spain learnt a little of the art of sculpture.

Much of the Late Classical tradition was continued by Hellenistic sculptors and, though the Classicizing school of later Hellenistic preferred fifth century models, the copyists were not so discrimi- nating. Indeed in the Roman period Praxiteles was the most admired of all ancient sculptors. In modern times no important original became known till the nineteenth century and, though copies were fairly common, they did not make much impression on Renaissance and later artists and connoisseurs. The chief excep- tion is the Apollo Belvedere, a marble copy of fine but hard quality from an original of perhaps around 330. This statue was found at the end of the fifteenth century and exhibited in Rome, where for three hundred years it ranked as a supreme master- piece, which painters and even sculptors continually used as a model. Then the revelation of the Elgin marbles dimmed its repu-

and in this century it has been either despised or ignored. Even so, though there is now original sculpture of the fourth century with which to compare it, the Apollo Belvedere is more than an accomplished exhibition of ideal elegance, if one can forget one's own or others' prejudices.

The Hellenistic Styles

The Hellenistic period, which stretches from Alexander to Augustus or for conventional precision from – say – 323 to 27, fills a span of time nearly as long as that of all earlier Greek sculpture. Since it was no longer in fashion when serious academic study began and is also bewilderingly diverse, its course is much less understood. At the beginning there was some continuation and development of Late Classical trends, in the middle the so-called Pergamene school shows an originality that may loosely be described as baroque, and towards the end a Classicizing movement became strong; but these distinct styles are not confined each to one part of the period and there is much more that has to be fitted in. Nor can the confusion be explained away by different local traditions: although Athens, it seems, tended to be conservative and at Alexandria some use was made of stucco, a material which invites soft modelling, still sculptors travelled as much as or more than before and Athenians, for example, could work in the full Pergamene style. 'Pergamene', incidentally, has here a stylistic and not a local sense. The Hellenistic kings of Pergamum, who grabbed much of western Asia Minor, were patrons of sculpture, collecting old works and commissioning new ones; and the style of the most famous of their new monuments has been called after them, though that style was not peculiar to Pergamum nor the only style fostered there.

Subjects were as diverse as styles, and the extremes of the Laocoon (plate 68) and the sitting Boy with a Goose (plate 63a), one a demonstration of heroic agony and the other of sentimental innocence, do not give its full range. Traditional figures of deities and athletes continue. There are realistic studies, straight or comic, of lower class life – the old fisherman, for instance, or the drunken old woman – of ethnic types, of Satyrs and other sub-human creatures, and even of animals. Personifications, as of the

Muses, become commoner. Coy, playful and erotic figures (including the young hermaphrodite) cater for other tastes. Portraiture flourished more freely. This enlargement of the sculptor's repertory and aims is often said to reflect the spiritual changes that followed Alexander's conquest of the Persian Empire: big centralized monarchies superseded independent city states, the centres of power and wealth shifted from European Greece to the new capitals in Asia and Egypt, old notions of political equality gave way to a more rigid stratification of classes, and ordinary people turned from civic to personal interests. Yet there is no reason to suppose that the course of Greek sculpture would have been much different if the old order had continued. The Hellenistic rulers were determined for political reasons to spread traditional Greek culture, in Greece itself the city states (which still kept considerable autonomy) looked conscientiously towards the past, and sculptors had a bigger market for their work. Nor does it seem that demand for sculpture in private houses affected the creation of new types and versions. The Boy with a Goose (*plate 63a*) may look as if it was designed specifically for domestic enjoyment. Yet according to Herondas, who was writing in the first half of the third century, a statue at least of this type was on view in a sanctuary of Asklepios; and around 100 the statues fashionable in houses on Delos included copies of reputable old masters. A style as confident and powerful as that of Classical sculpture is likely to have had its own momentum, and the Hellenistic styles can be explained as proceeding from the Classical tradition by evolution or reaction. After all, tendencies to naturalism, expression of emotion, and sentimentality are visible already in the fourth century.

Whatever one may think of the aesthetic value of their products, the leading Hellenistic sculptors were more accomplished than their Classical predecessors and added substantially to the knowledge they inherited. They improved the understanding of anatomy, both in the detailed configuration of the surface of the body and also in its response to tension and relaxation, but this understanding was used selectively according to the subject and character of the work. In the late fourth and early third centuries the followers of Praxiteles achieved an even softer modelling of flesh (*plate 62a-b*), which continued to be a favourite technique where sensuous or sentimental effects were wanted – for instance in female nudes, hermaphrodites and small children. Other early

Hellenistic sculptors concentrated on the type of the athletic male as remodelled by Lysippus or his contemporaries (*plate 59*) and, though they kept the lean forms and the leathery appearance of the skin, sometimes enlivened the effect by a dose of pathos: this type, of course, remained useful for commemorative nude statues of victors in the games, of heroized princes and notables, and even of private individuals, though later on there was competition from a revived Polyclitan standard (of the type of Plate 49). Another trend which developed in the early third century was towards a dry unclassical style that relied for emphasis on linear design rather than modelling, but this was more suited to drapery and portrait heads (as Plate 62c-d) than to naked bodies. More ambitious was the attempt to reuse old Classical forms and devices for violently dramatic effects, most notably on the main frieze of the Great Altar at Pergamum (*plate 67*), where on some of the torsos the musculation looks like a kind of cuirass. This Pergamene style had its beginning well back in the third century, but blossomed in the second and, to judge by the Laocoon (*plate 68*), was still practised in the middle of the first. For cult statues of gods Classical types had always had a continuing influence and finally, in the later second century, a reaction set in and many sculptors turned back to works of the fifth and fourth centuries as models of correctness, sometimes with a freshness of effect that may seem improper in derivative art (*plate 65*).

In the rendering of anatomy Hellenistic sculptors did not often escape from Classical formulas, since these were already fairly true to nature and there was no need to make a fresh start. Nor did they alter the systems of proportions for the male figure, though soon an alternative female canon was accepted, with narrower shoulders, higher waist and broader hips. In drapery there was more radical change. Here High Classical sculptors had worked out a system of devices which elucidated the forms and action of the body but, while optically effective, did not conform closely to nature; and this system remained valid in the fourth century, in spite of tendencies to arrange folds more naturally and to give the drapery importance in itself. These tendencies were taken further by some early Hellenistic sculptors, and there seems even to have been a deliberate rejection of Classical standards, perhaps more for novelty than from artistic principle. In a favourite scheme, still popular in late Hellenistic statuary, the female figure is

dressed in a chiton, often hiding the feet, and a fine tightly stretched cloak which runs diagonally from below one knee to above the other, is gathered in at the hip, and either rolls up across the waist or chest or – more often – covers the shoulders and sometimes the head as well. This cloak is patterned with thin sharp ridges, in part radiating from the hip, in part erratic and casually interrupted; and if there is a roll, it is usually narrow and twisted like a rope. In contrast the folds of the chiton are mostly close and vertical and, with a dexterity that becomes hackneyed, they are prolonged to show, suitably a little blurred, through the cloak that covers them. The Baker figurine (*plate 63b-c*) gives an idea of the new effects and, though because of its small scale the linear pattern has been simplified, it is obvious that drapery here exists in its own right without much relevance to the bodily forms it conceals. At the same time a basically Classical tradition persisted, especially in statues of gods. This tradition was reused eclectically by sculptors of the Pergamene style (*plate 67b*–Night) and revived with more fidelity by the Classicizers of the later second and the first centuries.

The Classical masters had preferred to suggest emotion by simple gestures and, though by the middle of the fourth century some intensity of aspect was allowed, it was left to the minor craftsmen who carved grave reliefs to show faces contorted with grief. Hellenistic sculptors had other standards. In work of traditional character they kept the old impassivity, but where the aim was naturalistic or dramatic they enjoyed their virtuosity. Pain, fear, pleasure, amusement, drunkenness, lassitude, sleep and death were within their range by the second century, so too were all the gradations of age and, when they wanted, they could produce plausibly differentiated racial types. Plates 63 and 66 show some of the new inventions; in Plates 67 and 68 one can see also some reminiscences of the Classical, where the effect is made more spectacular by the deeper cutting of drapery and the rich but decorative disorder of the hair; and on Plate 65 there is a partial return to Classical forms. As might be expected, portraiture became more vivid, though of course some regard for dignity was usually expected by the customer.

The wider range of subjects needed a wider range of poses. So there appear sprawling, crouching and lying figures; for upright figures momentary or trivial attitudes become more usual; and in

the Pergamene style violent contortions were welcomed (*plate 68*). Many of these poses had been used by Classical or even Archaic sculptors in pediments, but not in free-standing statuary, where the standard of decorum had been strict. Groups too became commoner and more systematically designed. But the most radical innovation was in composition. Classical statues had normally been constructed from a front and a side elevation, so that they presented four distinct principal views; and though during the fourth century there was some tentative variation of the strictly frontal view, as in the Apoxyomenos (*plate 59*), this was managed primarily by the placing of the arms. Hellenistic sculptors thought more deeply. Their first solution was to give a spiral twist to the figure, so that from any point of view some important part of it appeared more or less in frontal or profile elevation (as in Plate 63b-c, though here the twisting of the body is masked by the drapery). Yet effective as it is, so strong a twist is not easily justified, if one expects the action of a statue to have a logical purpose; dancing and fighting offer satisfactory reasons, but for some spiralling Hellenistic figures the only excuse is flippant, as in Aphrodite lifting her skirt to contemplate her bottom or the young Satyr who tries to inspect his tail. By the beginning of the second century a more sophisticated formula had been found, by which the spiral is reversed or stopped at the waist: of this the Venus di Milo (*plate 65*) is the most famous example. Still, at all times most Hellenistic statues were designed in the old way, with emphasis on the frontal view.

The Classical revival of the later second century not only produced new interpretations and adaptations of Classical forms, such as the Venus di Milo (*plate 65*), but led also to an industry of copying that lasted till the fourth or even the fifth century AD. From the Archaic period onwards duplicates had been made, like Cleobis and Biton (p. 95) and the Penelopes (p. 118); but the habit of reproducing masterpieces of the past seems to have started in the early or middle second century, when the kings of Pergamum, who were the first great collectors of works of Greek art, supplemented the acquisition of earlier originals by commissioning copies. Their example was followed by private individuals, including many Romans and Italians, who were in sympathy with the Classicizing trend but hankered after old masters. The copies found at Pergamum, even when in spirit fairly true to the

originals, render detail freely and in a contemporary manner and were evidently carved by sculptors capable of independent work; but later a more mechanical style and technique became regular, with craftsmen working from a master copy. Master copies could be made either from memory and sketches, as must have been those of the cult statue of Athena in the Parthenon; or, if the original was accessible, moulds might be taken from it, whether partial or complete, and casts made from the moulds. For copies in bronze this system could, by recasting, provide exact replicas of the original, apart from the cold work after casting, and for that reason it is difficult or impossible – and probably unimportant – to distinguish by style between an original and a good copy. For marble copies a pointing process was in use by the early first century. The copyist set up an open framework round his model and an identical one round the block he was working on, measured the distance from the framework of chosen points on his model and again by measurement marked their position on or in his block, and then carved by eye the surfaces between the points, more or less completing one part of the figure before going on to the next. Since ancient copyists used far fewer points than their modern counterparts, the accuracy of the detail was less, though usually without any gain in quality. There are a few fine marble copies (such as Plate 60a-b), but most are hackwork, harshly neglecting all subtleties in the modelling of the surface. Presumably for cheapness bronze originals were often reproduced in marble, with some consequent adjustments. Since the lashes of the eye cannot be carved in marble, the edges of the lids were made heavier, tufts of hair tended to be flattened, and probably the musculation was given higher relief. Possibly too some poses were modified, though the copyists were free enough in their use of struts and stumps, as much for safety in transport as to give stability to the figure or to prevent outstretched parts from breaking by their unsupported weight; the Doryphorus of Plate 49, a very fair copy from a bronze, would balance without the tree trunk. To judge by the location of their originals and by the kinds of marble that were used, most of the earlier copies were made in Greece and the Aegean, particularly at Athens.

Hellenistic sculptors made no change in the technique of carving marble, except for the new procedure for working from a model, which may in the first century have been used for some original

works as well as for copies. At its best the standard of finish was still equal to that of Classical work, though the marks of the running drill often show more obtrusively. With minor sculpture much more negligence was tolerated, in design as well as in execution, partly perhaps because the Italian and Roman customers, who were becoming important in the later second century, had little artistic experience or discrimination. For the colouring of marble there is evidence from sarcophagi and caskets (or 'urns') made in Etruria and Carthage and from Greek statues found in Delos and Alexandria. As might be expected, practice was not uniform; some sculpture was fully coloured, some more discreetly, and it seems that the two systems were concurrent. There was also more gilding of marble, especially for hair. In bronze statuary the only innovation claimed is that in some bronze portrait heads the features show the effects of modelling rather than of carving, and from this it has been inferred (but not proved) that a softer medium than before was used in the preliminary work.

We are short of fixed dates for Classical sculpture, but shorter still for Hellenistic. Nor have we as much information recorded about sculptors and their works, since Pliny leaves a gap in his account between 296 and 156, when he says the art was in abeyance. The Tyche (or Fortune) of Antioch, of which we have three miniature versions, should have been made very soon after the foundation of that city in 300. The marble statue of Themis from Rhamnus, an original work of Chairestratos, son of Chairedemos, may be put in the late fourth or early third century, if (as is likely) it was the sculptor's father who is mentioned in an inscription of 315. The posthumous portrait of Demosthenes, of which copies have survived, was made around 280, according to literary sources. A sitting boy with a goose, of which Plate 63a shows what may well be a copy, was described by Herondas in the first half of the third century. The seated Dionysus from the monument of Thrasyllos at Athens ought to be a dedication for a victory in the dramatic festival of 271. The Nike of Samothrace (plate 64) was set up about 200, to judge by pottery found round its base, and some fragments of pedimental sculpture from the same island have been dated, also by pottery, to the later second century. Delos had a sudden prosperity after 166 and still more after 146 and was sacked in 88 and ruined finally in 69, so that much of its sculpture can be dated to the late second or early first century and some of

it because of inscriptions still more closely. The sculptors of the Laocoon (*plate 68*), unless there was an improbably complex repetition of names, were (so inscribed records show) well known by 21. Finally portraits cannot be earlier than their subject, if he or she can be identified, and often may be contemporary; but this is more useful for portraiture than for sculpture generally. A little help, especially for draped female statues, can be got from comparisons with terracotta figurines found in datable contexts, and there is some vague utility in the style of lettering on bases of statues and for architectural sculpture in the style of the buildings they adorned. All considered it is not surprising that at present experts may differ by a hundred years or more in their dating of particular pieces, and because of the character of much Hellenistic production it would even be suspicious if there was ever full agreement. This may too be a warning about those dates based on style that are given in the next few pages.

How representative our remains are of Hellenistic sculpture is hard to guess. We have a fair number of original statues, mostly mediocre in quality and concentrated in the later part of the period, but copies – some themselves Hellenistic – make a useful supplement. Portraits too are numerous and include important originals, but the copies mostly show the philosophers popular in later times. Reliefs of high quality are rare, perhaps less because they were not produced than because they were not copied, and of pedimental sculpture almost nothing important has survived.

Though still in demand for commemorative statues and images of gods, the standing male statue did not have as much interest for Hellenistic sculptors. Poses might be rather more informal, but the old four-square construction remained regular, except for such undignified subjects as Satyrs and representations of low life. The standing draped female offered at least the drapery to play with, though here the new formula soon degenerated into a mannerism. The Baker statuette (*plate 63b-c*), an original bronze just over eight inches high, is a fairly early example, if (as dated terracottas suggest) it was made around 230. The figure is almost completely enveloped by its dress, which flares out to cover the feet and imprisons the arms, and the bodily forms – of the new feminine canon – are only implied, though evidently understood. In full-size statues with this kind of drapery the pose is usually designed for a frontal view and so does not twist; it is also usually

more upright and compact, often with one arm folded across the breasts and the other bent above it with the hand near the neck, so narrowing still more the distance across the shoulders. Such statues were still being made for portraits in the late second century. By then Classical types, of which modified versions had never disappeared, were coming back into favour.

The Nike of Samothrace (*plate 64*) is an example of the selective use of Classical forms. This extraordinary work, an original of Parian marble and about six feet eight inches high, was set up on the prow of a ship carved in an inferior stone and projecting obliquely into an artificial pool among carefully disposed rocks. Because of its situation the Nike could be seen well, though at some distance, from in front and more closely along the left side, but the right side and the back were reckoned to be out of sight and so never finished: this explains the special care given to the appearance of the statue in the quadrant between the front and the left lateral view. The transition between these two views is made by a spiralling twist, though this spiral is in the drapery – in the heavy folds between the legs and the opposite system around the left hip – but the figure, if stripped, has a four-square construction. The forms of the body are fairly Classical, except for the breadth of the hips, and even in the drapery the High Classical devices of transparency, modelling lines and motion lines are used with skilful if in part only decorative purpose. A detailed comparison of the Samothracian Nike with the Nike of Paionios (*plates 54 - 55*) is worth making and does credit to both statues. On style it would be hard to date the Nike of Samothrace, but the context of the monument puts it near 200. In a generic way it may be classed as Pergamene.

The standing female nude or semi-nude did not offer much scope for novelty. The proportions might be made more feminine and the surface be treated more softly, but the range of action was small. The Aphrodite of Melos (*plate 65*) or, as it is better known, the Venus di Milo has become the most familiar example of the type. Of Parian marble and six feet seven inches high, it is an original in a Classicizing style and for stylistic reasons is usually dated towards the end of the second century. The anatomy is basically Late Classical – the face, for instance, may be compared with that of the Leconfield head (*plate 60c-d*) – and so too is the drapery, though there are discordances in detail; but the pose has a marked

spiralling below the hips and the statue offers satisfactory views from almost all round. Though a mixture of Classical and Hellenistic occurs also in the Nike of Samothrace (*plate 64*), the two figures are essentially different in style; one might put it that in the Nike Classical forms are applied to an original Hellenistic conception, but in the Aphrodite a Classical conception has been modernized by the use of Hellenistic novelties. Even so, it is a confident work of sculpture and to dismiss it offhand as an academic concoction is doctrinaire.

It is useless to generalize about the poses of Hellenistic statues, many of them twisting or contorted and unsuited to the Classical four-square construction. For instance the sitting Boy with a Goose (*plate 63a*) has an obvious front view, but because of the outstretched arm and leg and the compactness of the whole most of the other views are satisfactory. This piece, a copy in marble, is about twenty-two inches high and shows, perhaps too well, the sculptor's intimate understanding of the anatomy and expression of a small child. Here, where the Classical tradition offered no useful precedent, Hellenistic art must have made an initial study of living models, though once established the special forms no doubt passed into the sculptor's stock. The date of this piece, which looks very remote from Classical, may be surprising, since Herondas, who was writing (it seems) in the first half of the third century, described the original or a very similar marble statue as set up in some sanctuary of Asklepios. It was presumably a thank-offering for the recovery of a sick baby.

There is a very different spirit in the Dying Gaul (*plate 66*), once celebrated as the Dying Gladiator, and a marble copy of – fairly certainly – a bronze original rather larger than life. It is usually dated just after 228, since in that year the kingdom of Pergamum finished one of its successful wars against those Gauls who invaded Anatolia and gave their name to Galatia; but other occasions are quite possible. The figure is a careful blend of naturalism and artifice. The pose of the dying man, wounded under the right breast, is twisted enough for good views most of the way round and even from above and yet is credible as an expression of physical exhaustion. The anatomical forms too have an ideal nobility, though in the modelling of the body the old linear divisions have been blurred by smooth transitions, perhaps less because the sculptor was an exponent of naturalism than to make

the lassitude of collapse apparent in detail too: at least other male statues related to this, one of them perhaps from the same dedication, have a strongly marked articulation of the chest and belly. In much the same way the Gaul's nationality is shown by conventional features – the matted hair, the deep bridge of the nose, the moustache (which Greeks and Romans never wore without a beard) and more pedantically by such accessories as the torque round his neck and the trumpet between his legs, rendered faithfully enough for Celtic specialists to use as illustrations; but the nudity belongs to the ideal tradition of Greek sculpture and, as the sculptor must have known, was not regular Gallic behaviour. The Dying Gaul belongs to the early stage of the so-called Pergamene style, which is the most independently original branch of Hellenistic sculpture. How this style arose we do not know, whether by continuous evolution from the Late Classical style or as the invention of some gifted and studious master of the mid third century. Its subjects were not only heroic, but included for instance, dancing and sleeping Satyrs, treated with a competent grandeur; and in a broad sense the Nike of Samothrace (*plate 64*) may also be reckoned as Pergamene.

In the second century the Pergamene style, or one strand of it, became more impassioned and more eclectic. For this stage the main frieze of the Great Altar of Pergamum (*plate 67*) is the showpiece. The altar itself stood on a big square platform and the frieze, of a bluish, presumably local marble and seven feet six inches high, ran round the outside wall, reinterpreting through a couple of hundred figures the old subject of the battle between the Gods and the Giants. The sculpture is in very high relief and deeply undercut, so that the figures have almost the effect of statues in the round; and that evidently was the designer's intention, since where the wall returns to flank the entrance to the staircase some of the wounded Giants support themselves on the steps, so projecting from the frame of the frieze into the field of the spectator. As the two excerpts that are illustrated show, the style is fuller, more florid and less consistent than early Pergamene. The anatomical forms, while soundly observed, are often reminiscent of High Classical, but in a more decorative way; this can be seen in the details of the chest and the hair of the Giant attacked by a dog, though the modelling of his belly owes more to nature. In the drapery too Night exhibits High Classical motion and modelling

lines but arranged rather to produce a pleasing pattern of light and shade than to clarify the figure, while Artemis has a much more frankly Hellenistic treatment of the folds. For historical reasons, which are not conclusive, this frieze is usually dated between 180 and 160. The Laocoon (*plate 68*) should represent a further development from this style.

Groups, as distinct from sets of independent statues, had been rare in Classical sculpture, though (if one looks at the pediments of the Parthenon) not beyond its capacity. In Hellenistic with its wider range of poses and subjects and its willingness to abandon four-square construction, closely unified compositions of two or more free-standing figures became regular. Some are designed to be viewed from all round and are usually more or less pyramidal in structure. A good example, probably from the same dedication as the Dying Gaul (*plate 66*), is the early Pergamene group known as the Ludovisi Gauls: here the man turns round defiantly as he stabs himself, while his wife (whom, to save from captivity, he has stabbed first) slips down below him. This gives not only a logically and aesthetically adequate composition, but also an effective contrast in forms and attitudes between vigour and limpness. Such ingenious arrangements are, though, much less frequent than one-sided groups, which might have been conceived as reliefs to be cut out and finished in the round, if there were prototypes for them in Hellenistic reliefs. Most one-sided groups are of playful or decorative subjects, such as the familiar Three Graces, a trio of female nudes who stand elegantly with their arms round one another, alternately in front and back view; but a few are in a grander style, notably the Laocoon (*plate 68*), unless – as has been suggested – the elder son should be turned ninety degrees on his axis so as to have his back to his father. In style this group is related to the main frieze of the Pergamum Altar (*plate 67*), though looser and wilder in its principles. Laocoon himself is anatomically a creation of the late Pergamene stage, but his two sons, disproportionately small, seem to be adapted from athletic or youthful types of the later fourth century; and while the appearance of strain and agony is convincing, perhaps there is some preciosity in the curves of the contours and the median line of the principal figure. The Laocoon group, which is of marble and – curiously for its effectiveness – not more than life size, should be the masterpiece mentioned by Pliny as the joint work

of three Rhodian sculptors, who – to judge by inscriptions – were active about the third quarter of the first century; and though some students believe that the style of the central figure requires a date a full century earlier, we know too little of Hellenistic sculpture to assert that the Pergamene manner did not continue or could not be revived after that time.

Portraits range from the idealized to the realistic, from the fluently modelled to those where detail is emphasized by hard lines, and though some show the qualities of the Pergamene or Classicizing schools most of them cannot – anyhow yet – be dated by style. Hellenistic portraitists were much more ready than Classical to reproduce individual abnormalities of feature, but even in their most realistic pieces they tried to show the character of the sitter, emphasized the structure of the face and rearranged natural irregularities to form an artistically pleasing pattern. The head of Plate 62c-d, a life-size marble original from Athens, gives the impression of a faithful portrayal of an elderly man, but the deep lines on the forehead and cheeks seem to have been plotted for their aesthetic effect. The piece has been dated – on style – in the mid first century. By then, as finds on Delos show, Romans and Italians were commissioning portraits in Greece and, since their native tradition was for a faithful if superficial likeness, this may have influenced some late Hellenistic sculptors. Incidentally, the unfinished state of the cranium of the Athens head, which still shows the rasp marks, is not a stylistic device; either that part could not be seen when the statue was erected, or perhaps it was the bedding for a coiffure of stucco. The clean-shaven face is normal in portraits of Hellenistic men, other than philosophers; Alexander the Great had been unable or unwilling to grow a beard and the fashion persisted till the emperor Hadrian in the early second century AD restored the old custom that men did not shave.

Hellenistic sculpture has not much to show in the way of reliefs and the main frieze of the Pergamum Altar (plate 67) remains exceptional, perhaps better classed with free-standing statuary. In lesser reliefs landscape elements became more frequent; and though most of these had occurred sporadically during the Classical period, especially on votive plaques, they were used now with more regular skill. The effect, with trees in leaf and foreshortened buildings, is like a simple or simplified painting in low projection.

The most imposing Hellenistic landscape relief that we have is the Telephus frieze, which ran round the inside of the Pergamum Altar and should be of much the same date as the main frieze, that is perhaps about 180–160. Here the figures are set at varying levels and some of them reappear in different parts of the frieze. This 'narrative' system has been claimed as an important innovation, but from at least the beginning of the fifth century it had been used in sets of metopes for episodes in the careers of Heracles and Theseus, only now the divisions are – sometimes at least – marked by landscape features instead of triglyphs. The other notable class of Hellenistic reliefs is the Neo-Attic, so-called because the main place of their production was probably Athens. The Neo-Attic reliefs are often carved on ornamental objects, such as marble craters, and the subjects are meaningless processions of stock figures, some of them copied from Classical reliefs of the late fifth or early fourth century and others Archaistic creations with the mincing gait and swallow-tail drapery which even High Classical artists had somehow thought characteristic of Archaic. This purely decorative line of work must have begun by the early first century, since specimens have been salvaged from a ship which, as other contents prove, was wrecked at that time off Mahdia. As for pedimental sculpture, too little has been recovered to allow useful opinions on Hellenistic composition and aims.

In the Hellenistic period Greek art had a far wider geographical range than before and even less competition, since after Alexander's conquest of the Persian Empire the official culture of those regions became Greek and native forms of art, especially such expensive forms as sculpture, receded or disappeared. The one exception was Egypt, where the new kings – the Ptolemies – needed the support of the local upper class and let them keep up their old traditions: here Greek sculpture gradually affected Egyptian, but in return borrowed occasionally and for external features, such as ceremonial dress. In Asia, though the kingdom of the Seleucids lost ground, Greek art was still admired and was a more or less important constituent of the sculpture of the Parthians, who conquered Iran in the late third century and expanded into Mesopotamia; and the Greek element in the Gandhara style, which appeared in Pakistan in the first century AD, may have come from a Hellenistic tradition in the region of Afghanistan. At the

other end of the world Carthage and Spain continued their clumsy use of Greek models, and perhaps there were some very dilute influences on the natives of southern France. Central Italy is much more important. Here the Etruscans welcomed Hellenistic sculpture, with which they became acquainted probably through the Greeks of South Italy, and imitated it with varying competence; their most original development was in portraiture, where in a dry and usually superficial way they aimed at a strongly personal if not exact likeness of the subject's features. Meanwhile Rome, which though politically dominant had in art been an Etruscan dependency, was making direct contact with Greek civilization. During the third century the Greek cities of South Italy and Sicily came under Roman rule and in the second Greece and western Asia Minor, and large stocks of Greek statues and pictures were brought to Rome as the booty of war and peace. By the late second century too some upper-class Romans were finding Greek culture attractive and even travelling for higher education to Greece, while middle-class Romans and Italians were making their fortunes round the Aegean, notably in Delos. So Rome became the principal customer for Hellenistic art and workshops in Greece began to look to the Roman market, without at first any perceptible effect on their style, though probably the production of copies and Classicizing works was boosted.

When at the end of the Hellenistic period Augustus established centralized autocracy and order throughout the Roman Empire, which now included all the countries round the Mediterranean, sculpture became one of the instruments of imperial propaganda and Rome the centre of a new Imperial style. This style was, of course, based on Greek models and executed by Greek artists, and beside it there continued a purer Hellenistic tradition, especially in Greece and Greek Asia, where most of the leading sculptors still trained. Most of our copies too are of the Roman period. It was not till about AD 300, whether because of lower technical standards or for some more positive reason, that any significant change of artistic direction becomes apparent; nor had it much effect on statuary, since in the fifth century in the Latin West and in the sixth or seventh in Greek lands sculpture as an art petered out. The Byzantine Empire, partly for religious reasons, turned to other media and elsewhere ancient civilization disintegrated.

Influence (*see also pp.* 91, 108–9, 118–9, 130–31, 141–2, 155–6)

Though the continuous tradition of Greek (or Greco-Roman)
sculpture had been broken, many examples of it were still to be
seen throughout the Middle Ages. In Constantinople we read of
Classical masterpieces set up in public places till one by one they
were destroyed in rioting and only the horses now on St Mark's in
Venice survived, but though admired by a few scholars these
works had no effect on the rigid canons of Byzantine art. In the
West, mainly in France and Italy, pieces of ancient sculpture,
especially of the carved sarcophagi of the late Roman period, were
occasionally reused and even more occasionally imitated, but
without much aesthetic understanding. It was not till the fifteenth
century that the artists of the Italian Renaissance, with their new
interest in the perfect human body, were able to appreciate the
intentions of the art of antiquity and to find in it answers to some
of their problems. Greek figurative art had been dominated by an
ideal approach to the human form, modifying observation of
nature by theoretical rules of proportion, and it was this quality
even more than its technical skill which now compelled attention.
So the search began for examples of that art, especially in and
around Rome, and since paintings perish easily it was mostly
sculpture that was found and studied, by painters as much as by
sculptors. Painters now learnt their art by copying the pictures of
others and drawing ancient statues or casts of them before they
drew from life, since (as was constantly repeated) this gave the
pupil a standard by which to correct the inevitable irregularities
of nature; and though the doctrine has been abandoned in the last
century, the practice still persists in some Schools of Art. Such
study of ancient sculpture was bound to have an influence on style,
through adaptation or imitation according to the originality of the
artist, and the taste for Greek and Roman mythology helped with
its appetite for nudes. This reliance on the antique lasted for
nearly four hundred years. In the fifteenth century the choice of
models was eclectic; in the sixteenth a new ideal detachment
came nearer to the Classical spirit; in the seventeenth the Baroque
artists still made familiar if casual use of ancient forms and details,
and in the later eighteenth the Neoclassicists (encouraged by the
discoveries at Herculaneum and Pompeii) attempted a super-
ficially closer revival of antique forms. All this had been based on

finds made in Italy, of which the finest were Hellenistic, and in spite of Winckelmann's lucubrations in the mid eighteenth century even he had very little notion of earlier Greek art. When at last in 1807 the sculptures of the Parthenon were presented to the Western world the artists of the time admired but did not imitate them and, though it may have helped to kill off Neoclassicism, High Classical statuary did not even begin to inspire a new Renaissance style. Art took another course and, while some sculptors have made use of the Archaic and Early Classical styles, the rare reminiscences of later and particularly of Hellenistic sculpture cannot be reckoned as more than whimsical.

5 METALWORK

Materials and Technique

Decorative metalwork was practised by major artists, for instance Phidias, and reckoned one of the major arts. It allowed the sharp definition required for figures and ornaments, was valuable for its material and, unlike sculpture and architecture, could always be enjoyed by private individuals with the extra pleasure of personal possession. Since all metals could be re-used profitably and except for gold are liable to corrosion, survival has been chancy, depending mainly on deliberate or accidental burial and suitable chemical contexts. So, though there is a fair quantity of Greek metalwork in museums and other collections, it is not properly representative. The metals in regular use were gold, electrum, silver and bronze. Gold, always the most precious, was kept mainly for jewellery, anyhow till the mid fourth century when the Macedonian and then the other Hellenistic kingdoms made regular issues of gold coinage. Electrum, which was an alloy of gold with some silver and occurred naturally in Lydia, was treated as an inferior sort of gold; it also provided the main coinage of some Asiatic Greek cities from the late seventh to the fourth century. Silver, the standard medium of currency in the rest of the Greek world, was relatively more valuable than now; it was besides employed for cheaper jewellery and more expensive toilet and table ware. Bronze, an artificial alloy of copper and tin with sometimes a little lead, was far commoner and being also much more tractable than iron it remained the normal metal for armour, vessels and stands, mirrors, plaques on furniture, and figurines. In value the ratio of gold to silver varied between 15:1 and 10:1, while the ratio of gold to electrum depended on its supposed composition; bronze was much cheaper – in the late Hellenistic period, for which we have some information, it was worth between 1:100 and 1:150 of an equal weight of silver.

The techniques that have been observed are hammering, stamping and impressing, repoussé, chasing (or engraving), inlay, gilding and silver-plating, solid and hollow casting, and – for jewellery only – filigree and granulation. Joins were made by folding, soldering, welding or riveting. Hammering, for long the basic method of making vessels and armour, must have been used continuously from the Late Bronze Age, when the art of the metalworker was highly developed, and so too with engraving and solid casting. The other decorative techniques reappeared or were improved in the late ninth or the eighth century under the direct or indirect tutelage of Eastern craftsmen. Metalwork, of course, was intended to be kept polished and bright. The admiration for the patina of bronze, which by its mattness obscures detail and incidentally makes mirrors useless, did not appear before the Roman period and is one of the more obvious instances where modern appreciation of the character of ancient art and architecture shows itself distressingly conventional and incomplete.

Jewellery

At the beginning of the Iron Age such jewellery as was made by the Greeks was simple and not very skilful, but in the later ninth century as luxury became possible output increased suddenly and both technique and style improved. Because the main purpose was to advertise personal wealth and there were limits to the quantity of metal that could be worn with propriety, the art of the jeweller tended always to intricacy and virtuosity. In early work granulation was especially important; by the fifth century the forms of figures and ornaments relied on filigree and enamel; and in the Hellenistic period and still more afterwards inlaying with precious stones became popular. Generally for figures the style in jewellery resembles that in other figurative arts, though on some gold bands of the eighth century an Orientalizing style appears earlier than in vase painting; but in wreaths and pendants from the Classical period onwards there is often a much closer and more sensitive copying of vegetable forms. On the whole Greek jewellery shows excellent craftsmanship, a good sense of design and delicacy of detail, but in the general development of art its importance was secondary: the scale was too diminutive for full exploitation of the human figure.

Larger Metalwork

When Greek metalwork revived in the early eighth century its most spectacular products were big tripod-bowls of bronze, of the type depicted on Plate 18. In these objects, which seem to have been intended for show rather than use, three long straight legs and two upright ring handles are fixed to the rim of a shallow open bowl. Decoration consists usually of narrow bands of Geometric ornament – especially zigzags and small concentric circles joined tangentially – which run down the legs and round the handles, and in some elaborate examples the handles had also cast horses (compare Plate 70a) or birds mounted on top and human figures either there too (*plate 70b-c*) or supporting the sides. By the end of the century these tripod-bowls were being superseded by a new, less open type of bowl with a separate stand. The models and perhaps some of the makers came from the East, probably from North Syria, but their style was soon imitated locally and, as the Greek Orientalizing style found canons of its own, almost as soon adapted. The bowls had two ring handles, again attached to the rim, each swivelling in a socket on the back of a human-headed bird (or 'siren'), which Greek taste determined should be female; but much more prominent were the heads and necks of animals, normally griffins, six or four of which soared up from the shoulder of the bowl. The handle attachments were cast solid, the griffin heads were at first hammered and then hollow cast with of course much cold working after. Decoratively the combination was uneasy and the Greeks soon abandoned the sirens, but the griffins allowed inventive elegance and were still being produced at the beginning of the sixth century. Plate 14 gives an idea of the type of the griffin's head, though the ears are shorter and the modelling is much coarser than in bronze.

For early engraved or relief decoration armour, so it happens, provides most of our examples. During the seventh century, as methods of fighting changed and bronze was easier to obtain, metal helmets, corselets, greaves and other protective pieces became more desirable and some of those who could afford it fancied decoration, drawn from the current stock of human and animal figures; but though craftsmanship was good, the shapes of the fields were often awkward and, whether for this reason or a dislike of conspicuity in battle, such embellishments became rare during the

sixth century. Plates 71a-b and 34b offer examples of early engraving and relief work. The first, of about 700, is the catchplate of a brooch, some two and a half inches square and engraved in a Boeotian Subgeometric style. The second, much the same in size, is more than a century later and was probably made in Argos; it comes from the handle of a mirror, but the mould in which it was impressed served also and probably more often to provide one of the panels that ran down the strap inside shields. The disc of Plate 34b, perhaps the blazon of a shield of the mid seventh century, is over a foot in diameter and its larger scale allowed much bolder work in repoussé. Here the connection with sculpture is close. The smaller works can be compared for style with vase paintings, though perhaps because of different shapes of field the repertory of subjects is not altogether the same.

Early in the sixth century the makers of bronze vessels took to casting handles and sometimes feet and rims and, since such parts were solid, they have survived damage and corrosion much better than the thin hammered bodies. The casting of the body as well, anyhow for larger vessels, came much more slowly and was not regular till the third century. Generally the shapes of bronze vessels relied on harmonious curves, since Greek methods of working thin metal did not encourage sharp angles on the body, but in contrast the heavy handles and rims were often moulded and chased very crisply. The rim and, if it was of any height, the foot might have bands of simple ornament in relief – such as eggs, tongues or beading; the body needed no such ornament to define its shape and was often, but not always, left plain; and decorative exuberance tended to be concentrated on the handles and particularly on the plates by which they were attached, though sometimes the grip itself took on human form. The Vix krater (plate 72), an abnormally large piece, has also (like some other kraters of its shape) separately cast figures attached to the neck and illustrates very fairly the ambitions and limits of this class of work in the second half of the sixth century, though the decoration of the handles is more complex than appears in profile. This krater, found in a Celtic grave in the northern half of France, appears to have been made in the Peloponnese or perhaps Southern Italy.

Hand-mirrors, about six to eight ins in diameter, were another important product of bronze workshops. During much of the sixth and fifth centuries the standard type was a smooth cast disc of

bronze, slightly convex on one side and concave on the other, and with a beaded rim. For handle and stand combined there was a solid-cast human figure, soon regularly female and draped, standing frontally in the poses more or less familiar in the sculpture of the time. So that the transition from the head of the figure to the handle should not appear too spindly, a small winged youth or animal was often added on each side, secured to the shoulder of the figure or the rim of the disc or to both. A similar sense of design is evident in the patera, an object much like a small frying pan, though its handle usually has the form of a naked youth. In the later fifth century a new type of mirror came in, with the disc protected by and often hinged to a lid. For decoration a head or a mildly erotic group, done in repoussé, was fixed to the outside of the lid and there might also be engraving on its inside too.

The repoussé technique had been practised since the eighth century and shows a slowly increasing affinity to sculpture, both in style and subjects. The Daedalic bronze disc of Plate 34b is for its period – the middle of the seventh century – unusually sculptural, but then its size is large, not so much less than life. A bronze shoulder plate for a corselet (*plate 71c*), said to have been found near the river Siris in South Italy, has figures only some six inches high, but in character is comparable with contemporary marble reliefs, except perhaps that the shape and scale of the field permitted a freer composition with figures appearing almost afloat in space. Its date is around 400. A bronze krater from Derveni in Macedonia (*plate 73*) is of probably the third quarter of the fourth century. Here the handles and the figures seated on the shoulder are cast and the figures of the main field – generous in scale since the vessel is three feet high – are repoussé. This is one of the finest examples of Greek metalwork; the forms and grouping of the figures are sculptural, but the richness of detail, which does not submerge them, belongs to a more decorative art. Hellenistic craftsmen were technically as accomplished, but tended to cleverness, whimsy or excessive elegance, though perhaps some of the objects from Pompeii and Herculaneum may be excused as Romanized.

Figurines

Besides serving as attachments to other objects metal figurines were more often prepared as independent pieces. They were, of

course, mostly of bronze and, unless of some size, cast solid or nearly solid. Their purposes were for dedication in sanctuaries and increasingly for private possession. Bronze figurines, roughly finished and clumsy in design, seemed to have been made occasionally throughout the earlier Iron Age. Then with the eighth century output became much greater, craftsmanship improved and a coherent style was created, parallel to that of the figures of Geometric vase painting (*plate 6a-b*); the leading types were similarly standing naked men (*plate 70b-c*) and standing horses (*plate 70a*). In the seventh century metalworkers adopted the Daedalic formula for their human figurines (*plate 35c-d*) and, as sculpture became established, generally followed its development for anatomical forms, though they always allowed themselves more liberty in the choice of types and poses. For example, naked women and integrated groups appear regularly among the figurines of the Archaic period, though in statuary these were not acceptable before the fourth century; and in the Hellenistic period hunchbacks were represented with full deformity only on works of minor scale. The reasons are obvious enough. It was very much quicker and cheaper to make figurines than statues, so that experiment could be afforded more easily; they were not so exposed to public view and consequently to the rules of public decorum; and their smallness did not present the same problems of aesthetic or mechanical balance. Generally the art of metal figurines reached its highest level in the sixth and earlier fifth centuries, when the forms of sculpture were still simple and strong, and though some excellent pieces were made later average quality declined; the small scale did not permit the subtle treatment of surface which began to become important in the High Classical style. The Baker dancer (*plate 63 b-c*), of the later third century, is an exceptional piece for its time; not surprisingly it is rather larger than average.

Influence

From the seventh century onwards Greek bronzework had a strong effect in Etruria, though the Etruscans (who had their own supplies of copper) were technically highly competent and maintained distinctive traditions of their own. In Spain the native metalwork, like the sculpture, eventually shows some not very profound

Greek influence. Elsewhere in Europe along the northern boundary of the Greek world there was a market for Greek products (of which Plate 72 shows an example), but the native style was too alien to be Hellenized, though some Greek workshops evidently tried to incorporate elements of Scythian art in objects for sale in the Ukraine. In the East some Greek components may be detected in the Achaemenid art of the Persian court from the late sixth to the late fourth century, but apart from this there was only a little casual export before Alexander's conquests. Then, as the new Hellenistic kingdoms imposed Greek culture on their subjects, the taste for Greek metalwork too became normal. A curious testimony, though belonging to the Roman period, is the discovery at Begram in Afghanistan of a craftsman's stock of plaster casts from which to make facsimiles of earlier Greek bronzework for local customers. How far a Greek tradition persisted in these parts is not known, but the main effect was in the Mediterranean lands, where the style of the Roman period directly continued or developed from Hellenistic. In the Renaissance the new study of the antique, based on central Italy, lacked Greek models to study; and when in the middle of the eighteenth century Hellenistic metalwork came to light at Pompeii and Herculaneum, it provoked only a little mannered imitation.

6 GEMS AND COINS

Gems

Gems decorated in intaglio, so that they can be used as seals, are like jewellery very much personal possessions. Though their material is durable and their designs, being sunk, are protected, not many Greek specimens are known – perhaps about 3,000 spread unevenly over some seven centuries. Since, as graves show, gems might continue in use for more than a hundred years, excavators' contexts (which are not very numerous) do not give close dates of manufacture and for these we rely mainly on style, a fairly accurate guide till the Hellenistic period. Yet though Greek gem-cutting was often of high quality and at least by Hellenistic times was considered a major art, it is now usually neglected. The designs are too diminutive and the lighting of intaglio in translucent stone is too tricky for convenient display in museums and even for study in the hand one needs good impressions (preferably in off-white plaster) and, if possible, enlarged and carefully illuminated photographs of those impressions.

Between the Late Bronze Age and the eighth century, so it seems, no new gems were cut in Greek lands, though (if only to judge by occasional finds in later contexts) some Minoan and Mycenaean specimens must still have been handed down or discovered by chance. Eventually a small manufacture of seals of white stone began, clumsy objects with latish Geometric decoration, while a more regular supply was provided by imports. Of these there were three principal groups current in the later eighth and earlier seventh centuries, all scarabs – that is shaped above like a dung beetle and with a design cut in the flattened underside – or else scaraboids, similar in general shape but with the upper side left smooth. The so-called Lyre-player group, mostly scaraboids of red serpentine, apparently came from Cilicia and their clumsy designs were in an uninspiring Eastern style. Another

group, mostly scarabs of a glazed composition which Greek archaeologists miscall 'faience', have Egyptianizing designs and were probably made in Phoenicia. Thirdly, there were glass scaraboids, also Egyptianizing and probably Phoenician. Though specimens of all three groups are numerous and widely spread, Greek art – even in this receptive period – did not choose to copy their styles, presumably because they were too alien or summary to be adaptable to its emergent Orientalizing standard. Still, the new demand for seals probably encouraged local production.

The first important group of Greek seals consists mainly of discs of ivory, a material imported from Syria or Phoenicia. These may be as much as two inches across. The designs, sometimes on both sides, are usually single animals (*plate 69a*), monsters or birds, cut in a full-bodied Orientalizing style and often of good quality for their time. They were made from the end of the eighth century to the middle of the seventh and, so the finding places argue, in the Peloponnese. The Island gems began as the ivory seals were ending. They are usually smaller, of pale green serpentine, and lentoid or amygdaloid in form – that is shallow circular or almond-shaped pieces with the two faces markedly convex. The favourite subjects are single animals (*plate 69b*) and monsters, but there are also human figures; the style shows some Geometric traces at the beginning but is usually fully Orientalizing; and the forms are at first very and later fairly angular, with much use of hatching and stippling and occasional repetition of Minoan postures (*plate 69b*), an anomaly most easily explained as casual copying of surviving Bronze Age gems. The Island group at its best makes an engaging impression of imaginativeness, partly because its style happens not to be paralleled closely in our other remains of Archaic art. Melos has been proposed as its home and its date seems to be from the middle of the seventh to the beginning of the sixth century. One might expect that there were other noteworthy schools of early gem-cutting, but if so they are still to be discovered.

The main Archaic series of gems begins a little before the middle of the sixth century. The commonest materials are red to brown cornelians, white or grey chalcedonies and clear rock crystal in that order and, since these stones are harder, the drill with emery powder as the cutting agent became an essential tool, though much of the detail was finished with a point or file and abrasives. The favourite shape now is a scarab, evidently borrowed from

Phoenicia, whether directly or by way of Cyprus. The subjects are single figures or less often compact groups (*plate 69d*), human or animal, though the repertory differs from that of Attic vase painting; this may partly be due to the different shape and size of the fields, but finding places and the style of various pieces suggest that some, perhaps most of the workshops were in the East Greek region or the Aegean Islands. Still, poses and anatomy conform to general Archaic standards and the workmanship is often of high quality, keeping abreast of contemporary developments in other arts. Besides gem stones there are also metal finger rings with designs in intaglio. These designs are on the bezel, where the field is often relatively longer than that of a scarab, and were cut without drilling. The quality tends to be poorer than that of the true gems, and animals are commoner as subjects.

Classical gems evolved from Archaic without any break. Grey and white chalcedonies and cornelian were the stones most in use, chalcedony being preferred for scaraboids. Scarabs with their now incongruous beetles soon became rare, and the regular forms were the scaraboid and the ringstone, usually oval in the fifth century and circular in the fourth. The style, still wisely content with single figures or close groups, passes through the same stages as sculpture, on which it becomes increasingly dependent not only for anatomical detail. The youth testing an arrow on Plate 69e shows the new twisting of the body that appeared in relief sculpture around 500 (compare Plate 45a). The naked woman feeding a heron (*plate 69f*), of the late fifth century, shows the plausibly natural grace of High Classical art, but though it looks sculptural cannot be based simply on sculpture, which did not tolerate the female nude for another fifty years. Characteristically the figure no longer appears cramped within the field like the figures of Plate 69d and even 69e. Animals are relatively less frequent than before. The group on Plate 69c shows the continuation of the Orientalizing tradition in the mid fifth century, but particularly in the stag (a frequent Classical species) there is a more sympathetic understanding of natural forms. This sympathy has fuller scope in less hackneyed subjects, such as the domestic heron on Plate 69f. Heads, whether human or animal, are not very common in spite of the smallness of the field. The finest and most remarkable (*plate 69g*) is by Dexamenos, one of the few gem-cutters who signed his work. This head, about contemporary with the

sculptures of the Parthenon (which were carved around 440), deliberately rejects the Classical ideal, but its apparently individual features may as easily be an experiment in creating a new type as an attempt at portraiture: Dexamenos was a gifted and versatile artist, and gems were designed for private, not public customers. Besides the true gems there was also in the Classical period a largish production of scaraboids of glass, at first clear and later greenish; these had the merit that the design could be cast with a little retouching, but as with most cheap imitations the quality was inferior. Metal bezels on rings also remained popular: their repertory of subjects was that of the gem stones, but the cutting was usually deeper with more emphatic linear detail and – to their detriment – less subtlety of modelling.

In gem-cutting, as in other branches of art, Hellenistic work has been studied much less than that of earlier periods. Alexander's acquisition of the Persian Empire had made a much wider range of stones available to Greek craftsmen, especially garnets and amethysts; even so, some (like diamonds) were too hard for ancient methods of working. With the rejection of the scaraboid in the later fourth century the ringstone, now oval again, became the standard type; and the ring with no stone but a metal bezel lost in importance. Glass imitations continued, as might be expected. A new development was the cameo, carved in relief and exploiting the differently coloured layers of onyx or some other banded stone to give, for example, white figures against a dark brown background: the technique was used also for larger pieces, such as cups. In style Hellenistic gems reflect trends familiar in Hellenistic sculpture, perhaps with most success the sensual, and – presumably towards the end – there is much Classicizing work. The ringstone of Plate 69h, with Cassandra taking refuge at the statue of Athena, is an excellent specimen of sensitive, if slightly academic, Hellenistic work and may be of the first century. Heads, especially portraits (*plate 69i* – perhaps of the third century), become common and, anticipating the practice of sculpture, there are also busts. To make a stylistic division between gems of the late Hellenistic and the early Roman period is impracticable, anyhow at present.

In gem-cutting the Greeks learnt much from the East, but they were soon themselves teaching. Greek gem-cutters seemed to have been settling in Etruria by the middle of the sixth century

and by its end local workshops there were developing a distinct Etruscan manner, which shows itself most obviously in clumsiness of proportions and misunderstanding of Greek myths. Production continued busily, with fairly complete if intermittent assimilation of current Greek modes, till local peculiarities were submerged by the spread of the late Hellenistic style in central Italy. A more surprising phenomenon is the occasional but strong Greek influence in a series of Phoenician gems, otherwise Egyptianizing in their devices, which begin before 550 and because of their finding places are sometimes incautiously attributed to Sardinia or other Phoenician settlements in the West. Later there are what are often called Greco-Persian gems, which extend from the end of the sixth to near the end of the fourth century. The favourite material is a bluish chalcedony, the styles ranges from the pure to the dilutest Greek, the subjects are often Persian and the shapes comprise both Greek and Eastern varieties. Some of the makers were evidently Greeks, at least by training, and presumably resident in one or other of the cities of western Anatolia, which throughout this period was wholly or largely under Persian rule. Others were probably Asiatics working in parts further East and taking more or less from fashionable Greek models, whether known directly or at second-hand. In Rome during the Hellenistic period Greek immigrants developed a variant school, but the main constituent of the style of the Roman Empire was more orthodox. Nor is this surprising, since patrons could improve their taste on the big collections of gems formed by Hellenistic kings and brought to Rome as loot.

In the Medieval period gem-cutting ceased or almost ceased throughout the West and even in Byzantium, but there was still a large stock of ancient gems, mostly Roman, and these were used without discrimination of style or subject for seals and to decorate reliquaries, cups and other appropriate objects of value. The attitude of the Renaissance was of course different. In the fifteenth century collecting began again, governed by aesthetic taste; from its rapid success it seems that the early connoisseurs made their acquisitions less by excavation than from the treasures of churches. Artists too took to cutting new gems, but in contemporary styles: though some of their results are admirable, technical refinement was generally inferior to that of the ancient craftsmen. Conscientious imitation of the antique, not always intended to deceive,

came with the Neoclassicism of the eighteenth century and there was also a good market for impressions in sulphur or glass pastes; but as taste shifted from Roman and Hellenistic towards the Classical, the majority of the ancient gems then known lost their attraction and since the middle of the last century the exacting art of intaglio has been neglected. There seems no likelihood of a revival.

Coins

Coinage was invented in Lydia in the late seventh century, perhaps as a convenient method of handing out wages to mercenary soldiers but certainly not for day to day purchases, since the value of the smallest denomination was much too high. The invention, convenient for payments to and by the state, was adopted quickly by Greek cities and gradually a monetary economy evolved. The materials were the precious metals – gold, electrum and most commonly silver – since generally coins were accepted at more or less their intrinsic value, though in time token currencies of bronze were issued for very small transactions. The first coins – of electrum – were roughly bean-shaped and marked with the end of a broken bar, but very soon special dies were made to stamp devices on the flans, both the principle and the purpose being like that of a seal; and as a result these became more or less circular, while still by modern standards very thick. Since almost every independent Greek state issued its own coinage, devices were often changed, and the metal dies (which were cut by hand) needed replacing, the number of varieties is very great. Besides human or animal figures or less often compact groups, usually in deep relief, heads were common devices, much more so than in any other branch of Greek art, even gems. The explanation of this peculiarity is presumably that striking was a rough process and both coins and dies were liable to wear, so that subtlety of detail was not pursued and perhaps the minting authorities were unwilling to spend much on die-cutting. Nor was there much concern for accuracy in striking; flans were often irregular, and dies were not properly centred and might even overlap the edge of the coin. There are some issues, especially from Sicily, with devices of admirable quality, and in many others the general level of craftsmanship ensured that composition was neat, poses and modelling

reasonably up to date and cutting of dies at least competent. For the study of Greek art the most interesting series are those with portraits of Hellenistic kings, since contemporary original portraits are rare in other media.

The Romans followed what had become the general Greek practice by putting a head on the obverse, but their reverse types were more instructive or propagandist and did not at first show much attention to composition. With the establishment of the Empire artistic quality improved, but in the late second century AD decline set in and it was from the debased Late style that the coinage of Medieval Europe evolved. Eventually the Renaissance brought a desire for higher standards and from time to time designers looked back at antiquity, but the models they used were mostly those of the early Roman Empire and so no more than indirectly Greek. For instance the figure of Britannia on coinage of the United Kingdom, introduced in 1672, was based on the Britannia of a series issued by Hadrian in AD 119, and this in turn was based on a Greek type of Athena. Another result of the Renaissance was the private collecting of ancient coins, a practice which still flourishes for mixed reasons but certainly to the encouragement of forgers, who have been more active in this than in any other branch of Greek art.

7 ARCHITECTURE

Sources

When the Mycenaean system broke down in the twelfth century its higher arts came to an end and for about five hundred years Greece had no architecture, that is building which was executed carefully to an aesthetically considered design. Then growing prosperity, stronger civic organization and pride, and also improving technique allowed the creation of the peculiar Greek style which, though not often understood, still looks familiar, even to those who have not seen original examples. Not that these are immediately illuminating, since apart from a few minor structures all our remains are fragmentary or ruinous or at best have suffered from more or less misleading adaptations and repairs. Though most of the materials of important buildings were durable, the timbers of their roofs were liable to decay and there were also the hazards of fire and earthquakes, so that in the course of time accidental ruin was almost inevitable. Yet human action has been much more destructive. While Roman concrete and brickwork have little scrap value except as hardcore, the neatly squared blocks of good stone habitual in Greek architecture were always serviceable for later builders, whether they used them complete or broke them up; columns, though, because of their inconvenient curvature were less attractive, and so too to some degree were triglyphs and moulded slabs from the entablature. Marble had the extra disadvantage, even more disastrous to sculpture, that it could be converted into good lime. Lastly, the scarcity of metal in the Middle Ages made it worthwhile pulling up heavy pavement slabs or hacking out holes at the joints of walls in order to extract the small metal clamps and dowels that tied the stones together. As a general rule the components of Greek buildings have survived only if the situation was very remote, as that of the temple at Bassae, or if they were buried by a landslide or silt, as at Olympia,

or if the structure remained in continuous use, like the so-called Theseum at Athens, which was reconsecrated as a Christian church. So when one views Greek ruins, it is easier to appreciate their picturesque than their architectural qualities and, though the plan and lay-out may be clear enough and fineness of workmanship is often still evident in the blocks lying around the site, to recover the original effect of the whole there is a need for precisely measured drawings and even these cannot often be complete. Recently a new hazard has been invented, that of 'anastylosis' or restoration, sometimes accurate and commendable (as with the little temple of Athena Nike on the Athenian Acropolis) but too often insensitive or false and justifiable only by the argument that tourists must have something imposing to photograph.

Besides what remains of the buildings themselves, chance has left us one ancient treatise on architecture, written near the end of the first century by Vitruvius, a professional architect who though Roman had had some Greek training. This treatise is valuable for its exposition of the techniques of his time, but for the niceties of style offers not Classical but Hellenistic precepts, some of them contrary even to Hellenistic practice. From other Greek and Roman writers we have only occasional remarks on special points and these are mostly trivial. Much more informative are the few inscriptions which give detailed accounts of expenditure or the specifications for a particular job; the fullest – both of the fourth century – are those for the Temple of Asklepios at Epidaurus, much of which survives, and the Arsenal at Piraeus which is wholly lost. Representations in other arts are, as one would expect, of little help, except for the models of early pre-architectural buildings; the drawings on pots, mostly of the sixth, fifth and fourth centuries, are simplified and careless, while the wall paintings of the Hellenistic period tend to fantastical elaboration. In effect our knowledge of Greek architecture comes almost entirely from the study of its material remains.

That knowledge is discreditably limited. The evidence is of course patchy and architecture, perhaps because it is abstract, is the most difficult of ancient arts to comprehend; but the main reason is that too few of those who study Greek architecture have had any architectural training nor do many trained architects now think its detailed investigation worth their time. So, though accurate measured drawings of Greek buildings were made and

published two centuries ago (*plates 83* and *87*), much earlier than accurate drawings of vase paintings or sculpture, there are still too few major temples or other sizeable structures for which reliable and significant measurements are available. This is especially frustrating in that ancient Greek architects more than any others were fascinated by the niceties of proportions, even if (like the sculptors) they did not usually apply numerical theories with rigid pedantry.

Antecedents

Not much is known yet about Greek buildings between the twelfth and the seventh century. Because of their materials and character such traces as they left have often been overlooked or neglected by excavators whose technical standards were low and whose interests were in the more spectacular remains of later or earlier times. Further, most of the sites of the Early Iron Age continued to be occupied afterwards and their older structures were in due course demolished to make way for grander and more modern successors. So the remains of that period are scattered and rarely rise above the lowest courses, while for the superstructure we depend on inferences and less often on components in the debris around. Luckily there are a few models of temples or perhaps houses, made of terracotta (*plate 74b*) or stone, which give a more direct impression of the complete effect.

The materials of these buildings were local – stone, clay, timber and thatch. Limestone of various grades crops up in most of the regions inhabited by the ancient Greeks and there were other local stones that were usable. Clay too is plentiful; mud (that is unfired) bricks were always in demand, but terracotta roof tiles were not made till about the beginning of the seventh century and fired bricks were hardly known till the Roman period. Lime for cement and mortar could be procured easily, but does not seem to have been used, anyhow structurally, in early works. As for timber, there was still a fair supply in Greek lands, if in some regions of shortish lengths; and reeds and straw were available for thatching and for the bedding of mud roofs.

Of specialized skills in building no trace remains, though Homer, referring probably to the eighth or early seventh century, speaks

of carpentry as a distinct craft. Walls were normally of mud brick or rubble, which any handyman could put up. Since mud brick is only sun-dried and not fired, it disintegrates if exposed to rain or damp and is best laid on a ground course of stone, coated on external faces with plaster and capped by overhanging eaves. Further, since unfired clay has a low bearing pressure, mud brick walls tend to be thick – a common size for the bricks was two feet by one (or later one and a half square) with a depth of four inches – and a timber frame may be needed to help with the weight of the roof. For rubble walls flattish field stones were laid without regular coursing, often visible faces were roughly levelled, and gaps were filled with small stones and clay packing. Squared masonry was very rare. At the top of both mud brick and rubble walls there were presumably timber wall-plates to secure the framework of the roof, which might be thatched or of mud. Thatched roofs generally have a high double pitch to shed rain and, if the building was long and undivided, a central row of posts was helpful to support the ridge beam (though the presence of central posts does not prove that a roof was thatched). Mud roofs, with a thick layer of mud over reeds and timber, are heavy and usually flat; they as well often had internal supports, but these did not need to be so regularly spaced. Finds at Emporio on Chios suggest that the mud-roofed houses there had wide chimney pots of terracotta, though there were no chimney stacks: with thatched roofs, which were higher, smoke probably found its way out through the eaves or an opening in the gable. Floors were simple. If the building was on rock, this was roughly dressed; otherwise there might be some sort of paving or a layer of pebbles or more often beaten earth, which has the merit for archaeology that when it became too foul or worn a new coat could be spread over the old one.

These early buildings (*plate 74*) were simple in plan, so far as we know them. Whether houses or temples, they consisted most often of a single room with or without a porch. The plan is sometimes squarish and sometimes long, the door then being at one of the narrow ends; and the long plan has two varieties in which the far end is either rectangular or apsidal. There is also evidence for oval and circular plans. In our present ignorance it is futile to look for ethnic or historical reasons for the differences, and it is unfortunate that the long type is often called a 'megaron', since this grandiose term has Homeric and Mycenaean implications. At

Emporio, which in size was only a village, both long and square buildings co-existed, though the long ones may have been put up first; and the models of long temples from Perachora and the Argive Heraeum, close to one another in time and place, show both the rectangular and the apsidal varieties. Perhaps the materials of a building often decided its plan. If the walls are of mud brick, the structure is likely to be rectangular, since it is composed of rectangular units; but rubble does not allow tidy corners and so one might expect rounded ends. Again, thatched roofs encourage long plans; but there is more freedom with mud roofs. Even so, there need not be a tidy reason for everything.

Though the square plan may have had effects on later houses, it was the long plan which Greek architects developed for their temples. Plate 74a gives the plan of the grandest house at Emporio in Chios. It has a single room, measuring inside about thirty-two by eleven feet, with a porch at the south end; there were two posts across the porch and probably three down the room, all on stone footings. The walls were of rubble, roughly trimmed on the outer and inner faces, and the roof was probably of mud and flat. The date of this house should be around 700. Another version of the long type of building is given by fragmentary terracotta models of slightly earlier date found in a sanctuary at Perachora near Corinth and presumably, because of the place of finding, representations of temples rather than houses. The restoration illustrated in Plate 74b is composite but trustworthy, except that the tops of the posts of the porch were missing and we do not know what kind of capitals they had, if indeed they had any. Again we have a single room with an open porch at the front, supported by posts, though here the posts are double, the back of the room is apsidal, and there is a steep thatched roof. The careful plait along the ridge, indicative of thatch, suggests that the shaping of external details was conscientious, but probably the painted decoration (which is characteristic of pottery) should be ignored and the proportions may have been adjusted for neatness or convenience. So far very few early long buildings have been recorded with posts round the outside, in anticipation of the later peripteral temple, and on present evidence none of them needs to be earlier than 700. To judge by the excavated remains and by the models, all these early buildings were innocent of any architectural grace.

The first Greek architects had other precedents to study besides such primitive buildings. Visible remains of important Mycenaean structures certainly included fortress walls and tholos tombs, better preserved than now, so that there were ready examples for the use of large blocks of stone, carefully dressed and squared masonry, corbelled arches and vaults and domes, stone columns with elaborate capitals and bases, and decorative carving. Further, by the early seventh century some Greeks had travelled to Syria and perhaps to Egypt (which specialized in all-stone buildings) and had seen the imposing effects of advanced architecture in various styles, and conversely some Eastern craftsmen seemed to have migrated to Greek lands, though of course neither the Greek travellers nor the Eastern immigrants are likely to have been builders themselves. For details of forms there is also the possibility of borrowing from other arts, such as furniture-making and metalwork. Lastly, one must never forget the factor of original invention.

Materials and Methods

When Greek architecture began in the seventh century, three structural principles soon had a strong and limiting effect on its development. Openings were spanned by horizontal lintels; stone was used as far as funds allowed for everything except the framework of the roof, internal ceilings and usually the tiles; and the building units – blocks of stone and tiles – were large and kept in position by gravity. At the beginning these principles may have been imposed partly by inexperience and ignorance, though corbelling could still be seen in the remains of Mycenaean buildings; but soon they became aesthetically established conventions, which persisted even after the Romans had developed new materials and methods. One obvious consequence was that unsupported spans of stone were rarely of much more than twenty feet, so that buildings tended to be narrow, and when the Greeks wanted a wide covered hall, they had to have numerous interior columns or piers. Other consequences were that roofs had a low pitch, to prevent the heavy tiles from sliding off, and that the arch, understood at least as early as the fourth century, was used very little and then almost always unobtrusively, though the apse was at first

tolerated and later even admired. Finally, skilled craftsmanship became a necessity.

Tiles of fired clay are reported, though very rarely, for the Greek Bronze Age, but do not reappear before the beginning of the seventh century. They are of two complementary kinds, pan tiles and cover tiles, with special forms for the ridge and the eaves, and there came to be three main varieties, known as Corinthian, Laconian – these two are ancient names – and Sicilian. Both pan and cover tiles were grooved so that each was held in place by the one below and, since they were laid at a low pitch (of 13° to 15°) and were too heavy to be dislodged by high winds, there was no need to peg them to the rafters. The method is explained in Plate 76a. Here the tiles are of the Corinthian variety, which was preferred in major buildings; the Sicilian has convex cover tiles and the Laconian – more in the modern way – slightly concave pan tiles too. In size pan tiles, which were oblong, usually measured between two and three and a half feet each way and the cover tiles (which had the same length) were about six inches across; both kinds were usually at least three-quarters of an inch thick. Terracotta roof tiles seem to have been invented at Corinth, since the earliest (and most complex) specimens come from Corinthian territory and Delphi. At first they were used only on important buildings, but gradually became regular even for good private houses. In a few very lavish structures of the fifth and later centuries marble was used instead of terracotta. Because of their weight and the consequent low pitch of the roof the introduction of tiles had a profound effect on the style of the new architecture.

Though rubble was still common in ordinary work and the upper courses of walls even in more important buildings might be of mud brick, the standard material of Greek architecture became large squared blocks of stone, too heavy to be lifted without tackle. This made transport troublesome and expensive, especially if the local product was poor and blocks were brought from a distance: in the fourth century, for instance, at the sanctuary of Asklepios near Epidaurus limestone for the main temple came from quarries near Corinth and marble from Attica. Marble, which one thinks of as the characteristic Greek material, cropped out in only a few places in Greek lands and, though it allows finer cutting of detail and has an attractive sparkle, took about five times longer to work than ordinary limestone. So it did not come into

favour till the middle of the sixth century and in general was used sparingly for the more delicate mouldings; in mainland Greece until the Hellenistic period large buildings in which the visible stonework was wholly of marble were very rare except in Attica. Still some of the effect of marble was often given to inferior stone by coating its surface with a fine stucco. In their treatment of masonry Greek architects seem to have had two contrary aims, or perhaps the technical skill of their craftsmen was tending to defeat its artistic purpose. By very fine jointing or stucco coating a more or less monolithic appearance was produced. Yet the blocks were so arranged that they (or their joints) formed a pleasing design. To set the joints of one course of blocks above the centres of the blocks of the course below is no more than good structural practice, and so is the use of headers and stretchers; but the preference for slightly projecting blocks of double to treble height at the base of the wall of a building – the orthostates of Greek architecture – and calculated variations in the height of courses show that the patterning of the masonry was studied (*plate 86*). Further, by the fourth century it had become acceptable even in temples to emphasize the edges of blocks by drafting, although the jointing remained as fine as ever (*plate 87*); and in later, if not also in earlier work, stuccoed walls were often marked by scored or painted lines to imitate the joints of squared blocks. Polygonal masonry, where the irregular edges were again fairly carefully fitted to each other, was mainly used in terrace walls and fortifications.

For the new masonry craftsmanship of precise and even per-nickety excellence was expected. Since mortar was not used for joints till Roman times, except in Hellenistic Egypt, the close fitting of blocks depended on the meticulous levelling and smoothing of their contiguous surfaces, though for economy of labour the surfaces in contact were limited to a strip two to three inches wide along the edges of a block while on the top and sides the area within this strip was dressed a little back and left rough. A similar anathyrosis was practised on the drums of columns, since for reasons of transport sizeable columns were very rarely in one piece. It was also necessary to prevent any shifting of blocks and drums after they had been laid in position. The blocks were tied together by clamps and dowels of iron set in lead, dowels tying blocks of successive courses and clamps those of the same course

(except understandably in a top course where clamping
have been unsightly). For the drums of columns a woode.. p..g
was sunk in the centre of both upper and lower surfaces, a hole
was drilled in the plug at the precise centre, and by means of a
wooden pin fitting the holes in both one drum was manœuvred
into its correct position above the other. Plate 76b illustrates
better than a long description the methods of anathyrosis, dowel-
ling and clamping of wall blocks. The tools and technique of
Greek masons were the same as those of sculptors (see pp. 77–
78); indeed it is very likely that the first sculptors had started as
masons, and their fields of work continued to overlap. There was
probably some use of templates and for mouldings and other
tricky details the architect presumably provided a specimen piece
from which the masons could take occasional measurements, but
(as modern reconstruction in Athens has shown) an experienced
craftsman can gauge by eye the depth of the fluting of a column.

Building procedure was in some ways curious, anyhow in such
structures as the standard Doric temple with an external colon-
nade (plate 78). First the foundations of the colonnade were set in
place, presumably to make sure that the edge of the platform fol-
lowed the intended line, whether horizontal or curved. Next
came the laying of the foundations for the cella block, the fitting
of the steps round the foundations of the colonnade, and the erec-
tion of the outer columns with at least part of their entablature.
After this the cella walls were put up. This sequence of construc-
tion, attested in the building accounts at Epidaurus, must have
caused extra trouble in getting the blocks for the walls into posi-
tion, since the space between the columns was narrow, and there
should be some compelling reason why the Greeks persisted with
it; perhaps it was because their architects worked without
detailed plans or elevations and so found it prudent to get the
façades right before proceeding, more or less empirically, to
the interior. When the cella walls had been built, the ceilings
and the roof were set in place and the pavement was com-
pleted. Lastly the stonework was finished and smoothed down,
doors and other fittings were put in place, and selected areas
and details were painted – by the encaustic process – or
even gilded. The finishing of the stone-work was a consider-
able job. To reduce the danger of damage in setting and from
later accidents, wall blocks and drums of columns (anyhow
if of marble) were left with a protective layer up to half

an inch thick, except that at junctions where chiselling would be difficult – especially at the re-entrant corners of steps and of walls and the lower edge of the bottom drum of columns – a two inch strip was dressed down to the ultimate surface, needing only a little smoothing. Other protuberances which had to be removed were the bosses (*plate 76b*) used presumably for leverage and not lifting, for which their shape and position are unsuitable. From the late sixth century on it seems to have been normal to lift wall blocks by a simple crane, set opposite the middle of the wall, and to slide them on rollers along the last completed course, the final adjustment of their position being made by levers. (In earlier work blocks were often much larger and too heavy for a Greek crane, so that the conclusion seems unavoidable that these were raised to the required height by pushing or pulling them up a ramp.) For capitals and entablatures a protective coat was either impractical or unnecessary and, since they were put in place complete (except for their painting), bosses could not be permitted; instead holes for tongs or lewis irons were cut in the upper surface. The roof tiles happily could be adjusted by hand. All considered, it is not surprising that few major buildings were finished completely, and at most ancient sites the visitor can see some examples of such forgetfulness or exhaustion of funds. Indeed, as so often happens, an accidental defect might become an aesthetic virtue; by the end of the fifth century architects seem sometimes to have made protective surfaces a deliberate element in their design of steps and walls (*plates 80* and *87*), and later even levering bosses were occasionally adapted for decorative effect or columns purposely left in whole or in part unfluted. For fortification walls and also for retaining walls expense had always restricted smoothing of surfaces, but (as Aristotle remarked in the fourth century) they were still expected to be pleasing aesthetically.

A characteristic of Greek architecture that is not obvious in its ruins was the use of colour. This one might well expect in interiors but it was applied also outside to mouldings and other primarily decorative members of elaborate buildings; and though occasionally and in a few positions there might be a deliberate contrast of dark and light material, the standard and universal practice was to paint the finished surface. On stone the colouring has nearly always vanished, except in a few underground tombs, but

sometimes its boundaries can be made out either by faint traces of discoloration or because surfaces once painted have weathered less than those which never had that protection; sometimes too, especially in Archaic work, the outlines of ornaments were incised lightly as a guide to the painting. On terracotta the colours often survive well, since they were fired on the clay; but after the sixth century the use of terracotta was limited more or less to simas and roof tiles, and the revetments that sheathed the timber and even the stone cornices of some earlier Doric temples and treasuries are not altogether canonical. Colours known to have been used in Greek architecture are various shades of red and blue, green, yellow and black, and occasionally details were gilded (over an undercoat of red). On stone red and blue were dominant, on terracotta – since Greek blues did not fire satisfactorily – red and black. To apply paint to stone the Greeks from the late sixth century on used the encaustic technique, anyhow on major works; but even so, the colours faded – the reds least so – and, when they were renewed, sometimes the scheme was altered. For terracotta the painting was done in the workshop before firing and it was durable. Details of the systems of colouring are given later (pp. 204–5, 225–6, and also 247–54).

The standard of constructional engineering was much less advanced than that of craftsmanship. For walls and the closely-spaced columns Greek stonework was unnecessarily massive, whether at first from unfamiliarity with a new material (as is often but not very cogently asserted) or because the designers or their clients were determined to emphasize the solidity and permanence of the new architecture. Later, of course, tradition was reinforced by aesthetic theories of proportion. In spanning the open space between walls and columns there was a similar lack of economy. By the fifth century, if not earlier, the principle of the masonry arch was understood, but till Roman times it was applied only very occasionally and almost always in minor or unobtrusive places; an ironic example of the second century is the arched retaining wall behind the Stoa of Eumenes in Athens, where the stoa has been demolished and the arches are now revealed in their nakedness. There is, though, no sign that vaulting was seriously contemplated for covering large public halls, where roofing by the standard methods was difficult and often unsatisfactory. These methods relied normally on large beams of wood or stone laid

horizontally, with vertical props where necessary to support the timber ridge beam and purlins, on which the sloping rafters rested (*plate 77*). Extraordinary as it may seem, Greek builders (except perhaps from the fifth century in Sicily) made no use of the more economical and efficient system of the truss, anyhow before the Hellenistic period. It is less certain that they were obtuse in their handling of single timbers; though they often laid beams of oblong section not on edge but flat, these were mostly ceiling beams which carried little weight. Anyhow, they realized that the weakest part of a beam supported at both ends is in the middle; and in the Propylaea of the Athenian Acropolis (*plate 82b*), where an architrave connecting two columns had to support a heavy ceiling beam at its centre, a channel was cut in the architrave to receive an iron bar, which rested only on the ends of the channel, and so, since the cross beam sat on the iron bar, the load of the cross beam was transmitted to the ends of the channel away from the centre of the architrave.

To judge by inscribed records of the fifth and fourth centuries, large-scale contracting did not exist then and the officials responsible for the erection of a public building either let out the work piecemeal or employed labour directly. The architect too had a low status or at least a low salary, which was only that of a craftsman; presumably he could supplement it by undertaking some part of the contract work, as Theodotos did at Epidaurus, where he was both architect of the temple and sculptor of some of its statuary. This combination of professions – sculpture and architecture – was fairly common and may in part explain (or perhaps be explained by) the conservatism of building methods in major works and the preoccupation with proportions and finely carved detail. In the Hellenistic period one might expect that with the much greater concentrations of wealth and the construction of new cities both contractors and architects would have become more important, especially in the big Eastern kingdoms; but we do not have the evidence to decide how far this occurred.

Types of Buildings

The types of Greek buildings were mostly simple, as were the requirements of Greek life, even in the Hellenistic period. There

were the temple, the 'treasury', the tholos, the propylon, the stoa, the fountain house, the palaestra and the gymnasium, the council chamber and the theatre. Altars too sometimes had monumental form; and some care was given to the appearance of fortifications, though more often by way of good craftsmanship than architectural design. Pretentious tomb buildings occurred only on the fringes of Greek culture, especially in Western Anatolia and later in Macedonia, while private houses did not regularly receive architectural treatment – or so it seems – before the fourth century and even then usually on the cheap. Greek architecture was primarily a civic art.

The *temple* was the dominant theme of Greek architecture and set the stylistic standards for both the Doric and Ionic orders. Curiously its religious function was secondary, as a store room for the holy idol (if there was one) and for ritual paraphernalia and offerings of value, but it was not usually itself a place of cult, for which an altar was the essential equipment. Some primitive and a few later temples had indeed an altar inside, but the regular place for the public altar of a patron deity was in the open in front of his or her temple or, to be more accurate theologically, the usual place for the temple was behind the altar, at which both public and private sacrifices were made and congregational worship – or its Greek equivalent – was performed. The difference between ancient and modern attitudes to the house of God is neatly illustrated at Syracuse in what was once the Temple of Athena and is now the Cathedral of St Mary; when it was converted to Christian use, the building was turned outside in by walling up the surrounding colonnade and cutting arches in the side walls of the cella. This meant that in the designing of temples Greek architects might be restricted by convention but hardly by function. The primitive temples of the eighth and early seventh centuries had differed little, if at all, from the various simple houses of the time (so that some students maintain, in spite of their being found in sanctuaries, that the terracotta models (*plate 74b*) reproduce houses and not temples); but very quickly it was the temple based on the long house that became accepted. The one necessary part of the temple was the cella, the room of the long house; and, as in the long house, there was usually a porch with free-standing columns in front (as on Plate 86 or in the Temple of Athena Nike on Plate 90) or else columns between antae, that is between the ends of the

walls (so with the inner porch of the Theseum – Plate 78): in the specialist's terminology the former kind of porch is called 'prostyle', the other 'in antis'. Simple temples of these two kinds were always common, but the standard came to be the more elaborate and expensive peripteral temple, completely surrounded by a colonnade (or pteron) with, as might be expected, six columns at the front – the so-called hexastyle system (*plate 78*). Not that there was an orderly progress from the simple to the peripteral temple: the primitive Hekatompedon at Samos had a surrounding colonnade early in the seventh century, as also had the more or less contemporary temple at the Isthmian sanctuary near Corinth, so that the first architects were familiar with the peripteral system. Of the many developed Greek temples still to be seen the best preserved are the Theseum at Athens, the Temple of Poseidon at Paestum, the Temple of 'Concord' at Acragas, all of them Doric, and the little Ionic Temple of Athena Nike by the entrance to the Athenian Acropolis.

The *treasury*, as the Greeks called it, was in its form identical with the simple temple consisting of cella and porch. The name meant 'strong room' and describes its purpose fairly. Treasuries were frequent at sanctuaries of international fame, erected by other Greek states to house their ceremonial equipment and also for self-advertisement and, since they were small buildings of about thirty feet long by twenty wide, they were often lavish. Indeed the first buildings where imported marble was used throughout were treasuries. The best preserved examples are at Delphi – the Athenian Treasury, which has been largely rebuilt on the site, and the Siphnian Treasury, of which the front is restored in the museum. This type of building is not known before the sixth century.

The *tholos*, a round building of uncertain purpose, seems to have been more for show than utility. The more elaborate examples had an outer colonnade, and the architectural forms were those of the side of the peripteral temple. The roof was conical, but probably not (as it is fashionable to suppose) in two stages. Tholoi occur, though rarely, from the early sixth century onwards. The one at the Marmaria site at Delphi now has parts of its peristyle and cella wall re-erected and at Epidaurus there are in the museum helpful reconstructions of parts of another.

The *propylon* was a pair of porches, usually like those of temples

or treasuries, set back to back on each side of the gate into a sanctuary (*plate 75c*) or occasionally some other important enclosure. The finest and best preserved example, which is also abnormally complex, was the Propylaea at the entrance to the Acropolis of Athens (*plates 90* and *82*). The propylon was an entirely decorative structure.

The *stoa* (to use the word in its restricted modern sense) was for a change a primarily useful structure, put up in sanctuaries or public squares as a shelter against sun or rain (see Plate 75 a–b). In effect it was a long narrow hall with an open colonnade along one side, the columns being usually from twelve to sixteen feet high. To give greater depth there was often a second row of columns inside, spaced normally opposite every second column of the outer row; and sometimes there was a line of shops, dining-rooms, taverns or offices inside at the back. A narrow stoa might have a penthouse roof, but in the standard stoa with internal colonnade the roof was wide enough for a double pitch. Architecturally such stoas were treated like the side of a peripteral temple, though capable of indefinite extension in length. Of more complex types, L-shaped (and Π-shaped) stoas are fairly frequent, some grander specimens had two short wings projecting forward like the ends of temples (*plate 75a-b*), and there are others – rarely earlier than the second century – that are two storeys high, the upper columns being between two-thirds and three-quarters the height of the lower. Another but rarer variant had an open colonnade at the back as well as the front and occasionally – on a steep slope – at a different level. The stoa had appeared already by the late seventh century; the earliest yet discovered may be that in the Heraeum on Samos of simple design but about 230 feet long and with an internal row of columns or posts. No ancient stoa has survived to the height of the roof, but at Athens the Stoa of Attalus has been reconstructed credibly and, though it is of a stylistically poor period, gives a good idea of the practical convenience of this type of building. The colonnaded street of the Hellenistic East is in form a development of the simple stoa: its original effect is most clearly appreciated at Jerash in Jordan, even though there the columns are of the Roman period.

The *fountain house*, sheltering a public supply of water, was another useful amenity. Like the propylon it was in its more elaborate versions modelled on the façade of the temple, though

often the materials were flimsier and – if vase paintings can be trusted – the style was laxer. Inside there was a paved court and against the back wall a row of basins into which the water gushed through spouts sometimes in the form of bronze lion heads. The earliest certain evidence for fountain houses of this kind (and for the piping of water) is of the early sixth century. The only reasonably well preserved examples are at Ialysos on Rhodes, partly restored, at Apollonia in Albania, and by the theatre at Ephesus.

The *palaestra*, an enclosed space for athletic exercise, became in the sixth century almost a necessity for males of the leisured classes. In its mature form, which seems to have been reached in the fourth century, it tended to be square in plan, with colonnades round an open court and behind the colonnade rooms for changing, douching, storage, and social or educational uses. In effect this form of palaestra was a complex of four joining stoas facing inwards and the outside, like the back of the normal stoa, was a blank wall. The *gymnasium* – the distinction of name is more modern than ancient – differed from the palaestra in containing running tracks, one of which (for wet weather) might be under a colonnade, but both about 200 yards long, that is the distance of the Greek sprint. Palaestras, so defined, were of course much commoner than gymnasiums. The best preserved palaestra is that at Olympia.

The *council chamber* (or bouleuterion) became a necessity for any self-respecting city state. Other similar structures were occasionally put up for musical or religious performances, such as the Odeum at Athens, now barely traceable, and the Telesterion (or Hall of the Mysteries) at Eleusis, of which there are still successive sets of foundations. The earlier buildings of this type were narrow and long, like the cella of the temple; but by the fifth century a squarish plan was preferred, presumably for the benefit of the audience who sat or stood on tiered benches or steps round three sides of the chamber. This change in plan caused trouble for the architects, if the chamber was large. Since Greek methods of construction did not allow free spans of much over twenty feet in stone or thirty in wood, it was necessary to put in internal supports – most often, of course, columns – although they interfered with the audience's view of speakers or performances. Normally such supports were placed in some simple rectangular grid, but once at least – in the Thersilion at Megalopolis – architectural

regularity was sacrificed to the users' convenience by arranging them in lines radiating from the rostrum, which was a little forward of the front wall. Another problem, this wholly aesthetic, was that, if there were several rows of columns, then because of the tiering of the floor their bottoms were at different levels, though with the usual flat ceiling their tops were at the same level. Sometimes too under the influence of the theatre the seating was semi-circular, with unhappy effect in a chamber of rectangular plan. Externally the roof had its awkwardness. Though the angle of pitch was low – not more than about 15° – in a squarish building of large area it rose in the centre to a height disproportionate to the height of the walls; and if, to give dignity to the front, there was a pediment, this too was liable to be oppressive in scale. Big covered halls were not among the successes of Greek architecture and, fortunately for its credit, none has survived in easily comprehensible condition. For the small council chamber without intermediate supports to the roof there are the intelligible remains of the Ecclesiasterion at Priene.

The *theatre* was a place for public meetings as well as dramatic productions. To begin with, the Greeks were content with a convenient hollow in a hillside, improved in time by banking and excavation and even the comfort of movable wooden seating; and it was not till the late fifth century that the first regularly planned stone theatre was constructed, still – for economy if not from habit – in the same sort of site. In these theatres the performance was concentrated in the circular space of the orchestra (that is dancing floor) and so there was some advantage for hearing and seeing if the auditorium came round it in more than a semicircle. The low 'skene' or stage building, set a little back from the orchestra, served at first only for dressing-rooms and as a support for scenery. Later, in the third century, this structure became more important, as its top became a platform for the actors to play on, and a second storey was added behind to provide a back wall for what was now a proper stage (*plate 75c*). In design the Greek theatre was always loosely organized, since the stage building remained separate from the auditorium, and it was left for the Romans to join the two parts in a fully unified structure. Till then architectural finesse was limited to the planning of the auditorium and the decoration of the stage block. The curve of the rows of seats was often splayed out – at Epidaurus the middle and the ends

of the rows are traced from different centres – and the pitch occasionally increased from the bottom rows to the top. For the stage building columns or engaged half-columns were the obvious embellishments. Of the many auditoriums which survive in a recognizable state that at the Epidaurian sanctuary of Asklepios is the finest and most impressive, but the general effect is clearer in the more modest theatre of the Amphiareion near Oropos and – though less purely – of Priene in western Turkey, since there the lower storey of the stage buildings has survived or been re-erected. Theatres of course had no roof, though there were some roofed buildings of theatral type – the Odeum (or concert hall) and, as has been mentioned, one type of council chamber.

The *altar*, on which to make sacrifices, was essential to Greek religion. Its height, as of any working surface, could not vary much; but a busy altar needed to be long and a desire for grandeur could extend it indefinitely. Since the structure had to be solid, decoration was limited to mouldings and ornamental fenders and occasionally a frieze, and further it might be raised up on a platform approached by a flight of steps. *Pedestals* for sculpture and other dedications were sometimes more obviously architectural. From the sixth century onwards a statue or even a votive relief might stand on a column, and in the third century there was a fashion for a pair of high columns linked by a length of entablature to serve as a base for a full-size figure. Still more elaborate were such follies as the Choregic Monument of Lysicrates at Athens (*plate 87*), built professedly to carry a prize tripod on its finial and, except for the tripod, miraculously well preserved.

Monumental tombs were alien to Greek habits, partly because of expense and partly from fear of seeming arrogant; but in western Anatolia, where Greeks were settled along the coastal fringe, some of the neighbouring potentates had both the taste and the means and were soon eager to employ Greek or Greek-trained sculptors and architects (often the same persons) for a more imposing job. In Lycia these monuments, which begin in the sixth century, generally resemble houses, presumably of the local style. Later, in the fourth century, Mausolus (who was the ruler of Caria) followed a more sumptuous standard and, though we do not know the details of his great tomb, which gave us the word 'mausoleum', it had a vast squarish podium supporting a colonnade and above that a stepped pyramidal roof. A little later, when

Macedonia became an important kingdom, some of its notables (who were dubiously Greek) had themselves buried in underground chambers entered through a porch like that of a temple: since these Macedonian tombs were to be covered with earth, the workmanship and even design tend to be careless, but several survive in excellent preservation, for instance at Pydna, Langadha near Naoussa, Varvares near Verria and Vergina.

Private *houses* and still more so *palaces* sometimes copied features of monumental architecture; but since domestic buildings had very different requirements and standards they are better discussed on their own (pp. 241–4).

The Doric Style (*plates 78-81*)

ORIGINS There were two principal styles of Greek architecture, Doric and Ionic. The Doric, which took form earlier, was the normal style of Greece itself and of Greek Sicily and South Italy. Its origins are disputed. Some of its decorative features, especially the guttae, the plates in which they are set, the triglyphs and the antae resemble or have been supposed to resemble functional parts of construction in timber: the guttae reproduce wooden pegs, the plates short lengths of planking, the triglyphs the ends of the cross beams of a ceiling or roof, and the antae timber sheathing of the ends of mud brick walls. Yet the Doric guttae are so placed that, if pegs, they could have little or no purpose and, as it happens, they do not occur on the earliest known Doric buildings; the triglyphs apart from their inordinate size come regularly at a lower level than the cross beams; and mud brick walls do not need a facing of wood (which itself was sometimes thought to need protection). So in spite of brave attempts at reconstruction, the Doric style as we know it cannot be a literal translation into stone of a structurally logical timber prototype. That does not, of course, mean that the decorative features of the stone style had not already appeared as decorative features in wood, which was indeed used extensively in early Doric architecture.

The first certain elements of the Doric style that we have are the terracotta metopes (*plate 28a*) and cornice blocks of the Temple of Apollo at Thermon, which from the style of the figures painted on the metopes are Corinthian work of about 630. Since Thermon

is in Aetolia, at the time a backward part of Greece, it is very unlikely that this was the first appearance of Doric features. In fact there are remains of monumental architecture of a generation or two earlier in the home territory of Corinth. At Corinth itself there was a temple on the site of the present Temple of Apollo, of respectable size, with walls constructed of large squared blocks of stone (which had grooves for levering with and were stuccoed) and roofed with terracotta tiles of an intricacy that suggests a new invention. At the Isthmian Sanctuary nearby another biggish early temple has been detected; it too had walls wholly of large stone blocks, grooved and stuccoed like those of Corinth, and similar, if perhaps less primitive, tiles. From associated finds the temple at Corinth should be of about 700 and that at Isthmia of about 675. Other early tiles from Perachora opposite Corinth and at the Panhellenic site of Delphi have no context. From none of these buildings is there any trace of columns or entablature, which presumably were of wood, and so we do not know if they were Doric in style, though certainly they had low double-pitched roofs. On the other hand we have models of temples from Perachora (*plate 74b*) and the Argive Heraeum, made respectively a generation or so before and after 700 at either Argos or Corinth, cities only thirty miles apart by road; and in these there is no intimation of the Doric style, though their makers were willing enough to give decorative details. Nor do the remains of contemporary buildings suggest any architectural finesse (compare Plate 74a). From all this the most reasonable conclusion is that both monumental architecture and the Doric style appeared suddenly at Corinth within the first half of the seventh century; and just as the new architecture with its large blocks and terracotta tiles must have been a revolutionary innovation, so the new style was invented to give it artistic form. In that case the inventor may well have used carpentry eclectically as a source of decorative embellishment, and also perhaps other branches of handiwork or even the remains of Mycenaean architecture. Further, in the sixth century, when we have many examples of Doric buildings, their remarkable uniformity in details of no structural importance argues that the style did not evolve locally and separately in several parts of Greece, but had been diffused in an already standardized form from a single area.

THE ORDER The temple was probably the earliest and certainly the pre-eminent concern of Greek architecture and on it the Doric style was established and refined. So for a description of that style it is again convenient to take as a standard the normal hexastyle temple with colonnade all round it, even though because of the adjustments needed to fit the Doric order to a surrounding colonnade one may well suppose that it was not for a peripteral temple that it was first devised. Externally the full Doric style comprises steps, columns, entablature, pediments and roof; inside there are also walls, antae and doorways; and the ceiling and the floor need mention too. Since Greek architecture relies very much on correctness of detail, it is proper to give careful attention to that detail and, since most of the blocks of a Doric building have a distinctive form, it is also flattering to one's self-esteem to be able to recognize and interpret them. Hybrid forms, mostly of Hellenistic date, are better described separately (pp. 228–30).

STEPS (*plates 79-80*) Neatly dressed steps were considered necessary in front of any external colonnade, unless there were strong practical objections. The bottom step rests on a rather wider foundation, whether built or cut out of natural rock, and the top of this foundation (the euthynteria) is normally left visible, though distinguished by its rougher finish and often inferior material. The top step serves also as the stylobate, that is the plinth of the colonnade. The regular number of steps was soon fixed at three, irrespective of their height, which was proportionate to that of the whole structure; and so in sizeable temples they became too big for comfortable use and were supplemented by a ramp or sometimes later by an inset stairway in the middle of the flight opposite the cella door. In refined building from the fifth century onwards the top step was often made slightly taller than the other two, and sometimes the bottom one also was taller than the second. At first their surfaces were kept quite plain (*plate 79*), but from the middle of the fifth century a strip at the bottom of the riser was sometimes recessed, perhaps for better visual definition, and occasionally the edges of the upper part of the riser might be drafted as well (*plate 80*). These innovations were probably suggested by the protective surfaces of unfinished steps, a sign that Greek architects too could deviate into preciosity.

COLUMNS (*plates 78-81*) Doric columns are set almost at the edge of the steps. They have no separately defined base, in this differing from the wooden posts of primitive Greek building; presumably even wooden Doric columns were considered to be well enough insulated from damp, if they stood on a stone pavement. The shafts taper upwards, canonically in a convex curve (the entasis) and are fluted. Normally there are twenty flutes, concave and separated by a sharp edge (the arris); though they diminish in width according to the taper of the shaft, the flutes keep the same depth (whether absolute or relative) and in good work of the fifth century their profile follows a composite curve, as if plotted from three centres. Partial fluting, where the lower part of the shaft is chamfered or quite unfluted, was not accepted till the third century; and cabling, where the flutes contain a convex rib, was a florid solution hardly favoured before Roman times. The tapering of the shaft may have its origin in the natural taper of the trunks of some trees, used for wooden columns or posts, and the fluting in the marks left by the adze when trimming such a trunk, but even so much more is owing to art. Entasis, though, was probably a later refinement; it seems to have appeared first in South Italy and in an exaggerated form, but did not become regular in Greece till the fifth century. Near the top of the shaft there are one or more horizontal necking grooves and above them the flutes usually flatten out in an outward curve against the three raised rings or annulets of varying profile at the base of the capital (which is, though, in practice normally of one piece with the uppermost part of the shaft, the division being either just above or just below the necking grooves). The capital itself, while undivided, is ostensibly composed of two members of about equal height, the echinus and the abacus. The echinus, circular in plan, spreads upwards in a hyperbolic curve, which in a series of abrupt changes became steeper and flatter till in Hellenistic work the profile is often meanly straight. The abacus is a simple rectangular member just greater in diameter than the echinus. A few early Doric capitals, perhaps in imitation of surviving Mycenaean examples, have a hollow channel at their base, sometimes ringed by overhanging leaves; but it is not known if this was the regular primitive type or an unsuccessful variant. Colour was limited to the necking grooves and the annulets, painted usually in red.

ARCHITRAVE (*plates 79-80*) The lowest member of the entablature, the architrave, is a series of beams stretching from one column to the next. In large buildings, for easier transport and hoisting, separate blocks were used for its front and rear parts. Its face, which is set a little back from the edge of the abacus of the capital, is quite flat except for a projecting rectangular band (or taenia) at the top and the small plates (the regulae) with round pegs (or guttae), which appear to be suspended from the taenia below but forward of each triglyph – a position in which pegs could have had no useful purpose. Although these members may seem to belong aesthetically to the frieze above them, they are always attached to the architrave, perhaps because it would have been more troublesome to carve them on the same blocks as the triglyphs and metopes. Generally the taenia was red, the regulae were blue and the guttae were left unpainted.

FRIEZE (*plates 79-80*) The Doric frieze, which stands a little back from the edge of the taenia, is composed of triglyphs and metopes. Normally the triglyph consists of three upright bars with bevelled sides, each bar being in plan a half-hexagon; the two V-shaped channels between the bars and the two half-channels at each end are at their tops rounded off and undercut or, increasingly after the fourth century, squared off; and both channels and bars are crowned by a projecting rectangular fillet. The front plane of the triglyph is also that of the architrave below the taenia. The metope, which is set back from the triglyph, usually has a flat squarish face, crowned by another fillet, often smaller than that of the triglyph. Triglyphs were painted, usually blue, as were the fillets of the metopes. The main field of the metopes was generally unpainted; but if (as on more elaborate buildings) it was decorated by sculpture in relief, that of course was coloured; and sometimes, perhaps not so rarely, it had instead a painted figure or group. Since elsewhere on Doric buildings only parts of little structural significance were painted, the painting of triglyphs suggests that Doric architects regarded the frieze, though apparently the most characteristic element of their style, as a wholly decorative adjunct; and in fact its only structural effects are to increase the height of the entablature and to raise the level of the ceiling inside, both modifications of more aesthetic than practical value. There remains the spacing of the triglyphs and metopes. The primary

rule was that there should be a triglyph at the corner of the frieze, the secondary that for a colonnade there should be a triglyph over the centre of each column and another triglyph halfway between each pair of columns (or, if there were more than one triglyphs between the columns, these should be evenly spaced). But in an outer colonnade the corner triglyph could be centred over its column only if the width of the triglyph was approximately equal to the depth of the frieze. For since, for structural stability, the frieze blocks had to be centred over the columns and the outer edge of the triglyph must coincide with the outer edge of the last frieze block of the adjoining side, then (as a simple diagram makes obvious) to be centred over the column the triglyph needed to have the same width as the end of that block. This solution was rejected by Greek architects, who for reasons that can only have been aesthetic required a narrower triglyph, and so the corner triglyph was always centred outside the centre of the end column. This meant, if the other triglyphs kept their supposedly correct positions, that the end metope was unduly widened and, to counter this breach of proportion, two devices were often used, separately or in combination: the next triglyph or triglyphs might be shifted nearer to the corner or the distance between the corner and the next (or next two) columns might be reduced, and so the increase in the width of the end metope was distributed over one or more of its neighbours, the increase diminishing progressively away from the corner. Though some purists from the fourth century on considered the adjustment of corner triglyphs a fatal defect in the Doric style, earlier Greek architects probably regarded it as a pleasantly teasing exercise and certainly Greek Doric had in spite of it a long and successful career. The problem of the internal corner triglyph, as in the angle of an L-shaped stoa, was much less tractable, though fortunately less often presented. Since here the triglyph had to abut on the edge of the adjoining row of frieze blocks, it was displaced – because of the thickness of those blocks – wholly outside the upper circumference of the corner column. The solutions generally adopted were at first either to omit the triglyphs and have two metopes meeting at the corner, or to reduce one or both of the corner triglyphs to a half-triglyph, in either case adjusting the spacing of the nearest triglyphs and metopes or of the nearest columns. Later, from the end of the fourth century, yet another device became popular, anyhow

in Ionia; the corner column was replaced by a pier with half-columns attached to its two forward faces and the angle of the extended frieze was filled with half-triglyphs. After all this it is pleasant to reflect that there were no corner problems over friezes on solid walls or above the colonnade of a tholos, since a circular building has no corners. Yet it is curious that on our earliest circular colonnade – that of the tholos known from the blocks re-used in the foundations of the Sicyonian Treasury at Delphi – the triglyphs were arranged in no relation to the columns, as if without his regular problem the architect of the early sixth century had already lost heart.

HORIZONTAL CORNICE (*plates 79-80*) Above the frieze comes the horizontal cornice, serving on the sides of a temple as the eaves. It is also continued horizontally across gabled ends, where the eaves are formed by the raking cornice, which differs only in the profile of its underside. This continuation of the horizontal cornice below a gabled roof is structurally unnecessary and might be a legacy from an initial stage of Doric where the roof was hipped, but even so it has an aesthetic justification in defining the roof more clearly and giving greater harmony to the favourite oblique view of the building. Afterwards it proved useful too as a floor and frame for pedimental sculpture. The horizontal cornice is a complicated member. It starts with a slightly projecting band that corresponds to the taenia below the frieze and like it was painted red. Above this the soffit extends forward and downwards; the forward extension brings its edge well clear of the line of the top step, a proper precaution for shedding rain off the roof (anyhow when the materials of the building were more permeable than stone), but the downward tilt is less than that of the roof, presumably again for some aesthetic reason. In standard Doric the soffit is heavily decorated with a series of rectangular plates (the mutules), each studded with three rows of six guttae; the spaces between the mutules are called viae. A mutule is placed directly over each triglyph (and regula) and over the middle of each metope and, since they are of the same width as the triglyphs, the mutules have the optical effect of uniting the cornice and the frieze. This effect was strengthened by their colouring, since the mutules were blue like the triglyphs and regulae, while the guttae were again unpainted. The viae, which were red, necessarily vary in width in

correspondence with the metopes, but remain narrow except at corners. If the corner is external, the via must be square; but the problem of an internal angle is tricky and can even determine the management of the frieze – a good instance of the complexity in use of the apparently simple components of the Doric order. That the mutules were a direct translation into stone of something practical in timber is unlikely because of the number of the guttae and the slope of the soffit; and perhaps the absence of mutules on the earliest surviving cornices indicates that they were not an original feature of the Doric style. Above and very slightly in front of the mutules another taenia forms the inner vertical side of a deep throating, the outer side of which makes a concave curve. This throating separates the mutules from the vertical front of the overhanging corona, itself surmounted by a projecting moulding, normally a hawksbeak (*plate 89d*), which is painted in red and blue and occasionally other colours. Properly the horizontal cornice was a bed for the roof, supporting the lowest tiles and the ends of the rafters, and so its top varies in contour, though usually sloping with the roof at least in its front part; sometimes this sloping part was a separate course dowelled to the lower part of the cornice and occasionally the tiles of the lowest row were made in one piece with it. The decorative horizontal cornice under a pediment has of course a flat upper surface, though if there was sculpture in the pediment this might be raised on a sort of step.

PEDIMENT (*plates 79-80*) At the gabled ends of Doric buildings the low triangular space between horizontal and raking cornices is filled by the tympanum, a plain wall set some way back and supporting the ends of the ridge beam and purlins. The raking cornice itself projects as far forward as the horizontal cornice. Its soffit has normally a hawksbeak moulding, painted red and blue, at the junction with the tympanum and from there projects in a gentle downwards curve. The outer face of the corona, with broad fascia surmounted by a hawksbeak, duplicates that of the horizontal cornice. At the angles, and especially the lower ones, where the raking cornice tapers to rest on the horizontal cornice, the termination of this hawksbeak and its painted decoration needed some finesse. Tympanum and raking cornice form the pediment.

ROOF (*plates 76a and 77*) At the sides of the roof the lowest row
of tiles rested on the cornice, and it was almost natural that the
end of the cover tiles of that row should be neatened and embel-
lished by an antefix. In early Doric this antefix often has the form
of the head of a Satyr or of a woman, presumably a Maenad (*plate
35b*); but during the sixth century the standard became a narrow
upright palmette, coloured red and black and with its detail either
moulded or only painted (*plate 76a*). Antefixes might be flush with
the edge of the cornice or project a little forward of it. With this
system of terminating the sides of the roof the rainwater was dis-
charged directly from the lowest pan tiles. An alternative system
was that of a gutter with spouts. The outer face of the gutter, the
sima, which is of about the same height as the cornice, was much
less constant than other Doric components in both profile and
decoration. Earlier simas are often composed of a vertical fascia,
a narrow half-round moulding and above it a large concave projec-
tion; the spouts are usually round tubes with discs at the end; the
decoration, mainly in red and black, is loud and varied. About the
middle of the sixth century a new type spread from, it seems,
Corinth; here the profile is a large ovolo springing immediately
from the fascia, the ovolo being painted in red and black with
alternating lotus flowers and palmettes and the fascia with a
meander, while the spouts have usually been elaborated into lion
heads. During the fifth century the ovolo became larger and the
fascia smaller and a final solution seemed to have been reached
(*plate 80*). Yet during the fourth century another version of the
sima was devised and became universal: this has a flattish vertical
face, decorated in relief or only in paint with a continuous leafy
scroll, of which the principal and perhaps only merit was that it
could be accommodated more easily to the lion heads (compare
Plate 84). This late type of sima is usually combined with antefixes
– unnecessarily, since to end in them the cover tiles have to ride
up on top of the sima. As for spacing, the spouts were usually
aligned in some regular relation to the frieze or colonnade below;
but the antefixes, if attached to the cover tiles, conformed to the
tiling of the roof and this was normally unrelated to the system of
spacing of the lower parts of the building. On the sides of a roof
the sima provided a useful deep gutter, but it had no such justifica-
tion on gabled ends. Yet, whatever the reason, a sima was normal
there above the raking cornice. This raking sima has, of course,

neither spouts nor antefixes, and its sections were made in one piece with the pan tiles of the end row. Where there was no sima along the sides, the raking sima was usually returned just round the corner to allow one dummy spout (compare Plates 76a and 80). Behind the raking sima, at each of the three angles of the pediment, a level platform rose to support an acroterion. The early forms of acroteria were on the apex of the pediment large discs and at the side perhaps heavy volutes, but in the sixth century floral ornaments or figures became regular; the new side acroteria tended to reach as high as the top of the tympanum or even the pediment and central acroteria were rather bigger. Finally, the crest tiles of the roof – that is the special cover tiles across the ridge – carried projecting palmettes similar to those of the antefixes and facing towards each side of the roof: at such a distance from the ground their detail could be and usually was rather coarse.

BACK OF ENTABLATURE (*plates 77 and 79*) Since the beams of the ceiling rested either on the top of the frieze or in cuttings a little way up the horizontal cornice (*plate 77*), most of the back of the entablature was visible. This was much plainer than the front. At the top of the architrave there was often a simple taenia without regulae or guttae, and immediately below the ceiling beams – and so either at the top of the frieze or at the bottom of the cornice – there was regularly a crowning moulding (or epicranitis), in a peripteral building repeated for balance round the outside of the cella. In good work of the fifth century the epicranitis consisted of a hawksbeak above a fascia, both painted appropriately. For convenience separate blocks, though of the same height, were used in larger buildings for the front and the back of both architrave and frieze; but the cornice or, if it was in two parts, its lower member was usually composed of single through blocks, as of course structural stability recommended.

ANTAE (*plates 78a and 81d*) An anta is the projecting end of a wall or the respond of a colonnade – especially in buildings or porches of in antis or prostyle types – which has received particular architectural treatment. It is sometimes said that this treatment originated in the protective wooden casing of a stub wall of mud brick, but structurally mud brick can do without such casing and there is no need to look for any explanation of antae other than the

desire to match the wall ends with the columns between them. To form a Doric anta the projecting end of the wall was thickened into a pier, either squarish or with a longer face on the inner side; or if the wall did not project, the anta was flattish like a pilaster. Properly the Doric anta has no base; its shaft is plain, though sometimes – in conformity with the wall – its outer face tapers upwards; and the complex rectangular capital, of much the same height as those of the columns, begins with a tallish plain member, projecting slightly from the shaft, then spreads in a large hawks-beak, sometimes supplemented by other mouldings, and ends in a shallow plain abacus which is occasionally crowned with another moulding. The mouldings, of course, have their regular colouring. This capital runs round each side of the anta and onto the short returns to the wall proper. As for the shaft, the anta is on average equal in width to the columns; but since it does not taper or, in conformity with the wall, only on the outer side of the face, it is usually rather narrower than the column at the bottom and broader at the top.

ENGAGED COLUMNS, PILASTERS AND PIERS Some architectural forms are not normal in strict Doric, but occur in laxer or later versions of the order. Engaged columns, usually half a column in circumference, were known in the fifth century, if not earlier, but did not become common until the third. They are found both on exteriors and inside buildings, and were applied to piers as well as to walls. In their details they follow the rules for whole columns. Pilasters, that is flattened columns without diminution or entasis, begin in the second century. At first their shafts were usually plain, but later taste preferred fluting or panelling; capitals in the initial stage corresponded to those of antae, afterwards to those of columns. Piers, unlike engaged columns and pilasters, have a structural purpose and so there are more examples of them. Generally they are square or oblong in plan and without entasis, and their capitals are much as those of antae. In the fourth century piers often acquired engaged columns, sometimes two on adjacent sides, though then the diminution normal to column shafts caused difficulties. An ingenious development was the substitution of a cluster of three columns attached to each other, the section being a sort of trefoil; this was used especially in Ionia and at re-entrant angles of colonnades.

DOORWAYS AND WINDOWS (*plate 78a*) The doorways of impor-
tant buildings were normally of stone, single blocks being used for
lintel, sill and each jamb. In Doric these blocks were considered
imposing enough to need little or no decoration, though the jambs
and lintel might have a facing of wood. Often the doorway nar-
rowed towards the top and the lintel might extend beyond the
jambs. The scale varied. The doors themselves, set far back, were
almost always of wood and, if large, were in two leaves, each
pivoting on a bar let into the sill and another let into the lintel
near the jamb. They might be panelled, sheathed in bronze or
studded. No wooden doors have survived, and for their appear-
ance we must judge from the stone doors (often false) of monu-
mental tombs, representations in Hellenistic and later pictures
and reliefs, and the cursory and perhaps simplified sketches on
vases (as Plate 27a). Windows were not much needed and it would
be rash to lay down rules about their treatment.

CEILINGS (*plates 77, 78a and 82*) The pitched ceiling formed by
the underside of the roof was rare in good temple architecture.
The 'slot' ceiling, where beams were set very close together with
planking above them, was more reputable but never common. So
one need consider only the coffered ceiling. Of this there were
two main varieties, one with narrowish strips or panels of coffer-
ing supported by wide beams, the other consisting of continuous
coffers which were separated by uniformly thin bars. Both varieties
and different versions of each might be used in the same building.
Where there were beams their spacing, anyhow in good work,
was not as a rule related to the spacing of the outer colonnade,
perhaps because this was itself not evenly spaced; and further,
without some abrupt change of design the coffering, unless very
wide, could not turn the corners of the passage round the cella
block. So in a peripteral temple this kind of ceiling was planned
in several compartments. At the ends the beams ran lengthwise
to the axis of the building, at the sides across it, in the porch or
porches lengthwise and in the cella again across (compare Plate
78a). Usually too, and probably not only for structural reasons,
the spacing of beams in the porches was independent of that at the
ends and, where the cella had internal colonnades, the aisles and
the nave may well have been treated separately. Because of these
difficulties and irregularities it is not surprising that some

architects preferred continuous coffering. Doric ceiling beams were normally plain, except for an ovolo moulding at the top; the coffers might have egg and dart painted on the risers or the soffits of their sides and a painted design – for instance a gold star on a blue ground – in their lids. In cellas and other enclosed buildings the ceilings were always of wood; in porches and within colonnades stone was preferred if it could be afforded.

FLOORS (*plate 78*) For ground floors large blocks or slabs of stone were usual, rectangular if the building was rectangular and usually wedge-shaped if it was round. Like the ceiling, the floor of the peripteral temple was planned in compartments. Normally each column stood on one squarish block and between each pair of columns there was another block of the same width from front to back: this series of blocks, the stylobate, which also served as the top step, was sometimes raised a little to form a continuous plinth for the colonnade. Since the space between the front colonnade and the porch was deeper than that between the side colonnade and the cella, it was convenient to plan their flooring separately, with of course rather smaller slabs than those of the stylobate. Larger slabs were wanted again for the colonnade of the porch and for the base of the cella walls, though these two series were not usually of the same size; they again might be raised slightly as a plinth. The floor within the porch had its own system too, and so had the cella. Not much attempt was made to co-ordinate the various systems. Upper floors, as in some stoas, were generally of wooden planking.

MOULDINGS (*plate 89*) Early Greek architects may have taken the half-round (or roll) and the cavetto from Egypt, but anyhow they soon improved on the simple forms and invented new ones, with careful attention to thickness and elegance. In Doric the most characteristic moulding was the hawksbeak, but the simple fillet was common, and some use was made of the astragal (or bead and reel), of the ovolo and of the cyma recta. Each had its appropriate decoration, sometimes thoughtfully recalling the profile of the moulding: on the hawksbeak there were flattened 'leaves', on the fillet – when it was decorated – a meander, on the astragal bead and reel, on the ovolo eggs and darts, and on the cyma recta lotus flowers and palmettes, which as a more naturalistic motive

underwent a steady evolution in form. In pure Doric architecture, uncontaminated by Ionic, the decoration of mouldings was not carved but only painted, mainly of course in red and blue, though details might be picked out in other colours and the beads of the astragal were normally left uncoloured. Compared with Ionic, the Doric style used mouldings sparingly. The exceptions are mostly of the Archaic period and especially in Sicily, where wooden or coarse stone cornices were often sheathed with extravagant revetments of terracotta, obscuring rather than emphasizing the architectural forms; and in the Hellenistic period there is a tendency towards incoherent enrichment. Generally the profiles of mouldings show a continuous though very gradual development till the end of the fourth century, remain fixed during the third, and then lapse into eclectic innovations or revivals of at best dubious taste. At present they offer the safest stylistic evidence for the date of Doric structures.

SCULPTURE (*plate 79*) Carved acroteria were required above both the end and the top angles of pediments of important buildings and usually had the form of a figure (or group) or of palmettes, whether simple or complicated; the commonest material was terracotta, but sometimes money ran to marble. Heads of Satyrs and Maenads were used as antefixes for some early roofs and later the sima regularly had spouts or false spouts in the shape of lion heads; again the material was terracotta or more sumptuously marble. There might also be sculpture, more or less in the round, within the pediment (*plates 46-47*) or, in relief, on the metopes. Here marble was regular, but neither of these embellishments was frequent, and carved metopes were often restricted to the ends of a temple or even put only above the porches of the cella block. Curiously, pedimental sculpture was always very rare in the West and till the fifth century carved metopes were nearly as rare in Greece itself. Perhaps here painted decoration was used more than we suppose; the earliest surviving metopes, so it happens, are painted (*plate 28a*) and there are a few examples from later periods. Architectural sculpture was of course coloured, like other sculpture.

COLOUR On the outside of Doric buildings painting was kept to the upper parts. The normal positions seem fairly certain, the

choice of colours less so. On the shafts of columns the necking grooves were generally red and on the capital the annulets of the echinus were similarly red. At the top of the architrave the taenia was red and the regulae were blue, but the guttae were plain. In the frieze the triglyphs were blue, as were the fillets at the top of the metopes; but the main field of the metopes was not painted unless it had sculpture, and then only the sculpture. In the horizontal cornice the mutules again were blue, the guttae plain, and the viae and the fillet above them red. The tympanum was blue, anyhow when there was pedimental sculpture. Antefixes and the decoration on simas and mouldings elsewhere were painted mainly with red and blue (or black if on terracotta), relieved as wanted by green, yellow and black. Sometimes too gold was applied, and plainly painted surfaces might be embellished with extra patterns. Architectural sculpture was, of course, coloured according to the current rules for statues and reliefs. As for roof tiling, Greek architects left it in its natural colour, red or yellow if of terracotta and whitish if of marble; nor did they mind combining a bottom row of marble tiles with upper rows of terracotta, since low-pitched roofs are not usually very conspicuous close to. These rules are not absolute and there were deviations, especially in later or less important structures. For instance regulae might be red like the taenia or not painted at all, guttae were sometimes coloured, triglyphs have been found which were red or had red bars but blue grooves, some carved metopes had a light blue ground, and both unpainted and black mutules are known. It is much rasher to be dogmatic about interiors. In a peripteral temple or a porch the outer face of the wall behind the columns was normally not painted (except for any mouldings on it) nor – so it seems – were the wall faces inside the cellas or enclosed rooms of important buildings, especially if they were of marble; but in lesser buildings, and probably increasingly as time went on, more completely decorated interiors might be expected (see pp. 247–54). Ceiling coffers were always gay, with painted mouldings on the sides and often patterning on the blue ground of the lid. Wooden beams too may well have been painted.

PROPORTIONS In the late first century Vitruvius prescribed comprehensive sets of proportions for the Doric temple and as early as the fifth century architects had begun writing treatises on their

buildings, which presumably explained the relations between one part and another. Yet Vitruvius's system has not been observed in entirety in any of our ruins, nor do measurements show that at any time the Doric order was subject to any simple numerical system. It seems then that like the sculptors Greek architects, though interested enough in proportion, did not often let theory obscure their eye for optical balance but allowed themselves reasonable latitude in applying whatever ratios might currently be accepted. In the standard temple with six columns at each end there was a general if erratic trend to shorter sides. Measured at the top of the steps the relation of length to breadth was in the early sixth century sometimes as much as $3:1$, in the fifth and fourth centuries often just under $2\frac{1}{2}:1$, and in the Hellenistic period at least occasionally less than $2:1$; or, to express the change less exactly but more obviously, the number of columns on the sides decreased from a maximum of sixteen to a minimum of ten, thirteen being the most usual number in the later fifth century. This shortening of the side colonnades meant that the cella block too had to be shorter and, since it soon became usual for the main room to be about twice as long as wide, in some very short temples the back porch of the block was eliminated. In the end elevations, on the other hand, the overall proportions remained remarkably constant: for hexastyle façades the combined height of columns and entablature was generally around five-ninths of the breadth at the top of the steps. Other constants were the height of the steps, which together equalled the lower diameter of the columns, and the height of the pediment, which with its regular pitch of not more than $15°$ was determined by the width of the façade. What changed – and fairly steadily – was the relationship between columns and entablature. In the sixth century entablatures were often around half as high as the columns supporting them, in the fifth century rather over and in the fourth rather under a third, and in Hellenistic times sometimes less than a quarter. Correspondingly the columns became taller; but though many Hellenistic shafts are distinctly thinner and some early ones either thicker or thinner, in general the diameter of the shaft was fairly constant, at the bottom keeping close to two-twenty-fifths of the width across the top of the steps of the hexastyle façade. A corollary of this elongation of column shafts – except in early examples – was that both diminution and entasis became less pronounced. At the same

ARCHITECTURE

time the capital lost in importance (*plate 81*). Early forms were
wide and rounded, the fifth century standard is taut and elegant,
and finally the member became little more than an impost with
slanting sides. For the entablature the norm was that architrave
and frieze should be about equal in height and the cornice about
half as high as the frieze; but though the architrave and cornice
could be reduced in height, compression of the frieze caused
difficulties. After some early experiments it had become normal
for the metope to be roughly square and for the triglyph to be
about two-thirds as wide as the metope, and it was also normal
in temples for the triglyphs to be spaced one above each column
and one halfway between each pair of columns, so that given the
spacing of the columns only limited adjustments could be made to
the height of the frieze. The solution, accepted by the fourth
century for stoas (where columns tended to be spaced more
widely) but for temples not generally till the second, was that the
number of triglyphs (and metopes) allocated to each column and
intercolumniation was increased from two to three or even four.
The main effect of all these changes was to make the building
appear lighter and more elegant, though by shortening the temple
and reducing the entablature there was also some saving in
materials. Rightly or wrongly, Hellenistic Doric is now usually
considered degenerate and it is the proportions of Athenian
architecture of the third quarter of the fifth century which are
taken as the correct standard.

SPACING (*plates 78b-79*) One might expect that in the Doric style
the position of columns and walls would conform to a simple grid.
This was not normal for peripteral temples, the most important
class of Greek buildings, until the Hellenistic period. First, the
front planes of the porches of the cella block lay somewhere be-
tween the second and third columns from the corners of the side
colonnades – the exact alignment at the east end of the Theseum
is due to the abnormal frieze across the front porch (*plate 78*) – and
the axes of the side walls of the block were usually a little inside
the axes of the columns next to the corners of the end colonnades,
with the further consequence that the columns of cella porches
were not regularly aligned with the outer columns in front of
them. These shifts, which had no structural advantage, produced
wider passages in front of the inner porches and along the sides,
but perhaps they are better explained as a device to detach the

cella visually from the outer colonnade and so make it appear more important. Nor were the outer columns set all at the same distance from each other. It was good practice, as far back as we can trace it, for the interval between a corner column and its neighbour on either side to be reduced – in the Theseum (*plate 78*) and in the Temple of Aphaia in Aegina (*plate 79*) by about one-eighth – and in Sicily during the fifth century there was often a further though smaller reduction of the interval between the next pair of columns. This 'angle contraction' helped with the problem caused by the corner triglyph (pp. 195–6), but its purpose may also have been to give an appearance of greater stability at a corner, as did the slight thickening of the shaft of the corner column. Another deliberate irregularity, not current after the sixth century, is harder to understand; in Greece the columns at the ends of a temple were a little further apart (and also thicker in diameter) than those of the sides, while conversely in Sicily and South Italy the columns of the sides were often further apart than those of the ends. Characteristically, Doric architecture did not emphasize the position of the entrance by spacing the columns there more widely, and indeed the standard approach to a Doric temple was not frontal but oblique (compare Plate 90): to this reticent treatment the main exception was the propylon (*plate 82*), where the central passage had to admit animals and carts. As for the normal interval between columns, this in temples was for long very roughly one and a third times the lower diameter of the columns, rather less if the scale of the building was large and more if small. In stoas, as was more convenient and economical, inter-columniations tended always to be wider (*plate 75b, central block*), enough so to require three pairs of triglyph and metope to each column, while the temple had only two, or in the laxer version of the Hellenistic style four or five pairs to the temple's three.

OTHER REFINEMENTS There were subtler irregularities devised by Doric architects for their most important buildings. The stepped platform may curve upwards from its corners – in the Theseum (*plate 78*) the rise at the centre of the ends is about three-quarters of an inch and of the sides about one and a quarter inches, or in proportion to the length rather less than 1 in 700 and 1 in 1000 respectively. This curvature which started on the foundation of the platform was repeated in the entablature, if (as was usual) the

columns were of uniform height, and in the Theseum it affects the raking cornice too. Though it is often impossible with ruins to detect such slight deviations from the horizontal, deliberate curvature – anyhow of the platform – had certainly been introduced by the middle years of the sixth century, was fairly frequent in the fifth and fourth, and still appears occasionally in Hellenistic architecture. Nor were verticals left unimproved. The shafts of external columns, but not their capitals, were tilted a little inwards – in the Theseum about one and a half inches or 1 in 150, except for the corner columns where the inclinations of both the end and the side were compounded. The members of the entablature and the pediment seem to have lent backwards, though Vitruvius says it should be forwards; perhaps in these higher reaches, where measurement is now rarely possible, Greek practice varied according to the taste or whim of the architect, as it apparently did with the face of the abacus of the capital. In the cella block antae may incline backward or forward, the side (but not the cross) walls sometimes have a backward slope of their outer face, and doors and windows generally narrow upwards. On what principles Greek architects calculated these and other refinements (such as entasis and corner contraction) we cannot know; but the execution of some of them, particularly inclination of columns, required very precise craftsmanship, even if the setting out could be done by simple instruments, such as the ruler and the plumb-line. The purpose must have been aesthetic, not practical. Vitruvius in the late first century regarded the refinements as optical corrections to counter disturbing effects of perspective and position and, though he is generally inaccurate in his rules for Greek architecture (including those for refinements), no better solutions have been conjured up. There is little conviction even in the theory that the curvature of the platform was devised originally to drain off storm water, since the fall is too little to be fully effective and, where the stylobate – that is the course supporting the columns – was slightly raised, that must have acted as a dam. The refinements are likely to remain a mystery. Some of them are evident to the modern eye, but others are barely or not at all perceptible and one may wonder if at times the ancient architect was not indulging his private fancies rather than satisfying the sensibilities of his clients, even though their sensibilities were more finely educated than ours.

DEPLOYMENT OF DORIC ORDER For the peripteral temple the full order of the pteron has been described already (pp. 193–200), but there are more temples and treasuries which had an imposing porch, whether prostyle or in antis, and no surrounding colonnade. Here the façade of the porch was treated in the same way as the end of a peripteral temple, except that the place of the end columns might be taken by antae; the exposed walls at the sides usually had a full entablature, though sometimes there was only an epicranitis immediately below the cornice; and the back, unless it too had a porch, conformed with the sides except for the addition, if the roof was gabled, of a raking cornice. It was much the same with stoas, though since their ends were unimportant a hipped roof was permitted. To return to peripteral temples, within the outer colonnade there was the cella with a prostyle or in antis porch (often closed with metal grilles) at one or both ends and, since it usually stood on the same level as the outer colonnade or only one or two steps higher, its scale was more or less the same. In its architectural treatment the cella porch followed the rules for a prostyle or in antis temple as far as the top of the frieze; but because of the ceiling there was not room for a full cornice and its place was taken by a low epicranitis, corresponding to the epicranitis on the back of the entablature of the outer colonnade. Though the entablature of the porch was not easily seen, it was considered important and in the Temple of Zeus at Olympia and a few other instances carved metopes were put above the porches and not in the external frieze. Inside the cella the walls were again plain except for a crowning epicranitis, but especially in larger Doric temples the span across the cella might be broken by a row of columns, in some early examples down the centre though usually – to leave a clear view from the door – along each side and sometimes across the far end too. Such colonnades, if Doric, were regularly of two storeys (plates 77 and 78a), the upper and smaller columns continuing the taper of the lower set and like them supporting an architrave but no frieze – a lightening of the entablature not practised on exteriors. This superimposition of columns, which the visitor can see in the so-called Temple of Poseidon at Paestum and, though restored, in the Temple of Aphaia on Aegina, was more or less necessary in a pure Doric style, since the ceiling of the cella was at least as high as that outside and so single columns of standard proportions would have been oppressively

bulky in relation to the room. It is not surprising that in the later fifth century architects took to using the relatively taller Ionic column in this position and so eliminated the cumbrous upper storey. Temples were of course especially elaborate in detail, but from the rules that have been given one can work out well enough how the Doric order was or might have been applied for other types or parts of buildings or quasi-architectural structures.

The Ionic Style (*plates 83-88*)

ORIGINS The Ionic style, lighter and more ornate than the Doric, is at its best admirably elegant. Its home was in the Greek cities of the eastern Aegean and, though the most grandiose of its early productions have been found in Ionia, it is possible that some of the Aegean islands – in particular Naxos and Paros – may have been important pioneers. Since very little is known of the architecture of this region till the second quarter of the sixth century, it may be accident that we have no older remains which are specifically Ionic, but certainly there was much more variation and experiment than in European Greece. At least two other types of capital competed with the ultimately successful Ionic and a refined standard for the order, so it seems, was not established till the later fifth century, when Athenian architects applied to it the discipline they had learnt on Doric.

The first hundred-foot temple on Samos, built early in the seventh century, is the oldest East Greek building yet discovered which had a surrounding colonnade; but since its superstructure has disappeared, presumably because neither stone nor terracotta was used in it, we know nothing of its style, if indeed it had any. Its successor some fifty years later had good limestone walls and perhaps a tiled roof, but there is still no sign of elaborate architecture. For this in the Asiatic region our first clear evidence is at Old Smyrna, where remains have been found of a monumental temple, perhaps not yet completed at the destruction of the city about 610. It had columns of whitish tufa but nothing of its entablature was identified. Fragments of capitals show a pair of tall volutes springing vertically from their base (of the type illustrated in Plate 88a); but since such volutes give the impression that the

capital is splitting, unless they are visually secured by some emphatic belt, it could be that the Smyrna capitals had as their lower parts the circular pieces found on the site, which are composed of a large torus above a flaring member, both carved lightly with leaves and flowers. A similar lower piece has turned up at Phocaea, some twenty miles from Smyrna, and further north in Aeolis, both in Lesbos and on the mainland, there are more examples of capitals with vertical volutes, sometimes certainly resting on a torus carved with leaves (*plate 88a*). The Aeolic specimens, mostly of the early sixth century, come from unpretentious buildings and are probably provincial, but it is noteworthy that they vary considerably in the details of the volute and of the torus. Related capitals were used in the sixth century for some votive columns in Delos and Athens. Sometimes the torus with leaves may have been used independently as a capital. The more complex palm capital certainly was, a sort of drum carved with long leaves curling over at the top; this is known from soon after the middle of the sixth century and seems to have survived into the Hellenistic period, when it had some popularity with the architects of Pergamum. The nomenclature of these capitals is confusing. Most writers call those with vertical volutes Aeolic, since the examples from Aeolis were the first to be studied, but others give that name to the palm capital and for the Aeolic volute capital use the tendentious term 'Proto-Ionic'. Definitely Ionic capitals – on our present evidence – first appeared around 570 in Naxos and Ionia. They very soon became the dominant type.

The origins of the specifically Ionic order are as obscure as those of the Doric. In western Anatolia the Greeks had foreign neighbours, not all backward; but we know too little to judge what, if anything, the pioneers of Ionic architecture borrowed from them. Some of the early capitals had or may have had an Eastern ancestry. Leaf types were widely spread and the palm capital, which also appears in Crete, may well have been borrowed directly from Egypt. Volute members too were known in Cyprus and further east, though these (so it seems) did not serve as capitals of columns and in architecture were usually squat, with vertical volutes separated at the base by a broad triangle. Yet even if such pieces are accepted as the source of the Aeolic volute capital (*plate 88a*), the properly Ionic capital (*plate 88b*) should be a Greek invention; with its horizontal volutes and – in the early stage – their much

wider extension it can hardly owe more, even to Aeolic, than the notion that volutes were a suitable decoration for capitals. Still, volutes were a common enough motive in other branches of Greek art (in simple forms for instance on Plates 14 and 17b) and early Greek architects could easily have picked up there both the notion and the general form. There is of course also the hypothesis that the features of the Ionic order were derived from functional forms of construction in timber. For wooden columns a stone footing is desirable as a protection against damp, even if the composition of Ionic bases is unnecessarily elaborate. The great width of the earliest Ionic capitals has suggested that they were a decorative version of the bracket capital, though we have no other evidence that the Greeks of the sixth century used this device to widen the bearing surface of a column and, if they did, the subsequent contraction of the volute member shows that it was not necessary here. Indeed, if a functional explanation is wanted, one might consider that the oldest Ionic capital so far recognized belongs to the Naxian Column at Delphi and this was not part of a building but the support of a sitting sphinx; conceivably then the proportions of the archetype were determined by sculptural chance. As for the architrave, its three horizontal fascias are often said to imitate planks, though it is not obvious why, in contrast to Doric, planks should have been preferred to beams and the fascias at the back normally do not correspond with those at the front. Again, the dentils which come above the architrave look very like the ends of joists; and yet in Ionic as we know it the dentils are higher than the ceiling beams (which also are heavier and more widely spaced) and, since they are set horizontally, cannot represent the rafters of a pitched roof. Dentils occur too, though how early is not known, in buildings in Anatolia that are not Greek, but a sufficient explanation is that early Greek architects on the east as well as the west of the Aegean, when looking for decorative features for their new styles, took whatever they found pleasing aesthetically without any pedantic regard to its structural relevance. A likelier debt to Anatolian practice is the use of deep bands of figured or floral decoration – 'friezes' in the sculptural rather than the architectural sense – to enliven a dado or wall or parapet; but this usage, of which there are also examples in Crete no later than the seventh century, does not appear often except on earlyish buildings of indeterminate style. Lastly, there is the

connection between Ionic and Doric, not only in types of build-ings and technique, but also in their general plan and design: both have a taste for peristyles and a distaste for annexes, and both insist on a low-pitched roof and the defining of the pediment by a horizontal cornice. Here, if (as seems likely) the Doric style developed first, Ionic must have been more often the borrower, though to judge by the comprehensive dissimilarity of their decorative features one might be tempted to suspect that the early East Greek architects set out deliberately to concoct something original or at least distinctive, but lacked a dominating inventor who could impose a firm canon.

THE ORDER In defining the rules of the Ionic style there are various difficulties. First, that style was much less uniform than Doric, at least till the Hellenistic period, and extra mouldings and other decoration might break out on almost any part of the order. Secondly, remains of Ionic buildings are scarcer and have been studied less systematically: indeed the earliest temple in Greek Asia of which the elevation can be reconstructed with certainty is only of the fourth century. Further, when Ionic was brought across the Aegean to Greece itself, it underwent important changes there, presumably through the influence of Doric, so that from the third quarter of the sixth century till the third or even the second century there were in effect two parallel Ionic styles, one Asiatic and one European. This is in a way surprising, since till the Hellenistic period Ionic was not much used in European Greece as an independent order and where so used the scale was generally small. Yet what is now generally thought of as standard Ionic is the European style as current in Athens in the later fifth century and, though this contributed much to the Hellenistic standard, it is for the architectural historian an impurer, if aesthetically more satisfying, recipe.

STEPS (plates 83 and 86) In Ionic, as in Doric architecture, a stepped platform was normal; but anyhow in Asia Ionic steps were usually of a height suitable for use, their number was not fixed, and the flights were sometimes interrupted by a landing. Further, the relation of height of platform to size of building was not fixed, though very low platforms are mostly early. Occasionally, even in the fifth century, an Ionic temple might have a podium or high

platform with steps only at the front; and in Lycia, where native rulers imported Greek art, there was a fashion for tombs consisting of a small Ionic building elevated on a very high and completely stepless podium. In Europe, of course, the example of Doric was more insistent and three steps were from the beginning or soon became the rule.

COLUMNS (*plates 83-88*) The Ionic column, which occasionally stood some distance back from the top of the steps, was slenderer than the Doric and always had an emphatic base with or without a plinth. This plinth, normally square but occasionally eight-sided, was low and only rarely decorated; though it occurs early, it did not come into common use till the later fourth century. For the base there were two main types, known as the Asiatic and the Attic. Essentially the Asiatic type consisted of a pair of discs, usually slightly concave in profile, and above them a strongly convex torus, enlivened by horizontal flutings: Plate 88c shows what was regarded eventually more or less as a norm, the upper part of the torus here being plain. Bases from the dipteral Temple of Hera on Samos, of the 560s, are the earliest specimens known of the Asiatic type and perhaps the earliest made: at least the imposing votive Column of the Naxians at Delphi, which was little if any older, was content with a simple cylindrical member and, so it appears, the fluting of the Samos bases was done on a stone lathe, a machine which (according to Pliny) was invented by one of the architects of this temple. In contrast the Attic base was simpler and more compact (*plate 83*). It was eventually composed of three parts – from bottom to top a low torus (occasionally fluted), a scotia (the concave member) and another but rather narrower torus – though some earlyish examples added a splaying foot at the bottom. This standard Attic base seems to have been an Athenian refinement of the later fifth century, based on earlier experiments, and in spite of the reluctance of the Asiatic Greeks, who accepted it only in the second century, and the weary variations turned out by lesser Hellenistic architects it set the pattern for the Roman and Renaissance world. All these bases may have been emphasized by colour. In a few lavish temples a high drum carved with human figures was inserted between an Asiatic base and the shaft proper; the first examples are of the middle of the sixth century, but such extravagances were always abnormal.

The shaft of the Ionic column narrows from bottom to top, though less than the Doric shaft; and entasis, when it occurs, is less pronounced. At the bottom the shaft flares out, sometimes to a small half-round moulding, so making a harmonious connection with the base, and there is a corresponding but smaller apophyge at the top. Fluting is a normal feature. Some early Ionic shafts had as many as forty-eight flutes, but by the early fifth century the standard number was fixed at twenty-four. Except in these early examples where the number of flutes is abnormal they are separated by fillets, narrow strips of the cylindrical surface of the unfluted shaft, and at the ends they generally die out within curving boundaries. In some instances there is a necking band at the top of the shaft above the flutes; this is usually carved with lotus flowers and palmettes or other floral ornaments. In the third century, as in Doric, it became permissible in inferior work to flute only the upper part of shafts, and in later times cabling – the insertion of a convex rib in the flute – was tolerated too.

The normal Ionic capital (plates 84, 85 and 88b,e) had three parts – the echinus, the volutes and the abacus – and its front and back views differed from those of the two sides. The echinus, circular in plan to match the shaft, had regularly an ovolo profile and was carved with egg and dart. In some very early examples, which may well be more primitive, the profile was a simple curve and the ornament short blunt leaves. The volutes, the dominant feature, were laid horizontally on the echinus, stretching beyond and overhanging it. From a central boss or eye a shallow channel, bounded by grooved ribs, made between two and three spiral revolutions, widening continuously, and then proceeded, horizontally along the top but often sagging along its lower edge, to join the channel of the other volute; the angle where the channel left the volute proper was filled with a small palmette. This is the Classical formula; but usually in the sixth century and sometimes still in the fifth the channel was convex and the volute without an eye, and occasionally – perhaps originally – the channels from the two volutes did not meet but stopped in rounded stumps with a flower or other ornament between them. On the sides of the capital the volutes formed the ends of a sort of bolster (the pulvinus), at first roughly cylindrical but soon more strongly flaring. In earlier examples the pulvinus was decorated by spaced vertical bands or with scotias recalling those of the base (plate 88c); but later, as the

waist became more pinched, there was a tendency to encircle it with a broad belt (*plate 85*) from which leaves or other ornaments might spread over the rest of the surface. The depth of the volute member from front to back was roughly that of the top of the shaft and perceptibly less than the greatest diameter of the echinus, but its width was much more. In very early Ionic capitals the volutes hung clear of the shaft (*plate 88e*), but there was a steady contraction till in the fourth century the eye was aligned with the edge of the shaft (*plate 88b*), and in the Hellenistic period there was a tendency – especially in Asia – to raise the echinus and so flatten the drooping link between the volutes. Above the volutes came a low abacus, at first oblong in plan but later, as the capital became narrower, square or at least equilateral: its profile was a cyma reversa (*plate 89e*) or sometimes an ovolo, each decorated appropriately. Occasionally, but not in the earliest capitals, the abacus was omitted. As might be expected, colour was used to clarify the details.

A capital of this kind, with its different front and side faces, was not suited to corners where two rows of columns met, so that one may suspect that its first architectural use was not in peripteral buildings. For external corners there was the obvious remedy (*plates 83, 84* and *88b*) of putting volutes on both the contiguous outer faces, with the adjacent spirals bent forward against each other to give an effect rather like that of a ram's horn; the other two faces of the capital had bolsters, which met at a right angle and, as the volute member became narrower, ostensibly intersected. Such corner capitals can be traced back as far as the 530s and may well have been invented for the first peripteral temple with Ionic capitals. In re-entrant corners, such as those of a stoa with projecting wings, the normal volute member could not be adapted plausibly and here architects preferred square piers with anta capitals, at least until the diagonal capital had been accepted. This diagonal Ionic capital was a logical development from the corner capital just described. Each of the four faces, now of the same width, was provided with a volute member, bent out at the angles, so that the capital was equally serviceable at corners and in a row. Yet though the diagonal capital was envisaged before the end of the fifth century – in the attached half-capitals inside the cella of the temple at Bassae – it was not used much for free-standing columns before the first century. Perhaps the diagonal

accents were felt to be excessive. For both the normal corner capital and the diagonal capital the echinus followed the contour of the volute member.

The Corinthian capital too (*plates 87* and *88d*) belongs properly to the Ionic order, since in Greek architecture the so-called Corinthian order has nothing distinctive except its capital. The principal member, tall and compact and with four similar faces, consists essentially of a bell with a double ring of acanthus leaves and on each face two pairs of vertical volutes springing from them; the outer volutes are bent forward to accommodate their counterparts on the adjoining faces of the capital, and the inner volutes (which are lower) meet below a palmette or flower. Below the bell the top of the shaft usually has a simple roll moulding; and the abacus, which is deeper than that of the Ionic capital, is usually complex in profile and in plan a concave quadrilateral, sometimes cut off at the corners. The Corinthian capital, which serves more ornately the same purpose as the Ionic diagonal capital, appears with half-capitals of that type inside the cella of the temple at Bassae, which was built in the later fifth century, and Vitruvius says that it was invented by Callimachus, a sculptor and metalworker of that time; but though the crisp design may look metallic, there are intimations, especially at Tarentum, that architects or at least monumental masons had been experimenting already in this direction. For the next century or so the Corinthian capital was used occasionally in interiors, but except on the little Choregic Monument of Lysicrates (*plate 87*) it is not found externally before the third century nor did it reach its full popularity till Roman times. Though a standard form was established only in the late first century, some general sort of trend can be observed before: the acanthus leaves become taller; the stalks of the volutes are encased in a fluted sheath, and the palmette or flower moves up from the volute member to perch on the abacus. Again the detail was elucidated by colour.

Still other types of capital were tolerated by Ionic architects. Of these the tight palm capital (see p. 212) was the most reputable. It had appeared before the Ionic style was established, was selected for two Ionic treasuries at Delphi soon after the middle of the sixth century, and probably continued in occasional use till Pergamene architects gave it a limited vogue in the second century. Even so, the palm capital seemed too austere to some

architects and by the mid first century (since it is found on the
Tower of the Winds at Athens) a richer hybrid had been devised,
where the palm leaves emerged from the foliage of the lower part
of a Corinthian capital. Sometimes too the Ionic capital was en-
livened by more exuberant conceits, mostly of the Hellenistic
period, with heads or foreparts of animals or human beings pro-
jecting from or substituted for volutes or affixed to spirals or less
obvious places; but none of these inventions developed into a
regular type.

Lastly, there are the Caryatids, statues of standing women which
did duty as columns (*plate 83*). Since human proportions are much
squatter than those that Ionic architecture required in this posi-
tion, such statues had to be set on high pedestals and, so that the
figure should not appear to be oppressed by the entablature, head-
room was provided by inserting a polos (or cylindrical hat)
between the statue and the capital, unless – as in the South porch
of the Erechtheum (*plate 83*) – the superstructure was relatively
light. Further, the capital proper could not be allowed to distract
attention to itself and appropriately had the form of a low spread-
ing member, much like a decorated Doric echinus with a square
abacus above it. Though Caryatids had been invented by about
540, they were always rare; in Greek architecture the notion of
human supports was incongruous, and generally they were risked
only in small showy structures.

ARCHITRAVE (*plates 83-85*) In larger buildings, for convenience
of transport and erection, the Ionic architrave was divided verti-
cally – into front and back blocks – but not horizontally. Yet in its
familiar form the face is given a strong appearance of horizontal
division by the three bands (or fascias) which run across it in
ascending order of size and projecting a little one above the other;
these fascias are capped by a small astragal and a big ovolo, carved
respectively with bead and reel and with egg and dart. The fasci-
ated architrave is with very rare exceptions the only form known
in Greek Asia, where the first surviving example is of about 530,
and presumably it goes back to the earliest stage of the Ionic style.
In European Greece on the other hand the oldest architraves –
admittedly from treasuries – are, like those of Doric, uninter-
rupted by fascias, though they always have the astragal and ovolo
at the top; still even there the Asiatic form is regular in the late

fifth century. Apart from the crowning mouldings architraves were not usually decorated before the late Hellenistic or Roman period. Then a luxuriant, if turgid, taste often inserted astragals between the fascias and enlivened the soffit between the columns by sinking a long narrow panel and lining it with bead and reel and other carved ornaments. An earlier but modest example of such panelling can be made out in section on Plate 85.

FRIEZE (*plates 83 right, 86 and 87*) The frieze is a simple member, crowned like the architrave with an astragal and an ovolo, both appropriately carved. Its height is about that of the architrave, rather less if plain and rather more if sculptured, and its face is in much the same plane. Friezes with curved profiles, later common in Roman architecture, occur rarely from the fourth century on, and then associated with the Corinthian rather than the Ionic capital. At first and for a long time the frieze was an alternative feature of Ionic. In entablatures from the Asiatic region there is no example of a frieze earlier than the middle of the fourth century and till about 300 it was regular for the dentils of the cornice to rest directly on the architrave. Yet in European Ionic, where our evidence goes back to about the middle of the sixth century, it was equally regular to insert a frieze but do without the dentils (*plate 83 right*), and the first known use of the Asiatic formula is about 415 in the Caryatid porch of the Erechtheum (*plate 83 left*). Later, about the 330s, some European entablatures began to combine frieze and dentils (*plate 87*), and in the next century this now familiar compromise became frequent in Asia too (*plate 86*). How the early divergence arose we can only guess. The likeliest reason is that the European Greeks, accustomed to the proportions of Doric, felt that the Asiatic entablature was too squat (compare Plates 83 and 84) and so they added a structurally unnecessary member, though this does not explain their omission of the dentils. It may have been an extra recommendation that the frieze provides a field for sculpture in relief; yet in practice most Ionic friezes were plain and, as rare examples show, sculpture could find a place on the architrave.

HORIZONTAL CORNICE (*plates 83-86*) We know almost nothing of early Asiatic cornices and so must assume that they were like those of European Ionic (*plate 83*), but with the addition of dentils

(*plates 84-85*). It is presumably chance, whether of material or survival, that the earliest Greek dentils yet known are of the mid fifth century and come from a building of Asiatic style at Locri in South Italy, though there are rather earlier examples at Persepolis in Achaemenid work which shows some Greek derivation. Anyhow, Ionic dentils appear as rectangular blocks projecting from a vertical fascia and covered by a horizontal plate. In the standard order their height is roughly a third that of the architrave, their width about two-thirds of their height, and the intervals between them rather less; but some provincial structures show much bigger dentils and this may have been the original practice. Usually there is no dentil at an external corner, so that a square piece of the plate shows, sometimes decorated with a palmette; but in a re-entrant angle a square dentil can hardly be avoided. Dentils are regularly plain, though in later work there may be a low step across the middle of the plate between them. The plate extends a little forward of the dentils, then turns upwards to be surmounted by mouldings, particularly the astragal and the ovolo. Above the dentil system – in European Ionic directly above the frieze – the corona projects boldly forward, its soffit making a long concave curve (much like that of the Doric raking cornice) down to a squared beak and its outer face rising vertically to another astragal and ovolo, sometimes of smaller scale. The use of brackets and modillions to replace or supplement dentils, was beginning in the first century, but their full exploitation did not come till the Roman period.

PEDIMENT (*plate 83*) The normal Ionic pediment is very shallow, with the face of the tympanum well forward of the architrave, and it did not contain sculpture. In a few very large temples the tympanum was broken by three 'windows', which reduced the load on the wider spans of the architrave but, since they could have been but were not masked, perhaps have some aesthetic intention too. The raking cornice is similar to the horizontal cornice, though without dentils except in a few late instances (as Plate 86), and consequently the tympanum appears much more heavily framed than the Doric.

ROOF In Ionic, as we know it, the roof was tiled, with a pitch of perhaps around 13°, slightly lower than was regular in Doric.

Some early Ionic buildings had antefixes along the sides, but the continuous sima is more characteristic. The Asiatic version is at first a tall simple member, sometimes decorated with figures in relief and on the sides of the roof pierced for spouts. It is thought to be derived from the parapet of flat-roofed buildings of native Anatolian type, and during the sixth century and later it seems that terracotta sima slabs of this kind, made from moulds and arranged in monotonous repetition, were the main embellishment of many nondescript buildings in Greek Asia and further inland. In European Ionic the sima usually had a moulded profile, with the appropriate carved pattern; and during the fourth century this kind of sima was accepted in Asia too – cyma recta in profile and carved in the contemporary manner with leafy scrolls (*plates 84-85*). There is nothing peculiar about Ionic tiling.

BACK OF ENTABLATURE (*plate 85*) In Ionic architecture the ceiling normally was lower than in Doric and nothing higher than the architrave was visible from below. This tended to be lower at the back than at the front, especially in larger buildings where separate blocks were used for the two faces. So the fascias did not regularly correspond in height or indeed in number; where the front had three, the back – anyhow in the Asiatic style – more often had only two. There were of course crowning mouldings, particularly the astragal and the ovolo.

ANTAE (*plate 83*) In Asiatic Ionic it seems that antae were originally no thicker than the walls of which they form the ends, but European Ionic like Doric preferred thickening and this became common in Asia too from the fourth century on. Bases normally resembled those of columns without always repeating them, though some early buildings in Chios found a place here for gigantic lion paws. The shaft is plain and does not taper upwards; and sometimes, as on columns, there is a necking band with lightly carved ornament. Capitals are richly moulded. In early Asiatic there was a liking for such heavy effects as a triple bank of ovolos, each with its astragal below it; but the decoration of the sides may differ from that of the front, with for example a volute corresponding to each ovolo. In the European style the decoration, which is uniform on front and sides, again has three tiers, but is more delicate; favourite units are – from bottom to top – the half-round, the cyma reversa and the ovolo. (On Plate 83 there are

two ovolos and a cyma reversa and the shaft has a necking band.) A quite different anta capital, the so-called sofa capital, was also developing before the end of the sixth century. Here the face is framed by two vertical volutes, bonded together at the bottom by a horizontal fillet; the field between the volutes has figures or ornaments carved in relief; and above there is a shallow abacus. The earliest known example of the type comes from Sicily and some think it began there, but there are others not much later in date in the Peloponnese. In Asia the sofa capital became regular in the fourth and third centuries.

ENGAGED COLUMNS, PILASTERS AND PIERS In Ionic architecture the treatment of piers, engaged columns (*plate 87*) and pilasters is similar to that in Doric, though the features of course are Ionic and include bases of the kinds used for columns.

DOORWAYS AND WINDOWS (*plate 86*) Ionic doorways were generally more ornate than Doric. In elevation they may be trapezoidal or rectangular, the lintel often projects beyond the jambs, and the stone frame might be lined with wood. Decoration tends to be richer; the sides and top usually have a complex recession of smallish mouldings, sometimes surrounded by a broad smooth band carrying carved rosettes, and above there may be some sort of cornice and sima, in some examples supported on volute brackets. Or the jambs may be connected by a simple architrave. Sills sometimes have mouldings on the outer face. Windows are treated much as doorways, though usually with less elaboration.

CEILINGS (*plate 85*) Ionic ceilings are low. Often the beams are set halfway up the architrave and very rarely rest higher than its top – another indication that the frieze was an intrusive member. Again wood was used for cellas or other enclosed rooms. For coffered ceilings the beams, wider than those of Doric, are regularly aligned on the columns and, since Ionic columns are more equally spaced, the pattern of the ceiling too can be more regular. Supplementary beams between the columns seem to have been an Athenian innovation. There should be, of course, a crowning moulding, usually an ovolo with its attendant astragal. The coffers also are larger and deeper, with as many as four recessed stages, each decorated with mouldings; the ovolo with astragal is a

favourite. Development was to still greater exuberance, and in Hellenistic work beams were assimilated more closely to architraves by the provision of fascias on their sides and sunken panels on their soffits.

FLOORS Ionic floors are like Doric, except that the shape and arrangement of the slabs tend to be more uniform. This was at least in part an effect of the more equal spacing of the columns and walls and perhaps also of the setting of outer columns some distance back from the edge of the steps.

MOULDINGS (*plate 89*) Ionic mouldings are not more elaborate than Doric in profile, but they are used more profusely and their decoration is more emphatic, since it was carved as well as painted, whereas in the pure Doric style it was only painted. In Chios during the late sixth and earlier fifth centuries this decoration was even more extravagant, with palmettes or scales in low relief encumbering the surfaces of eggs and Lesbian leaves. The favourite Ionic moulding, especially in early work, is the ovolo, carved with egg and dart; it appears in various sizes, according to its position, and very often has a small astragal below. Next in frequency is the cyma reversa (or Lesbian cymatium) on which ogival leaves (or 'hearts') are punctuated by darts; this moulding with its subtler curve gradually replaced the ovolo in some positions. Both eggs and leaves in their outline echo the profile of the mouldings to which they belong, as with the hawksbeak in Doric. The relationship is more casual in the cyma recta, with its lotus flowers and palmettes (or, later, scrolls of leaf-work) in low relief; its main use was for simas, when the old straight type was given up. Lotus flowers and palmettes are sometimes applied to flat surfaces too, particularly on necking bands on columns and antae and in the crowning decoration of walls. There are also the convex and concave members which form the bases of columns and occasionally have subsidiary ornament carved on their surfaces. All these mouldings made much play with colour, especially red and blue, or even with gilding. In general Ionic architects relied greatly on accessories to give liveliness to their buildings, and from the beginning down to the Roman period there was a progression, eventually suffocating, from fewer and heavier to more numerous and usually lighter mouldings.

SCULPTURE Asiatic Ionic made little regular use of architectural sculpture and European not so much more. Acroteria allow figures in the round as well as palmettery, spouts can take the shape of heads, the frieze may be used for continuous and important relief, and antae have room for a little trivial carving on sofa capitals. There are also some less orthodox positions. In a few early Asiatic buildings sculpture is found on the sima and perhaps on a dado round the cella and Gorgon heads are inserted where mouldings turn a corner, and at least two big temples of the sixth century had carved pedestals or bottom drums for some of their columns – a vagary imitated when they were rebuilt – and on one of them figures in relief also invade the architrave. European Ionic seems to have been satisfied with inventing the frieze and perhaps the Caryatid, though this showy substitute for the column was used only rarely; still rarer was the borrowing from Doric of pedimental sculpture. Lastly, some elaborately architectural tombs in Lycia and Caria, designed like small temples on high stepless platforms, exhibited sizeable statues in the spaces between columns. For all this sculpture marble was the material preferred, though acroteria probably were more often of terracotta.

COLOUR Much less is known of the colouring of Ionic buildings than of Doric and one cannot say even whether the Asiatic and the European rules were the same. It is likely that at least sometimes the bases of columns were coloured, since where the upper torus had carved ornament that must have been painted too and, if the higher part of the base was painted, the lower part can hardly have been plain. On shafts with a necking band not only the ornament but the ground also was painted – on the Erechtheum apparently red; and there are instances of colouring at the top of the shaft above and between the flutes. In capitals of Ionic type the echinus and abacus, as mouldings, had their proper polychromy. As for the volutes, eyes and ribs and palmettes were picked out, as well as any decorative detail on the bolsters; here blue has been noted on ribs and yellow on palmettes, but it is likely that there were other combinations and sometimes gilding. The Corinthian capital invited completer colouring. An example from Olympia began with the leaves in the successive rows green, yellow and green with red overhangs, the volutes red with yellow edges, and the flower at the top yellow with red edges and pistil; but in a

later repainting the colouring was changed. Similar schemes may be assumed for Aeolic volute capitals and for palm capitals. Architraves were not painted, except for their mouldings. Friezes with sculpture normally had blue backgrounds. Dentils were not coloured, but the plate above them was and perhaps their background. The tympanum of the pediment may have been blue, and simas are known with a blue background to their ornament. Mouldings, of course, which are used more profusely than in Doric, required colour in addition to their carving. For ceilings and interiors Ionic practice was otherwise presumably like Doric, and sculpture followed its own rules.

PROPORTIONS Since few important Ionic buildings have been measured completely and Vitruvius's precepts are not generally reliable, no comprehensive rules can be set down for the proportions of Ionic architecture. In Greek Asia there seems always to have been an admiration for outsize temples with eight columns on the front, so that there the hexastyle façade did not set the standard as it did in Doric. Possibly, because of this, plans of temples were at first less extended: certainly the huge Asiatic showpieces of the sixth century are only about twice as long as wide, though in European in the fifth century and generally later the hexastyles of ordinary size have much the same ratio of length to breadth as contemporary Doric. In elevation it appears normal for Ionic façades, even those without a frieze, to be proportionately a little higher than those of Doric. This extra height is obtained from the columns, which though more widely spaced are relatively much taller: in terms of lower diameters (measured above the apophyge of the shaft) Ionic columns are generally from eight to ten times as high as wide, later examples on the whole being taller than earlier. As for the entablature, the Asiatic form seems to have been under a sixth of the height of the columns and the European around a quarter, anyhow till the fourth century, though later it tends to become more compressed. Compared with Doric the Ionic entablature, even in its European version, is low in relation to the columns, though not to the width of the façade. Finally, the pitch of Ionic roofs was often fractionally less than that of Doric, with in consequence a slight reduction of the height of the pediment.

SPACING Ionic architects were not much interested in subtleties of spacing and some later theorists evidently preferred a neat numerical grid. At first external colonnades are often, especially in Asia, set well back from the top step of the platform. On the front the interval between the central pair of columns is sometimes widened to produce a more impressive entrance, and occasionally there is a graded widening of other intervals; but in general Ionic columns stood at equal distances from one another. So in the very early temples of Samos and Ephesus, though the middle four of the eight columns of the front were spaced out to give a wider entrance, the columns at the back were equidistant and numbered nine. This lack of sensitivity shows also in the intervals between columns, which varied considerably from one building to another without much relation to size or date, the mean for temples being about two lower diameters of the columns, though in slighter and less pretentious structures it was of course often much greater. As might be expected, cella walls were aligned axially with outer colonnades. The other notable peculiarity of Ionic spacing is the doubling of the outer colonnade, an extravagance which presumably was introduced for the very big Asiatic temples of the 560s but still had its attraction for later generations. A cheaper form of this dipteral system was the pseudo-dipteral, where there is no second line of columns but the cella is placed two intercolumniations back as if there were. Sometimes also extra rows of columns were marshalled behind or inside the porch to give it still more grandeur, and then for balance it was necessary to add others at the back of the cella.

OTHER REFINEMENTS The calculated deviations in line and volume, which so interested Doric architects, were always rare in Ionic and then usually borrowed. Curvature of the platform has been observed in a very few Ionic buildings, but not before the mid fourth century. The increase of the diameter of columns appears on the front of some early Asiatic temples, but contrary to Doric reasoning the thicker columns are in the centre where the intervals are wider. Thickening of corner columns, though prescribed by Vitruvius, is abnormal as well as late. Entasis of columns is exceptional and then slight, and inclination more so (if indeed it ever occurs). There is sometimes at least a forward tilt of the entablature. Walls are usually strictly vertical. Even in its

European branch, in late fifth century Athens, the Ionic style relied for its effect not on optical refinements but on elegance of proportions and the rich delicacy of its decoration.

DEPLOYMENT For prostyle or in antis buildings of Ionic style, which had exposed walls on their sides and often at the back, the outer faces of the walls were entitled to decoration (*plate 86*). At the foot there is emphatic moulding, repeating in part or in whole that of the bases of the columns, whether Asiatic or European. At the top there is a full entablature, with an extra epicranitis below the architrave to distinguish it from an ordinary course of masonry. For porches and cella walls of peripteral temples (*plate 85*) the low ceiling allowed nothing higher than the architrave, again with crowning mouldings; generally they correspond to those of the back of the architrave of the peristyle, though in early work a single large ovolo with its astragal was considered to be enough. In a few of the first Asiatic temples there may also have been a dado, carved with figures in relief. Presumably inner faces of walls were decorated at top and bottom in much the same way. Where a wide cella needed internal supports, colonnades were normal, but they were rarely (as in Doric) of two storeys. For other structures the less rigid rules of the Ionic style, anyhow in Asia, make it less easy than with Doric to guess how it should be adapted. So, for example, the indifference about the height of the platform encouraged the design of decorative monuments set on high piers; and the irregularities of the Erechtheum at Athens (see Plate 90) are hardly thinkable in good Doric.

Mixed Orders

The accepted proportions for Doric colonnades made them too massive for simple deployment inside the cella of a temple and, as taste grew more refined, a two-storeyed colonnade (as in Plate 78a) was felt to be unsatisfactory. A convenient alternative was to substitute a single storey of Ionic columns, since they were about two-thirds higher than the Doric columns of the same lower diameter, and indeed the first use of the Ionic order for the interior of a Doric temple may have occurred before the end of the sixth century, even if it did not become regular till the fourth. Here,

though the two orders were employed in one building, it was in distinct parts of the building and they were not visible together. A bolder juxtaposition, with Ionic columns directly behind Doric, had appeared rather before 500 in Greek Italy (where architects were eccentric), but in Greece is known best in the west porch of the Propylaea of the Acropolis of Athens, planned in the 430s, where immediately behind a Doric façade the central passage is flanked by Ionic colonnades (*plate 82*). Rather earlier a similar system had been adopted for two-aisled stoas, with Doric columns in the front row and Ionic columns, spaced more widely, behind them (*plate 75a-b*): since most stoas did without a horizontal ceiling and had the ridge beam of the roof supported directly by the internal columns and since internal columns should not be thicker than outer ones, the Ionic column's more slender ratio of height to diameter was very convenient. There was less architectural logic in the practice, regular by the third century, of having a lower Doric and an upper Ionic order for the façade of two-storeyed stoas, both (since they were external) with full entablature.

The combining in the same order of Doric and Ionic elements was much more disruptive of established principles, but it had been accepted by the end of the fifth century, if vase paintings are to be believed (compare Plate 27a), and a good fifty years earlier according to terracotta plaques from Locri in South Italy; still artists are often careless about this sort of detail and architectural remains suggest that till the third or even the second century substantial combinations were uncommon, anyhow in reputable work. In Classical Doric an alien moulding occasionally replaces an orthodox one, and very rarely the outside of a cella has a moulding at the base of the wall or at its top an Ionic frieze with sculpture (*plate 78a*). Hellenistic taste was more eclectic and tended to consider Doric and Ionic counterparts as interchangeable, so that by the second century many minor and some major buildings had above the columns, whether Doric or Ionic, an entablature composed of Doric architrave and frieze and Ionic cornice, often with dentils. Other abnormalities were Doric columns with bases or fillets between the flutes or a carved echinus, all features borrowed from Ionic. Even so, stricter canons were not forgotten completely and in late first century Athens a pure Doric style could still be produced and with understanding.

There is one example of a more intimate fusion of the orders. In the curious 'Throne' of Apollo at Amyclae, built by an Asiatic Greek for the Spartans in the late sixth century, we have among other oddities Ionic volutes clipped round the top of the shaft of Doric columns to act as consoles. So far as is known, this experiment was not repeated: Greek architecture, once established, did not encourage bold originality.

The Development of Public Architecture

Formal architecture began in Greece about the beginning of the seventh century or not much earlier. At first the columns and entablature, if nothing else, were of timber and mud brick and, since these rarely survive, the history of the beginnings both of the Doric and of the Ionic styles will always be vague. The first known temples where carefully dressed stone was used extensively are not much before 600. Near Tegea in Arcadia the small Doric Temple of Artemis Knakeatis was built up to the cornice of marble, a surprisingly early use of this hard stone but explained by the nearness of the Doliana quarries; and about the same time at Old Smyrna in Asia an imposing temple, which was probably destroyed before completion, had tufa columns with capitals of the Aeolic volute type. By now stone was being recognized as the proper medium for architecture, and other materials were tolerated only for practical or financial reasons. So the Temple of Hera at Olympia, of about 590, was a cheap job with an entablature of wood and terracotta and some, if not all, of its columns also of wood, but its plan was up to date; in particular, to give a clear view of the cult statue at the end, there were two rows of columns inside the cella, though one central row – as in earlier buildings – would have been structurally sufficient.

During the sixth and early fifth centuries Doric architecture progressed steadily in Greece itself, refining its details and proportions but without any major innovation except for the introduction of sculpture in pediments. In the West the Greek cities of South Italy and Sicily adopted the Doric style but did not altogether comprehend its niceties, and their buildings show aberrations which are hardly consistent enough to constitute an independent Western school. There was also a little infiltration of Ionic notions,

in both details and planning, and of course the retardations to be expected in any provincial art. Some Sicilian preferences or peculiarities of the sixth century may be mentioned. In the planning of peripteral temples there is a liking for a more spacious ambulatory between the outer colonnade and the cella; this may be obtained by setting the cella porch one column further back from the front of the peristyle, or by inserting an extra row of columns two spaces behind the front and setting the cella porch a normal distance behind that, or even by leaving an extra column space all round the cella (according to the pseudo-dipteral system of Ionic). Cellas often have a back room opening off them, sometimes without a back porch; internal colonnades are rare; and there may be concealed staircases to the loft. Angle contraction of the outer colonnade is unknown, but the central intercolumniation on the front may be widened. In the proportions of triglyphs and metopes some confusion is apparent, and in their detailed forms. Sculpture appears on metopes, but not in pediments. Terracotta revetments to cover wooden and sometimes stone cornices too are excessively elaborate, mutules and mouldings tend to be irregular, and against reason simas occasionally run along the floor of the pediments. Most of these Sicilian abnormalities are found in South Italy too, though there architectural style was generally still more backward or erratic. Columns have often an exaggerated entasis of the shaft and regularly a concave scotia below the echinus, an early (but not necessarily universal) feature that by then had been discarded in Greece; in the Temple of 'Ceres' at Paestum the horizontal cornice on the ends was suppressed and the other cornices were coffered underneath; and – less forgivably – the Temple of Apollo at Crimisa exhibits mutules and guttae on its raking cornice.

On the east side of the Aegean the first and apparently still experimental specimen of formal Greek architecture is at present the temple of Old Smyrna, which probably was being built about 610. For the next forty years, presumably through the accidents of survival and discovery, there are several more temples but only on the island of Lesbos and the mainland opposite. These still have capitals of the Aeolic volute type, but seem provincial – old-fashioned in plan and poor in quality – and need not reflect the architectural style of more important East Greek cities. There about the 560s we find capitals with horizontal volutes, elaborate bases and other features which are definitely Ionic. In the two

principal examples, the first dipteral Temple of Hera on Samos and the Archaic Temple of Artemis at Ephesus, there is also the novelty of enormous size and opulence; each was more than 370 feet long and half as wide and, since the cella did not need comparable enlargement, had a double external colonnade and extra columns in the porches. The scale was soon emulated in other cities of Asia, but we know very little of sixth century Ionic temples of normal dimensions; it seems, though, that a uniform Asiatic canon had not been accepted by the end of the sixth century and that in the fifth century, probably for economic reasons, architecture was rather stagnant in the East Greek region. In Europe an Ionic style had appeared hardly later than 550, in the beginning copied or adapted presumably from minor buildings in Asia or the Aegean islands; anyhow it was used, so far as we know, only for small structures such as the treasuries at Delphi. This European Ionic quickly established rules of its own and its further development seems to have been largely or wholly independent of contemporary Asiatic fashions.

The second half of the fifth century was dominated by Athens where, partly to replace the wholesale destruction done by the Persians in 480–79, a very big programme of civic building was undertaken and more or less completed. Athens then was the wealthiest Greek state in public revenues, there was a widespread appreciation of the arts, and marble (which allowed more delicate effects than limestone) was available in local quarries. Later generations of Greek architects looked back with admiration or at least respect to the Athenian works of this period and most modern critics see in what survives, which is unusually much, the finest achievement of both the Doric and the Ionic styles. In Doric the Parthenon at Athens, built by Ictinus and Callicrates between 447 and 432, is generally reckoned the masterpiece for its proportions, refinements and craftsmanship; but it is untypical in having eight columns at each end, perhaps because six columns on the same frontage by enlarging the scale of the order would have given a temple aesthetically too high and massive for its situation. So the Theseum (or more correctly the Temple of Hephaestus) also in Athens, a hexastyle building of comparable quality and exceptionally well-preserved, is more instructive on the Doric ideal. These temples show some decorative borrowing from Ionic. In the Theseum (*plate 78a*) a continuous sculptured frieze runs across

each porch of the cella; the Parthenon has a similar frieze all round the cella block and the back room was Ionic internally; and in the Temple of Apollo at Bassae, in the Peloponnese but begun perhaps just before the Parthenon, the inside of the cella is wholly Ionic, improved with the earliest Corinthian capital yet known. The subsidiary use of Ionic was now becoming regular. As for Doric buildings of other types, the Stoa of Zeus at Athens (*plate 75 a-b*) had short wings projecting forward at the ends, perhaps the first instance of this plan; and at Eleusis the Telesterion, a big square hall for the celebrations of the Mysteries, was designed (partly by Ictinus) with a grid of internal columns and a small central clerestory. These are, though, simple developments and there was not much scope for radical innovation.

It is worth studying more carefully the grand entrance to the Athenian Acropolis, the Propylaea (*plates 82* and *90*), which was designed by Mnesicles in the 430s, though never completed. Here for once a Greek architect attempted a structure on different levels and of complex plan. Since he wanted similar porches on each side of the gate and the ground at the front was considerably lower than at the back, he also made the roof lower at the front than the back; but Greek roofs had a horizontal axis and so that of the Propylaea was inevitably stepped, giving a junction that was awkward stylistically, though because of the depth of the front (and lower) porch, the fall of the ground in front of it, and the flanking structures this junction was visible only at a distance. Secondly, the steep approach to the front porch was to be flanked by colonnaded wings, but of smaller scale. Reasonably the columns of the wings stood on the same level as those of the porch, but their entablatures were lower and so, since there was no aesthetically neat method of joining the side entablatures to the main façade, each wing was set back a little to overlap the porch and leave a narrow passage between. On the other side too preparations were made for colonnaded wings, not as it happens executed, of smaller scale than the back porch but running parallel and not at right angles to it; here the junction was to have been made on the side walls of the porch behind its columns. A further problem was set by the steps of the front porch, since the height of steps was fixed by the scale of the order, which differed for the porch and the wings; Mnesicles compromised with a continuous flight of four steps, the four steps of the porch having a total height

to that of the normal three, while on the wings each step a proper height and the lowest was negated optically by being of dark stone. Yet another ingenuity appears in the projecting south-west wing, where the sanctuary of Athena Nike encroached and to give the desired length to the façade an isolated pier was put at the end carrying a useless strip of roof, a device that looks clumsy in the view of Plate 90 but could not have been noticeable from the ground. All these difficulties of the Propylaea might have been avoided. For instance the back porch could have been lowered by quarrying out a sunken court for access to it. The wings at the front could have been of the same scale as the front porch – much as in the slightly later stoa of Zeus (plate 75 a-b) – and to keep symmetry they could have been shortened; but evidently Mnesicles was determined on the proportions of his composition and perhaps welcomed experiment for its own sake. Yet though the detail of his porches was admired and the central block imitated, his radical innovations were ignored. Successful though it is, the Propylaea shows by the direction its ingenuity takes that Greek monumental architecture was or had become adaptable only within narrow limits.

For Ionic of the later fifth century most of our knowledge comes again from Athens. A temple on the river Ilissus, measured in the eighteenth century but now destroyed, and that of Athena Nike, happily rebuilt, were both delicate little buildings with a porch of four columns at each end. The Erechtheum (plate 90), of the last quarter of the century, was more ambitious both in size and in plan. Like the Propylaea it is a rectangular building on two levels and with excrescences. On the higher level a regular porch of six columns decorated the east front and a small false porch with caryatids supporting a flat roof projects without organic connection at the end of the south side (plate 83). At a much lower level, reached by a fine flight of steps beside the east porch, one comes to the north porch, four columns wide by two deep and larger in scale, though its top is lower than that of the main block; curiously it overlaps the west end of the block by one intercolumniation. The west end, again on the lower level, starts with a plain wall and above had four partly engaged columns between pilasters; but though the capitals of these columns reached the architrave of the main block, their bases are set at a higher level than its steps. The interior, which was divided in an unusual way,

has been gutted. The detail of the Erechtheum is admirable and influenced later architects, ancient and modern, but the general effect seems wantonly irregular; anyhow its predecessor was of simple plan (shown by broken lines on Plate 90) and on one level. Perhaps the architect was incited by the Propylaea to experiment with new principles, but his failure must have been a warning to other would-be innovators.

In the fourth century Doric passed from correctness to elegance but there was less scope for exploiting its refinements. By now Greece and the Western colonies were well provided with sacred edifices and the usual occasions for a new temple of respectable size and quality were that its predecessor had burnt down – for cellas served also as store rooms – or was beyond repair; and even then the architect might be obliged to re-use the existing foundations and so have to repeat a plan that had become old-fashioned. More rarely the expansion of an old sanctuary or the foundation of a new one justified elaborate buildings, as at Epidaurus, though the temple erected there for Asklepios is distinguished less by its style than by the survival of a detailed record of the costs. In compensation there was an increase in civic building for other purposes – stoas, of which the Greeks seem never to have had too many, council chambers, law courts and other public offices, gymnasiums and palaestras, and theatres, which were at last being made of stone. Generally such structures were less finely designed and meticulously executed than temples and, though there were advances in planning, the forms (except in theatres) remained conventional. A particularly remarkable building of this type was the Thersilion in the new city of Megalopolis. This was a very large squarish hall, constructed soon after 371 for meetings of the Arcadian voters, the 'Ten Thousand'. Outside there was a wide Doric porch, extending across half the front wall. Inside the roof was supported by columns arranged in five rows parallel to the sides and the back and spaced on lines radiating from a point – the speaker's platform – which was rather short of centre. By this thoughtful planning the audience's view of the platform was much less obstructed than if, in the old way, the columns had been arranged on a simple grid. Unfortunately little else is known about the Thersilion, except that the auditorium was tiered or banked, so that the visible height of its columns must have decreased from the inner to the outermost row. It seems also that the porch

served as a background for the stage of the adjacent theatre and, since the site was virgin, this must have been premeditated.

In Asia the Greek cities had been depressed throughout the fifth century, but in the fourth they began to revive and there was a great increase in building, both on old and new sites, an example followed by some of their non-Greek neighbours, who were now adopting Greek civilization more comprehensively. With this demand for architecture came the revival of the Ionic style; in a few buildings Attic influence may be suspected, but generally it was the Asiatic tradition which dominated, though of course with modernized proportions and details. The Temple of Athena at Priene (Plate 84 and in the background on Plate 75c), built soon after the middle of the century, is and was intended to be a model of the contemporary style, though Pythios, its architect, was un-usually concerned with simple numerical ratios for its major and minor dimensions. The new Temple of Artemis at Ephesus, begun a little earlier, shows greater originality in its detail but may have owed its fame more to its sculpture (*plate 57b*); in plan and general design it followed the Archaic temple, except for a much higher stepped platform. At Didyma too near Miletus another outsize temple was begun, to replace that destroyed in 494, but though work proceeded very slowly the plan must be of the later fourth century. It is, exceptionally, hypaethral – with an open court instead of a cella. This court, which was sunken, had a broad flight of steps descending to it at the east end; its side and back walls were decorated with pilasters, though with the form of antae, which stood on a high podium; and near the far end there was a miniature temple with a porch of four columns. Another curiosity was a pair of staircases roofed with barrel vaults, but the vaults were constructed later, perhaps in the third century, and may not be part of the original design. Work on the outer colon-nade, which was double, stopped at the horizontal cornice, so that we do not know what kind of roof was intended. Further south at Halicarnassus the Mausoleum was constructed around 350, perhaps also by Pythios, as the tomb of a non-Greek ruler. It measures more than a hundred feet each way and had a high colon-nade above a high podium, in this following earlier native practice, but the pyramidal roof seems an innovation. What survives does not allow even a probable restoration. In Europe the Choregic Monument of Lysicrates at Athens (*plates 87* and *57a*), built in 334

or just after, is a charming folly, very well preserved. It too has a high podium, which is square, and on it a cylindrical drum with attached columns: the capitals are Corinthian, used now at last externally, and the entablature has both frieze and dentils. This combination appears elsewhere in Europe about the same time.

In 334 Alexander the Great began his successful invasion of the Persian Empire and when he died prematurely his Macedonian generals divided but kept his dominions. One result was that the central importance of Greece itself, both politically and economically, vanished for ever; another was that the new territories were infused with a Greek urban culture, since the Macedonian rulers regarded themselves as a superior breed of Greeks. So from Egypt to Afghanistan new cities were founded with all the conventional attributes of Greek life except independence. Probably the demand for architects and building craftsmen encouraged a decline in standards, though there had been signs of this before, and also a less strict respect for the orders. The Doric style was already becoming weary; in the Hellenistic period it was no longer as favoured for sizeable new temples and, though convenient for lesser and repetitive buildings such as stoas, its forms tended to be simplified and contaminated. Ionic did better, partly because western Anatolia, its home country, continued to flourish, and also it was more ornate; and in the third and second centuries a new canon developed which accepted European forms and combined frieze with dentils. Corinthian capitals too became respectable in the external colonnades of important temples, though their heyday did not come till Roman times. More characteristic, especially in minor work, was the mixture of Doric and Ionic in the same order and an indiscriminate search for novelty in details. So the outer faces of cella walls could be variegated by drafting, columns might be only partially fluted or eventually cabled (with a convex rib inside the fluting); in the second century the pilaster was exploited; and in the first the modillion began to be fashionable. Even where the forms were correct their use might be incoherent. A fair example is the mounting of statues on columns; here earlier practice had preferred a single column with its capital, but in the later third century there was a fashion for paired columns – Ionic of course – crowned by a strip of entablature. More valuable innovations were in the use of curving forms, though these were not systematically developed. Internal apses

became very common, for instance as a setting for the cult statue in a cella; the vaults at Didyma have been mentioned; and by the second century, notably at Priene, the arch could be made an independent architectural feature. Among types of buildings the two-storey stoa now became more frequent, usually with Doric columns in the lower and Ionic in the upper storey and, if the stoa also had two aisles, then in the upper storey – to avoid two rows of Ionic – some other kind of capital might be used for the internal columns (so in the Stoa of Attalus at Athens these inner columns were distinguished by palm capitals). The basilica too, a long enclosed hall serving as a market or court of law, seems to have been developed by Hellenistic architects; the best known example, the so-called 'Hypostyle' Hall at Delos, has columns supporting the roof and a central clerestory, but we do not know if Hellenistic architects ever carried a clerestory over the full length of a hall. Though it is easy to dismiss the style of this period as decadent, it was equally one of transition. The impression is that of an architecture groping for but not determined enough to decide on a new direction. That decision was left to the Romans, when in the first century they began to look for a properly Imperial style.

Planning of Towns and Precincts (*plates 90-91*)

The old Greek cities, like old cities elsewhere, grew up haphazardly with narrow winding streets. Usually too, for safety against attack, they clustered round or on a small hill, the Acropolis, which was walled; and if the lower town was of any importance, it too had a wall, anyhow by the sixth century. The course of the town wall was determined by the lie of the land as well as by the size of the community, though once built it tended to restrict new building to the enclosed area and so, where population grew, encouraged denser occupation. When temples became fashionable, the principal temple was normally on the Acropolis and there were more temples and shrines scattered round about the town. The other civic necessity was an Agora, an open space for meetings and for the market; this needed to be fairly central and, if the city grew, might have to be extended or moved to a new site. By the sixth century civic offices too were

beginning to be wanted and these tended to be round or near the Agora, while public fountains were put up at springs or where a conduit brought in water. Later, in the fifth and fourth centuries, other amenities were fitted in. Gymnasiums and palaestras could be anywhere, theatres were preferably in a bay in a steep hillside, and for a stadium it was convenient to use some natural hollow: these structures, and particularly the stadium, might be outside the city wall, as were many temples, since Greek warfare usually spared the property of the Gods. In general there does not seem to have been any serious attempt to replan an existing city nor much compulsory expropriation of private property except for the Agora and its adjuncts, and so even Athens was still in the Roman period largely primitive in its disposition.

For a new city some deliberate planning could hardly be avoided, to fix the boundaries of sanctuaries and the Agora and to divide out plots among the pioneers. So Megara Hyblaea in Sicily, founded in the later eighth century, seems to have been laid out on a partly rectangular grid and, more surprisingly if old rights had to be surrendered, a similar system seems to have been introduced about 700 at Old Smyrna after a catastrophe which destroyed the earlier settlement. This type of city plan, first applied perhaps only for its practical convenience, had acquired professional respectability by the fifth century, when its most famous exponent was Hippodamus, who laid out the new town of Piraeus according to what is often called the Hippodamian system. To judge by what remains, it was not imaginative. A regular grid was imposed on the ground, flat or hilly, with the main streets preferably along the contours to give easy gradients and cross streets cutting off blocks of uniform size. This grid had no necessary relation to the course of the city wall, which could not ignore the contours, and even the gates were not always aligned with streets. The streets themselves were usually unpaved, without side walks and narrowish; the main thoroughfares were rarely more than 20 feet wide and alleys were very narrow. The size of the blocks varied from city to city, but usually gave room for four to six fair-sized houses. For the Agora several central blocks were united and some sanctuaries and civic buildings might also need more than one; the theatre and the stadium, of course, because of the terrain might be outside the grid. Shops and workrooms were mostly congregated by trades in the less select quarters, often combined with their owners'

dwellings, though for amenity kilns tended to be outside the built-up area. In all this there was no attempt at grand vistas, public parks or impressive street fronts, but even if the effect was dull the character of the building, both public and private, prevented disharmony and on hilly sites the terracing of important buildings gave some accidental variety. It should, though, be noted, that Greek cities were mostly small; few had a population of more than fifty thousand and Priene, a respectable minor community, apparently only about five thousand. Its plan and restoration on Plate 91 give a good idea of a grid town laid out about the middle of the fourth century: the empty space at the north on the steeper slope of the hill was included in the walled area not for growth but from defensive necessity.

For Agoras and sanctuaries planning was different. In old cities the Agora was originally an open space of irregular shape; but when public offices and stoas were required, they were mostly put up round its edges to keep the centre clear and, since in Greek architecture buildings were normally rectangular in plan, the sides of an Agora tended to become straight. Even so, not much effort was made to impose stricter regularity: at Athens, which built more busily than most cities, the Agora even in its Hellenistic form was a quadrilateral with only one right angle, the stoas which fronted it were of various sizes and the miscellaneous structures along the west side were not set forward to the same line. In new foundations on a grid plan the Agora was of course rectangular, but the main street to and through it was not across the centre but along one side and, even if there were uniform colonnades on three sides, the fourth was likely to be distinctive: at Priene the north stoa was not only on a higher level but had a longish extension to the east (*plate 91*). This deliberate avoidance of regularity in the grouping of buildings is more obvious in sanctuaries. The Acropolis of Athens (*plate 90*) had three major buildings – the Parthenon, the Propylaea and the Erechtheum – executed in that order within one generation. Yet their axes are not parallel, though they could have been without any difficulty, and the line straight through the Propylaea passed between the two temples. Similarly the little Temple of Athena Nike, though so close to the Propylaea, is on yet another alignment. It seems also to have been usual for the approach to a temple to be oblique, and that this was intentional is shown by the position of the main entrance of

sanctuaries outside cities, even though space was less congested. By the second century admittedly some Hellenistic planners were experimenting with limited axial arrangements, as at the Sanctuary of Asklepios on Cos, where the new temple on the upper terrace stood alone in the centre of a uniformly colonnaded court and was approached by a propylon and a broad staircase directly in front; but it was the Romans who developed axial symmetry on the grand scale.

It is hard to decide what coherent principles governed Greek town-planning. For the gridded city it may have been no more than utility, unaffected by aesthetic theory, which perhaps was not thought applicable to conglomerations of this scale. In smaller groupings of architecturally important buildings it seems that Greek taste preferred to isolate each unit rather than to treat it as a constituent part of a larger complex, and indeed not much attention was paid to congruity between one building and its neighbours. If restorations of big sanctuaries usually give a satisfactory effect, that is because the style of formal architecture was fairly homogeneous, the separate units were complete in themselves and casualness has its own attraction.

Private Houses (plates 74a, 92-93)

Greek houses normally had mud brick or rubble walls and were irregular in design, so that their ruins are less clear than those of more important public buildings nor are isolated fragments as informative about scale and style. Further, there has been less interest in them. At present the most extensive remains are at Zagora in Andros, Emporio in Chios, Olynthus, Priene, Pella, Delos and Pompeii. Emporio was a village with some sort of petty lord, which existed in the eighth and seventh centuries; Zagora, as humble, was rather older. At Olynthus and Priene the houses were for comfortable middle-class families, most of them presumably living off landed property, and they are much later: the North quarter of Olynthus was laid out just after 432 and destroyed in 348, and Priene was a new foundation of the mid fourth century and much of the building is of its early years. At Pella the development seems to be of the first half of the third century and for wealthier clients. At Delos some of the houses go

back to the third century, but the main period is between 146 and 88 when commercial privileges attracted an enterprising and cosmopolitan population. Pompeii, unfortunately, has to be ignored, since the houses of the Greek city, mostly of the second century, appear to be Italian or Etruscan rather than Greek in plan. At many other sites too houses have been discovered, and of various periods, but most of these are isolated examples or not well-preserved. As a result we still cannot trace the history of any type of house, nor do we know the relations between different types or indeed how many types there were.

The accommodation of the poor, often a single-roomed shack, can hardly be classed as architectural and here only the wealthier houses are considered. The big house at Emporio (*plate 74a*), which is not later than the seventh century, belongs to a type misleadingly described as a 'megaron', that is it consisted of a long room with a porch at the front and sometimes partitioning at the back; the detail was crude and the roof more probably of mud than thatched. A more elegant house of the same simple type has been found in Aeolis at a site misnamed Larisa and, since it is on the Acropolis, must have been for the ruling family. This building is of the early fifth century, replacing one of more Eastern type, but was soon made part of a larger complex of rooms round a square courtyard. Yet as Old Smyrna, not far away, the houses of the citizens of the seventh century seem mostly to have had a row of two rooms and a courtyard (or else three rooms) and even an upper storey. Since the megaron type resembles the early temple, it is easy to assume that it was the standard better-class house of the early Archaic period, but certainly later the enclosed courtyard was a constant and essential feature of domestic architecture. Perhaps there was more variety, even in the Hellenistic period, than is allowed for.

In the courtyard house, both in town and country, the normal plan, allowing for irregularities of the shape of the plot, has main and subsidiary rooms on the north, a portico in front and then a courtyard with rooms and sometimes a colonnade on one or more of the other three sides. If the portico runs right across the house, it is often called a pastas. If it is limited to being a porch to the main room, especially if that room is of megaron type, the term prostas is used (*plate 92*). Further, if there are columns all round the court (*plate 93*), one may speak of a peristyle house. These

definitions do not fit all plans and are rather artificial, but in the treatment of the main room behind the portico there seems to be a valid distinction between the pastas house of Olynthus and the prostas house of Priene. Of the two it is the pastas type which seems more prevalent and the peristyle houses of Delos should be a development of that type. The peristyle, of course, is an obvious addition to a court, found already in some houses at Olynthus and at Pella, and though it appears to be commoner in later times may be a sign more of wealth than of date.

It is often said that Greek men of independent means, of the classes who occupied the houses being discussed, used their homes only as places to eat and sleep in. This must be an exaggeration. Although it was ungentlemanly for citizens to have a job, they had some business to deal with privately and many cannot have had the strength or taste to be out all and every day; and there were also the wealthy aliens who engaged in commerce or manufacture and presumably often had their offices or workshops at home. Anyhow Greek houses were not neglected. The normal household consisted of the master, his wife (who kept more or less to the house), their children and other dependent relatives and a few slaves. Much of the life and work went on in the courtyard and its colonnades. Off it was at least one principal room, since on occasions the householder gave dinner parties for male guests, all reclining on couches round the walls. Near the dining-room was a kitchen. There was also a simple bathroom and latrine emptying into an open or covered drain behind the house, with luck to be flushed by rain. Other rooms round the court might be living-rooms, storerooms or bedrooms, though bedrooms were often on an upper floor. In larger houses there was sometimes a small room for a porter near the street door. Cellars were certainly uncommon, though at Delos, where there were no springs to feed public fountains, rainwater was collected in cisterns under the court. Greek houses were, by modern standards, sparsely furnished; the main necessities were beds or couches, simple chairs and stools, small tables, chests and shelves, and there do not seem to have been many knick-knacks.

Houses built round a courtyard naturally faced inwards. Upper rooms often had windows and sometimes perhaps balconies too, but on the ground floor the outer wall was generally blank, unless in a busy street a detached small shop was cut out of the front.

Architectural embellishment may always have been welcome in grander houses, as at Larisa, but evidently was demanded more as time went on. Its principal place was the court, where colonnades on upper as well as ground floors could be dignified by the use of an order, commonly of Doric type and of poorish quality: in peristyle houses the colonnade in front of the main rooms might be given extra height, in spite of the difficulty of connecting the side colonnades to it. As for details, important doorways could be emphasized by mouldings and at Delos, where there were well heads, they too were moulded. This kind of work obviously required better materials and at Delos even marble was in use for it. Palaces, of which a few are known, appear to have been planned like houses, though with more and larger rooms; the standard of workmanship too was better. The effect of the middle-class Hellenistic house can be appreciated best by a visit to Delos, but something can be made out from Plate 93. Interior decoration is described later (pp. 247–54).

Influence

From the later sixth century on the local princes of south-west Anatolia were receptive of Greek art and they pursued architectural effects in their rock-cut or masonry tombs; but though an Ionic temple had been built at Sardis in Lydia in the mid sixth century, it was not till the fourth century that a recognizably Greek style of building was established in Lycia and Caria. As geography would suggest, this style was Ionic and so too were the Greek contributions to the very eclectic court architecture of Achaemenid Persia of the late sixth and fifth centuries. Here, though the plans and general design are Eastern, some details – notably the bases and fluting of columns and occasional mouldings – suggest that Greek craftsmen were at work, drafted from the Asiatic cities under Persian rule. Elsewhere in the East such influences were very rare, till in the Hellenistic period Greek architecture gained an unchallenged dominance in the Macedonian kingdoms. In Italy, when the Doric and Ionic styles began, the Etruscans were the only people civilized enough to appreciate them but had enough independence to adapt the foreign novelties of both. Their Tuscan order – to use the term loosely – had a

lower entablature and wider eaves, indulged in terracotta she
ings and excrescences even more than the Greeks of South It.
and Sicily (with whom their contact was closest) and gave strong
emphasis to the strictly frontal view. With intermittent modifica-
tions from recent Greek practice this rustic style can be traced
from the sixth century for at least four hundred years. Rome for
long followed Etruscan precepts till in the second century, as
master of much of the Greek territories, it began to study
Hellenistic models directly and developed them for other purposes
and techniques. Though the older Greek cities remained faithful
to their own tradition till the second century AD and this still had
occasional influence elsewhere, the new Roman Imperial style
became standard throughout the Greco-Roman world and it was
from that style and only indirectly from the Greek that Byzantine
and Romanesque architecture evolved. From then till the end of
the Middle Ages direct imitation of ancient architecture occurred
only rarely and casually.

The new interest in the antique, which was a characteristic of
the Renaissance, had a profound effect on architects and from the
mid fifteenth century onwards the more enterprising of them
puzzled over the treatise written by Vitruvius in the late first cen-
tury and, more profitably, investigated the remains of Roman
buildings in central and northern Italy. Curiously, since Greek
literature was one of the great discoveries of the time, there was
no attempt to look for specimens of Greek architecture: though
Greece itself and Asia Minor were more or less inaccessible, there
were well preserved Greek temples at Paestum and other places in
South Italy and Sicily. It was not till the eighteenth century that
interest in Greek as opposed to Roman style became active. Of
the pioneers the most notable were James Stuart and Nicholas
Revett, both professional architects who had been studying in
Rome. Reasoning that the finest Greek buildings should have been
in Athens, they moved there in 1751 and spent more than two
years making measurements of the ruins, which were published
slowly but admirably in four volumes of *The Antiquities of Athens*.
The first, which appeared in 1762, illustrated with lucid and
accurate details the Gate (or Propylon) of the Roman Agora, the
little Ionic temple near the Ilissus – the later destruction of which
has been compensated by the recovery of the closely similar
Temple of Athena Nike – the Tower of the Winds and the

Choregic Monument of Lysicrates; the second volume, dated 1787, included the Parthenon, the Erechtheum and the Propylaea; and the third, seven years later, added the Theseum. Meanwhile other architects, mostly British, were extending knowledge of Greek models by expeditions to other sites, but not surprisingly it was the repertory of Stuart and Revett that had the greatest influence. What first struck contemporary professionals and connoisseurs, whose interest was much more practical than archaeological, was the austerity of Classical Greek architecture – in the Doric column, for instance, the plain if vigorous form of the capital and the absence of a base – and prejudice dies hard. Even in Britain, where the prevailing style was Palladian and not the incompatible Baroque or Rococo of the Continent, the earliest derivative buildings, such as Stuart's two Doric temples of 1758, were usually follies, copied fairly closely from ancient structures though they fitted remarkably well into the northern landscape; but it was gradually accepted that Greek forms were purer than Roman and that the Greek use of columns not as decorative adjuncts but as structural supports was more correct, and the new architecture was used increasingly for porches and porticos of great houses. By the early nineteenth century the Grecian style, helped partly by Napoleon's imperial programme, was fashionable in much of northern Europe and in the more settled parts of the United States. By now, though direct imitation continued, well-bred eclecticism was more normal and the Greek orders were incorporated in useful and complex compositions, sometimes with an imaginative comprehension unknown to the Greeks themselves. Even so, Grecian austerity palled and before 1850 the style was generally out of date, though it still recurs now and then. It seems unlikely, if only because of expense, that there will be another revival of the Doric and Ionic orders, but modern architects might still learn something from their careful insistence on proportions.

8 INTERIOR DECORATION

Introduction

In Greek temples and other public edifices of any importance the coffers of ceilings were painted, but walls and floors—it is supposed—were normally plain. If of marble, they were polished and left in their natural whitish colour or, if the material was an inferior stone or mud brick, the walls at least were coated with a fine stucco to imitate marble. For private houses decorative as well as architectural canons were less strict. The poor, of course, had to be content with earth floors and bare walls of unplastered mud brick or roughly coated rubble. So too in the Classical period were the well-to-do in the less consequential parts of their houses, but they did not think money wasted on decorating the best rooms. So, especially for dining-rooms, the habit grew of plastering and painting the floor or even covering it with mosaic, of plastering and painting the walls, and of painting the ceiling (which the guests could easily inspect as they lay back on their couches). For an obvious reason the ceilings of houses are usually altogether lost, but they seem to have been of wood and, to judge by tombs and architectural paintings on walls, the Greeks always had a preference for coffering, genuine or simulated; the stuccoed ceiling with ornament in relief, which had so great an influence during and after the Renaissance, was a Roman development of the first century AD, associated with an increasing use of the vault. In general later Greek houses had more extensive and elaborate decoration than earlier ones. This was partly because taste and social standards changed, but there was also a shift in the distribution of wealth from the fourth century onwards and the gap between poor and rich became wider and sharper.

Mosaics

At Gordion in Phrygia two houses of the late eighth century had floors of small pebbles – white, blue or black, and red – arranged to form irregular patches of simple patterns. So far nothing else of this kind is known till the Greek pebble mosaics about three hundred years later and, since the idea of arranging pebbles in patterns is an obvious one, there is no need to assume a connection between them and those from Gordion.

The Greek pebble mosaics make do with black and white pebbles, occasionally supplemented with a few of other colours, but their design is carefully and symmetrically planned. Most have simple decoration of such convenient patterns as lozenges or squares – a formula that was always popular because of ease and so cheapness of laying. Others were more ambitious, and in the principal group of pebble mosaics (*plate 94*) the composition is normally concentric, with narrowish bands surrounding a central panel, which may be circular or square or – especially in a doorway – oblong. The repertory of motives comprises abstract and floral ornaments, animals and monsters, and even mythological groups: two characteristic subjects are a horse savaged by griffins and Nereids riding sea-horses as they bring armour to Achilles (Plate 94a, at bottom). All this decoration, both figures and ornament, is executed – either white on black or less often black on white – in a technique of coarse line drawing and in a style that belongs to an unprogressive tradition of minor decorative art and may well be derived from textiles. The effect is often fussy.

A few pebble mosaics are of higher quality and form a group of their own. The basic colours are still black and white, but in figure scenes details are often picked out systematically in other colours or tones and lines may be sharpened by strips of terracotta or lead; forms are sometimes modelled lightly but skilfully by shading; and, more impressively, the character of the figured subjects is no longer decorative but pictorial (*plate 95*). These mosaics have evoked comparisons with earlier red-figure vase paintings, but the connection must be indirect; both arts relied on clean and economical line drawing and rejected the advanced devices of painting as unsuited to their medium. Indeed, though the best of these mosaics have a remarkable freshness of style,

they can hardly be any earlier in date than the original painting which was copied in the Alexander mosaic (*plate 32*), but whether their immediate models were in some simpler branch of painting or in superior textiles is a question that is probably unanswerable.

In dating the pebble mosaics style is not of much help, since – as often in minor arts – they used a repertory of more or less traditional designs that did not respond quickly to advances or changes in the progressive arts, and so comparisons can be deceptive. It is safer to rely on contexts, though these are still surprisingly few and vague. For the larger decorative group (of which Plate 94 is typical) an example at Motya in western Sicily was in a house that was probably ruined in 398–7; another from Corinth had been scrapped by the early fourth century; those from Olynthus should be later than 432 when the city was reorganized and must be earlier than 348 when it was abandoned; some from Sicyon cannot be later than 303, since they come from the area from which the city was removed at that time; and one at Palatitsa in Macedonia should be a little after 276. As for the more ambitious, pictorial mosaics one from Alexandria must be later than 332, the year of its foundation; two in South Russia are dated by associated finds to the third or even the second century; and for general historical reasons those from Pella should not be earlier than the late fourth century and would fit better after 276, when that city was reinstated as capital of a now peaceful Macedonia. On the other hand tessellated mosaics had begun before the middle of the third century, and one would expect that the less satisfactory pebble technique was not used much longer for work of good class. On this evidence it looks as if the decorative style of pebble mosaics was current from the late fifth to at least the middle of the third century but did not develop significantly, and that the pictorial style was a sideline of the third century. Examples of the decorative group have been found all over the Greek world, and for this reason and because of the general uniformity of style it is simplest to suppose diffusion from and invention in some central city of the Classical world, as for instance Sicyon or Corinth or Athens.

Tessellated mosaics were being made by the middle of the third century. In the developed technique the units of the mosaic, the tesseras, are small squarish pieces of naturally coloured stones set in a bed of cement and ground to a smooth face; in size they

average 1/16 inch to 1/8 inch across the face and for fine work less than half that. Later there was some use of glass and gilded tesseras too. Lead strips continued in occasional use to give sharper definition to major outlines. An early experimental stage is represented by mosaics in a house at Morgantina in Sicily and there is a comparable specimen from Alexandria. Here the size of the tesseras varies and larger pieces of stone, some specially shaped, and even pebbles are used as well. Since the mosaics at Morgantina are the earliest that can be dated by their context – to about 260–50 – and there is a record of a ship with mosaic flooring, probably tessellated, that was sent from Sicily to Alexandria not much later, many students conclude that the tessellated technique was invented in Sicily. Whether or not this is right, the invention is not likely to have been at Morgantina, which was a provincial city, as the style of its mosaics shows.

The tessellated mosaic from Alexandria which is technically experimental continued the tradition of line drawing of the pebble mosaics, and so do a few other mosaics elsewhere of more advanced technique but presumably early; but since in the new medium the grain of the mosaic was much finer, it was tempting to imitate the more ambitious techniques of painting. Even on the Morgantina mosaics some of the meanders are rendered in isometric projection – in one instance with an extravagance that suggests its novelty – and the face of Ganymede is heavily if clumsily shaded. There is more finesse in mosaics from Pergamum probably of the early second century, and by then it was regular for figures and other objects in the panels to be modelled with strong light and shade, though normally the background was ignored and the choice and treatment of subjects was more decorative than pictorial (*plate 96*), more so in effect than in the earlier pebble mosaics of Pella (*plate 95*). The tessellated mosaic of Plate 96, which belongs to one of the houses in the international port of Delos, is a fairly typical specimen of the mid second century. The smallish central panel exhibits a single figure or object or a compact group and is surrounded by bands of heavy and boldly coloured abstract ornament. As is obvious, the ornament required much less skill to execute than did the panels and these were often bought from specialists, made up on trays and ready to be inserted in the floors by the craftsmen who set out the ornament; such inserts were known as 'emblemata'. Panelled

mosaics are of course the best known, but there are many more mosaics which because of expense or position consisted wholly of abstract ornament.

Some of the specialists acquired a remarkable virtuosity and one at least, Sosus of Pergamum, who worked in the early second century, was ranked by Roman connoisseurs among the old masters for his panel of doves drinking and preening and for an all-over trompe l'oeil design of a floor littered with the droppings of a dinner party. Examples of such highly illusionist mosaics survive, normally small in size and executed in diminutive tesserae. The subjects are usually arrangements of still life or cosy illustrations of domestic pets, but a few are straight copies of important pictures, among which the Alexander mosaic (*plate 32*) is unique for its scale and audacity. Generally, though, Greek householders do not seem to have thought floors the right place for pictures.

In the Hellenistic period another kind of elaborate flooring was developing besides mosaic. This was 'opus sectile', also known as 'intarsia', 'opus Alexandrinum' and perhaps 'lithostroton'. Here the units, much larger than those of mosaic, were pieces of stone (especially marble) of various colours, cut to fit each other in carefully considered arrangements. Generally the arrangements made symmetrical abstract patterns, but occasionally there were figures, though shading and gradation of colour were not practicable. Perhaps for this reason 'opus sectile' was used much less than mosaic till well on in the Roman period.

In the Roman period there was a tendency to more dispersed and looser composition, figures and ornaments were less insistently modelled, new styles appeared and often a closer connection with textile decoration becomes apparent; but in spite of provincial barbarization, of which Britain provides good examples, much of the Hellenistic tradition survived. This indeed still shows strongly in the mosaics of the Great Palace at Constantinople, laid hardly before AD 500, and can be traced even in the Ummayad hunting lodge of Khirbat-al-Mafjar near Jericho, which belongs to the early eighth century. But these mosaics were designed for profane residences and to decorate floors and so could be more conservative than the devotional mosaics on the walls and ceilings of contemporary churches. The application of mosaics to walls and vaults had begun in earnest in the first

century AD, particularly for fountains in private gardens, and it soon developed into a distinct branch of art. Since they had less wear than on floors, friable or fragile materials such as glass and gold were used more freely for tesseras, so that a more luminous and less naturalistic system of colouring developed. Further, the position and shape of the field encouraged a different kind of composition, much more closely related to painting. It was this branch of mosaics which recommended itself to Byzantine churchmen and became a principal vehicle of their hieratic style, while the older tradition of the floor mosaics withered away. Their place was taken by 'opus sectile'.

Wall Decoration

The simplest kind of decoration for the walls of private houses was to paint the whole surface with a plain colour, especially Pompeian red, but for important rooms a more elaborate style soon became fashionable. This style imitated or at least was based on the appearance of the construction that was regular in formal architecture, and to judge by Etruscan tombs (like that of Plate 29a, though the illustration omits the lower part of the wall) it must have been established in Greek lands by the end of the sixth century. The wall is divided into three principal zones – the dado, which represents the orthostates of masonry, the main field, which corresponds to the coursed blocks or mud brick wall, and the cornice. In careful work the dado ostensibly stands on a low plinth and is topped by a narrow coping, and above the cornice there is an upper field (what builders today call the 'frieze', though to avoid confusion 'attic' is a safer name). These parts of the wall were distinguished by different colour – at Olynthus around 400 the dado was usually white and its coping yellow, and the main field was often red – but other methods of division were used as well. At Olynthus joints between courses and even blocks were sometimes suggested by incised lines or narrow bands of paint, and at Priene and Morgantina no later than the third century we find the plaster modelled to draft the edges of the notional blocks and to allow the cornice to project. During the Hellenistic period there was a growing fondness for more fanciful colouring of blocks and the imitation of variegated stone,

for more complex division of the surface and, as houses at Athens and Delos show, for more elaborate architectural effects (*plate 93a*). This 'Incrustation' or 'Masonry' style is found in all parts of the Greek world including Italy, where the First Pompeian style (so-called through the accidents of discovery) is a later version of it. It seems that palaces too were decorated in the same way, if more expensively; that of Mausolus at Halicarnassus, built rather before 350, was famous for its marble veneering.

As the style became more showy, architectural effects were heightened by illusionist painting. The earliest example so far discovered is in a house at Delos and is dated about 100: here there are, normally enough, modelled pilasters and entablature in the upper part of the main field, but below the entablature a foreshortened coffered ceiling is painted in, so that the space between the columns is presented as if open. From this apparent denial of the solidity of the wall there developed the Second Pompeian or Architectural style, which treats the surface as an architectural frame to vistas of town or country or to scenes of human action. Perhaps to save expense, the use of plaster relief is now rare and instead columns and other architectural members are modelled by appropriate shading. At Pompeii, admittedly a provincial town, this style was coming in around 80, flourished for about sixty or seventy years and then evolved into the Third Pompeian style, in which the architecture is attenuated fantastically and pictures appear in panels of the walls that are depicted between the columns of the foreground and the open vistas at the back. Both the Second and the Third styles seem to have been created for Roman taste, though possibly by Greek artists; but the Greek half of the Roman Empire, that is roughly the lands east of the Adriatic, still preferred the more sober Incrustation style. This had no direct influence on Medieval wall decoration, and since the Renaissance occasional imitations of ancient models have been based on discoveries in Rome, Herculaneum and Pompeii, which went back no further than the Second Pompeian style.

The orthodox Incrustation style had not much use for figures. They appear occasionally, painted or in relief, on the narrow coping above the dado, and sometimes there are painted figures or garlands in the attic. For larger figure painting the obvious place was the undivided middle field of the wall, and there is

some evidence for murals of this sort. The painted Etruscan tombs (*plate 29a*), for which a system of decoration was established in the Late Archaic period, presumably follow private houses of that time; about 420 Alcibiades forced the well known painter Agatharcus to do work in his house, and presumably this was pictorial in quality; and in the mid first century the famous wall paintings of the Villa of the Mysteries at Pompeii seem to continue or revive the tradition. Still, such paintings were probably rare in Greece. Easel pictures must have been much more common, standing on the cornice or perhaps hung in the middle field; at least this is suggested by the imaginary back walls represented in murals of the Second and Third Pompeian styles.

We can only guess at the status and organization of the trade of interior decorating. Plain colouring, of course, could have been done by ordinary workmen, though in the Archaic and Classical periods professional artists who painted pictures (like Agatharcus) were presumably called in for figure scenes. Later the elaborate imitation of variegated stone needed specialized craftsmen and the illusionist architecture and still more the pictorial embellishments of the first century seem to imply some studio training and also, to judge by the repetition of themes (*plate 31a–b*), the use of copy books, however summary the designs they contained.

NOTES ON MUSEUMS

The principal countries where objects of Greek art are found are naturally Greece, Turkey and Italy. In Greece opportunities for collecting and excavating were uncommon till the 1830s and then, as the Turks withdrew, the free export of antiquities was prohibited – with fair success, since the foreign archaeologists who were welcomed there usually accepted the prohibition, if only from prudence. In Turkey and the other territories it ruled, which till 1912 included Rhodes and Samos, no such law was in effect before the First World War and, though travellers were hardly encouraged, those with the right connections could search for works of infidel art and without much difficulty arrange for their removal. As for Italy, where exploration and collecting began before 1500, some local restrictions were imposed in the eighteenth century; but before its unification in the 1860s there was no general law controlling exports and this only became stringent some thirty years later. Antiquities legislation, as it is now enforced, has had two effects. First, the producing countries have conserved much of their artistic patrimony, so that as discovery proceeds they often have difficulty even in storing the objects they accumulate. Secondly, to supply the growing demand from museums and collections elsewhere, smuggling has become an organized business, based mainly on clandestine digging in ancient cemeteries, nor is it likely to decline, unless (like Egypt) the producing countries undercut the market by licensing or operating a largish export of their better surplus stocks. In these conditions the museums of other countries vary greatly in the character of their acquisitions: funds, energy and flair, the times when these were available and, of course, luck have been the main determinants. Nor is any of the collections of Greece, Italy or Turkey by itself fully representative of surviving Greek art;

having enough antiquities of their own they very rarely import from or exchange with others and, as local museums are set up to house local finds, the central museums can no longer draw on the whole national territory. The notes that follow give rough guidance on museums which are rich in one branch or another of Greek art.

Painted Pottery

So far Italy has provided the greatest number of fine and complete pots in the Protocorinthian, Ripe Corinthian, Attic Black-figure, Attic Red-figure and – of course – South Italian Red-figure styles, the most prolific strike being that made at Vulci in Etruria in 1828. This and other early discoveries form the basis of most North European collections, supplemented by East Greek, Corinthian and Attic from Rhodes before 1912. Further, since pots are the commonest goods in graves and are not too large or heavy, they are the staple commodity of smuggling, so that some other wares (such as Geometric) have come on the market in fair quantity. For these reasons Greek pottery is now diffused very widely. In Greece itself the National Museum of Athens has the most comprehensive series of the Attic school, though the quality of the mature Black-figure and of the Red-figure may disappoint visitors. In Italy the Vatican Museum and increasingly the Villa Giulia Museum have admirable collections from Etruria. Elsewhere there are at least equally distinguished and more varied assemblages in the Louvre in Paris, the British Museum in London, the Museum Antiker Kleinkunst in Munich, the Antikenabteilung of the Staatliche Museen in Berlin-Charlottenburg, the Metropolitan Museum in New York and the Museum of Fine Arts in Boston; but there are many lesser institutions which are well stocked, for instance the Ashmolean Museum in Oxford and the University Museum in Philadelphia; and even quite small collections may have some surprisingly good Greek pots.

Panel and Mural Painting

Most of our wall paintings of Greek style and any quality have been found in Italy – in the Etruscan tombs of Tarquinia, the

houses of Pompeii and Herculaneum and Stabiae, and houses in and near Rome. Since detachment and transport are difficult, these have usually been left where they were or taken to the nearest museum. Of the Etruscan finds most are still at Tarquinia, either in the tombs or the museum; the Roman murals are in the Vatican and the Museo Nazionale Romano (or delle Terme); and of the much more numerous pastiches from Pompeii, Herculaneum and Stabiae some are in the Naples Museum and some in their original positions.

Sculpture

Innumerable Roman copies of Greek statues and also some later Hellenistic pieces have been unearthed in Italy since the late fifteenth century, and both the Roman museums and the major collections outside the producing countries are well provided with them. There was also some export of originals from Greece and Turkey, before antiquities laws came into effect. Since then relatively few pieces have been smuggled out; sculpture does not turn up often in illicit digging and may be too heavy and bulky to be transported secretly, anyhow by amateurs. So for Greek works Greece is outstandingly rich: the most comprehensive series is in Athens, in the National Museum and the Acropolis Museum, and the museums of Olympia and Delphi are also important. There are good originals in Istanbul in Turkey and in the Vatican and the Museo Nazionale (Terme) at Rome, while elsewhere in Italy Paestum and Palermo have interesting provincial reliefs; they are, though, less important than some of the North European and American collections. The British Museum has much of the sculpture of the Parthenon, the Temple of Apollo at Bassae, the Nereid Monument of Xanthus and the Mausoleum of Halicarnassus – all of the Classical period – and a good deal else. The Louvre and the Glyptothek at Munich also profited by early enterprise; one possesses, among other famous works, the Nike of Samothrace and the Venus di Milo, and the other acquired in 1812 most of the pedimental sculpture of the Temple of Aphaia at Aegina. Among the late entrants were the Staatliche Museen of Berlin, now by accident divided, so that the sculpture remains in East Berlin and the smaller objects have a new home at

Charlottenburg in West Berlin; they made some enviable hauls in Turkey and Turkish territory – most notably the friezes of the Great Altar at Pergamum – and also bought on the market with skill and determination. So too have the Ny Carlsberg Glyptotek in Copenhagen, the Metropolitan Museum in New York and the Museum of Fine Arts in Boston. In all these museums the visitor can see a fair sample of good Greek sculpture, though none as complete as that in Athens, and since photographs do not give an adequate impression of three-dimensional statuary, there is value in collections of plaster casts, unfashionable though they now are. The best cast collection, anyhow in English-speaking countries, is that of the Museum of Classical Archaeology in Cambridge, where the surface of the plaster has been treated so that it gives a granular appearance and reflects light in fair simulation of the marble of the originals.

Metalwork

Figurines, armour, utensils and other objects of metal are found occasionally in sanctuaries and in graves. They are mostly small enough to be smuggled easily. In Greece the National Museum at Athens has a big and excellent collection, though for Geometric and Archaic work Olympia perhaps is better. In Italy the Vatican and the Villa Giulia are well endowed with Etruscan products, which differ appreciably from Greek. Turkey so far has little to show. Elsewhere most of the big museums have their quotas and there are a few good examples in smaller collections. Jewellery, which comes mainly from graves, invited illicit export. Its present distribution is much like that of less valuable metalwork, except that Olympia has little or nothing and the Hermitage in Leningrad is particularly rich from finds in South Russia, where the native kings and nobles were good customers of their Greek neighbours.

Gems and Coins

Gems, from graves and sanctuaries and casual finding, are too minute for any regular control and most examples of the more

advanced classes have wandered from their country of origin. The largest collections, though not always readily visible, are in the British Museum and the Ashmolean at Oxford, in Berlin (the Charlottenburg museum) and the Münzsammlung at Munich, in Leningrad, in the Bibliothèque Nationale and the Louvre in Paris, and in the Museum of Fine Arts at Boston and the Metropolitan Museum of New York. For earlier seals and gems, turned in by conscientious excavators, the National Museum at Athens is preeminent.

Coins, of which hoards come to light in unexpected places, are also too small for any restrictions there may be to have much effect. Most big and many lesser museums have good cabinets, usually housed in a separate department, and there are also some private collections of importance. Numismatics is in practice a separate and often self-sufficient branch of Classical Archaeology.

Architecture

Architectural members are too big to be removed unobtrusively, even if there were buyers for them. Pieces with finely cut mouldings are often taken to a local museum, but most of the blocks are left lying about ancient sites, more or less meaningless except to the knowledgeable. Ruins well enough preserved to give a fair idea of the original building are uncommon: for public buildings Athens excels, and other self-explanatory remains are mentioned on pp. 185–91. There are also a very few partial reconstructions in museums; the most notable are various edifices from Pergamum, Priene, Miletus and Magnesia – all Hellenistic – in the Pergamon Museum in East Berlin, in the British Museum the Nereid Monument of Xanthos, a fair Ionic structure of the early fourth century, and the rather later tholos of Epidaurus in the little museum on the site.

Interior Decoration

The painted decoration of walls, unless pictorial, is generally left in position, with or without protection against natural or human

destruction. The most complete examples are in some underground tombs, but for the Hellenistic period the most typical may be seen in houses on Delos, sometimes revealing in different patches earlier and later schemes. Mosaics are more durable, though even in Greece most that survive are of Roman or Early Byzantine date. For the older pebble mosaics those at Olynthus were reburied at the end of the excavation, but some from ancient Sicyon are in the museum there. The more advanced pebble mosaics of Pella are also visible – the figured panels in the site museum and the plainer parts in the ruins where they were found. Tessellated mosaics are sometimes treated in the same way, sometimes – as on Delos – left entire in the houses. Still, both wall decoration and mosaics can be studied satisfactorily in illustrations and, unless they are swilled with water, original mosaics tend to look dull in colour.

BIBLIOGRAPHY

PAINTED POTTERY

LANE, [E.]A., *Greek Pottery* ed. 3 (Faber and Faber, London: 1971). A good introductory account.

COOK, R.M., *Greek Painted Pottery* ed. 2 (Methuen, London: 1972). An attempt at a systematic survey, with detailed bibliographies.

DESBOROUGH, V.R.d'A., *Protogeometric Pottery* (Clarendon Press, Oxford: 1952). A comprehensive survey of Protogeometric.

COLDSTREAM, J.N., *Greek Geometric Pottery* (Methuen, London: 1968). A comprehensive survey of Geometric.

AKURGAL, E., *The Birth of Greek Art* (Methuen, London: 1968). Helpful for the sources of the Orientalizing style.

JOHANSEN, K.F., *Les Vases sicyoniens* (Champion, Paris and Pio-Branner, Copenhagen: 1923). The basic study of Protocorinthian, though now the dates need revision and the attribution to Sicyon is discredited.

PAYNE, H.[G.G.], *Necrocorinthia* (Clarendon Press, Oxford: 1931). The basic study of Ripe Corinthian, though the analysis of painters has progressed since then.

BOARDMAN, J., *Athenian Black Figure Vases* (Thames and Hudson, London: 1974). A good survey of Attic Black-figure.

BEAZLEY, J.D., *Attic Black-figure Vase-painters* (Clarendon Press, Oxford: 1956). Catalogues about 10,000 pieces by painters and groups.

BEAZLEY, J.D., *Attic Red-figured Vases in American Museums* (Harvard University Press, Cambridge, Mass.: 1918). The most appreciative account of Attic Red-figure to the end of the fifth century.

RICHTER, G.M.A., *Attic Red-figured Vases* (Yale University Press, New Haven: 1958). A methodical survey.

BOARDMAN, J. *Athenian Red Figure Vases: the Archaic Period* (Thames and Hudson, London: 1975). A good survey of earlier Attic Red-figure.

BEAZLEY, J.D., *Attic White Lekythoi* (Oxford University Press, London: 1938). A good short account.

GREEK ART

BEAZLEY, J.D., *Attic Red-figure Vase-painters* ed. 2 (Clarendon Press, Oxford: 1963). Catalogues over 20,000 pieces by painters and groups.

BEAZLEY, J.D., *Paralipomena* (Clarendon Press, Oxford: 1971). Additions to his catalogues of Attic Black-figure and Red-figure.

TRENDALL, A.D., *The Red-figured Vases of Lucania, Campania and Sicily* (Clarendon Press, Oxford: 1967). Catalogues by painters about 5,000 pieces of these South Italian schools.

TRENDALL, A.D., and **CAMBITOGLOU**, A., *The Red-figured Vases of Apulia I–II* (Clarendon Press, Oxford: 1978 and 1982). Catalogues some 10,000 pieces of the Early and Middle stages of the principal South Italian school.

NOBLE, J.V., *The Techniques of Painted Attic Pottery* (Watson-Guptill, New York: 1965 and Faber and Faber, London: 1966). A detailed account of the technical procedures.

PANEL AND MURAL PAINTING

RUMPF, A., *Malerei und Zeichnung* (Beck, Munich: 1953). Includes a lucid and intelligent, but often speculative account.

VILLARD, F., in J. Charbonneaux, R. Martin and F. Villard, *Grèce Hellénistique* (Gallimard, Paris: 1970). Now translated as *Hellenistic Art* (Thames and Hudson, London: 1973). Well-reasoned and well-illustrated, but also speculative.

JEX-BLAKE, K. and **SELLERS**, E., *The Elder Pliny's Chapters on the History of Art* (Macmillan, London: 1896). For an ancient account of Greek painters.

SCULPTURE

LAWRENCE, A.W., *Greek and Roman Sculpture* (Cape, London: 1972). An intelligent survey, though patchy on Archaic.

RICHTER, G.M.A., *The Sculpture and Sculptors of the Greeks* ed. 4 (Yale University Press, New Haven and London: 1970). A workmanlike account.

CARPENTER, R., *Greek Sculpture* (University of Chicago, Chicago: 1960). The most perceptive general study, though erratic.

LIPPOLD, G., *Griechische Plastik* (Beck, Munich: 1950). Invaluable for references, which can be traced through the index of museums.

ADAM, S., *The Technique of Greek Sculpture* (Thames and Hudson, London: 1966). A useful study.

AKURGAL, E., *The Birth of Greek Art* (Methuen, London: 1968). Helpful for Eastern art in the early Iron Age.

ADAMS, L., *Orientalizing Sculpture in Soft Limestone* (BAR Supplementary Series 42, Oxford: 1978). A good examination of the beginnings of sculpture in Greece.

JENKINS, R.J.H., *Dedalica* (Cambridge University Press, Cambridge: 1936). The basic if over-precise classification of the Daedalic style.

BOARDMAN, J., *Greek Sculpture: the Archaic Period* (Thames and Hudson, London :1978). A judicious survey.

RIDGWAY, B.S., *The Archaic Style in Greek Sculpture* (Princeton University Press, Princeton: 1977). Fuller, but more speculative.

RICHTER, G.M.A., *Kouroi* ed. 3 (Phaidon, London: 1970). A comprehensive illustrated catalogue, logically classified.

RICHTER, G.M.A., *Korai* (Phaidon, London: 1968). A similar catalogue, though the classification is less certain.

PAYNE, H.[G.G.] and YOUNG, G.M., *Archaic Marble Sculpture from the Acropolis* (Cresset Press, London: 1950). A fully illustrated catalogue with detailed study (the Acropolis is that of Athens).

RICHTER, G.M.A., *The Archaic Gravestones of Attica* (Phaidon, London: 1961). A well-illustrated survey.

RIDGWAY, B.S., *The Severe Style in Greek Sculpture* (Princeton University Press, Princeton: 1970). A useful survey of the Early Classical style.

ASHMOLE, B. and YALOURIS, N., *Olympia: the Sculptures of the Temple of Zeus* (Phaidon, London: 1967). A well-illustrated survey.

RIDGWAY, B.S., *Fifth Century Styles in Greek Sculpture* (Princeton University Press, Princeton: 1981). A useful though patchy study of High Classical.

GREEK ART

BROMMER, F., *Die Skulpturen der Parthenon-Giebel* (von Zabern, Mainz: 1963). An exhaustive publication of the sculpture of the pediments of the Parthenon.

BROMMER, F., *Die Metopen des Parthenon* (von Zabern, Mainz: 1967). A similar publication of its metopes.

BROMMER, F., *Der Parthenonfries* (von Zabern, Mainz: 1977). A similar publication of its frieze.

CARPENTER, R., *The Sculpture of the Nike Temple Parapet* (Harvard University Press, Cambridge, Mass.: 1929). An informative analysis.

BIEBER, M., *The Sculpture of the Hellenistic Age* ed. 2 (Columbia University Press, New York: 1961). A usefully illustrated but too dogmatic compendium.

RICHTER, G.M.A., *The Portraits of the Greeks* (Phaidon, London: 1965 and 1972). A comprehensive illustrated catalogue.

JEX-BLAKE, K. and SELLERS, E., *The Elder Pliny's Chapters on the History of Art* (Macmillan, London: 1896). For an ancient account of Greek sculptors.

ROWLAND, B., *The Classical Tradition in Western Art* (Harvard University Press, Cambridge, Mass.: 1963). A useful survey of the effects of Greek sculpture in the Medieval and Modern periods.

METALWORK

LAMB, W., *Greek and Roman Bronzes* (Methuen, London: 1929). Still the best book, though badly needing revision.

CHARBONNEAUX, J., *Greek Bronzes* (Elek Books, London: 1962). Too short, but more up to date.

HIGGINS, R.A., *Greek and Roman Jewellery* (Methuen, London: 1961). A convenient survey.

GEMS

BOARDMAN, J., *Greek Gems and Finger Rings* (Thames and Hudson, London: 1970). The best general study, though short on Hellenistic.

COINS

KRAAY, C.M., *Greek Coins* (Thames and Hudson, London: 1966). A sound introduction.

ARCHITECTURE

DINSMOOR, W.B., *The Architecture of Ancient Greece* (Batsford, London/New York: 1950). The standard historical survey with full bibliographies.

ROBERTSON, D.S., *A Handbook of Greek and Roman Architecture* ed. 2 (Cambridge University Press, Cambridge: 1959 and paperback 1969). A shorter historical survey.

LAWRENCE, A.W., *Greek Architecture* ed. 2 (Penguin Books, Harmondsworth: 1969). A broader and more critical survey, and better illustrated.

PLOMMER, [W.]H., *Ancient and Classical Architecture* (Longmans, Green and Co., London/New York: 1956). A shorter critical survey.

MARQUAND, A., *Greek Architecture* (Macmillan, New York: 1909). Still the best analytical account, though needing revision.

COULTON, J.J., *Greek Architects at Work* (Elek Books, London: 1977). An illuminating examination of principles and practice.

ORLANDOS, A.K., *Les Matériaux de construction et le technique architecturale des anciens Grecs* i–ii (De Boccard, Paris: 1966 and 1968). A useful detailed account.

HODGE, A.T., *The Woodwork of Greek Roofs* (Cambridge University Press, Cambridge: 1960). A rational study of the remains.

SHOE, L.T., *Profiles of Greek Mouldings* (Harvard University Press, Cambridge Mass.: 1936). Comprehensive and fully illustrated.

STEVENS, G.P., *Restorations of Classical Buildings* (American School of Classical Studies at Athens, Princeton: 1955). A helpful though small collection.

STUART, J. and REVETT, N., *The Antiquities of Athens* i–iv (London: 1762–1816). The pioneering work and still useful for its measured drawings.

PENROSE, F.C., *An Investigation of the Principles of Athenian Architecture* (Macmillan, London: 1888). Still valuable on proportions and refinements.

WYCHERLEY, R.E., *How the Greeks Built Cities* ed. 2 (Macmillan, London: 1962). A clear short account of town-planning and types of buildings.

Vitruvius, *The Ten Books on Architecture*, translated by M.H. Morgan (Dover Publications, New York: 1960). The only ancient manual on architecture, but misleading on the Greek styles.

CROOK, J.M., *The Greek Revival* (Country Life Books, Feltham: 1968). A summary illustrated record of Grecian architecture in Britain.

RICHARDSON, A.E., *Monumental Classic Architecture in Great Britain and Ireland during the Eighteenth and Nineteenth Centuries* (Batsford, London: 1914). Knowledgeable and well illustrated.

INTERIOR DECORATING

RUMPF, A., *Malerei und Zeichnung* (Beck, Munich: 1953). Includes an intelligent, though partly conjectural survey of wall decoration and mosaics, before the discoveries at Pella.

ROBERTSON, C.M., in *Journal of Hellenic Studies* 1965, pp. 72–89 and 1967, pp. 133–6. On the earlier mosaics: speculative, but useful for references.

INFLUENCE OF GREEK ART AND ARCHITECTURE

SCHLUMBERGER, D., *L'Orient hellénisé* (Michel, Paris: 1970). A speculative but illuminating assessment of the effects of Hellenistic art and architecture in the East.

(Other, more specialized works on Greek influence are mentioned in the appropriate sections above.)

GLOSSARY

(Terms already explained can be found through the Index.)

ADYTON An inner room at the back of the cella of a temple.

AEGIS A sort of cape with the Gorgon's head at the front and a fringe of snakes; it is often worn by the goddess Athena.

AMPHIPROSTYLE Having a row of columns across each end, but not along the sides (compare p. 186 on 'prostyle').

ANDRON The 'men's room' of a Greek house, usually the dining-room.

ANTHEMION A band of floral ornament, usually lotus and palmette (as Plate 89a and on the sima of Plate 80).

APOTROPAIC A scholarly term for something that averts evil magically (see p. 104).

ARCHAISTIC Imitating Archaic.

ARGOLID The district of which Argos was the principal city.

ARTEMISIUM A sanctuary or temple of the goddess Artemis.

ATTIC (adjective) Of Attica, the home territory of Athens: 'Attic' and 'Athenian' are used more or less interchangeably.

BEZEL Here used of the broadened decorated protuberance of a finger ring.

BUCRANIUM An ox head or skull, especially when carved in relief for architectural decoration (as on the frieze of Plate 86).

CANALIS A more learned name for the channel of the Ionic volute.

CAULICULUS The grooved stalk from which in Corinthian capitals some acanthus leaves and volutes sprout (see Plate 88e).

CAVEA The auditorium of the Greek theatre.

CAVETTO A simple concave moulding (Plate 89a, at the bottom).

CELLA The main and most often the only room of a Greek temple.

CHAMFERED Bevelled (the bevelled surface being flat and not curved).

CHLAMYS A short cloak or cape.

CHTHONIC Of the gods of the underworld (as opposed to those of the heaven above).

COFFER A recessed rectangular panel in a ceiling etc. (a very large example is shown in section on Plate 85 and smaller ones on Plate 77).

CONSOLE A projecting vertical bracket supporting a cornice or door-hood.

CORBELLING In architecture the covering of a room or opening in a wall by horizontal courses, each projecting beyond the one below till the spade is closed.

CORONA The upper projecting part of a cornice.

CREPIDOMA The stepped platform of a Greek temple or more narrowly its outer part.

CREPIS As 'crepidoma'.

CYCLADIC (1) of the southern islands of the Aegean Sea (including most notably Delos, Paros, Naxos, Thera, Melos and Siphnos). (2) Of the Bronze Age culture of these islands.

DADO The lower part of the face of a wall, if visually distinguished from the upper part.

DAIMONIC A fashionable term used loosely of supernatural powers extraneous to orthodox religion (compare p. 40).

DIAZOMA A corridor separating upper and lower rows of seats in a Greek theatre.

DISTYLE (in antis) Having at the end two columns (between antae).

DRAFTING In architecture the dressing back of the edge of a block of stone (as on the base of Plate 87).

ENGAGED An engaged column does not stand free, but appears to project from a wall.

ENTASIS The convex tapering of the shaft of a column.

EPISTYLE Another word for 'architrave'.

EUXINE The Black Sea.

EXEDRA (1) A rectangular or curved recess in a wall. (2) A semi-circular stone seat, usually in the open in a sanctuary.

EXERGUE A segment at the bottom of a circular field (as on Plate 16b – the small field with the fishes).

FASCIA In architecture a flat projecting band, rather wider than a fillet.

FIBULA A brooch.

FILLET In architecture a narrow flat projecting band.

FRET (Greek) A meander.

GANOSIS The waxing of the surface of painted marble or stucco to preserve the colouring.

GEISON Strictly a block of a cornice.

GORGONEION The head of a Gorgon, till the Classical period represented as monstrous (compare Plate 44c – shield blazon of second soldier from right).

GRANULATION In metalwork the soldering of very small globules of gold onto a smooth surface.

HEADER A brick or oblong block of stone laid with its (short) end to the face of the wall.

HEKATOMPEDON A temple 100 feet long.

HELLADIC Of the Bronze Age cultures of the Greek mainland.

HERAEUM A sanctuary or temple of the goddess Hera.

HERÖON The sanctuary or shrine of a 'hero', that is a semi-divine personage.

HIPPED A hipped roof is one where the ends as well as the sides are sloping.

INTAGLIO A design cut into the surface, as the device on a seal.

ISLAND More or less equivalent to CYCLADIC (1).

ISODOMIC Of walls where the courses are of the same height.

KEY (Greek) A meander.

MAGNA GRAECIA Strictly the Greek districts of South Italy, but extended sometimes to include Sicily.

MEANDER A continuous rectangular ornament that keeps returning on itself. Plate 3 shows the simple form near the top and a complex form at the middle of the neck, and there is another version on Plate 24.

MEDIAN LINE An imaginary line which divides the front of the torso vertically.

MODILLION A projecting horizontal bracket supporting a cornice.

MORBIDEZZA The excessive smoothness obtained by polishing marble to a high gloss, as in some Hellenistic and Roman sculpture. This condition is also called 'Sfumato'.

NAOS In modern usage another name for the cella of a Greek temple.

OCTASTYLE Having a row of eight columns at the end.

OCULUS The eye of a volute.

OECUS Sometimes used (as by Vitruvius) for the main room of a house.

OPISTHODOMUS Strictly a recessed porch at the back of a Greek temple, but sometimes used as a back room in the cella.

ORIENTAL In Greek archaeology this refers to the nearer East –
Syria and Phoenicia and the countries beyond them and
also Egypt. Hence 'Orientalizing'.

OVOLO See Plate 89b.

PALMETTE An ornament composed of simple leaves arranged in
fan shape: there are examples on Plates 6c (rudimentary),
9, 13, 16a, 18, 19 and 26 (degenerate).

PERISTYLE A (surrounding) colonnade.

PINAX (1) A painted plaque or panel, large or small. (2) A dinner
plate, though this use is now uncommon.

PLINTH A low, usually square member at the bottom of a column
(or a low projecting course at the foot of a wall).

PODIUM Platform with mouldings like those of a pedestal, but
supporting an entire building.

PONTUS (1) The Black Sea. (2) A region in northern Turkey, bor-
dering on that sea. (The name 'Pontic' for a class of
painted pottery is due to a mistake about its place of
manufacture.)

POTNIA THERON An erudite name for Mistress of the Beasts
(p. 40).

PRONAOS The porch in front of the cella of a temple.

PROPONTIS The Sea of Marmara.

PROSCENIUM The front of the stage building ('skene') of the
Greek theatre.

PROTHESIS The lying in state of a corpse (compare Plate 6a).

PROTOME An independent forepart of an animal (as on Plate 14)
or upper part of a human figure.

PRYTANEUM The office and dining-room of the presiding officials
of a Greek city.

PSEUDOPERIPTERAL Of a building in which part of the sur-
rounding colonnade, normally the sides and back, is
engaged (q.v.).

REPOUSSÉ In metalwork this means hammered from the back so
that the decoration is in relief.

SFUMATO See MORBIDEZZA.

SLIP In Greek archaeology 'slip' usually means a thickish coating
of clay of a different constitution from that of the rest of
the pot: a thin coating of this kind is called a 'wash'.

SOFFIT In architecture the visible underside of a member.

STELE An upright slab, usually of stone, serving as a grave monu-

ment (and then often carved or painted) or to display public notices (usually inscribed).

STEREOBATE All or some part of the substructure of a building.

STRETCHER A brick or oblong block of stone laid with its (long) side to the face of the wall.

-STYLE The Greek word 'stylos', which means 'column', forms the second part of many compounds of various types – viz. 'peristyle' (where it refers to the form of the colonnade), 'hexastyle' (where the Greek numeral prefixed gives the number of columns at the end) and, though not now in regular use, 'eustyle' (indicating one of the systems of spacing listed by Vitruvius).

TEMPLATE A pattern laid against a profile to test its accuracy.

TETRASTYLE Having four columns at the end.

TOREUTIC A Greek term of uncertain definition, but usually more or less equivalent to 'metalwork'.

TROCHILUS A Greek word for 'scotia'.

TRUSS A framework (of a roof) in which sloping and horizontal members are tied together.

VERMICULATE Of mosaics this refers to the use of lead strips.

Note. The modern use of Greek words is not always the same as that of the ancients.

INDEX

abacus 194, 217, 218
Achaemenid art 108, 119, 165, 170, 221, 244
acrolithic 75
acroterion 200, 225
adyton 267
aegis 267
Aeolic capitals 212
agora 238-40
alabastron 28
Alexander mosaic 68-9, 251
altar 185, 190
amphiprostyle 267
amphora 27
amygdaloid 167
Analatos painter 41, 45, 46
anastylosis 174
anathryosis 180-1
Anatolian influence 213
Andocides painter 53
andron 267
angle contraction 208
annulet 194
anta 200-1, 222-3
antefix 199, 222
anthemion 267
Aphrodite of Cnidos 137
apophyge 216
apotropaic 267
Apoxyomenos 136
apse 176-7, 178-9, 237-8
arch 178, 183, 238
Archaic period 12

Archaic smile 99
Archaistic 267
architecture 173-246
 colouring 182-3, 204-5, 225-6, 247-54
 Corinthian Order 218, 220
 deployment of Orders 210-11, 228
 development 230-8
 Doric 191-211, 230-1, 232-4, 235-6, 237
 influence 244-6
 Ionic 211-28, 231-2, 234-5, 236-237
 Mixed Orders 228-30, 232-3, 237-8
 origins 175-8, 191-2, 212-214
 proportions 175, 205-7, 226
 refinements 208-9, 227-8
 sculpture 204, 225
 sources of knowledge 174
 spacing 207-8, 227
 survival 15, 18, 259
 types of buildings 184-91
Architectural style (murals) 253
architrave 195, 219-20
Argolid 267
arris 194
Artemisium 267
aryballos 28, 43
Assyrian influence 40
astragal 203, Plate 89b

INDEX

INDEX

INDEX